LIMNERS AND LIKENESSES

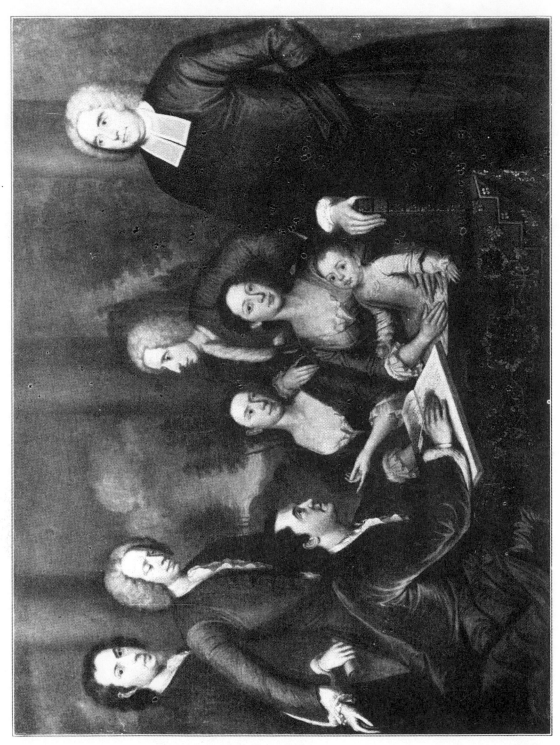

BISHOP BERKELEY AND HIS FAMILY BY JOHN SMIBERT, 1729

Yale University, New Haven, Conn.

LIMNERS AND LIKENESSES

Three Centuries of American Painting

BY

ALAN BURROUGHS

NEW YORK / RUSSELL & RUSSELL

1965

HARVARD–RADCLIFFE FINE ARTS SERIES

To

M. L.
PAINTER AND AMERICAN

CONTENTS

CHAPTER IV

CHAPTER V

LIMNERS AND LIKENESSES

INTRODUCTION

SINCE the purpose of this criticism is to define whatever tradition of painting exists in what we call euphuistically the United States, the first matter for attention is one of nationality. The colonies which preceded the states were obviously not one nation; yet as one considers the pre-Revolutionary painters, many of whom were born abroad, one realizes that nationality is not only a matter of birth and politics. In art it is primarily a matter of environment. Although El Greco was born a Greek and educated in Italy, he became more Spanish than Spain; Picasso is a French modernist, though born in Spain. And Whistler, who might have become an army officer in the United States had he not failed in chemistry at West Point, was not so much an American as he was a French-feeling artist roused by the novelty of Japanese patterns. The spirit and character of time and place produce traits independent of accidents of birth and early training.

Nationalism seems to exist even when there is no political reason for it. Smibert, the Scotchman, coming to Newport in 1729 as a member of Bishop Berkeley's company, found the new England different and acceptable; he became a New Englander and relished the marvelous people who wanted to be painted as they were and not as they might have been painted in England. Among Smibert's contemporaries Joseph Badger, born in Charlestown near Boston, painted his bold and simple records of an unperplexed society, foretelling the best part of Copley's achievement. Although not all of the so-called Primitives were forerunners of the future — Greenwood, for instance, was merely an unskilled limner trying to be stylish in the way that Thomas Hudson was being stylish at "home" — a new and distinguishing element frequently entered into colonial painting. The same independent spirit

which directed the Puritans to New England seems to have given the descendants of Puritans a taste for independent art and for hard likenesses, as Copley noted, instead of grace of line. And the difference between life in the colonies and life in the old country was approximately the difference between the art of the old and the art of the new world, the more democratic, more nervous, more realistic, and more solid existence of the "yeoman" colonist having produced its effect on the colonial painters as a whole. Copley's first contribution to the exhibition of the Society of Artists of Great Britain, a novel success ten years before the Revolution, was known as "the performance of a young American." Joshua Reynolds and others recognized the nationality of the picture before there was an American nation.

CHAPTER I

The Effect of Netherlandish Realism in the Seventeenth Century

THE VERY early colonists knew only a European type of art which was not to become Americanized for several generations. All over northern Europe painting was being done in a mixture of Dutch and Flemish styles. The success of Van Dyck produced a succession of artists more or less related to him by their mannerisms, the elegance of their effects, their luxurious and metallic draperies, their love of haughty poses and technical dexterity. Dobson, painter to Charles I in 1641, Sir Peter Lely, who came from Holland at that time to study under the Anglicized Sir Anthony Van Dyck, Beaubrun, painter to Louis XIV and one of the founders of the Royal Academy at Paris in 1648, were among those so successful in their turn that their followers spread an aristocratic Netherlandish style wherever there were Europeans claiming any aristocratic position. Among the English followers were Robert Walker, John Riley, Mary Beale, and Hargrave,[1]* who are of interest to us since it was their versions of Flemish art which were current during the period of the main settling of New England. Vanderspriet and others, trained in the Low Lands, catered to the English with a provincial but sincere and realistic kind of portraiture. Herbert Tuer, whose portrait of *Leoline Jenkins* (National Portrait Gallery, London), dated 1679, serves as counterpart to certain portraits much liked by the colonists in Massachusetts, worked in Holland for several years. Sir Godfrey Kneller, whose name is attached in vain to many a family portrait in the

* Notes and references will be found at the end of each chapter.

South, was of course a Fleming and the continuator of the Van Dyck-Lely tradition.

<div align="center">I</div>

PAINTINGS IMPORTED BY THE ENGLISH COLONISTS

Thus the portraits which a few of the more wealthy pioneers brought with them to America bore the stamp of the Low Countries, affixed either in England by the popular painters, or in Holland by admired foreign masters. *John Winthrop*, as portrayed in the picture owned by the Antiquarian Society, Worcester, Mass., which is the original of a group of similar portraits in Boston and Cambridge, was painted in Holland, obviously. The silvery portrait of *Sir Richard Saltonstall* (Mrs. Richard M. Saltonstall, Boston) may not have been done by Rembrandt, as tradition says, but it was surely done by someone who knew Rembrandt's style of about 1640. *William Pynchon* (Essex Institute, Salem, Mass.), who left America in 1652, is represented according to the Dutch formula in a picture dated 1657. The dim and damaged likenesses of *John Endecott* (William Crowninshield Endicott, Boston), *John Leverett* (Essex Institute, Salem, Mass.), and the *Unknown Lady* (New Haven Colony Historical Society, New Haven, Conn.), of 1635, were all painted by Dutchmen, probably. The group of eight family portraits imported in 1675 by Nicolas Roberts, including his own portrait and that of his wife (Fig. 2), suggest one or more followers of the tradition which produced Herbert Tuer. *George Jaffrey* (Mrs. James Howard Means, Boston) may also have been painted in England by a Dutch-trained journeyman master. When these and other pictures were imported is not always easy to determine. But it is clear that they were not the product of local limners, if those limners were like the few whose careers will be suggested in section 3 (page 8). The solid, suave modelling of the portrait of *Simon Bradstreet* (Boston Athenaeum), which is close to the Rembrandt School,[2] the Lely-like portrait of *Joseph Dudley*

and the sophisticated head of *William Hayley* (Massachusetts Historical Society, Boston), the delicate modelling of the portrait called *The Lynn Gentleman* (William Tudor Gardiner, Boston), which is perhaps a mortuary portrait, since the cloak spread across his chest could not remain in its place unless the body were lying flat, are all in a class which is definitely beyond the scope of the native art which can be identified in Massachusetts, or the South, at this early date. In spite of the tentative identification of the portrait of *Gov. Richard Bellingham* (Estate of Thomas B. Clarke, New York) as the work of William Read, a resident of Massachusetts,[3] it is impossible to credit any of these portraits to local artists.

<div align="center">2</div>

<div align="center">THE DUTCH TRADITION IN NEW AMSTERDAM</div>

Naturally in agreement with this taste for Netherlandish realism, relieved only by the sentimental filtering which took place in England under Kneller's rule, was the taste of the Dutch colonists in New Amsterdam, who had excellent home-trained painters to serve them, and who also had for models imported paintings of standard worth, like the portraits of *Lazare Bayard* and his wife *Judith de Vos* (New York Historical Society), which were brought over by Stuyvesant in 1647. Jacobus Gerritsen Strycker, born in Holland, came to New Amsterdam in 1651 and was made a burgher in 1653; he later became an alderman, attorney general, and sheriff, which is evidence of his good education and ability. The picture of *Jan Strycker* (Estate of Thomas B. Clarke, New York), dated 1655 and bearing an inscription on the back, presumably two generations later, to the effect that Jacobus Strycker was the painter of his brother Jan,[4] allows one to believe that the artist had been a pupil of some first-class Amsterdam realist. Henri Couturier, French in name but having a son in Holland in 1663, according to a bill of goods bearing the same monogram [5] that appears on the graceful por-

trait of *Frederick Philipse* (Estate of Thomas B. Clarke, New York), dated
1674, may have been a Franco-Flemish painter. Evert Duyckinck came
from Holland to New Amsterdam in 1638 as a limner and glazier; he
founded a family of painters and artisans who continued to serve the
public well into the next century. He became an Englishman by oath
in 1664 when New Amsterdam was captured by the English, and is sup-
posed to have painted *William Stoughton* (Boston Athenaeum) in 1685,
according to a mysterious Bible record said to belong to the descend-
ants of the "Brown family" of Boston. At least the vanished entry after
Stoughton's name, which says "His likeness drawn by Evert Duyckinck
limner 1685 in north room," has been considered to refer to this par-
ticular painting, even though the style of the picture reminds one of
anonymous English portraits of the period.

If these documents and inscriptions identify the art of these painters,
it is difficult to accept the evidence of other signatures and the attribu-
tions of other portraits to the same artists. There is a confusing dis-
crepancy between the portrait of *Frederick Philipse*, mentioned above,
and the red-faced portrait of *Oloff Stevense van Cortlandt* (Estate of
Thomas B. Clarke, New York) which is also signed with the monogram
found on Couturier's bill of goods. Although these portraits have not
been accessible to the public, it is clear from photographic illustrations
alone that there are differences in characterization and modelling which
are not easily explainable as coming from the hand of a single artist.
The bold portrait of *Peter Stuyvesant* (Fig. 1) tentatively attributed to
Couturier at one time by John Hill Morgan [6] and to Strycker by
Charles X. Harris, in a report published by the New York Historical
Society, seems to be in a class by itself; it is a better version of the
broadly modelled style of portraiture which will be considered in the
next section, dealing with Dutch influence on the Massachusetts paint-
ers in the last part of the century. The rather soft and Kneller-like por-
trait of *Stephanus van Cortlandt* (Estate of Thomas B. Clarke, New York),

said by F. F. Sherman [7] to have been painted by Evert Duyckinck in 1693, and the portrait of *Caleb Heathcote* (Fig. 3) which Mr. Morgan [8] considered might be by the same painter, do not resemble the portrait of *William Stoughton* already mentioned. The latter is modelled delicately, with greater precision about the eyes and more detailed folds in the shoulder. However, the portrait of *Caleb Heathcote* has also been attributed to Evert Duyckinck III, the son of Evert I, who was born about 1675. Whatever resemblances there are between these various portraits, as in the matter of painting lace, might be explained by the simple fact that the pictures are the work of competent craftsmen who followed a well established tradition of painting, derived from that in the Low Countries.

There are other early pictures, like the portrait of *Adrian van der Donck* (Estate of Thomas B. Clarke, New York), which Mr. Sherman [9] says was painted by Strycker in 1654 and which has a convincing resemblance to the portrait of *Jan Strycker*. But they cannot all be placed. An equestrian portrait of *Nicholas William Stuyvesant* (New York Historical Society), dated 1666, is such a mixture of bland realism and stiff pattern that it may be assumed two artists have worked on the canvas, one on the head and one on the toy-like hobbyhorse. More interesting still are the questions raised by the portrait of *Sir Edmund Andros* (Henry L. Shattuck, Boston), which suggests vaguely the portraits considered to be by Evert Duyckinck and which also suggests the English style branching from Dutch and Flemish art. In most of these pictures dignity and austere taste, good drawing, and a sense of reality help to convince us today that the portraits were good likenesses. The choice of the early settlers in both New Amsterdam and Boston was evidently for plain face-painting and simple patterns.

3

A LIMNER OF 1670 AND HIS ASSOCIATES

The occupation of New Amsterdam by the English in 1664 may have
been responsible for the appearance in and about Boston of journeymen
painters who adapted the Dutch style to their own rather clumsy ends
and painted a surprising number of quaint likenesses, many of which
were recently exhibited together at the Worcester Art Museum.[10] A
series of children's portraits and a few scattered portraits of men have
been tentatively attributed to one artist whose chief characteristic is a
frank insistence on the pattern made by stiff clothes. Although this
characteristic has been noted in provincial painting of most countries,
especially early Swedish painting,[11] one need not travel so far for a clue
to the origins of such a style. In the American wing of the Metropolitan
Museum, New York, have been exhibited two portraits of children,
dated 1631, representing *Jacques* and *Sara de Peyster* (Mrs. Charles H.
Jones, New York), who were born in Holland and never came to
America. They are painted full length in much the same way that
Govaert Flinck with his greater skill painted the *Portrait of a Girl* (Royal
Museum, The Hague) in 1640. And they indicate beyond question the
Dutch origin of the stiff mannerisms found in the astonishingly numer-
ous portraits of New Englanders painted in 1670, and soon afterwards,
by an unknown country limner.

Or should one say the unknown limners? Three groups can be de-
termined for the nine portraits dated 1670. And to these groups can be
added three additional portraits dating from a few years later. Al-
though closely linked in type of pose, setting, color, costume, and con-
ception, the pictures within these groups are distinguishable on a basis
of skill and manner of handling pigment. Were it not for the fact that
the differentiating characteristics can be found in portraits which must
have been painted concurrently, instead of successively, the differences

between groups might be explained as due to the development in skill of one individual. It is not likely, however, that the artist who painted the crudely flat and amateurishly handled caricature of *John Davenport* (Fig. 4) could in the same year portray the so-called *John Quincy* (Fig. 6) with delicately blended brush strokes and minute care for the rotundity of cheeks. Nor could he have painted, still in the year 1670, the remarkably vigorous portrait of *Robert Gibbs* (Fig. 5), which seems, in contrast with the other two likenesses mentioned, a stylized and elegant portrait.

The chipped and yellowed surface of the group portrait of *Three Children of Arthur Mason* (Paul M. Hamlen, Boston) tends to disguise the fact that this painting is smoothly handled with short, blended strokes in the same technique evident in the portrait called that of *John Quincy*.[12] Being in better condition than the group portrait, the latter, modelled as if in a miniaturist's technique, pearly in surface, clear in shape, and bold in mass, may be taken as representing the work of a Dutch-inspired artist of some ability, working in Massachusetts in 1670 independently of the Anglo-Flemish style of the popular followers of Van Dyck.

Compared to this anonymous limner, the painter of the portrait of *John Davenport* (Fig. 4), who was also the painter of the so-called *John Cotton* (Connecticut Historical Society, Hartford, Conn.), is a tyro; his brushwork is messy and repetitious, instead of being smooth and neat. His technique is especially erratic in the portrait of *John Cotton*, which has been considerably altered since it was first painted and inscribed to the left of the head, "Anno Domini 1670 Aetatis. . . ." Originally the sitter had his right hand raised to the bottom edge of his cravat, which was then larger and perhaps not intended to have a clerical significance. This original cravat, appearing in two distinct positions, probably was changed in an effort to make the chest appear deeper and more solid. The sitter's left hand grasped the book by its bottom edge, instead of resting it upon his palm. Although the head and features were origi-

nally much the same as on the surface, the eyes looked out more nearly ahead — that is, to the spectator's right. All these changes, revealed by X-ray examination of the repainted picture,[13] seem to have been made by the original artist, presumably in an effort to please himself or his patron. These second thoughts and fussy corrections imply that the artist was in temperament exactly opposed to the placid, neat, and consistent painter of the assumed *John Quincy* and the *Mason Children*. Ingenuous as it is, his artistry has a certain amount of breadth and vitality. Looking for other examples of the same technique, one finds that the portrait of *John Wheelright* (State House, Boston)[14] corresponds in its erratic brushwork and heavy-handed caricaturing not only with the portrait of *Davenport* (Fig. 4) but with the portrait of *John Cotton*. As in the last-mentioned effort, the portrait of *Wheelright* contains hidden corrections in the size and position of the collar. Since the picture is dated 1677,[15] one can thus predicate a seven-year activity for the artist in and near Massachusetts.

Half-way between the two groups of portraits already defined comes another group, typified by the freer, more lively, and better controlled technique which appears in all three portraits of the Gibbs children, *Margaret* and *Henry* (Mrs. Alexander Q. Smith, Charleston, W. Va.) and *Robert* (Fig. 5), each dated 1670. If anything, this artist is closer to the *Davenport-Cotton-Wheelright* painter than to the author of the *Mason Children*, because he was a lively craftsman and one who believed evidently in the artistic value of a spontaneous touch. He set down what he had to say about the features of *Robert Gibbs* without hesitation and without corrections. He had certain dainty mannerisms, as in the graceful gestures attempted in the hands of the girls, but he was essentially a rapid, masculine type of painter, distinct from the delicate person who gradually modelled the portrait called *John Quincy* into a state approaching perfection of surface. That he was the painter of two portraits of *John Freke* and *Elizabeth Freke with Baby Mary* (Figs. 7 and 8)

must be evident on comparison of the brushwork and drawing of comparable details, such as mouths, and because of the fine realistic spirit coupled in each case with a bold sense of design. But the *Freke* portraits, datable in 1674, are more sensitive in some ways than the *Gibbs* portraits of 1670. Baby Mary's pose was altered by the artist, probably in an effort to bring mother and daughter into a closer relationship. The baby originally did not have her left arm raised, nor did the mother's left hand reach out to steady the child; at first the baby held something resembling a glove in her right hand. In further proof of the painter's sensitiveness to details of drawing, design, and reality of pose, it should be mentioned that John Freke's eyes were originally painted $\frac{3}{8}$ of an inch lower in position. The alteration to their present position could only have been prompted by a desire to better the proportions of the face.

Could this painter who corrected his drawing so freely in 1674 be the same as the *Davenport-Cotton-Wheelright* painter, who also, it has been shown, changed his mind in the course of painting a portrait? Logically one cannot admit that he was, because then one would have to believe that in 1670 he painted portraits as coarse as the portrait of *Davenport* (Fig. 4) and as sophisticated as the *Gibbs* portrait (Fig. 5), and that in 1674 he painted the most skillful and sensitive portraits of them all (Figs. 7 and 8) only to follow in 1677 with the awkward caricature of *Wheelright*.

The painter of the *Gibbs Children* and of the *Frekes* would be noticed as a charming genius in any sophisticated society, one may suppose, especially in a society which was suspicious of social pretense. But it seems astounding that before King Philip's War, when the Indians burned houses close to Boston, in Weymouth, Andover, and Sudbury, a sensitive limner was quietly following his trade with such assurance that he must be recognized today as one of the leaders of the new civilization in the wilds of Massachusetts, and that he was but one of three painters who used the same formulas in their work.[16]

What documentary evidence is there for the identification of these portraits? In all the items listed in the wills of the people represented and in the wills of their descendants, including apparently every spoon, dish, stool, and drape, and including the mirrors hanging on the walls, there is scarcely the mention of a painting. In all the items listed in diaries, notebooks, and business records, there appears only an occasional reference to a portrait. Furthermore, only a few names of XVIIth century limners are known; and none of them can be linked with the pictures already mentioned. John Foster, who died in 1681, is known merely as an engraver, although his print of *Richard Mather* resembles the painting of *John Davenport* to such an extent that Theodore Sizer has suggested attributing the *Davenport* portrait to him. The artist whom Cotton Mather introduced to John Wilson in 1667 is unnamed in the Reverend Doctor's Magnalia Christi Americana. In 1684 a painter named Joseph Allen was sent by Nathaniel Mather to Increase Mather. A certain Tom Child, strangely mentioned in Sewall's Diary,[17] was obviously not typical of the 1670 painters, if the portrait of *Sir William Phips* (William Tudor Gardiner, Boston) is correctly inscribed upside down on the back of the canvas, "Ye Child portrait (or pictur?) William Phips Knight and Govr. of ye province." The style of the portrait is sophisticated and Kneller-like, recalling T. Brownover's portrait of *John Locke* (National Portrait Gallery, London), and especially a pair of portraits, dated 1711, five years after Tom Child's death. One of these, that of *Mrs. Mary Hooker Pierpont* (Fig. 15), done in exactly the same style, with the same brush strokes, as the portrait of *Phips*, tends to discredit the attribution to Tom Child of any portraits done in this accomplished manner.

Only one artist mentioned in XVIIth century records may be considered identified; and he, Thomas Smith, has no more to do with the artists of 1670–77 than has Tom Child, as far as we know. In 1680 "Major" Thomas Smith copied a portrait of Dr. Ames for Harvard

University,[18] and in 1693, according to tradition, he painted a portrait of Maria Catherine Smith. The portrait of *Dr. Ames* (Harvard University, Cambridge, Mass.) which thus might seem to be identified as the work of Tom Smith is unfortunately of no use in tracing his style, since the picture was given to Harvard in recent years and cannot be traced to the copy formerly in the possession of the University, which presumably was burned in the fire of 1764, as Clifford B. Clapp has suggested.[19] In fact the skillful style of the portrait now extant suggests a Dutch painter close to Willem van der Vliet.[20] Furthermore there are no indications of copyist's technique, no excess of outlines, no flat areas painted in imitation of a pattern without underpainting, no simplifications of method as when the copyist sees the modelling all worked out for him. The portrait of *Dr. Ames* is evidently early XVIIth century work and may thus be tentatively set down as the original from which Tom Smith made his reported copy.

However, the portrait of *Maria Catherine Smith* (American Antiquarian Society, Worcester, Mass.), traditionally attributed to Tom Smith in Civil War times, when the identity of the artist would be difficult and meaningless to "forge," gives the chief clue to the artist's style. Obviously the portrait is patterned after the Lely-Kneller model. Yet just as obviously the technique, characterized by large, erratic brushwork, is bluff in a Netherlandish, but provincial, manner; the artist followed set rules, it seems, in defining the forms of the face and in creating a mask of geometrical shapes. Incidentally this artist, so sure of himself in shaping Maria's large eyes, fiddled clumsily with the frill of undershirt across her bosom, changing the line of décolletage and covering over a design which he had at first painted on the edge of her bodice. The inevitable conclusion is that in 1693, the traditional date of the portrait, he was not a highly trained or skillful craftsman. His technique was formalized to a certain extent, but he did not know how to create an illusion of light on cloth; his method of painting a face

was bold and energetic, but he did not endow his sitter with personality.

This is exactly the conclusion reached through study of the portrait of a man, called a *Self-Portrait* (Fig. 10), which is signed T. S. on a paper bearing a pietistic inscription. Perhaps the view of a fort and sailboat through the window refers to some incident bearing on his career; but the facts are not known. Here the technique is rough, elementary, impatient, and not skillful; the brushwork is scratchy, as if the artist were working in short-hand, instead of in the rather elaborate manner of the portrait of *Maria Smith*. Again one sees in the forms of the face an interest in pattern, but no special concern for personality. Evidently Tom Smith may be called an energetic, but cold, artist.

Was he then the painter of a group of portraits which have been tentatively linked to him since they were assembled recently at the Exhibition of Seventeenth Century Portraits in Worcester? The earliest picture of the group may be the portrait of *Mrs. Patteshall with Her Baby* (Fig. 11); if correctly identified, she was married about 1672 and might therefore be represented with a daughter nearly two years old about 1674. The painter evidently was familiar with standard Flemish designs of the period and applied his pigments thinly in a skillful effort to represent the depths of form which he observed in his sitters. He was not an inspired draftsman, especially when it came to wrist joints, but he strove honestly to record the fullness of sleeves and to project the figures like columns in front of the background. His brushwork was subtle, his temperament deliberate, if one may judge by the static arrangement of details in the design.

Probably the same artist painted the portrait of *Major Thomas Savage* (Fig. 12), which is dated 1679. Not only do the two portraits agree in subtlety of modelling and point of view; they agree in brushwork with much exactness. The shoulder of *Major Savage* is painted with delicate, sweeping strokes that create an illusion of bulk in the same way that

delicate strokes create a sweeping effect of space in Baby Patteshall's apron. The eyes, lips, brows, and fingers in each case convey the same preoccupation with subtle modelling. One feels that this painter, Flemish in training, who had a liking for quizzical expressions and dreamy moods, was a poetic fellow and sensitive in a way that his contemporaries were not. It is difficult to link him with Tom Smith's bold patterns and rough brushwork.

Yet half-way between the two stands the portrait of *George Curwen* (Fig. 9), or rather the original part of it, since Corné, the French artist hired by Dr. Bentley to repair the portrait in the first years of the XIXth century, is known to have changed the neck-cloth after remounting the cut-out head and neck on another canvas, and since H(ilda?) C(rownin-shield?) corrected the clumsiness of Corné's work.[21] Utilizing the X-ray to determine the nature of the original brushwork, one finds that the artist was not as subtle in modelling as was the painter of the *Patteshall-Savage* portraits, nor as brusque as Tom Smith. Comparing the heads of *Savage, Curwen,* and Tom Smith's *Self-Portrait* (Figs. 12, 9, and 10), it should be evident that here is a transition from subtle recording of mood to vigorous recording of pattern. Consider the treatment of hair in the three heads. Savage's is vaguely indicated; it is a misty shape behind his head. Curwen's is definitely waved down to his shoulders, the outline as a whole being distinct, even though there is not much definition within the general shape. In the *Self-Portrait* the hair is accurately delineated and brought forward about the face to play a distinct part in the design. Presumably the three heads of hair did actually differ and would normally be painted not alike. However, the differences noted in the hair seem to typify the differences in aesthetic interest. Consider the three pairs of eyes. Savage's are veiled windows to his mind. Curwen's are better drawn, as far as objective observation goes, and are seen as pronounced details in the surface of the head. The eyes of the *Self-Portrait* are still more boldly drawn and shaped symmetrically in a bold

pattern. Consider the wrinkles in the corners of the eyes. Savage's are barely suggested. Curwen's are well defined. Those in the *Self-Portrait* are stylized and artificial.

If the portrait of *George Curwen* be dated earlier than the *Self-Portrait* it is not impossible that one artist, developing from comparative neatness and smallness of brushwork into breadth and roughness of technique, could have painted both portraits. That is, Tom Smith may have painted the portrait of *George Curwen*. But considering the impatient vigor which marks Tom Smith's known work, and the patient subtlety of the *Patteshall-Savage* portraits, it does not seem possible that Tom Smith was the author of the last named likenesses. In other words, the same kind of distinction made among the portraits dated 1670 can be made among portraits slightly later in date, the difference in handling and conception suggesting more than one temperament.

At the same time, it must be remembered that these differences, however true, are subordinate to an important similarity among the pictures dating from 1670 to about 1693. This general similarity in stiffness of pose, in simplicity of pattern, in love of fine lace and embroidery, except where insulting to the severe taste of clergymen, is only what one would expect within the confines of a generation and a thirty-mile radius from Boston. Whoever these artists were, they can scarcely have been oblivious of one another. Several, like the three personalities of 1670, may have worked together in the same shop, perhaps together on the same canvas. The fine anonymous painter of the *Freke* portraits may have known the non-spectacular but worth-while painter of the *Patteshall-Savage* portraits. In the present state of our ignorance we can only exclaim at the newly established fact that Massachusetts, two generations before the arrival of Smibert and the beginning of a well documented history of painting in colonial America, patronized artists of countrified taste and charm.

The struggling colonists had within fifty years reached a state of lux-

ury which permitted them the enjoyment of family likenesses. As early as 1670 an American taste — not exactly similar to the Netherlandish or Anglo-Netherlandish taste of people back "home" — had begun to take form. Although there was no continuous development of this kind of taste, as expressed in provincial imitations of European models, the fact remains that from the very start of colonial civilization there are distinct characteristics for the art of the limner in this country. These characteristics — static realism, self-sufficiency, and friendly charm — having an obvious importance to the critic who is concerned with tracing the growth of an American tradition of painting, will be found recurring through the pages which follow, like a theme with variations, scarcely heard at times because of the louder themes of English and European art, yet nevertheless existent. It is a simple theme and a universal one, even if it was localized in the most self-sufficient communities, especially Boston, where society was concerned with new forms and changed values, as society was not in the southern plantations of the early period. The grandfathers of the people who achieved a democracy in the belief that they were founding a republic early patronized a democratic form of art and created a demand for unpretentious records of physical appearance. To them the art of painting consisted in tracing the facts which they themselves could see, without the aid of artistic tradition or education in the matter of design and technique. The art of the limner was already established as the recording of likenesses.

NOTES

1. See British Painting, by C. H. Collins Baker and Montague R. James, Boston, 1933.
2. Examination by means of X-ray shadowgraphs reveals that the portrait has been "freshened" by the addition of a knot in the cravat, by straightening the nostril, which was originally higher, and by flattening the curve of the upper eyelids. This was done probably in the late XVIIth century. The portrait, judging by the age of the sitter, must have originally been done about the middle of the century.
3. Portraits of Early American Artists, by Thomas B. Clarke, Philadelphia Museum of Art, 1928. Although the inscription on the reverse of the picture reads "Govr. R. Bellingham, Effigies Delin. Boston Anno Dom 1641 Aetatis 49, W. R.," the style is Dutch or Anglo-

Flemish, somewhat in the manner of Cornelis Johnson. Another version of this portrait, a copy of which is in the Boston State House, is said to exist in Castle Bellingham, County Louth, Ireland.

4. Thomas B. Clarke, op. cit.

5. Thomas B. Clarke, op. cit.

6. Early American Painters, by John Hill Morgan, New York, 1921, 25.

7. Early American Painting, by Frederic Fairchild Sherman, New York, 1932, 11.

8. Op. cit., 19.

9. Op. cit., 8.

10. Seventeenth Century Painting in New England, edited by Louisa Dresser, Worcester, Mass., 1935.

11. As in the portrait of a baby, dated 1613; repr., The Connoisseur, November, 1933, p. 290.

12. The latter is perhaps the portrait of an earlier ancestor of the Quincy family, Alice Mason. In 1670 John Quincy was not yet born, let alone aged two years, as was this child, according to the plain statement in old pigment to the right of the head. Alice Mason was. Furthermore the costume is that of a girl.

13. Repr., Seventeenth Century Painting in New England, 57, 59.

14. Repr., Seventeenth Century Painting in New England, 153.

15. The date may be repainted, but probably is correct, since Henry Sargent's copy of this portrait (Essex Institute, Salem, Mass.), done in 1800, bears the same date.

16. Perhaps the portraits of *Edward* and *Rebecca Rawson* (New England Historic Genealogical Society, Boston), now badly repainted and damaged, may be considered to belong in the *Gibbs-Freke* group. Judging merely by the X-ray shadowgraphs, which disclose the remnants of the old pigment, — the mouthless, eyeless face of *Edward Rawson* and the shattered features of *Rebecca*, — the technique is here flatter and neater than the *Davenport-Wheelright* manner of painting, and yet not as smooth as in the *Mason Children*. These portraits are likewise dated 1670.

　　The portrait of *Elizabeth Paddy Wensley* (Pilgrim Hall, Plymouth, Mass.) does not seem to fit readily in with the three groups mentioned. It is difficult to place, since although the stiffness of the pattern suggests the same provincial Dutch point of view, the picture has either been entirely skinned by careless cleaning or was deliberately left "unfinished." It is not impossible that the artist, who liked geometrical forms in the folds of the costume and red-brown flesh tones in a rich red and brown color scheme, was in some way connected with the author of the so-called *Boxford Portrait* (Repr., Portraits of the Founders, by Charles K. Bolton, Boston, 1919–26, III, 929) and the very geometrical portrait of *Sir George Downing* (Frederick Winthrop, Boston).

17. In a jingle which characterizes him, perhaps sentimentally and inaccurately, as one "who often painted death"; see the Massachusetts Historical Society Collections, 5th series, VI, 170.

18. Massachusetts Historical Society Proceedings, November, 1862, 340.

19. Colonial Society of Massachusetts, Publications, XXV, 80.

20. Compare van der Vliet's portraits in the National Gallery, London, no. 1168, dated 1631; in the Liechtenstein Gallery, Vienna, no. 103, dated 1624; and in the Rijksmuseum, Amsterdam, no. 2568A, dated 1638.

21. The Diary of William Bentley, D.D., Salem, Mass., 1905–14, III, 481, and IV, 631.

CHAPTER II

The Growing Tradition of English Style

AT THE close of the XVIIth century the religious and economic prob-
lems which had led to the colonizing of the Atlantic coast were out-
grown by new problems. From being themselves dissenters, the author-
ities of Massachusetts became the suppressors of new dissenters. The
exploiters of the southern colonies were settling down to plantation
home-life. The pioneers were changing into "original" inhabitants.
And the society which they developed was essentially English, in spite
of important differences which gave a national flavor to the country long
before it thought of itself as a nation. It would be strange if the art of
this new version of English society remained Dutch in character, in-
stead of following the English trend to style and prettiness, to poise and
not too insistent realism. That it did find in English art a satisfactory
solution to the problem of where to get the most effective official por-
traits and the most pleasing decorations for the drawing-room, will be
amply illustrated by the pictures now to be discussed, whether produced
on the spot in Charleston, S. C., in Maryland, and in Boston, or im-
ported from England, along with other refinements such as broadcloth,
glass, wine, and silk stockings. Only New York lagged behind, natu-
rally, since the Dutch character of the city was not at once abolished by
the surrender to the English fleet. But by 1720 even the Holland-born
Pieter Vanderlyn and the obscure artists of New York state were paint-
ing with at least some slight knowledge of the designs and superficial
mannerisms of the fashionable English portraitists who followed Kneller.

4

JEREMIAH DUMMER AND HIS CONTEMPORARIES IN
MASSACHUSETTS

The transition to an English manner of painting can be illustrated by
the family portraits attributed to Jeremiah Dummer, the silversmith,
whose career can be followed rather closely,[1] but whose activity as a
painter is not noticed in any contemporary reference. The reasons for
believing that he did paint four portraits are as follows: a *Self-Portrait*
(Fig. 14) is inscribed on the back in black pigment containing traces of
earth red, the same in composition as the black pigment used in the
shadows on the picture surface, according to the analysis made by
members of the Fogg Art Museum Technical Department; the in-
scription reads "Jeremiah Dummer pinx. Delin. Anno. 1691. Mei
Effigies, Aetat 46." The portrait of *Mrs. Anna Dummer* (Paul M. Ham-
len, Boston) is as fully inscribed, and is dated 1691. The portraits of
John Coney and *Mrs. Coney* (Estate of Henry Davis Sleeper, Gloucester,
Mass.), who were related to Mrs. Dummer, are also inscribed as from
the hand of their brother-in-law and dated 1708. Furthermore the
handwriting of these inscriptions corresponds, according to the late
Frank W. Bayley[2] and Frederick W. Coburn,[3] to the autographs of
Jeremiah Dummer preserved at the Massachusetts Historical Society
in Boston. Finally, the history of the *Self-Portrait* was said by Bayley
to be convincing evidence of direct descent from Dummer himself.

On the other hand, it is doubtful whether a penned signature can be
successfully compared to a painted one, and whether there is not a gap
in the history of the *Self-Portrait* unexplained by Bayley; the chemical
analysis may prove nothing more than an accidental relationship be-
tween the pigments in the signature and on the painted surface. Since
the style of the portraits is such an advance over the styles of the por-
traits previously discussed, it seems strange for the artist to have re-

mained unnoticed by his contemporaries even when he was well known among them as "a Justice of the Peace and one of the Judges of the Inferior Court and serviceable as a goldsmith." [4] The style, moreover, is smartly up-to-date, reflecting the Kneller influence in a way which must have appealed to Dummer's contemporaries as notably sophisticated.

Facing the Dummer problem on stylistic grounds alone, since the circumstantial evidence conflicts with the direct evidence of the signatures, it is evident that the four portraits bearing signatures do not strikingly resemble one another. The *Self-Portrait* (Fig. 14), lean and economical in brushwork, seems to be the most skillful of the lot. The portrait of *Mrs. Dummer*, supposed to date from the same year, is heavily painted, with bolder, more caricatured touches than those in the *Self-Portrait*. The two portraits of the *Coneys* are more fluid than *Mrs. Dummer's* portrait. Nevertheless, if the artist was an amateur and a clever man with his hands, who amused himself by doing a few family likenesses, it might plausibly be argued that these variations in manner mean nothing. If so, and this seems to be the only reason for accepting the variations as being from the hand of one artist, then it will be implausible to attribute to him many other portraits, painted in any style remotely connected with the four signed pictures. As a matter of fact the portrait of *Paul Dudley* (Boston Athenaeum), which represents the sitter at about twenty-five years of age or, in other words, about 1700, closely resembles the *Self-Portrait* in modelling. And the portrait of *Richard Middlecott* (Fig. 16), which is signed "N. Byfield pinx. 1713" and inscribed "Aetate Suae 37," is suavely modelled in almost exactly the same spirit as the portrait of *John Coney*. The inscription is puzzling. Richard Middlecott died at an advanced age nearly a decade before 1713. Since the costume is typical of the date on the face of the portrait, the obvious explanation is that the sitter has not been correctly named, even though Dr. Bentley in 1809 identified him as "Con. Middlecott." The signature appears to be old, yet is amateurishly lettered.

Then who was "N. Byfield"? None of Sewall's many references to his friend Judge Nathaniel Byfield gives a hint of him as a painter or as a man with any talent or interest in crafts demanding a knowledge of color and drawing. If it is correct to link the portrait of *John Coney* and the so-called portrait of *Richard Middlecott*, it is then apparent that the inscriptions involved are no longer valid, and that the choice of two names, well known to antiquarians and genealogists, becomes suspicious when attached to paintings similar in style. Until new facts are uncovered the critic is limited to believing that, whether Dummer or Byfield, or neither, painted the portraits in question, the style is English rather than latently American. It is the same in pose and manner of painting as that employed by an anonymous copyist after Kneller who used for his copying a canvas already painted upon, placing Kneller's likeness of *John Locke* (Harvard University, Cambridge, Mass.) on top of the profile of a woman who wears her hair in a mid-XVIIIth century mode.

These are not the only portraits showing English ancestry at the turn of the century. Other artists, anonymous all, were involved in the Kneller tradition, perhaps at second hand, and produced portraits which have a superficial resemblance to the works of the so-called Dummer. The subtle painter who portrayed *Benjamin Wadsworth* (Harvard University, Cambridge, Mass.) and *Mrs. Elizabeth Browne Holyoke* (Essex Institute, Salem, Mass.) in the first or second decade of the XVIIIth century was not the simple artist who painted a severe-faced man wearing a cravat of the very first years of the century, and who painted also the portrait of *John Rawlins* (Essex Institute, Salem, Mass.) and perhaps the portrait of *Mrs. Addington* (New England Historic Genealogical Society, Boston). The reason for suspecting that these pictures should be grouped together is that the portrait just mentioned, of a severe-faced man, was discovered, as a result of X-ray examination, *beneath* the portrait of *Benjamin Wadsworth*. Who the sitter was, how it happened that

his likeness was turned upside down and painted over by another artist, what was the relationship between the artists or between the sitters, are as yet mysteries.

There are other mysteries. The portrait of *Isaac Addington* (New England Historic Genealogical Society, Boston), in which he is represented at about forty-five years of age, that is, in the years around 1690, may have been painted in England by some artist acquainted with the artist who portrayed *George Jaffrey* a few years before. If so, he was strangely simple and direct in the American manner. Of the same approximate date are portraits of *William* and *Mrs. Margery Pepperell* (Reginald R. Belknap, Boston), which bring to the front another artistic personality,[5] similar in training to the author of the so-called Tom Child portrait of *Sir William Phips*, or the portrait of *Mrs. Pierpont* (Fig. 15), yet quite distinct from him in skill. A succession of portraits which agree in their simplicity, sincerity, painstaking observation of facial expression, and indifference to academic rules of modelling define an artist working from the early nineties, when the *William Pepperells* were painted, through the first decade of the new century, when *Andrew Pepperell* and his wife *Jane Elliott* (F. S. Welch, Mount Kisco, N. Y.) may have been painted. In between these dates one may place the portrait of *Mary Pepperell Ffrost* (Estate of George Ffrost, Dover, N. H.) and of *Lucy Wainright Dudley* (Boston Athenaeum), who was born in 1685 and painted early in the new century, judging by her youthful appearance. The portraits of *John Dolbeare* (T. S. McLane, New York), *Mrs. William Dummer* (Governor Dummer Academy, South Byfield, Mass.), *Elisha Cooke, Jr.*, and his wife, *Jane Middlecott* (Mrs. Richard M. Saltonstall, Boston), may also be placed in this group. The artist, or artists, may not have been as stylized as the painter of *George Jaffrey* or as accomplished as the painter of *Mrs. Pierpont* (Fig. 15), but he was obviously aware of current ideals of portraiture as practiced in England. And he was a good craftsman — better than the so-called Jeremiah Dummer or N. Byfield. He

was much better than the clumsy author of a portrait of *John Ffrost* (Estate of George Ffrost, Dover, N. H.), husband of the Mary Pepperell previously mentioned. *John Ffrost's* likeness is not by the artist who painted his wife, but is evidently by the same hand that painted *John Colman* (Mrs. Clayton C. Hall, Baltimore). Although the latter was formerly attributed to Smibert, it is done in imitation of Kneller's broadest manner, probably in the first decade of the XVIIIth century.

All these comparisons show that the so-called Tom Child and these anonymous limners may form an interdependent group analogous to the Tom Smith-Patteshall-Savage-Curwen group. Portraits as fundamentally different in technique as those of *Andrew Pepperell*, *John Ffrost*, *Isaac Addington*, and *John Woodbridge* (Mrs. David Pearce Penhallow, Boston) — the last a hesitating imitation of the style of the *Ffrost-Colman* painter — contain, nevertheless, hands which are modelled according to the same formula; and this fact implies that the painters picked up their training from a source open to them all and perhaps borrowed freely from each other, irrespective of skill. As in the case of the painters of 1670, the wonder is that so many can be distinguished amid a dearth of names. Aside from the doubtful Dummer and Byfield, we know for a fact only that one Lawrence Brown was mentioned in the selectmen's records of Boston as a limner, under date of 1701.

Time may bring more information and prove that several sturdy painters were working in Massachusetts before the arrival of Smibert and Pelham. Among them, we hope, will be disclosed the name of the artist whose portraits, as yet unmentioned, deserve special fame because they reveal, during a period of neo-Kneller stylishness, a concern for the psychology of sitters and a sensitiveness to mood not found elsewhere than in the *Patteshall-Savage* portraits. Painting the likeness considered to be that of *John Wilson* (Fig. 18),[6] he sought to penetrate superficial appearance and make tangible a kindly soul, humorous on occasion, devout, a trifle worried by the pace of the world, and alto-

gether a complete being, distinct from the formal mask so often transcribed in provincial portraiture. The modelling is so delicate that the paint seems breathed on to the canvas, yet the forms remain cleanly defined. The same technique found in the moody portrait of *Increase Mather* (American Antiquarian Society, Worcester, Mass.) leads one to believe that the artist was working in Boston after 1700.[7] And something of the same moodiness in the expression of *Sarah Manning* (Charles K. Bolton, New York), who wears a costume dating from about 1720, leads one to believe he may have lived until then. Is it possible that the Joseph Allen whom Nathaniel Mather knew as a man with "good skill in watchmaking, clock making, graving, limning," [8] and whose inventory after his death in 1728 included Dutch pictures, was the artist?

Then there is the strange personality of the artist who painted *Thomas Thacher* (Fig. 13) and *Elisha Cooke, Sr.* (Mrs. Richard M. Saltonstall, Boston) in a fine spirit of world disdain, deliberately creating a mask with holes left in the flesh paint for eyes, brows, and lips, but doing it with such clear-cut sensitiveness to the geometrical form of features that the effect is super-realistic. Nearly the same effect can be seen in the portraits of *Pierre Baudouin*,[9] which was probably painted about 1700, *John Walley, Jr.* (Granville Vernon, New York), painted about two decades later, and *Benjamin Colman* (Harvard University, Cambridge, Mass.), formerly attributed to Smibert. The portrait of *Anne Pollard* (Fig. 17), dated 1721, is thinner but quite similar in its insistence on caricatured realism and delicacy of modelling within a very definite pattern. The portrait of *William Stoughton* (Fig. 19), pointing out the building he gave to Harvard in 1700, one year before his death, seems to be a drier and clumsier version of the same style and may be said to link the *Wilson-Mather-Manning* portraits with those just mentioned. Presumably these are accidental resemblances, unless the portraits of *Wilson* and *Thacher* can be dated later than the deaths of those

gentlemen and closer to the early seventeen hundreds. It is difficult to believe that one artist could have so active a life for half a century and yet remain unnoticed by his contemporaries. If incorrectly identified, these portraits may represent the exceptional talents of an artistic group which was at work during the early years of the XVIIIth century. At any rate the pictures indicate, in contrast with the work of the so-called Dummer-Byfield and *Pepperell Family* portraits, a branch of the limner's art in Massachusetts which is more aptly considered native and farther removed from influences abroad. It will be interesting to investigate on some other occasion the possibility that Smibert, arriving with a competent technique acquired in England and Italy, found in the already existing art of some Boston painters an ideal of realistic portraiture which enabled him to become the first of truly American artists.

5

THE TASTE OF THE MIDDLE CITIES

In New York the painters at the turn of the century were the second generation of those who brought with them the lessons of Dutch training, and they deteriorated in taste and skill from the high standards set by Strycker and perhaps by the first Evert Duyckinck. Evert Duyckinck III and Gerret Duyckinck, instead of ranking ahead of their Boston contemporaries, are only equal to them. Indeed, comparison between the Byfield portrait of *Richard Middlecott*, so called, and the portrait of *Abraham de Peyster* (Hiram Burlingham Sale, New York, 1934), attributed to Evert Duyckinck III, indicates a close dependence in style, as though the Dutchman had looked to English models, once his city had become English in rule. Certainly the Dutch realism is considerably softened by English suavity, the painting of folds has become stylized in the Kneller fashion, and only the difficulty of finding an actual connection between the two prevents one from classifying them

together. Evert III remains a vague person, since the only signed por-
trait by him, that of *Ann Sinclair Crommelin* (Estate of Thomas B. Clarke,
New York), is dated 1725, two years before his death at the age of fifty.
The six portraits of the *Beekman Family* (New York Historical Society)
which Mr. Morgan ingeniously attributed to him [10] on the strength of
family history and tradition are about the same in date. The uniform-
ity of these likenesses seems to show that Evert III, if he is the artist,
was a rather plodding portraitist.

Gerret Duyckinck came earlier than Evert III but was a clumsier
painter, as his only signed portrait, dated 1699, that of *Anne van Cort-
landt* (Estate of Thomas B. Clarke, New York), seems to prove. Other
pictures attributed to him, a *Self-Portrait*, the portraits of *Mrs. Gerret
Duyckinck* (Fig. 22), *Mrs. Augustus Jay*, *David Provoost*, and *Tryntie
Laurens*, wife of David Provoost (all in the New York Historical Society),
establish an artistic personality difficult to account for except on the
grounds of meager training. His mannerisms are so clear that one can
add to his work the portrait of *Margaret Provoost* and that of *Mrs. Barent
Rynders* (New York Historical Society), the latter having been attributed
to Evert Duyckinck III in spite of its obvious resemblance in drawing to
the portraits attributed to Gerret. These are no better than the Boston
portraits of the period. The Dutch magic in modelling is replaced by
harshness of form. Only an exceptional picture like the double por-
trait of *Captain and Mrs. Johannes Schuyler* (New York Historical Society),
attributed at one time to Evert III without much evidence, suggests
that European standards were still alive. If Gerret van Randst and
Nehemiah Partridge, named as freemen and artists in New York in
1715 and 1718, were no better than Evert III and Gerret Duyckinck, it
is no wonder that Massachusetts painters, and the Boston public, turned
back to London for a new mode.

Nevertheless it is true that a Boston painter, Joseph Badger, was to
produce toward the middle of the century portraits which seem to be

linked, at least in harshness of technique and simplicity of form, with those painted in New York. Perhaps he never knew a New York artist; he may merely have been following a logical way out from clumsiness toward a countrified kind of style. At any rate he was the last of those who even approximated the Dutch manner. Even Pieter Vanderlyn, born in Holland in 1682 and married in New York in 1718, who must have begun his career with the work of Gerret and Evert Duyckinck III in mind, was only a trifle less influenced by English stylishness than was the Boston painter, Badger. Vanderlyn's portrait[11] of *Johannes van Vechten* (Estate of Thomas B. Clarke, New York), which is dated 1719, and the two portraits of *Thomas van Alstyne* and his wife, *Maria van Alen* (Fig. 20), dated 1721, reveal an artist of simple power, sublimating the clumsiness of the Duyckincks into caricature. The prompting forces were probably engravings, since the linear quality of the pictures is pronounced. Probably they were English engravings, full of dash and freely designed, serving as fashion plates for the young Dutchman who was no longer Dutch but English. It is, of course, a tremendous jump from Lely to the flat, geometrically fantastic Pieter Vanderlyn. Yet that is the jump one suggests in order to appreciate what was going on aesthetically in upper New York state about 1720. Vanderlyn, or an unknown artist who went through the same process, painted in Albany the portrait of *Catalina Schuyler* (New York Historical Society), and the portrait of a *Miss van Alen* (Downtown Gallery, New York) in Kinderhook, N. Y. These likenesses are quite similar to Vanderlyn's work. So are a group of portraits of Jewish people, *David and Phila Franks*, *Jacob Franks*, *Mrs. Jacob Franks*, and *Moses Levy* (N. Taylor Phillips, New York). Probably the same influence was felt by the artist who painted the child's portrait, believed to represent *Levinah Cock* (Robert Feeks Cox, Media, Pa.), which is inscribed on the back "To Robert Feke at Mr. Judea Hayes in Newyork," and which Dr. Foote[12] catalogues as a picture *by* Feke. Still other portraits, like that of *Elizabeth van Brugh*

(New York Historical Society), seem to belong to this group. And even though Mr. Morgan [13] attributed the portrait of *Johannes Schuyler* (New York Historical Society, no. 491) to the same artist who painted the double portrait of *Captain and Mrs. Schuyler* already mentioned — namely, to Evert Duyckinck III — here again one meets the same bland type of work, a little more restrained and better drawn, perhaps, but related in some fashion to the flat, hard patterns which mark the known work of Pieter Vanderlyn.

Before leaving New York to see what the situation was in the South during the early XVIIIth century one should mention John Watson, who came to New York in 1715, a Scotchman, according to Dunlap.[14] He settled in Perth Amboy, N. J., and had a collection of imported pictures. Because of his collection and his activity as a sketcher of small portraits in ink,[15] he may eventually be proved an influential person. If the portrait of *Sir Peter Warren* (Estate of Thomas B. Clarke, New York) is typical of Watson's work in oils, he must have had a taste for Kneller's style at a time when some New York portraitists were still struggling to bring the Dutch style up to date, as was Gerardus Duyckinck, of the third generation of Duyckincks, who lived until 1742, and F. van Doornick, who signed a pair of portraits of *Anne* and *Isaac de Peyster* (Ehrich-Newhouse, Inc., New York) in 1731. Gerardus Duyckinck was in 1728 painting in the manner of Evert III, provided the portrait of *James de Lancey* (Estate of Thomas B. Clarke, New York) is correctly signed. But Watson's portrait of *Sir Peter Warren*, dated 1731, is an attempt at the grand style — gesture, piled curtains, and all. This influence, or something corresponding to it, was known in New England, judging by the striking similarity between the portrait of *Sir Peter Warren* and two portraits presumably painted in Massachusetts, one of *Oxenbridge Thacher* (Chester Dale, New York), and the other of *Charles Chauncey* (Harvard University, Cambridge, Mass.), both attributed to Smibert. The latter is confusingly and carelessly inscribed

on the back as if it were the portrait of the former president of the col-
lege, who died in 1671. But below the inscription, and partly erased,
are the letters "DEL . . . DC . . . XXVIII," which may refer to the
picture having been painted in 1728, at which time the wig which the
sitter wears would have been popular.

By the middle of the century the English style was familiar to all,
from the woods of New Hampshire to the loneliest plantation of the
far South. Following Watson came other Englishmen. Lawrence Kil-
brunn advertised in 1754 in the New York Gazette; his portrait of
Mrs. James Beekman, dated 1761, is graceful and up-to-date,[16] which is
to say, far ahead of our subject at present. Even before Watson's ar-
rival, Gustavus Hesselius came from Sweden with an English style, and
painted in Delaware, Philadelphia, and Maryland. His work seems to
be rare. And his documented *Last Supper* (Mrs. R. N. Warrington, lent
to the Pennsylvania Museum, Philadelphia)[17] is merely an academic
arrangement showing the influence of an Italian, almost Byzantine,
type of art. Thus his artistic development is not clear. The signed
portraits of *William Smith* and *Mary Het Smith* (Fig. 23) are delicate, like
pastels by Henrietta Johnson, and smoothly modelled in the best Eng-
lish manner. About 1721, or, according to family tradition, about the
time he painted the *Last Supper*, he is supposed to have painted the por-
trait of *Anne Galloway* (Metropolitan Museum, New York); and this
portrait has a pronounced strength of character, with less dependence
on fashionable methods. The same vigor makes one admire the *Self-
Portrait* and the portrait of *Mrs. Gustavus Hesselius* (Fig. 24), which seem
to date from close to the middle of the century because of the apparent
ages of the sitters. Hesselius thus may have found in the people of
Annapolis a liking for plainly told character studies which induced him
to forget some part of English grace. Rembrandt Peale believed, ac-
cording to Dunlap,[18] that Hesselius was a pupil of Kneller. And so one
could believe, looking only at the portrait of *Mary Het Smith*. But the

portrait of *Mrs. Hesselius* is thoroughly American and realistic, more in sympathy with the plain-mannered, intellectually curious Philadelphians than with the tradition-loving aristocrats of Charleston, S. C.

6

THE TASTE OF THE SOUTHERN PLANTERS

These aristocrats, holding to the English law of primogeniture, as Massachusetts and New England did not, preserved what they inherited in a compact family unit, proud of their success and of the culture enjoyed through their leisure. Naturally they preferred aristocratic-looking family portraits. Henrietta Johnson, one of the first resident artists to cater to this taste, did so with a highly specialized product; she signed pastels of a monotonous charm which are English in origin, as Homer Eaton Keyes has pointed out,[19] and which found an appropriate audience in Charleston, where the amenities of social life were early fixed and long cherished. A portrait of *Sir Nathaniel Johnson*, dated 1705, which, according to the Rev. Robert Wilson,[20] was painted in the Province, has been attributed to her, as has been a portrait of *Robert Johnson* (Estate of Thomas B. Clarke, New York) dated 1718. The latter was originally owned by Col. Moore, who came from Charleston and for whom Henrietta Johnson made three pastels in New York in 1725, including one of *Frances Moore* (Luke Vincent Lockwood, Stamford, Conn.). Such pastels, many of them dated from 1708 to 1728, when the artist died, are much prized as heirlooms. But their vague gracefulness, like that of the small portraits attributed to Elizabeth Le Serurier by Dr. Wilson,[21] seems of less importance than the sturdy realism of Gustavus Hesselius, much less the skillful effects of Charles Bridges.

A letter from Col. William Byrd in 1736 introduced to Gov. Spotswood of Virginia a "man of good family. . . . His name is Bridges. . . .

He has drawn my children and several others in this neighborhood, and tho' he has not the master hand of a Lilly or Kneller, yet had he lived so long ago as when places were given to the most deserving he might have pretended to be Sergeant Painter of Virginia." One may judge, therefore, the taste of the southern gentlemen by examining the gracious portraits thus documented, of *Evelyn Byrd*,[22] another *Miss Byrd* (Otway Byrd, Brandon, Va.), and *Maria Taylor Byrd* (Metropolitan Museum, New York), affectedly posed with a shallow cup in her hand. Bridges' portraits of men, like those of *Gov. Hugh Druysdale* (Fig. 21), signed and dated 1725, *William Gooch* (Estate of Thomas B. Clarke, New York), painted in 1740, *Sir John Randolph* (Descendants of Philip Grymes, Brandon, Va.), painted in 1733, and *Mann Page II* (College of William and Mary, Williamsburg, Va.), seem to be consistently more robust and characterized with greater skill. He learned Kneller's style thoroughly, posed his sitters with easy gestures, lavished much care on the gentlemen's waistcoats and the artificial folds of the ladies' robes, added details of pleasing disorder in their skirts, and otherwise won the well-born sitters to his art. In all this, however, Bridges is not merely a poseur; he had a genuine gift for painting men's faces, which he utilized in spite of the non-flattering results sometimes achieved. His exemplars in England had found that chivalry would not permit them to tell anything like the truth about female sitters, but that masculine pride would often allow them to paint a man as pronouncedly ugly as he was, provided they made it clear that he was a superior being, indifferent to looks. This Bridges also found out, judging by the portraits mentioned. *Mann Page II* is not flatteringly portrayed, but he is represented as a dominant masculine figure, almost careless of his dress and preoccupied with his own thoughts. This is truly aristocratic painting.

Compared to it the work of Jeremiah Theus, even at its best, seems stiff, as in the portraits of *Elizabeth Rothmahler* (Brooklyn Museum), signed "Jh. Theüs, 1757," and of a man resembling *Theodore Atkinson*

(Fig. 25), signed "Theus" and dated 1755. Theus, a Swiss, had come to South Carolina in 1735, when Bridges was making his reputation with Col. Byrd and when one B. Roberts was advertising himself in the South Carolina Gazette as a portrait painter and engraver. He was in Charleston in 1740 when he advertised that he was "willing to wait on (sitters) at their respective plantations." [23] Like Bridges he flattered the ladies by painting them all alike, if they were young and supposed to be attractive. And also like Bridges he made more of men sitters than he did of the ladies, painting *Dr. Lionel Chalmers* (Fig. 26) with naive sincerity. Probably Theus' training was continental and French. At least he painted somewhat in the style of Etienne Liotard, the pastellist whom Copley was to consult about crayons, and who was the painter of the "Chocolate Girl," now widely known through its use as a commercial trade-mark. Theus' work of the fifties and later — he lived until 1774 — may have been influenced by the more stylish portraits of the English artist, Wollaston, who travelled through the South after establishing his reputation in New York. And this influence from England may account for the fact that some of Theus' portraits have been attributed to Copley, who climaxed the taste for English elegance by adapting it to his own hard-headed ends, and doing it so well that anything resembling his work is apt to be attributed to him. With Henry Benbridge, who returned to the South in 1770 from an international education in painting, chiefly under Mengs and Batoni in Italy, the South continued the eclectic taste which it showed in patronizing Theus. But once again we are getting ahead of the story. The most important examples of English influence have yet to be cited. And before those citations are complete, this account will be carried through another chapter, dealing with the beginnings of what may be called generally the American taste for realism and matter-of-fact art.

7

JOHN SMIBERT AND PETER PELHAM

Returning to New England one finds new strength in portraiture about a generation after Jeremiah Dummer's supposed transcripts of the English style. The combined forces of John Smibert and Peter Pelham raised the arts in Boston to a European level. Although still Englishmen in their own opinion, they adapted themselves, particularly Smibert, to the point of view of established colonists who wanted likenesses done, not in distant and ornamental fashion, but with intimate and forceful conviction. Although painting and engraving in the manner taught them in England, for instance in the manner of Jonathan Richardson, whose bland portrait of *Alexander Pope* (Boston Museum) shows the current English style at its serious best, as it developed from the formal stiffness of Kneller, they felt the conquering spirit of the new world which moved Bishop Berkeley to write prophetically, "Westward the course of empire takes its way." Born in Edinburgh in 1688, John Smibert [24] became a student of Italian art and a fellow-pupil of Hogarth in Thornhill's London Academy. That he was somewhat an idealist may be taken for granted by his presence in Berkeley's Utopian expedition to found an American university in Bermuda, even without the first-hand evidence of Horace Walpole.[25] The expedition landed in Newport in January, 1729. When it became stranded for lack of funds, Smibert found his way to Boston, married, and settled down to portraiture of a consistently high order. In 1729 he had painted *Bishop Berkeley and His Family* (Frontispiece), differentiating the features of all the sitters and endowing each with his distinct, personal character in such a way that they appear almost caricatured. Like Bridges, and even like the quaint Pieter Vanderlyn, he had a formula for the folds of costumes which was acquired second-hand from England; he felt it necessary to show the hands in expressive gestures; and he lengthened the necks of

the ladies for the sake of grace. But even in this first American picture he achieved a nervous intensity which makes his likenesses fundamentally realistic. This characteristic of his art appears in all his work, early or late. A copy of Van Dyck's portrait of *Cardinal Bentivoglio* (Harvard University, Cambridge, Mass.), which must date from Smibert's student days in Italy, seems less characteristic of the great Fleming than of the serious Scotch student. An early portrait of *Bishop Berkeley* (National Portrait Gallery, London), while smug in modelling and pose, is nevertheless vivacious. In spite of the smooth cheeks and mild manners of the three young *Sons of Daniel Oliver*,[26] which must date from Smibert's first year in Boston, character and differentiation of characters dominate. Smibert struck his mature stride very quickly. The portrait of old *Judge Samuel Sewall* (Fig. 31), who died in 1730, must have been done from life; the Judge's hands are rheumatic and trembly, his eyes are weak, and the strong will, so apparent in his Diary, seems to illumine the painted head to the point of creating a masterpiece of portraiture. The likeness of *Nathaniel Byfield* (Metropolitan Museum, New York), dated 1730, shows a repulsive nose and staunch personal qualities. *Mrs. Thomas Bullfinch* (Fig. 32), whose big eyes look at the world with disarming candor, is a real and amusing person. Though Smibert was essentially a man's artist, he painted the ladies with a not overwhelming gallantry, as the sentimental portrait of *Mrs. Joshua Gee* (Massachusetts Historical Society, Boston) or the long-faced *Mrs. Mary Ann Jones* (Massachusetts Historical Society, Boston) indicates. Whatever was his training in England and Italy, it was American people who interested him and roused him to good portraiture.

Probably he was influenced by the strong drawing of the engraver, Peter Pelham, who had come to Boston sometime before 1727 — that is, before Smibert had thought of America. Pelham's engravings, several of the later ones made from paintings by Smibert, are forcefully modelled with round and shining forms, comparable to the fully

rounded modelling in Smibert's portrait of *Jeremiah Gridley* (Harvard Law School, Cambridge, Mass.), which is dated 1731. Since Pelham's work in England is not generally so robust in modelling [27] as his work in Boston, one can believe it was a profitable influence which the two artists exerted upon each other. The professional association of the two may be dated from 1735, when Pelham engraved Smibert's portrait of *Benjamin Colman* (which is not the primitive-looking portrait at Harvard University), to 1750, when he engraved Smibert's portrait of *Henry Caner*; that is, they continued together until the close of their careers.[28] But it is evident that the two artists had known each other from soon after Smibert's arrival in Boston. Not only the portrait of *Jeremiah Gridley*, already mentioned, but Smibert's complete work, illustrated by outstanding examples, like the portraits of *Rev. James McSparren* (Bowdoin College, Brunswick, Me.), which the artist sent in 1735 to Newport,[29] of *John Reed* (Phillips Academy, Andover, Mass.), which is dated 1738, and of *Sir William Pepperell* (Essex Institute, Salem, Mass.), engraved in 1747, is robustly modelled, much as in Pelham's style as an engraver. Even in such grandiose official portraits as that of *Sir Peter Warren* (Portsmouth, N. H., Athenaeum), Smibert pays close attention to the objectivity of the representation. There seems to have been no hesitancy in his methods; he even modelled flesh with ridges of clear lavender, as in the study of *John Turner* (Boston Museum), and sharpened his effects by simplifying his colors and brushwork. The result is that one recognizes his hand and spirit readily in a variety of pictures, at the same time failing to recognize them just as readily in a still greater variety of pictures which have been attributed to him.

But before taking up the question of imitations and odd attributions, it would be best to inquire into the manner of painting employed by Peter Pelham. According to some of the inscriptions on his engravings, he was the painter as well as the engraver of portraits of *Cotton Mather* and *Mather Byles*, both of which appear to be extant (American Anti-

quarian Society, Worcester, Mass.). Indeed there are two portraits of *Cotton Mather*; and the best preserved of the two is surely a copy, judging by the thinness of modelling, the stiff precision, the emptiness of the drawing, and the lack of underpainting, disclosed by X-ray examination. The other portrait of Mather, well modelled, but rubbed and damaged, is delicate in brushwork and might plausibly be considered to parallel Pelham's style as an engraver. However, the portrait of *Mather Byles*, equally well authenticated by an engraving, is quite different in effect, being smooth and polished in modelling and dull in character. It looks almost like a painting made after an engraving, because of its precision and flatness. And it contrasts with the energetic, lumpy modelling of the portrait of *Gov. William Greene* (Fig. 28), which is signed on the back "P. Pelham pinxit 1750," much as the Dummer portraits are signed, in large-scale painted script.

Many portraits attributed to either Smibert or Pelham can be discussed in this connection. That of *Judge Quincy* (Fig. 27), which has also been attributed to Smibert, might on the basis of comparison with the best of the *Cotton Mather* portraits be called a Pelham; at least it is delicately, thinly painted, without Smibert's habitual vigor. The portrait of an elderly man, called *John Smibert* (Estate of Thomas B. Clarke, New York), which appears in reproduction to be somewhat damaged, has little superficial resemblance to Pelham's portrait of *William Greene*, but does recall the best of the *Cotton Mather* portraits. In spite of a very pretty signature the portrait of *Samuel Shute* (Mrs. Thomas Brattle Gannet, Boston) does not resemble in any way the portraits previously mentioned and, were it not that the supposed sitter died in 1742, might easily be attributed to Blackburn. As a matter of fact, the identity of the sitter may be questioned since Samuel Shute, born in 1653, would have to be an old man approaching ninety, instead of a youngish-looking man, when the shirt with the double frill, which he wears, became popular. Then there is the portrait of *Jonathan Law* (Estate of Thomas

B. Clarke, New York), attributed to Pelham, which reminds one of the work of Gerardus Duyckinck; could not Pelham, the engraver, draw better than this?

Although it is disappointing that so little can be positively identified of Pelham's work in oils, we at least know more about Pelham than about Nathaniel Emmons, who was born in Boston in 1704, and who died in 1740. It was his house that Smibert occupied after his early death. His will records among pictures and artists' supplies the Hon. Judge Sewall's picture, which may be the bust portrait (Massachusetts Historical Society, Boston) copied from Smibert's half length already described. The stiff brushwork and cramped modelling of this work should therefore agree with the style of the portrait of *Jonathan Belcher* (Estate of Thomas B. Clarke, New York), said to have been painted by Emmons in Boston in 1738.[30] If these canvases are typical of Emmons' work, then the portrait of *Peter Faneuil* (Massachusetts Historical Society, Boston) is not by Emmons, as some have believed, but is by Smibert himself, though whether or not identical with the portrait that once hung in Faneuil Hall, Boston, is not clear. The modelling is bold and the brushwork nervous in Smibert's characteristic manner.

The portrait of *Deborah Clarke* (Fig. 29), on the other hand, should be more at home under the name of Emmons than under its present attribution to Smibert. At least it is painted smoothly and stiffly, more delicately than the copy of Judge Sewall's portrait attributed to Emmons, yet not differently in spirit. Probably by the same artist is the smooth portrait of *Benjamin Clark* (Yale University, New Haven, Conn.) and the softly outlined portrait of the *Rev. John Rogers* (Essex Institute, Salem, Mass.), long attributed to Smibert, even though too tame in modelling and feeble in brushwork to compare with the bulk of Smibert's work. Possibly the double portrait of *Two Little Girls* (Fig. 30), which descended from the Perkins-Mascarene family, is the work of the same painter, trying to make a more dashing effect. Even though the

drawing is elementary, the figures have bulk and life. Comparison between this and the portrait of *Deborah Clarke* indicates a close parallel in temperament as well as technique. However, if the *Two Little Girls* be identified as Joanna and Elizabeth Perkins, who were respectively two and four years old in 1749, the comparison discredits the attribution of all these paintings to Emmons, since it is certain that this painter died in 1740.

Edward Truman, who painted a portrait of *Thomas Hutchinson* (Massachusetts Historical Society, Boston) in 1741, as his signature testifies, had little to do with either Pelham or Smibert. He seems more likely to have come from England after contact with Highmore and Hudson, who painted graciously and gave their sitters something of the haughty air conveyed by Truman's portrait of *Hutchinson*. Some other portraits may eventually be linked to Edward Truman, like the portrait of *Chambers Russell* (Mrs. George R. Fearing, Boston) and the portrait of *Charles Paxton* (Massachusetts Historical Society, Boston); but it is at present difficult to trace his style, so overpainted is his one certain picture.

After all, there are many portraits and only a few identifiable artists. John Furnass, a "servant" of Smibert who occupied his studio after 1751, and Samuel Minot, who did the same, may have painted pictures known to us under the too ambitious label of their master. They may even have turned out imposing likenesses, such as the portrait of *Mrs. Epes Sargent* (Boston Museum of Fine Arts), which is stiffly done in a superficial manner of modelling. Presumably the same hand painted the full length, exaggerated, and Vanderlyn-like figure of *Mrs. William Browne* (Fig. 34). Since the companion portrait of *William Browne* (Fig. 33) is one of the best Smibert portraits — clear, firm, and free in brushwork — the unknown painter may be tentatively identified as an assistant or pupil of Smibert. Probably another pupil or follower painted the *Parting of Hector and Andromache* (Mrs. Jacob

Storer Cobb and Miss. E. W. Fuller, lent to the Boston Museum of Fine Arts), leaving us a clue as to the nature of the "history pieces" known to have been left in Smibert's studio. That this particular picture is not by Smibert is obvious; one look at the unstable, misshapen figures is enough to cause that decision. One look is also sufficient to raise doubts about the attribution to Smibert of the portrait of *Bishop Berkeley* (Worcester Art Museum), which at one time may have been signed with his name and dated 1728.[31] The picture is no longer signed and no longer has anything to do with Smibert's rough manner of painting faces and drapery. Another portrait of *Bishop Berkeley* (Massachusetts Historical Society, Boston) seems to be the work of an amateurish Emmons. But all that needs to be said about these portraits is that they do not convey the forceful, clear, and personal impression which one admires in Smibert's authentically signed masterpieces.

We know well enough the style of Smibert's son, Nathaniel, who died at the age of twenty-two, since he signed a picture of *Dorothy Wendell* (Mrs. Edward B. Alford, Boston) and a portrait of *Ezra Stiles* (Yale University, New Haven, Conn.), and since a portrait of *John Lovell* (Harvard University, Cambridge, Mass.) is documented by letters reprinted by William H. Whitmore.[32] But these portraits, dating from about 1755, seem decidedly limited; and there is little likelihood that Nathaniel produced enough work to warrant exhaustive study. He may have painted a portrait of *Edward Bromfield* (Harvard University, Cambridge, Mass.) which resembles closely the tightly modelled portrait of Lovell; but Bromfield, painted as a student of about eighteen or twenty, was born in 1723, which makes the date of the portrait probably 1741–43, when Nathaniel Smibert was a child. Either the sitter is not Bromfield or Nathaniel copied an earlier portrait, if one is to believe the evidence of the design, color, and brushwork.

Another artist might be mentioned here; but his connection with Smibert is so little a matter of puzzlement that he scarcely seems worth

considering out of his proper artistic order. He is John Greenwood, who helped make the inventory in 1752 of Smibert's estate, noting "13 landskips £2.13 ... 2 conversation pieces £23.6.8 ... 41 history pieces and pictures in that taste £16 ... 35 portraits £60.5.4." [33] This array leaves the critic dazedly wondering at the low price and the number of the landscapes, and at the large lot of portraits left on the painter's hands. When Trumbull rented the studio in 1777, Smibert's pictures, or some of them, were still there, including the copy of *Cardinal Bentivoglio* after Van Dyck which Trumbull purchased and presented to Harvard University in 1791. Although some of the "history pieces and pictures in that taste" may have been prints after Rubens, Raphael, and Poussin, such as Smibert had advertised for sale in 1735,[34] the portraits at a much higher price probably were not. Is it possible that Smibert's vigorous realism was too much for some of his sitters? One thinks of the portraits left by Thomas Eakins at the time of his death in 1916 in Philadelphia — a house full of intense personalities, of living representations unwanted by the people who refused to believe they "looked that way." Like Eakins, Smibert seemed to see beneath surface resemblances; he painted men's experiences into their faces and gave life to hidden feelings. As Abbey the painter said in refusing to sit to Eakins for a portrait, "He would bring out all the traits of my character that I have been trying to hide from the public for years." [35]

<div align="center">8</div>

<div align="center">THE NEW ENGLISH TASTE</div>

We have been discussing one aspect of New England taste in the first half of the XVIIIth century, the taste of one man powerful enough to create a taste. We are now to deal with other aspects of New England's growing admiration for the assured painting of the English portraitists. And these other aspects fall naturally into two groups: one, the

importation of new delights through the excellent portraits by Feke and
Blackburn; the other, a native effort to keep up with the imported
fashion. Of course both aspects appear side by side at any given time.
While Feke was painting his lovely gesturing ladies, Badger and Green-
wood were struggling to make arms appear attached to bodies, and
hands appear actual. Evidently there was room for both kinds of art,
since both were supported. Perhaps the public as a whole could not see
a vast difference between them, except in finish and price; or portraits by
Badger would appeal to persons of puritanical taste, where Feke's would
seem wickedly sensual. At any rate, they existed in the neighborhood of
each other; and the true account of what New England thought of the
arts must take notice of that fact.

Robert Feke, about whom the Rev. Henry Wilder Foote has written
an excellent book [36] which contains in addition to the facts many plausi-
ble surmises about Feke's life, remains a problem in spite of a number
of fine pictures, authenticated by signatures. No one has accounted for
his style. According to a Dr. Hamilton [37] who in 1744 visited Feke in
Newport, the painter was self-taught. But that was before Feke had
done his best work. Feke's mature portraits suggest a careful training in
the style of Richardson or Highmore, or the same type of training that
produced Thomas Hudson and Allan Ramsay. Feke, evidently depend-
ing on the same sources, formed American style toward the middle of the
century. Some of the pleasantly stiff and poetic portraits of Allan Ram-
say are especially close to Feke's more robust portraits. But no English
painter is obviously Feke's teacher, unless one assumes that John Van-
derbank, who died in 1739 after founding a painting academy in Lon-
don, had a remote hand in his training. One dares to make such an
assumption because of the trimly designed and elegantly posed *Portrait
of a Lady* (Dulwich College Gallery, Cambridge, England) which Van-
derbank painted in 1738,[38] thereby anticipating an effect of gracious
affluence utilized by Feke for several years later. At least one may say

that Feke could not have attained his mature, full-blown grandeur of style without coming in contact with more than native American artistry.

His early style may be judged by only two canvases, a *Self-Portrait* (Rev. H. W. Foote, Belmont, Mass.) and the group of *Isaac Royal and His Family* (Fig. 37). The group portrait is signed on the back and dated 1741. The *Self-Portrait*, though unsigned, fits Hamilton's description of the painter who had "a long pale face, sharp nose, large eyes with which he looked at you steadfastly; long curled black hair, a delicate white hand, and long fingers"; furthermore, the picture descended in a family owning other portraits traditionally attributed to Feke. Assuming, as Dr. Foote does, that Feke painted himself at the age of about twenty, the probable date of the picture would be close to 1725. But surely Feke has represented himself as older, for instance, than Isaac Royal, represented at the age of twenty-two, as the inscription states, or *Robert Auchmuty, Jr.* (Herbert L. Pratt, Glen Cove, L. I.), aged about twenty-six. One may even believe that the *Self-Portrait* was painted at the age of thirty, within five or six years of 1741.[39] And this dating bears out the stylistic evidence that the portraits are alike in brushwork and method, even though the group of the *Royal Family* is more sophisticated and pretentious. A difference in date of six years would sufficiently explain the increased objectivity and greater fullness of form in the group portrait. Shortly before 1741 Smibert was painting in full swing; Badger, the native Bostonian whose relationship to other artists is one of the most interesting of problems, was of an age to work, although no pictures are attributable to specific years as early as this; Nathaniel Emmons and Peter Pelham were also at work in Boston. In New York, Gerardus Duyckinck, Pieter Vanderlyn, and John Watson; in Maryland, Gustavus Hesselius; in the South, Charles Bridges and perhaps the young Theus, were all active. Of these only Smibert could have influenced Feke in painting his *Self-Portrait*, with its straight-

forward modelling, simple design, and sincere spiritual feeling. It appears to be the work of a sensitive but steady hand and to portray a scholarly person of moody character. Akin to the *Self-Portrait* are the early studies of *Mr. and Mrs. Tench Francis* (Mrs. Sidell Tilghman, Madison, N. J.) and the so-called *Pamela Andrews* [40] (Rhode Island School of Design, Providence); yet there is no clear development marked out from picture to picture which might reveal Feke's origins. From the *Self-Portrait* to the *Royal Family* is indeed a development, but the thin qualities of the *Self-Portrait* appear again in the portrait of the *Rev. Thomas Hiscox* (Mrs. Cornelius Vanderbilt, Newport, R. I.), which is signed and dated 1745, four years later than the *Royal Family*. One can only follow the course of dated pictures.

Charting the range of our knowledge about Feke's life is all too easy. Beginning with 1741, there is a dearth of dated work until 1745, when a succession of portraits cover the years to 1749 with the exception of 1747. In 1742 the artist was married in Newport. According to the presentation inscription on the back of a child's portrait attributed to Feke by Dr. Foote, but which is here linked with a New York painter of the time of Pieter Vanderlyn (see section 5), Feke was at some time in New York. Signatures on portraits of Philadelphia people show that he was there in 1746, just as other signatures indicate that he was in or near Boston in 1741 and more extensively in 1748–49. The Diary of John Smith [41] shows that Feke was again in Philadelphia in 1750. Adding the fact that he is mentioned in 1767 as "Robert Feke, Mariner, deceased," completes the meager history of one of the most stylish of colonial artists.

Like Smibert's first work in America, Feke's earliest dated work is a group arrangement; but Feke had no taste for the interlocking design of the *Berkeley Family* group (Frontispiece), nor the intense personality of each sitter. He did not try to make the hands expressive. Instead he adopted a severe pattern which is as rigid as the table-top in the

foreground, and on which he applied careful likenesses, not so much detailed and individualized as conforming to a formula for good looks which faintly recalls Smibert's more assertive types. The ladies are not yet as stylized and stunning as *Mrs. James Bowdoin* (Fig. 35) and *Mrs. Ralph Inman* (William Amory, Boston) were to be represented in 1748. But they are objectively done, and effective in their setting. The baby seated on the table is a later addition, probably inserted by John Greenwood after Feke had moved Penelope Royal, who is second from the left, several inches to the right, as the X-ray shadowgraph proves.[42]

These evidences of struggle and correction in the design suggest a certain amount of immaturity on the artist's part. And the next dated portraits, those of the *Rev. John Callender* (Rhode Island Historical Society, Providence) and *Rev. Thomas Hiscox*, already mentioned as dating from 1745, are perfunctory in design. But beginning with 1746 Feke's work becomes freer and bolder in pattern, more surely constructed; *Mrs. Charles Willing* (Vincent Astor, Rhinecliff, N. Y.) and *Tench Francis* (Dr. Henry M. Fisher, Jenkintown, Pa.) are represented in that year with poise and attention to draperies and accessories; the faces are lively, with details of modelling about the eyes and mouths which tell of the painter's maturing skill. Since these sitters were Philadelphians, one may suppose that Feke found some artistic stimulation between painting the reverend gentlemen in Newport and the stylish people in Philadelphia. If he had come into contact with the work of Joseph Highmore or some painter as skillful — Allan Ramsay, perhaps — all would be explained. It could not have been a Philadelphia artist, like James Claypole, whose portrait of *Margaret Hamilton Allen* (Estate of Thomas B. Clarke, New York) is signed in 1746, because that portrait contains only a naive suggestion of Feke's stylish method; the influence must have been the other way. Nor could it have been Gustavus Hesselius, whose development was away from stylishness towards simple

realism. Guessing wildly, one imagines that Feke, the mariner, made a trip to London which gave him more confidence in himself and brought him up to date on the art fashions of the active English painters.

It is not such a wild guess, at that. A genre painting of merchants and travellers on a shore, waiting for a boat (Mrs. L. K. George, Nottingham, England), which, according to an unpublished note by Dr. Foote, is probably by Feke, must have been inspired by a Flemish visit or a Flemish picture or print. Although the work is signed R. Feke at the left and again R F on a trunk, it is totally different in scope from Feke's other work, excepting perhaps the landscape (see section 20, page 143) which used to hang over the mantle in a house built by Josiah Martin, whom Feke painted. One therefore can scarcely pretend to say that the Flemish influence amounted to anything, whether acquired on a visit abroad or from an engraving, like that of the *Judgment of Hercules*, which Feke is known to have copied.[43] But taken in conjunction with the increased suavity in portraiture, the fact of some Flemish influence, no matter how brief, points to a trip abroad.

What happened to Feke in 1747 cannot even be guessed. But by 1748 he was completely master of an easy, sophisticated formula for painting handsome people. He had learned to simplify the folds of dresses so that they gave weight and depth to the design, as in the portraits of *Mrs. James Bowdoin* (Fig. 35) and *Mrs. Charles Apthorp* (Mrs. Ben P. P. Moseley, Boston). He learned to soften the severe lines of men's costumes by draping their coats realistically and by separating their arms from their bodies, as in the portraits of *Charles Apthorp* (Cleveland Museum) and *Oxenbridge Thacher* (Col. Archibald G. Thacher, New York). But his last dated picture, the portrait of *Mrs. Thacher* (Col. Thacher, New York), inscribed "R. F. Pinx 1749," is the most solidly constructed portrait of all, with its severely arranged skirt and dominating, erect head.[44]

If Feke did not acquire his skill in London it is astonishing. Consider the difference between Smibert's lively realism and Feke's sculpturesque, refined, and formal art. The difference is approximately that between the portrait of *James Bowdoin as a Boy* (Bowdoin College, Brunswick, Me.), which Dr. Foote attributes to Feke [45] in spite of chronological difficulties, and the portrait of *Robert Auchmuty, Jr.* (Herbert L. Pratt, Glen Cove, L. I.), which is signed "R. F. Pinx, 1748." That the *Bowdoin* portrait is by Smibert seems certain because of its technique, its orange flesh tones, and its resemblance to other children's portraits by Smibert, like that of *Mary Pemberton* (George H. Davenport, Boston), which is constructed with the same smeared highlights in the dress and thick, lumpy face modelling. Feke's portrait, much smoother in finish, seems in contrast with Smibert's to be introspective and delicate; it has a drawing-room quality never achieved by Smibert, even when he tried for an attractive effect, as in the portrait of *James Bowdoin*. Smibert's bluntness is characteristic of the most original work done in America, by Badger, Pieter Vanderlyn, and Hesselius (Figs. 40, 20, and 24), before and after this time. Feke's formal charm is characteristic of aristocratic English portraiture, as are Bridges' elegant mannerisms. Certainly nothing in America could have produced Bridges' style. It seems equally plain that no artists and no social conditions in America could account wholly for Feke's style.

More likely, Feke influenced society in Boston and Philadelphia by bringing to his sitters a new taste for elegance in portraiture. If this is true, Feke should have influenced his fellow-artists in America. And this he obviously did, giving Badger and Greenwood their conception of fashionable portraiture and perhaps influencing the work of Philadelphia artists of the time of James Claypole. As has already been suggested, Claypole's portrait of *Margaret Allen*, dated 1746, is a naive approximation of Feke's sophisticated manner. The portrait of an *Unknown Man with a Spaniel* (Sears Academy, Elgin, Ill.), which Dr. Foote

attributes to Feke,[46] appears to be an approximation of the same kind, though better drawn than the portrait of *Margaret Allen*. Its resemblance to the portrait of *Gerrit Abeel* (New York Historical Society) may suggest an attribution to Matthew Pratt.

Feke may, in addition, have had a hand in developing the mature style of John Wollaston, who was painting in New York in 1751. Wollaston's earliest attributed work, a portrait of *George Whitefield Preaching* (National Portrait Gallery, London), supposed to have been painted in London about 1742, reveals Hogarth's influence. Even though this picture may possibly be by John Wollaston senior, the later work of the younger Wollaston suggests this bold, limpid manner, which recalls that of Hogarth in a less sensitive form. The portrait of *William Smith* (The Misses Wetmore, New York), which has a fancy label on the back, giving the name and age of the sitter and then "Johannes Wollaston Londinensis Pinxit Novi Eboraci A.D. MDCCLI," shows that the painter came from London already trained. His style is bland and fresh; and he consistently painted people's faces with a distinctive, lumpy, staring effect, as in a large number of portraits painted in New York, Philadelphia, and the South. How closely Wollaston approached Feke in stylish posing can be judged from the fact that a portrait of *William Plumstead* (Pennsylvania Academy, on loan at the Historical Society of Pennsylvania, Philadelphia), which Dr. Foote [47] attributes to Feke on his last visit to Philadelphia in 1750, contains the most pronounced characteristics of Wollaston's style in its lumpy modelling and "almond-eyed" effect; the portrait may be dated later than 1750, because of the evident age of the sitter, and attributed to Wollaston. Some relationship between these artists may be further deduced by comparing two portraits of *William Allen* — at least the sitter seems to be the same in both portraits. Wollaston painted him (Fig. 44) at about the same age that Feke painted him (Fig. 36). Even though Feke's canvas in Philadelphia has been attributed to Benjamin West, it seems to be a good

example of Feke's mature technique, which is too mature for the young Benjamin West (Fig. 56). The portrait is stably composed, with details carefully studied. So is Wollaston's portrait, which, however, lacks the elegance he sometimes achieved in posing a sitter. The point is that Wollaston here attempted a sober likeness more in Feke's serious mood than in his own rather frivolous spirit, typified by his 1760 signed portrait of a man, also called *William Allen* (Brooklyn Museum, New York), although the sitter does not appear to be the same as in the other portraits just mentioned. Whatever the confusion about the names of these sitters, it is plausible that Wollaston admired Feke's skill and realism. One may even guess at the occasion for an influence from Feke, since a copy of Feke's portrait of *Mrs. Charles Willing* [48] is characteristic of Wollaston, who painted the companion portrait of *Charles Willing* in Philadelphia.

Also Feke apparently shared with Wollaston the doubtful honor of influencing John Hesselius, son of Gustavus, who was painting in Philadelphia as early as 1752. Later portraits by Hesselius, like the portrait of *Thomas Johnson* (Estate of Thomas B. Clarke, New York), dated 1768, and that of *Samuel Washington* (Mrs. Samuel Walter Washington, lent to the Corcoran Gallery, Washington, D. C., 1923),[49] reveal gestures and designs typical of Feke, while the round-faced, slant-eyed modelling of *Charles Calvert's* portrait (Fig. 43), signed and dated 1761, shows a relationship to two portraits attributed to Wollaston, *Governor Mifflin as a Boy* (Historical Society of Pennsylvania, Philadelphia) and the *Children of Mr. and Mrs. Warner Lewis* (G. A. Greaves, lent to the College of William and Mary, Williamsburg, Va.). In fact, one could believe that it was John Hesselius and not Wollaston who painted the two last-mentioned canvases. A certain kind of southern portrait, slant-eyed, heavy-lidded, round-faced, brightly dressed, and artificially posed, seems to be attributable to Jeremiah Theus, Wollaston, or John Hesselius almost indiscriminately. At any rate, these three painters carry

on the tradition of English style in the South up to a time when the first pupils of Benjamin West were returning to America with still newer ideals.

More interesting things were happening in Boston, partly as a result of Feke's example, but chiefly as a result of Blackburn's meteoric appearance. To appreciate the novelty of Blackburn's style, one should first take up Badger and Greenwood, who may be coupled together since they approached portraiture from the same point of view and were influenced by Smibert and Feke. Neither artist seems to have been highly trained either in art or in "book learning." Joseph Badger's career can be followed, as in Lawrence Park's account,[50] from obscurity to brief fame and obscurity again, in spite of the fact that he apparently did not sign his pictures. A document furnishes the information that in 1757 Badger was paid £6 apiece for portraits of *Timothy Orne* and *Mrs. Orne* (Robert Saltonstall, Readville, Mass.); and these portraits establish a truly primitive manner of painting. The patterns are stiff, the likenesses formalized, the effect provincial. Yet Badger was a true primitive in that he put into his work a sincere knowledge of what a portrait should be and the essentials of the accomplished style which grew out of Smibert's characterful work and the brilliant adaptations of English art by Feke. In fact, the portrait of *Mrs. Orne* seems reminiscent of Feke's arrangements of the arms of feminine sitters, of the turn of their heads and the elegant pose of their fingers. Other portraits painted in the same precise, thin, pedantic manner, with the same adherence to simplified reality, like the full length of *Capt. John Larrabee* (Fig. 40), reveal an influence from Smibert's full lengths of *William Browne* (Fig. 33) and *William Pepperell*. So pronounced were Badger's odd habits as a painter that Lawrence Park was able to attribute to him eighty portraits, which can be dated from 1743, when died *William Cooper*, whose portrait (Massachusetts Historical Society, Boston) is typical of Badger's vaguely formed but realistic work. Badger himself

died in 1765, and was therefore active during the period not only of Feke's but of Blackburn's visit.

Something of Blackburn's prim expression appears in the face of the portrait of *Sarah Savage* (Mrs. F. T. Bowles, Boston), who, considering her age, must have sat to Badger about the time that Blackburn disappeared from Boston in 1763. Yet what surely must be one of Badger's last pictures, the portrait of old *Mrs. Jonathan Edwards* (Fig. 41), does not show any appreciable lessons learned from the fashionable painters; the exaggerated lines of the chair in which she sits, the geometrical but smudged modelling of her face, and the hieratic folds of her dress tell that an instinctive artist was at work, oblivious of — or unable to accomplish — the pearly flesh tones, graceful designs, and sleek satins of his superiors. He may have attempted in his portraits of children to do what Highmore had done, or Smibert did in his portrait of the young *James Bowdoin*, by setting them out-of-doors at play with a dog or a bird; but he remained a primitive, more concerned with his idea of a likeness than with an objective study of children at play. If the portrait of *George Whitefield* (Fig. 42) is by Badger, as it seems to be,[51] it is a perfect example of his primitive, simple, direct method. That Whitefield was cross-eyed and dominating, one appreciates with the first glance at the canvas; scarcely anything more is recorded in this astonishing picture. So clearly expressed are Badger's portraits that one willingly tolerates the limitations of his technique. He was a minor artist, but a true one. And his work has a solidity which many a more polished painter lacks.

Now the dividing line between Badger and Greenwood is not easily placed, and one might be tempted to attribute to Badger a kind of small-town smugness and hard manner which John Greenwood had, especially in his portraits of women. A rather crude but ambitious *Family Group* (Henry L. Shattuck, Boston), containing his own portrait in the background, is typical of his shallow manner and makes use of Feke's group of the *Royal Family* (Fig. 37) in a crude way which must have been

particularly offensive to the sensitive Feke. One believes that Feke may have known Greenwood, because of the misshapen child painted into the composition of the *Royal Family* with Greenwood's hard, bad drawing, and because Greenwood's signed portrait of *Benjamin Pickman* (Fig. 39), dated 1749, resembles Feke's work of 1748, for example the portrait of *Richard Saltonstall* (Mrs. Richard M. Saltonstall, Boston), in pose and attempted firmness of modelling. Greenwood was born in 1727, was apprenticed in 1742 to Thomas Johnston, the engraver, and left Boston for Surinam ten years later. His American portraits must thus date from the few years between the end of his apprenticeship, perhaps as late as 1747, and 1752. Although he helped make the inventory of Smibert's estate, he does not seem to have been closely attached to Smibert; he may have been influenced by Smibert's technique, as in the portrait of *Ephraim Turner* (New England Historic Genealogical Society, Boston), which is typical of his rougher likenesses. But he also may have known Badger well. A portrait of *Henry Flynt* (Harvard University, Cambridge, Mass.) seems indeed to be painted by Greenwood under the influence of Badger's thin and direct handling of men's features.

Other portraits attributed to Badger are very close to Greenwood's signed work. Note especially the portrait of *James Bowdoin* (Bowdoin College, Brunswick, Me.), which probably dates close to 1747, when Bowdoin died; the portrait of *Thomas Cushing* (Essex Institute, Salem, Mass.), which is the same in pose and duplicates the folds of the coat worn by *Bowdoin*, as do the portraits of *Cornelis Waldo* (Worcester Art Museum), of *John Adams* (Detroit Institute of Arts), with its "liney" face but Badger-like hands, and the portrait of *Edward Gray* (Mrs. Gedney K. Richardson, Boston). This is all very confusing. As one reviews Badger's work, with Greenwood's signed portrait of *Benjamin Pickman* (Fig. 39) in mind, one feels like invoking a third artist who borrowed freely from both painters and thus produced the most puzzling of these

likenesses. If one dares rely on the apparent fact that *Thomas Cushing*, supposed to have been born in 1725, is represented as a man of at least fifty, one must date his portrait ten years after Badger's death and more than twenty years after Greenwood left Boston. Even if the identification of Cushing as the sitter is doubted, there is still the problem of the chronology of these canvases as a group.

The problem of authorship confronts one in the portrait of *Benjamin Franklin* (Fig. 38), which Lawrence Park [52] attributed to Feke and dated about 1746 in Philadelphia, but which is amateurishly painted, compared to Feke's Philadelphia portraits. The hard style, the incorrect but summary draftsmanship, and the black and white coloring are characteristic of the Badger-Greenwood group, as in the portrait of *Henry Flynt*. If the subject is Franklin, as seems certain because of the picture's history, the artist could have painted him in 1746 when Franklin, aged forty as represented, returned to Boston for a brief visit. If by Greenwood, this would be one of his early efforts, corresponding in date to the portrait of *James Bowdoin*, attributed to Badger. Then by comparing the techniques in the *Franklin* and *Bowdoin* portraits one sees at once that, though closely linked in style, they are not by the same hand. This allows one to believe that Badger and Greenwood developed simultaneously, with mutual influences. The portrait of *Thomas Prince* (Massachusetts Historical Society, Boston), documented as the work of Greenwood by Pelham's engraving of 1750, is certainly close in spirit to Badger, and suggests that the Badger influence followed an influence from Smibert in Greenwood's work.

In this highly theoretical view of Greenwood's development it is difficult to place the portrait of *Samuel Mather* (American Antiquarian Society, Worcester), which is painted with lumpish facility, squinting eyes, and zigzag folds, vigorously reminiscent of Wollaston's signed portrait of *William Smith, Jr.*, painted in New York in 1751. Since the same style is suggested by the portrait of *Mrs. Abigail Gerrish* (Essex Institute,

Salem, Mass.), attributed without conviction to Greenwood, as well as by the portrait of *Henry Flynt* already mentioned, the whole question of attribution, as well as of chronology, is thrown in the air, and one feels more and more the need of another artist to explain these strange differences and resemblances. Although it is easy to recognize Greenwood's hand in the portrait of *Ephraim Turner* (New England Historic Genealogical Society, Boston), because of its complete resemblance in pose, dress, and technique to the signed portrait of *Benjamin Pickman*, one can only guess that this portrait preceded a number of thinly painted, erratically modelled likenesses, among which are those of *Mrs. Cunningham* (Boston Museum) and *Capt. Tracy* (Mrs. Henry B. Bigelow, Concord, Mass). If *Mrs. Cunningham* is twenty years old in her party dress, she must have been painted just before Greenwood left Boston in 1752. And that suggests the limits of Greenwood's style.

Thus begins a period of rapid development in the fine arts as practiced at Boston. After Greenwood left, young Copley began to study Badger's work, as will be shown; and Badger remained the leading artist of New England until the arrival in 1755 of an Englishman, or Scotchman, named Joseph Blackburn, who apparently left America after 1761. By that time Copley had become the most important painter in America; his skill and realistic taste were in 1765 to astonish sophisticated London painters. Thus, in little more than a decade, Boston knew the elegance of Feke, saw the passing of the grimly realistic Smibert, patronized the uncharming Greenwood and the náive Badger, awakened to a new standard of grace in the work of Blackburn, and hailed the master craftsman of them all in Copley.

These sudden shifts in artistry were, of course, due to various impacts of English art. The whole coast was receiving them, not only in New York, where Wollaston, Kilbrunn, and M'Ilworth appeared, but in the Carolinas, where Alexander Gordon had settled in 1743, coming from Aberdeen. Thomas Coram came from Bristol to Charleston in

1769 and was instructed by Benbridge, according to Dunlap.[53] Although no pictures by M'Ilworth, Gordon, or Coram have been identified, any more than the pictures which may some day reveal the styles of Wardwell, Senior, who advertised in South Carolina, and Henry Warren, who was noticed in Virginia, the English element is strong in all portraits of the time. It is obvious in the work of Blackburn, who came to Boston by way of New York or Newport, as a signed portrait of *Mrs. David Cheeseborough* (Metropolitan Museum, New York), dated 1754, indicates. Blackburn was, of course, fully trained at this time. Not only the portrait of *Mrs. Cheeseborough*, who was painted according to family tradition in New York, and who married a Newport merchant in 1749, but the portraits of *Col. Henry Tucker* and *Frances Tucker*,[54] painted, it is said, in Bermuda in 1753, form a stylistic link between Feke and Copley. Like Feke, Blackburn left little trace of his activity save through his art. His origins are obscure, though certainly British. His handling and use of satin, the poses of his women sitters, their gestures, and their sidelong glances suggest that Blackburn continued where Feke left off in 1748–49 — that is, in the style of Thomas Hudson, pupil of Jonathan Richardson and teacher of Reynolds, or of John Vanderbank, whose portrait of a lady already mentioned has a decided resemblance to Blackburn's graceful work of a decade and a half later.

An interesting letter written about 1757 and published by Lawrence Park [55] shows what was the attitude of an intelligent member of the society for whom Blackburn worked. The writer asks, "Have you sat for your picture? Is the mouth placed in the proper order? Do your eyes roll about? Tell Mr. Blackburn that Miss Lucy is in love with his pictures, wonders what business he has to make such extreme fine lace and satin, besides taking so exact a likeness. It is thought your lady makes the worst appearance in Mr. Blackburn's room, that she is stiff and prim and wants an agreeable something, but that may be and yet a good likeness. I hope you will excuse the freedom from yours," etc.

One wonders whether the last bit is merely a sisterly joke or a general judgment. Certainly most of Blackburn's portraits, even stunning examples, like the portrait of *Mrs. Jonathan Simpson* (Boston Museum), dated 1758, are stiff and prim. His limitations are readily shown by pointing out the repetitions in gesture and even in complete designs, as in the portraits of *Mrs. Cheeseborough* of 1754 and *Mrs. Greenleaf* (Richard C. Greenleaf, lent to the Metropolitan Museum, New York), painted in 1757. From 1754 to 1761 he signed portraits which nevertheless possess style and occasionally rise to an impressive height, especially in his portraits of men. A development from stiffness to breadth and variety of pose can be followed in dated pictures, and an important change in his ideals can be dated about 1756, when he began signing portraits that are character studies as well as pretty pictures. The change may be suggested by such portraits as those of *Joseph Dwight* (Fig. 47), dated 1756, *Sir Jeffrey Amherst* (Herbert L. Pratt, Glen Cove, L. I.), *Mrs. Samuel Gardner* (A. Lawrence Lowell, Cambridge, Mass.), and *Mrs. Jonathan Simpson*, mentioned above. The only portrait dated 1759, one of *John Wentworth* (Miss Susan J. Wentworth, Portsmouth, N. H.), is, like the portrait of *Thomas Amory* (The Misses Metcalf, Los Angeles, Calif.), dated 1760, a Copley-like study which turns away almost entirely from the "stiff and prim." Other portraits of 1760, two of *Theodore Atkinson* (Worcester Art Museum and Cleveland Museum), and a full length of *Gov. Benning Wentworth* (Miss Susan J. Wentworth, Portsmouth, N. H.), carry on this growth in realism which is climaxed in 1761 by four portraits of considerable strength, *Jonathan Warner* (Boston Museum), *Elizabeth Browne Rogers* (Mrs. Katherine Wentworth Ruschenberger, Stafford, Pa.), who sails majestically into view with a flutter of drapery, *Mrs. Joshua Babcock* (Mrs. Henry A. Murray, New York), and *Mrs. Nathaniel Barrell* (Mrs. Leonard Wheeler, Worcester, Mass.).

Could Blackburn have been influenced by a Boston artist? We only know about Badger and Copley at this time; and the very idea of

Badger, the painter of *Timothy Orne* in 1757, influencing Blackburn, painter of *Theodore Atkinson, Jr.* (Fig. 51), to incorporate more spontaneous poses and more accurately studied characters in his stylish work, seems ridiculous. As a matter of exact observation, there appears one case of possible influence from Badger, and that is in the feet of *Gov. Wentworth*; but Blackburn probably had never drawn a foot before, and was in this detail merely struggling for reality in a way which is only accidentally like Badger. This leaves Copley, a youth of twenty, who at the age of eighteen had begun to paint satins and folds in Blackburn's manner, as critics have pointed out. Now it seems from the evidence of signed and dated pictures that Copley was the only artist who could have influenced Blackburn in 1756; if he did, it is a hitherto unnoticed case of the teacher being taught. There was no other source for such an influence at this moment, except popular taste. Consequently it is important in our study of the trend in taste to recapitulate the scope of Blackburn's work, before describing Copley's precocious talents.

Blackburn, let it be repeated, came to America a mature, but stiff, painter of stylized portraits, although his studies of men are generally less stylized than his portraits of women. Were it not for the associations attached to his pictures, through the names of sitters, it would be difficult to distinguish between Blackburn and a follower of the English painter Hudson. But about 1756 Blackburn's portraits become better individualized. Even though he still paints clothes in the usual way and still makes his sitters pose with shop-worn gestures, as in the portrait of *Mary Sylvester Deering* (Fig. 50), he reveals a new skill in painting faces. And by the time he painted in 1761 his last American portrait known to us,[56] Blackburn was poaching in the realistic field which Copley had begun to cultivate as early as 1753, when, as a boy of fifteen, he painted and etched a portrait of *Rev. Welsteed* (Fig. 46), which will be discussed in the next chapter.

In closing this account of Blackburn, it is therefore suggested that the English training which he brought to New England was turned into a new channel by the realistic taste of pioneers who had for two generations been quite settled, and who could look on the latest style from London, as did Mrs. Mary Russell, without missing its artificiality. She was the lady who wrote about Blackburn's portrait, "Is the mouth placed in the proper order? Do your eyes roll about?"

NOTES

1. Jeremiah Dummer, by Hermann F. Clarke and Rev. Henry Wilder Foote, Boston, 1935.
2. Old Time New England, July, 1921.
3. Art in America, xx, 72.
4. Samuel Sewall, Letter to Sir William Ashurst, under date of 1704; Massachusetts Historical Society Collections, 6th series, I, 311.
5. The usual attribution of the portrait of *William Pepperell* to Smibert is not borne out by comparison with Smibert's signed work, nor is it possible, because of chronological discrepancies.
6. According to Cotton Mather, Magnalia Christi Americana, Wilson refused to have his portrait painted in 1667, the year of his death. The wig and the manner of painting suggest a date long after Wilson's death.
7. According to the dating of Kenneth B. Murdock, Three Portraits of Increase Mather, privately printed.
8. Massachusetts Historical Society Proceedings, September, 1867, 47.
9. Repr., Bolton, op. cit., III, 925.
10. Op. cit., 20.
11. Charles Harris, New York Historical Society Quarterly, v (1921), no. 3, 61, states that none of the portraits by Vanderlyn in the New York Historical Society and in Albany are signed. The attributions rest upon the complete history of the portrait of *Mrs. Schuyler Vas* (Albany Institute of History and Art).
12. Robert Feke, by the Rev. Henry Wilder Foote, Cambridge, 1930, 136.
13. Op. cit., 32–34.
14. History of the Arts of Design, by William Dunlap, Bayley-Goodspeed edition, Boston, 1918, I, 12.
15. See section 19, 135.
16. Little Known Early American Portrait Painters, by Frank W. Bayley, Boston, 1915–17 — a series of pamphlets.
17. Repr., Pennsylvania Museum Bulletin, XXVI, 11.
18. Op. cit., I, 150.
19. Antiques, December, 1929, 490.
20. Art and Artists in Provincial South Carolina, by the Rev. Robert Wilson, Charleston Year Book, 1899.
21. Op. cit.
22. Repr., Dunlap, op. cit., III, 286.

23. Rev. Robert Wilson, op. cit., 137–147; also see John Hill Morgan, Brooklyn Museum Quarterly, XI, 47.
24. Rev. Henry Wilder Foote is preparing (1936) an authoritative book on Smibert.
25. He considered him "a silent, modest man, who abhorred the finesse of some of his profession." See Theodore Bolton, The Fine Arts, August, 1933, 15.
26. Lent anonymously to the Massachusetts Bay Tercentenary Exhibition, Museum of Fine Arts, Boston, 59.
27. Except when copying a Rubens, from which he borrowed richness and depth of form.
28. Smibert wrote in 1749, "My eyes has been some time failing me but I'm stil heart whol and hath been diverting myself with some things in the landskip way which you know I always liked." Smibert-Moffatt Correspondence, Massachusetts Historical Society Proceedings, 1915.
29. Smibert-Moffatt Correspondence, op. cit.
30. Thomas B. Clarke, op. cit.
31. Dunlap, op. cit., I, 17, note by Frank W. Bayley.
32. Notes Concerning Peter Pelham, by William H. Whitmore, Cambridge, 1867.
33. William H. Whitmore, op. cit., 18.
34. Arts and Crafts in New England, by George F. Dow, Topsfield, Mass., 1927, 3.
35. Thomas Eakins, by Lloyd Goodrich, New York, 1933, 116.
36. Robert Feke, by the Rev. Henry Wilder Foote, Cambridge, Mass., 1930.
37. Itinerarium, by Dr. Alexander Hamilton, privately printed, St. Louis.
38. Repr., Baker and James, op. cit., Pl. 39.
39. Theodore Bolton and Harry L. Binsse, Antiquarian, October, 1930, agree with this dating.
40. Repr., Rev. Henry Wilder Foote, op. cit.
41. Hannah Logan's Courtship, edited by A. C. Myers, Philadelphia, 1904, 290.
42. According to the inscription on the reverse of the canvas, the portraits were "finisht Sept. 15th, 1741 by Robert Feke." But baby Elizabeth, born June 7, 1740, would not have been "aged 8 months, 7th instant," as the inscription also states, unless the picture had been first completed in February, 1741. The finishing process thus may have consisted of moving Penelope's position to a point equidistant between the other women. When the present baby was added is not clear; she was painted over an area which had been scraped down and presumably had contained another child's portrait. If the present baby was added by Greenwood she was probably not painted until about 1748 and might then represent a second Elizabeth, born in October, 1747.
43. Dr. Alexander Hamilton, op. cit.
44. Theodore Bolton and Harry L. Binsse, Antiquarian, October, 1930, consider the last mentioned pair of portraits less able; "indeed they possess many characteristics of the work of Blackburn." The present writer does not agree.
45. Op. cit., 127.
46. Op. cit., 196.
47. Op. cit., 175.
48. Repr., Hannah Logan's Courtship, 134.
49. Repr., The American Magazine of Art, XXIV, 408.
50. Massachusetts Historical Society Proceedings, 1917.
51. Annals of Salem, by Joseph Felt, Salem and Boston, 1849, II, 79, mentions a portrait of Whitefield Preaching by Blyth (see section 9, p. 69), but there is no evidence that this was the portrait given to Harvard in 1852, which was formerly owned by a Mrs. Waters.
52. Art in America, XII, 29.
53. Op. cit., I, 165.

54. Repr., The Emmet Family, by Thomas Addis Emmet, 1898.
55. American Antiquarian Society Proceedings, 1922, XXXII.
56. Frank W. Bayley's statement, Five Colonial Artists, Boston, 1929, 53, that "several of the artist's pictures are signed and dated 1763," refers to no pictures known to the present writer. The portrait of "*Marchioness*" *Wentworth* (Minneapolis Institute of Arts), signed "J. Blackburn Pinxit 1767," strongly resembles the work of Benjamin West. The portraits of *Governor Bernard* and *Lady Bernard* (Wadsworth Athenaeum, Hartford, Conn.), signed and dated 1760, are not painted in Blackburn's manner, nor in that of the Minneapolis portrait. John Hill Morgan and Rev. H. W. Foote are at present writing preparing a new catalogue of Blackburn's works which will contain, it is reported, some portraits painted in England.

CHAPTER III

Rise of a Distinctive American Taste

THE sophistication and intelligence of colonial society may be taken for granted, since enough letters, diaries, and comments have come down to us with a fine flavor of independent thought to reveal the mind of pre-Revolutionary times. Then, as always, people had their own likes and dislikes; but it seems as though the rare personal opinions expressed by Samuel Sewall in his voluminous papers and by John Hull and Samuel Curwen in their Journals, and the more "modern" personalities expressed by Copley and his contemporaries, give us an insight into the origins of the Yankee temperament, which is fundamentally as intellectual as it is shrewd. And this peculiarity is confirmed by the contemporary observations of the sophisticated traveller, Dr. Hamilton, who noted the difference between people, their manners, and choice of living conditions all the way from Maryland to Albany and Boston. Unlike the society of the South, the society of New England was in close touch with the backbone of the nation-to-come, the yeoman class, composed of shopkeepers, small but independent farmers, artisans, and clerks. There was less spread between the top and the middle layers of society. Although "the best" families retained their positions, new families were joining them at the top, and the general movement was an upward one rather than a levelling off on a lesser plane. Far into the country people of modest means were building houses of excellent taste and utilizing furniture that today seems aristocratically elegant. Yankee ingenuity was characteristic of small home owners, as well as of merchants, manufacturers, and politicians. Patiently and cleverly, the New Englander was making his world.

And he was forming, through his choice of things utilitarian and ornamental, a kind of taste which is distinctive. Though he took his ideas for a house or a table or a law from a book published in England, he produced architecture, furniture, and a political state which are not English in appearance. The American characteristics, unconsciously achieved in all probability, may have resulted merely from limited means, which prevented exact duplication of English ideas. Or the natural ingenuity of pioneers may have suggested new ways of accomplishing what were thought to be the old results. Whatever the explanation, the prosperous family of about 1750 in Boston was not surrounded by products of artists and craftsmen identical with similar products made in England. And the difference consisted in a new emphasis on simplicity, reality, and serviceability. The American artist, like the artisan, was not thinking in harmony with Charles F. McKim, whose architecture, according to Royal Cortissoz,[1] had such an important effect on American taste today; McKim once said, "Plan is essential, but first and last the thing for you to aim at is beauty." That Smibert, Badger, or Copley thought of beauty at all is doubtful. Certainly nowhere in Copley's letters is there any mention of that quality, divorced from practical things such as likeness, exactness, finish, or professional honesty. And Copley, as he suggested in a letter to Benjamin West, was sympathetic to a tradition of style which might easily be interpreted as a tradition of "beauty in the large sense," as Mr. Cortissoz calls it. Not only is there an absence of the beautiful in early American taste; there is a lack of conscious planning, inasmuch as any and every influence from abroad was taken over without much discrimination, just as Blackburn's rolling eyes and prim mouths were accepted. What took the place of beauty and consciously artistic structure was simply good eyesight. The ability to make the hand accomplish what could be seen with the eye differed, of course, in different artists. Smibert had not only a very able hand; he must have thought about what he saw. Badger

had a very limited ability, although he made up for it somewhat by his intense and dignified respect for reality. Copley, as can easily be shown, relied entirely in his American portraits on his skill in transcribing a visual impression in detail and with exactness.

9

COPLEY'S REALISM

One may learn about John S. Copley through various biographies, including one by Frank W. Bayley; [2] but the most important source of information for the critically-minded is the volume of letters [3] containing, besides a few Pelham family letters, business notes, and general correspondence, the correspondence between Copley and his half-brother, Henry Pelham. Here one finds out what kind of man Copley was, how meticulous in business, hard-working, serious, methodical, and even pedantic, and how much of a Yankee in point of view, as well as how little of a patriot. Copley belonged to what Dunlap a few generations later proudly called "the yeomanry." He must have had a sharp struggle for existence in his youth, since his mother found it necessary to continue her tobacco shop even after marrying Peter Pelham in 1748, when Copley was about ten years old. When Pelham died in 1751 — he was a school teacher at the time, which also points to financial difficulties for the family — he could not have given young Copley much more than rudimentary instruction, probably but a taste for hard lines and round forms, such as an engraver of Pelham's capacity would insist upon. In 1757, however, Copley received an invitation to paint portraits in Halifax,[4] which presupposes an appreciable amount of local fame and ability. Of course, this is obvious in signed pictures, dating from 1757, like the fine and precocious portrait of *Mary Otis Gray* (Massachusetts Historical Society, Boston), painted when Copley was only about twenty. But the question of Copley's development between

the years 1751 and 1757 is not so obvious, since his earliest pictures are few and scattered. The painters in Boston who could have influenced him after the death of Peter Pelham were, of course, Badger and Blackburn, the latter's influence having been noted by several critics, especially in the graceful posing, the painting of satin, and the gestures of hands. A more careful survey of Copley's earliest works leads one to believe, however, that the young painter began his career under the influence of Badger. This is evident in the earliest of Copley's pictures, the portrait of *Rev. William Welsteed* (Fig. 46), which is crudely modelled and hesitating in draftsmanship. One does not wonder at Mr. Bayley's reversal of opinion [5] when he wrote that this portrait "undoubtedly was painted by Badger." But in spite of Badger-like, orange flesh tones, pale gray eyes, and simplified handling, the portrait of *Rev. Welsteed* must be accepted as by Copley in 1753 because of the engraving in reverse which, signed "J. S. Copley pinx et fecit," can only mean that the one who painted it made it into a print. What Copley accomplished at this early date is an improvement over Badger's habitually archaic expression; and this he achieved by softening the outlines and paying more attention to accidental shadows. Except for this heightened sense of reality the portrait might easily be dismissed as an imitation, if not the work, of Badger. That Copley was actually striving for an improvement over Badger's style is implied by the fact that in the engraving, made after the oil painting, the modelling is deeper, the drawing more assured, and the expression more realistic. Or is this effect of self improvement due merely to the fact that Copley's earliest training was as an engraver? The careful delineation of light on the folds in the print is more reminiscent of Pelham's engravings than of Badger's paintings.

Copley's further struggles to achieve a technique can be followed in a few pictures which range from the stiff, hard likeness of *Jonathan Mountfort* (Mrs. C. O. Farlean, Detroit) to the Blackburn-like portrait of *William Brattle* (Fig. 48), dated 1756. The Badger influence, so patent

in the portrait of *Welsteed*, appears somewhat altered in the portrait of *Jonathan Mountfort*, signed and dated in the same year; Copley has caught a youthful expression, posed the young sitter with naturalness, and studied the folds in his coat so that they do not appear done from a formula. It is astonishing work for a painter sixteen years old. Badger's portraits of children, like that of *James Badger* (Metropolitan Museum, New York), dated on the back of the canvas 1760, are stiff little men and ladies, as artificial as dolls, compared with Copley's portrait of seven years before. Not that Copley was already an unexcelled interpreter of casual poses! Two groups of children of the *Gore Family* (Richard Robins and The Misses Robins, Boston), which were probably painted about 1754, judging by their Badger-like characteristics, reveal the artist striving to put two and four figures together as units of design and forcing their gestures, probably in an effort to link one figure with another. His method of studying composition is suggested by the painting of *Mars*, *Venus and Vulcan* (Dr. F. H. Brown, Boston), signed and dated 1754, which is imitated from an engraving.

By 1755, apparently, Copley had enough knowledge of his painting materials and enough dogged patience in recording details to do the portraits of *Peter Pelham* and *Charles Pelham* (Fig. 45), which are generally attributed to Copley at the age of fourteen, because of the tradition that the Peter represented is the engraver and step-father who died in 1751. But Peter Pelham was well over sixty when he died and could not in middle age have worn the style of coat painted, for it was not yet in fashion. Nor does it seem likely that this is a portrait of Peter, son of the engraver, since Peter II went to South Carolina in 1741 while Copley was a baby and raised a family of five children there before 1762. Of the other children of Peter I (the engraver), Henry, Copley's half-brother, was not born until 1749; this leaves Charles, born in 1722, and William, born in 1729, to be represented in these family portraits. In 1755 their ages would have been thirty-three and twenty-six, which is

plausible for the men represented, though how Charles could be represented as an engraver sharpening a burin is not easily explained. At any rate, the accurate delineation of these tools, not to mention the calm solidity of the face, is the best authentication of Copley's signature on the portrait of the engraver. The date, which is illegible, must be later than 1753, and even later than 1754, provided the signature and date on a labored pastel of *Richard Ward* [6] (Rhode Island School of Design, Providence) are genuine, and yet not later than 1756, because the hands in the engraver's portrait are reminiscent of Badger, and the face modelling not as free or as penetrating as in the portrait of *William Brattle*, dated 1756 (Fig. 48). If one were pressed for more exact comparisons, one might have difficulty in showing that the portrait of the younger-looking of the two Pelhams (Fig. 45) was the same in date. However, this must be approximately right. The portrait of *Thomas Marshall* (Mrs. Elizabeth Knox Campbell, Boston) belongs to the same period in which realism and stiffness of design, strong modelling, and weak proportions meet in an experimental sort of way.

With the portrait of *Brattle*, as has been said, Copley began to learn from Blackburn how to adorn with grace the bulk of New England's best people. Compare this portrait (Fig. 48) with Blackburn's signed portrait of *Joseph Dwight* (Fig. 47), dated the same year, for a most illuminating parallel in pose and gesture, expression of mouth and eyes, and drawing of the outstretched hand. Although Copley's portrait has a solidity which Blackburn's lacks, Blackburn's has a fluid grace and delicacy of color which Copley's lacks. It has been already suggested that Copley's realism may have had something to do with the increasing character in Blackburn's work after 1756. See now how Blackburn's English training furnished Copley with a badly lacking graciousness. The influence seems positive. The portrait of *Ann Tyng Smelt* (Fig. 49), which is signed and dated 1756, shows Copley imitating from Blackburn's signed portrait of *Mary Sylvester Deering* (Fig. 50) the whole con-

ception of a shepherdess in fancy dress, with crook and lamb complete. Though Blackburn's portrait is not dated, the sitter was married in Boston in 1756; and it seems likely that Blackburn should have painted her then, if not in her home on Shelter Island or in New York in 1754, as Mr. Park believed.[7] If the signature reported by F. F. Sherman [8] on a portrait of *Jane Brown* (Estate of Thomas B. Clarke, New York) is actually that of Copley, here is one more link to Blackburn in 1756, since the long bodice, disarranged sleeves, formless shoulders, smirking lips, and inaccurately drawn (or damaged?) eyes unquestionably reflect Blackburn as a model.

From then on one may trace in Copley's work, beginning with the 1757 portrait of *Mrs. Daniel Rea* (Charles Thompson, Boston), a subordination of grace to the necessity for catching the likeness which was, as Copley wrote in 1765,[9] "a main part of the excellency of a portrait in the opinion of our New England Conoseurs." By 1759, the date of the portrait of *Mrs. Michael Gill* (Tate Gallery, London), which is an astonishing study in tiny wrinkles so neatly drawn that the effect is photographic, Copley rises above Blackburn's flair for prim poise; this is among the earliest of a series of vivid, easily painted studies of people, including the amiable *Mrs. Nathaniel Appleton* (Harvard University, Cambridge, Mass.) painted in 1763, and the portraits of *Col. and Mrs. George Watson* (Henderson Inches, Boston) dated 1765. Although Blackburn still furnished a feminine type for Copley's portraits of young women, even as late as 1770, as in the portrait of *Mrs. Benjamin Davis* (Brooklyn Museum, New York), Copley fitted the ideal to what his eyes told him. "Your cautioning me," he wrote West in 1766,[10] "against doing anything from fancy I take very kind, being sensible of the necessity of attending to Nature as the fountain head of all perfection." And this "necessity" enabled Copley to redeem formal portraiture from affectations of pose and background, and to breathe such life into the alert figure of *Thomas Hancock* (Fig. 55), for instance, that one forgives

the painter all his neo-classical trappings, including colonnade, curtain, tassel, and rococo furniture. Incidentally, the design and character of this portrait seem to have been suggested by Blackburn's full length of *Governor Wentworth*, dated 1760. Comparing the two, it is obvious that Copley was already a great artist in his twenties, combining the sophisticated manner of English portraiture with a Smibert-like vitality. Even if he seems to have resented painting only portraits,— he wrote peevishly,[11] "Was it not for preserving the resemblance of particular persons, painting would not be known in the place," — his ability to create exact appearances, "to make the figure exist as mass, to seek the glint of stuffs, to search the minuter forms and the character,"[12] was equal to that of any European artist of his time.

Offhand, one would believe that such a painter could dominate all circumstances and emerge, by force of hard-headed common sense, on the right side of the ledger when confronted by aesthetic problems, such as the choice between fancy and realism. But the Revolutionary War, which at first seemed to Copley an opportunity for an indulgent trip to Italy and an increased value for his art, banished him from American realism and an assured success. After study in Italy, he changed from eyesight to fancy, took everybody's advice, tried to interpret instead of record subjects, settled in England as a painter of "histories," and lost himself in trying to be, what he never was, an imaginative artist. Previously, in the sixties, when he introduced neo-classical arches and balustrades into the backgrounds of his portraits, as in the full length of *Nathaniel Sparhawk* (Boston Museum), he had copied some engraving. When he painted in Italy the durable double portrait of *Mr. and Mrs. Ralph Izard* (Fig. 54), he assembled in the background an Italian-Greek urn, a view of the Colosseum, and the statue of Orestes and Elektra from the National Museum at Rome, and placed the sitters among heavily carved furniture of the newest style. Doing so, he merely cluttered his portraits with bits of extraneous, realistic detail; he was no inventor of

details, and he never succeeded in combining them with mood or dramatic feeling, except in some of his earliest and simplest studies of fact. Without imagination, his taste for embellishment and grandiose effects naturally turned sour. He became the most stilted painter in England. However, in spite of his determination to be an Englishman, he had been one of the most skillful of self-taught American realists. Thus he appears to later generations. "He knew more than all of us put together," said Stuart.

But he seems to have left no school or extensive following before he left Boston in 1774. In 1768, after ten years of success, he wrote West,[13] "Having no assistance I am obliged to do all parts of my Pictures with my own hand." In spite of the hints in later letters, especially those of 1771 when Copley was in New York, that Henry Pelham was as much of an assistant as anyone could be to a painter who depended so much on accuracy of eye and hand, there is no evidence that young Pelham imitated Copley. An oil portrait of *John Cushing* (Estate of Thomas B. Clarke, New York), boldly signed Henry Pelham, is not as realistic as it is moody; it is far less sure in either craftsmanship or character than the remarkable miniatures which Pelham made;[14] and it resembles the work of a New York painter, John Mare. Very few of these miniatures are known (see section 19), but they establish an artistic personality of high rank, different from Copley's. Pelham's technique allowed him to paint bluff and vigorous likenesses in little (Fig. 111B), arbitrary and rich in color, in contrast to Copley's delicate and pearly miniatures.

A group of oil portraits and pastels (Essex Institute, Salem, Mass.) which can be placed between Copley and Henry Pelham, as far as technique and temperament can be classified in this way, seem to be from the hand of Benjamin Blyth, who did, among others, the pastels of *Sarah Curwen, Elizabeth Stone White* (Fig. 53), *George Cabot* (Henry L. Shattuck, Boston), and *Judge Samuel Curwen* (Essex Institute, Salem, Mass.). The first of these is dated 1772; a pastel of *Mary Holyoke*

(Andrew Nichols, Boston) is dated 1771. All are primitive, compared to Copley's pastels. As Dr. Bentley remarked in the early eighteen hundreds about a portrait by Cole and Blyth, "They were wretched daubers at best. . . . None of their portraits are finished but they some times have taken likenesses." [15] Joseph Felt [16] mentioned Blyth as a limner in 1787. Whether the pastel portraits resembling that of *Joseph Ruggles* (Essex Institute, Salem, Mass.) can be accredited to him, or to the mysterious Cole, they reveal a Badgeresque honesty of purpose. One would like to investigate these pictures more carefully, in the hope of finding out who painted in the manner of Blyth with occasional flashes of genius. In particular, there is a portrait of *Theophilus Parsons* (Miss Caroline L. Parsons, Boston) which suggests Blyth in a more skillful phase, or a country Copley.

Winthrop Chandler of Connecticut and Worcester seems to have had Copley in mind when he painted the hard *Self-Portrait*, the portrait of his wife, *Elizabeth Chandler* (American Antiquarian Society, Worcester), *Lucretia Shaw* and *Mary Woodbridge* (New London Historical Society), and also *Mrs. Joseph Blaney* (Boston Museum of Fine Arts), whose hard likeness used to be attributed to Copley as the portrait of Catherine Winthrop Brown. Judging by the pictures in New London, one must believe that Chandler admired the designs of Blackburn almost as much as those of Copley.

Perhaps George Mason, who advertised portraits in crayon at Boston in 1768,[17] was influenced by Copley and painted somewhat in the manner of Blyth. Christian Remick, known to have been in Boston at the same time, was not, since five pictures by him are views of Boston in water color.[18] In New York, John Mare shared some of Copley's preoccupation with factual details, but probably had nothing to do with him. His career can be traced through town and family records,[19] and through signatures on pictures ranging in date from 1761 to 1768. His signed portrait of *Sir Henry More* (Hiram Burlingham Sale, New York,

1934) suggests a talent like that of Blyth. J. Mitchell painted a portrait of Samuel Adams which was engraved by Reak and Okey, who engraved one of Feke's portraits in 1775. And T. Mitchell, if he is not the same gentleman disguised under a different initial, copied the XVIIth century portrait of *John Endicott* (Essex Institute, Salem, Mass.).[20] Perhaps he made contemporary likenesses. If Copley's influence extended to him, it is not evident in his copy of a crude XVIIth century portrait.

However, Copley did furnish, in all probability, the ideal of sturdy realism which illumines the portraits of *Mrs. Henry Carpenter* (Fig. 52) and *Capt. Benjamin Carpenter* (Peabody Museum, Salem, Mass.). The portrait of *Mrs. Carpenter*, supposed by family tradition to have been painted in Italy in 1774–75, resembles no Italian portrait known to the present writer; its technique is bold, rough, and masculine, yet the effects achieved are lovely, especially in the accessories, and the figure is confidently set up in space, with air about it. The portrait of *Capt. Benjamin Carpenter* appears heavier in execution, recalling somewhat Winthrop Chandler's *Self-Portrait*. But both these portraits seem to have been painted by John Durand, judging by their many resemblances in color and spirituality to the portrait of *Frances Payton Tabb* (Mrs. John Hill Morgan, New York). According to Sully,[21] this artist painted an "immense number of portraits in Virginia; his works are hard and dry, but appear to have been strong likenesses, with less vulgarity of style than artists of his calibre generally possess." He also worked in New York, where he advertised a Drawing School in 1767 and 1768, informing his prospective students that although lacking an ample fund of universal knowledge "in geometry, geography, perspective, anatomy, expression of the passions, antient and modern history, etc., etc., yet he hopes . . . that his humble attempts . . . will meet with acceptance . . . and he proposes to work at as cheap rates as any person in America." Little else is known about this fascinating painter who used color so delicately and felt form so surely. It is difficult to imagine his origins

without taking into account some contact with Copley's work. The facts as known, however, are that Copley left no school comparable to that left by Benjamin West and Charles Wilson Peale, both contemporary with the great realist from Boston.

10

THE INTERNATIONAL BENJAMIN WEST

Between West and Copley there is a moral for young painters who are in danger of succumbing to formal art, official fame, social success, academic honors, and the like. Both had talent enough to put themselves among the best of XVIIIth century painters; and both in later life frittered their talents away on formalities. Instead of painting what they saw and could understand, they tried to imitate the grand style. However admirable their personal qualities, they were not poets, and failed as artists when they heard the siren voice of the lyrical old masters.

Like Copley, West began as a realist. His teacher, if one can call him that, was a William Williams, born in England, who advertised in Philadelphia in 1763 that he had returned from the West Indies. This of course cannot be the William Williams born in 1759, who was briefly the teacher of Dunlap and who painted a portrait of George Washington in 1794.[22] By the first William Williams no pictures are known; perhaps he painted in the manner of John Mare of New York. But it was in Philadelphia in 1756 that West acquired his practice, and there he was more or less in competition with Claypole, Wollaston, and John Hesselius. The influence of the last-named is surely evident in the portrait of *William Henry* (Fig. 56), which, although neither signed nor dated, was probably done in 1756, when Henry became West's patron.[23] Another early portrait, that of *Stephen Carmick* (Louis G. Carmick, Washington, D. C., lent to the Corcoran Gallery), which, the owner believes,

originally had on the back the signature B. West, and the date, "if memory serves," 1759, seems to combine influences from Feke and Wollaston, in pattern and in brown-green tones. But in 1760, when West sailed for Italy, he painted a *Self-Portrait* (Estate of Thomas B. Clarke, New York) which is beyond the scope of his immediate contemporaries. He placed himself gracefully and romantically in a strong light and painted the forms in the shadow carefully, as if imitating the effect of a mezzotint engraving. Even if the brushwork is tight, the conception is broad. He thus paralleled Reynolds' development away from the most formal type of English art, well illustrated by Reynolds' teacher, Thomas Hudson. And he was doing it before he could have met Reynolds or studied his effects. Striking evidence of West's steadiness as an artist is the fact that the portrait of *Charles Wilson Peale* (New York Historical Society), painted in London between 1767 and 1769, shows chiefly an increase in skill and ease, instead of a difference in tone and point of view, from the simple posing and dramatic lighting of his earlier, well contained design. In both pictures West characteristically emphasized the large masses. The later portraits, too, a *Self-Portrait Painting* (Ehrich-Newhouse, Inc., New York), for example, which is dated 1806, are built on the same principles. Even so ambitious a group as the nine members of the *Family of Adrian Hope* (Fig. 58) is composed simply and drawn with breadth. He was an excellent portraitist, not as Copley was, but in his own unassuming way. He smoothed and refined features, but caught personalities; he eliminated details of costume, but conveyed a sense of well-being. If he tried for too much grace, without good draftsmanship or sense of proportion to back him up, he nevertheless was sincere in his efforts.

What were West's ideals? Considering his tremendous influence on his contemporaries and his patient teaching of a long list of American artists, including Charles Wilson Peale, Robert Fulton, Ralph Earl, Trumbull, and, to some extent, Morse, one believes that any opinions

he held are important. In his discourses he sententiously said, "The true use of painting resides in assisting the reason to arrive at certain moral influences, by furnishing a probable view of the effects of motives and passions." [24] But from a letter to Shrimpton Hutchins [25] one learns that in 1771 he believed simply in the study of nature as the ground-work for successful painting. Further, he advised young art students to learn how to surmount the mechanical difficulties of painting, in order "that their hand might keep pace with their ideas, so as to receive Pleasure from their Performances . . . as it is that alone which can compensate for the gret fatigue which must arise from the prodigeous Length of Time necessary to make a painter, let him have ever so great a share of genius." And he added that he himself was fortunate in having been grounded in "the Knowledge of Nature, while had I come to Europe sooner in Life, I should have known nothing but the receipts of Masters."

Ironical words! West gave good advice for the development of young painters, but he frequently painted in other people's styles and was, from the point of view of the present, obviously a practitioner of the receipts of old masters. "Europe's worst daub, poor England's best," Byron viciously put it, to the delight of art critics. Had he limited himself to the kind of portraiture already mentioned, West undoubtedly would have been more esteemed by posterity and more effective as a teacher of young men who had their living to make from taking likenesses. But even as he was painting the clearly seen portrait of *Charles Wilson Peale*, he was dabbling in school-of-Raphael effects, as in the signed portrait of *Lady Diana Barker* (Minneapolis Institute of Arts), dated 1766, or in Van Dyckian elegance, as in the double portrait of *Robert and Thomas Hay-Drummond* (Addison Gallery of American Art, Phillips Academy, Andover, Mass.), dated 1767. He had early acquired a taste for the antique, probably from reading Dufresnoy's De Arte Graphica — in translation, naturally, since West's education

in the three R's was quite sketchy. Dunlap[26] says that William Williams lent the youthful West this volume as well as a volume of Richardson, both works dealing with the nobility, utility, invention, grace, etc., of "the whole art of painting." West's historical and allegorical pictures go in heavily for these abstract qualities and neglect that very craftsmanship which he advised young painters to acquire early. In addition, although he contributed to art what Reynolds thought was a revolutionary idea, that of clothing the figures in the *Death of Wolfe* (Duke of Westminster, London) in realistic uniforms instead of Roman togas, his fate was to popularize a romantic type of subject-picture which bases its appeal on "justness of sentiment" or "noble rage" or "sweetness of character." These emotional concepts, derived through such abstractions as are to be found in Dufresnoy's book, are, of course, completely opposed to the realism with which West painted some of his earliest and best portraits, and which was so much in demand in American portraiture. He thought himself cut out for finer things than mere likenesses, "the common level of my practice," as Copley called it.[27] Yet West's interest for us today as an artist centers in the common level of his portraiture, instead of in his heavy flights of ambitious historical painting.

As a teacher of history painting, however, he deserves study. With the often copied *Penn's Treaty with the Indians* (Independence Hall, Philadelphia), *Venus and Adonis* (Carnegie Institute, Pittsburgh), and *Death on the Pale Horse* (Pennsylvania Academy, Philadelphia), we "arrive at certain moral influences," as West desired we should; Penn's honesty and kindness, the grief of lost love, and the ruthlessness of death are the subjects West chose to illustrate. And the success which these pictures had with West's contemporaries shows that these were good subjects for the time. One cannot believe that the paintings were admired for purely aesthetic reasons. They were admired, as they were painted, for abstract reasons — for their justness, their sweetness, and their nobility.

Such reasons are not at all intellectual; they are emotional. It takes little intelligence to appreciate that buying is more honest than stealing, that grief is sad, that death is universal. Only from a naive or an emotional point of view can these truisms seem important. And yet it was not wholly a naive public that admired West. Whatever were the causes of the romantic flood which swept aside national boundaries and washed all classes of society into a heap of tangled feelings, the pictures of West may be recognized among the first waves of romantic painting (see section 18, page 128). Even the least intellectual country gentleman could in all sincerity admire the melodramatics of West's "histories," just as Reynolds could honestly admire West's modicum of originality in portraying XVIIIth century heroes in proper costume. Aesthetically West contributed little to art, because he derived his ideas on design, movement, color, mood, and character from the work of other artists. Only an occasional glance at reality, which he called being grounded in the knowledge of nature, kept his work alive and guided him to a figure, or more often a portrait, which is characteristic of a personal and subtle experience. If his pictures had been as charming and as correct as his manners must have been,[28] one feels that he would be today not merely an historically interesting painter and that his influence would have been more positive than it was. As much as his pupils admired him, none of them could make good pictures without denying in some way his teaching. From him they only acquired a taste for the receipts of masters and respect for their trade. They did not acquire solid draftsmanship, modelling, and respect for what they saw. Unless they acquired these elsewhere or were endowed with them, they ended, like Allston, the aesthete, and Trumbull, the politician, as disillusioned followers of an art that was merely illustrative and abortive.

II

CHARLES WILSON PEALE, AMERICAN

Neither West nor Copley was a patriot. Copley fled the Sons of Liberty and had no sympathy with America outside his family, his friends, who were generally Loyalists, and his income-making patrons. West may have had sympathies, but being a Quaker in principle, if not in dress, and an expatriate, he scarcely entered into the lives of his former countrymen save as personal counsellor. But Charles Wilson Peale, born in 1741, only three years after Copley and West, turned out to be not only a patriot but the inheritor of the realistic, native American school of painting which was founded by Smibert in his adopted home of Boston, and which was abandoned by both Copley and West. After being apprenticed to a saddler in Maryland at the age of thirteen, then defrauded by a partner, being forced to pay off his debts by clock-making and silversmithing, and turning to politics in Annapolis, all before the age of twenty-four, he decided to become a painter. Almost immediately, in 1765,[29] he visited Smibert's studio and received some slight instruction from Copley, as Horace Wells Sellers stated [30] on the authority of autobiographical material not yet published. After wandering in search of work as far as Newburyport, Mass., he was sent in 1766 by a group of the Maryland Governor's Council to study under West in London, where he helped support himself by continuing to paint portraits. However, the political situation was boiling. When Parliament annulled the New York Charter, Peale, vowing he would never again pull off his hat for the King, gave up prospects of success after two years in England. Being an ingenious, rapid workman, he found he could do very well at home too, even while serving as Captain of Volunteers in the Revolution. He made his way so easily, indeed, that he soon could afford to indulge his curiosity in the bones of a mammoth and became a naturalist and lecturer, founding a Museum of Natural History in

1785. Because, says Dunlap,[31] who thought little of his art, "the loss of his front teeth interfered with his oratory, he became a dentist to supply the deficiency; first working in ivory, and then making porcelain teeth for himself and others." In 1805 he accomplished a desire of more than ten years' standing by organizing the Pennsylvania Academy of the Fine Arts. He was a healthy, public-spirited man as voraciously energetic as Franklin. And when he was not improving conditions for others, he painted people with much sympathy and with intensity.

Peale's origins as an artist are undoubtedly to be found in Boston, rather than in the Kneller influence which Rembrandt Peale supposed was exerted on his father through Hesselius.[32] A certain Mr. Frazier of Norfolk is also supposed to have had a hand in Peale's early work. But since nothing is known of Frazier's style, and since Peale went to Boston only a few months after deciding to become a painter, one looks to Copley and the relics of Smibert's studio for a formative influence on Peale's clear, clean, hard work. A portrait of *Thomas Cadwalader* (Dr. Charles E. Cadwalader, Philadelphia), which, according to the age of the sitter, must have been painted before Peale's trip to London, reveals a severe and splendid realism that could only be expected from an artist who had seen portraits like Copley's *Mrs. Nathaniel Appleton* or *John Hancock* (Boston Museum). Of course, Peale's technique is not as sure as Copley's; his drawing is more "liney" and the proportions of the figure are not quite convincing. But he appreciated the depth and weight of the human frame, and he modelled the forms of the face with careful attention. He was doing approximately the same kind of work in London, judging by the portrait of *Charles Waterton* (Fig. 57), with its patient realism and concentration of well studied details, including the bird, the leather cover of a book, the mounted cat's head, and the sitter's intellectual face. Even though the textures of flesh, shirt, and feathers are somewhat alike, the portrait is a vital one, painted independently of Benjamin West.

Undoubtedly West's advice had been helpful in general. As late as 1774 Peale made use, for instance, of West's typical arrangement of background and lighting, in the portrait of *Captain William Stone* (Mrs. J. William Middendorf, Baltimore). But, needless to say, West gave him no help in character study. And it is the engaging honesty of Peale's representation of *Captain Stone* which lifts the portrait out of the class of neo-English school work. Elongated as the figure is, badly drawn as are the legs, and commonplace as is the gesture of the right hand, which points to a sloop in the background, the combination of these peculiarities with strong character "makes" the picture. In spite of an attempt at ease and the grand manner of posing, the essential tone of the picture is racy and very real; Captain Stone appears to be saying, "Thar's the sloop," and using the least amount of energy in pointing her out.

Most of Peale's male portraits are powerful in the same way, even brilliant in their characterizations. An earlier work, the portrait of *John Philip de Haas* (Estate of Thomas B. Clarke, New York), dated 1772, and a later work, the portrait of *Samuel Mifflin* (Metropolitan Museum, New York), dated 1777, reveal that he gained in assurance, and consistently studied life for his designs, gestures, and those details which create personalities on canvas. His best portraits, like that of *James Peale* (Herbert L. Pratt, Glen Cove, L. I.), his brother and a miniaturist, accomplish all that is required of realistic portraiture and have in addition a warmth of feeling which even Peale's characteristically hard color cannot obscure. The still-life on the table in the portrait of *William Buckland* (Yale University, New Haven, Conn.) is equal to Copley's best, and that is high praise, considering the portrait of *Thomas Hancock* (Fig. 55). Peale's beady-eyed sitter, smiling directly at the spectator, is presented as completely as in Copley's most patient portraits. And his compositional *tour de force*, the *Staircase Group* (Fig. 61), crisply lighted and boldly designed, is as successful as many an official

full length by Copley. Novelties of pose and sentiment became an asset in Peale's hands.

Though his portraits of women are not generally as well studied as his men, he never seems to have failed making lively studies of his wives, children, and daughters-in-law. His devotion to facts could not always have pleased the ladies. Looking over a number of reproductions of his pictures, one even suspects that he developed a feminine type as a compromise with reality, giving to *Mrs. John Cadwalader* (John Cadwalader, Jr., Philadelphia), represented with her husband and child in 1775, the same tight-mouthed expression he gave to *Mrs. Harwood* (Metropolitan Museum, New York) and to his wife in the ambitious *Family Group* (Fig. 64) which he painted off and on between 1773 and 1809. On the other hand, *Mrs. James Peale* (Herbert L. Pratt, Glen Cove, L. I.), posed with a classic urn and Gainsborough effect, seems wholly, realistically herself; perhaps she had a type of face, long and bold, which suited him. Evidently Peale did not hesitate to exaggerate features, as in the *Family Group*, where details are worked out with such fidelity that the total result is almost crude. The crowded and compact design, consisting of ten people and a dog about a table with fruit, is directly descended from Smibert in its lively spirit, although it suggests West and Benbridge, the most Italianate painters of the time, in pattern. The boldness of the conception, the phlegmatic cheerfulness of the sitters, the complete frankness of all concerned, including the artist who is showing off with a sketch of his wife, remind one of Flemish rather than English art, of Jordaens and Cornelis de Vos instead of Gainsborough and Zoffany. Admirable in the same independent way is the group of *Thomas Johnson and Family* (The C. Burr Artz Library, Frederick, Maryland, lent to the Maryland Historical Society, Baltimore), which, dating from 1771, shows that, early as well as late, the painter was instinctively a more vivid realist than any artist then active in England.

Henry Benbridge, born in Philadelphia three years after Charles Wilson Peale, perhaps influenced him, as well as others who had studied with West. Benbridge had a thorough training under Mengs and Batoni in Italy before going to London about 1769, where he painted Franklin and where, it was considered, according to Franklin,[33] "few or none excel him." If a portrait of *Benjamin Franklin* in the possession of his descendant (Russell Duane, Philadelphia) is the one exhibited in London in 1770,[34] it reveals Benbridge in a metallic, Italian phase. On his return to America, Benbridge painted in 1771 his mother and step-father with their children, the *Gordon Family*,[35] in the hard manner which became his stock in trade for many portraits painted in Charleston and Norfolk. In a way, Benbridge's *Family Group* seems close to Peale's, especially in the brittleness of the modelling. If more accurate information was available, it might be possible to show that Peale's compact style, as developed in his late work, for example the portraits of *Mr. and Mrs. John de Peyster* (New York Historical Society), dated 1798, was acquired through Benbridge's direct contact with Mengs and Batoni, rather than through West. There is, for instance, a strong similarity between Peale's portrait of *Mrs. de Peyster* and Benbridge's portrait of *Mrs. Simmons* (Fig. 62), even though Benbridge's work lacks the ringing vitality of Peale's.

But none of Charles Wilson Peale's contemporaries combined observed facts, gusto, and influences from West, as he did. When one searches for a parallel among what can be called by this time the native realists of America, one must go to Connecticut and Ralph Earl for so effective and straightforward an art. None of Peale's relatives shared his talent to the same degree, although James Peale, the miniaturist, adopted his brother's style excellently. None of the painters of Washington who challenged the elder Peale's preëmpted position as the best painter of the First President — not James Peale the son, nor Charles Peale Polk, who repeated portraits of Washington over and over and

over again — had the sense of reality which makes the painting of the elder Peale a positive, if only half appreciated, value in American art.

Robert Edge Pine, who painted the sophisticated and continental portrait of *David Garrick* (National Portrait Gallery, London) before coming to America in 1783, caught something of the American insistence on accurate eyesight and restraint in his plain portrait of *Mary Ball Washington* (Percy A. Rockefeller, New York) and the severe likeness of *General Horatio Gates* (Estate of Thomas B. Clarke, New York). The difference between his work in London and his American portraits is what one would expect had Charles Wilson Peale influenced his five years of activity in the United States. As a comment on American taste, it is worth mentioning that Pine brought with him a cast of the Venus de Medici "which was kept shut up in a case . . . as the manners of our country at that time would not tolerate a public exhibition of such a figure." [36] It is also worth noting that Pine's purpose in visiting America was to paint scenes of the Revolutionary War, but that he was forced into portraiture because of lack of interest in historical pictures. Doubtless the same necessity turned him from a romantic artist, who felt the necessity of painting *Mrs. Reid as a Sultana* (Fig. 63), to a plain realist in the manner of Peale.

Only Matthew Pratt, some seven years older than Charles Wilson Peale, managed to rival him in reading of character. And Pratt's type of work is a strange mixture of poetry and practicality. He began his studies under James Claypole in 1749 and worked in Philadelphia and New York from 1756 to 1764, probably in the manner of his teacher, or, in other words, in the manner of the portrait of *Gerrit Abeel* (New York Historical Society), which John Hill Morgan [37] attributes to Pratt. The style is heavy and pedantic, recalling second-rate English painters of the time, especially those who wandered to America. In 1764, however, Pratt found personal interest in painting *Mr. and Mrs. Benjamin West* (Pennsylvania Academy of Fine Arts, Philadelphia) and did the work

gracefully and sensitively; the portrait of *Mrs. West* is charming, with its alert character and interesting triangular design. In 1765 he painted the group of students in West's studio called *The American Academy* (Metropolitan Museum, New York), which in its quiet realism reminds one of Devis or other English painters of conversation pieces. But after his return from London in 1768 and after a second trip to England by way of Ireland in 1770, he broadened out. The combined influences of Copley, who was in New York in 1771, and Charles Wilson Peale, whom he knew in Philadelphia, gave Pratt such assurance that he could paint in 1772 the dignified and energetic portrait of *Governor Colden* (New York Chamber of Commerce) and, about the same time, the delicate but intense head and shoulders of *Elizabeth Colden de Lancey* (Fig. 59). The portrait of *Governor Colden* seems to reveal Copley's influence in lighting and pose. The portrait of *Mrs. de Lancey* seems to reveal Peale's intense objectivity, as if passed through a sensitizing screen. It was Peale again who influenced Pratt in painting the double portrait of *Cadwalader Colden and Warren de Lancey* (De Lanccy Kountze, lent to the Museum of the City of New York) at a later date, judging by the age of the sitters, or at two different dates, judging by the lack of relationship between them. That more pictures by Pratt are not known [38] complicates one's estimation of his ability, since his beginnings, as in the portrait of *Benjamin West*, let alone the portrait of *Gerrit Abeel*, are far less impressive than his work of about a decade later. Part of his activity may be accounted for in producing "the best signs I ever saw," as Neagle wrote Dunlap,[39] which were well known in Philadelphia in the first two decades of the next century. But an artist of Pratt's evident talent and sincerity might have done extraordinary work in portraiture before his death in 1805. Like Abraham Delanoy, whose portrait of *Benjamin West* (New York Historical Society) is a thoughtful, but not energetic, study quite similar to Pratt's, and who was a sign painter in 1780–83 when Dunlap knew him,[40] Pratt challenges one's curiosity as much as

one's admiration. Even at his best, as in the portrait of *Mrs. de Lancey*, he seems overshadowed by the elder Peale.

Ralph Earl, on the other hand, cannot be overshadowed, once his scattered works are thoroughly studied. He had a bad reputation among his contemporaries, family evidence having charged him with habitual drunkenness, wife desertion, and general irresponsibility.[41] Yet he painted vigorously, with deep sensitiveness at times for subtleties of design and characterization. In spite of several years spent in Lon- don, he remained an American in taste and point of view, and not only an American but a New Englander, localized in Connecticut. Since there are interesting developments in the society which patronized artists like Earl and others who combined in their painting English and American and even French characteristics, it is necessary to introduce Earl by generalizing a little about the conditions which affected artistic production before democracy actually materialized at the beginning of the XIXth century.

NOTES

1. Creative Art, xii, 20.
2. The Life and Works of John Singleton Copley, Boston, 1915.
3. Massachusetts Historical Society, 1914.
4. Copley-Pelham Letters, 23.
5. Five Colonial Artists, by Frank W. Bayley, Boston, 1929, 3.
6. Rep., Five Colonial Artists, by Frank W. Bayley, 275.
7. Descriptive List of Blackburn's Works, by L. Park, American Antiquarian Society Pro- ceedings, 1922.
8. Art in America, xvi, 122.
9. Copley-Pelham Letters, 31.
10. Copley-Pelham Letters, 50.
11. Copley-Pelham Letters, 65.
12. Frank Jewett Mather, Pageant of America, xii, 5.
13. Copley-Pelham Letters, 67.
14. A bill dated 1774, Elihu Hall esqr. to Henry Pelham, "To his own portrait half length," published by Denison Rogers Slade, Transactions of the Colonial Society of Massachu- setts, February, 1898, proves that Pelham was a painter in oils as well as a miniaturist.
15. Op. cit., ii, 470.
16. Joseph Felt, Annals of Salem, op. cit., 79, 307, 452.
17. George F. Dow, op. cit., 2.
18. Christian Remick, by H. W. Cunningham, 1904, a pamphlet.

19. Thomas B. Clark, op. cit.
20. John Adams noted in 1774 that "the old lady has got a new copy of her great grandfather . . . hung up in the house." Charles K. Bolton, op. cit., 640.
21. Dunlap, op. cit., I, 169. A John Durand exhibited landscapes at the Royal Academy, London, in 1777 and 1778.
22. Dunlap, op. cit., I, 36.
23. Pennsylvania Magazine of History and Biography, xxvii, 91.
24. American Painting, by Samuel Isham, 1927 edition, 59.
25. Copley-Pelham Letters, 118–119.
26. Op. cit., I, 39.
27. Copley-Pelham Letters, 67.
28. Dunlap, op. cit., passim.
29. Sartain, Reminiscences of a Very Old Man, 1899, 146, quotes Peale's letter giving 1768–69 as the date of the visit to Boston and 1769 also as the time of his leaving for England. This letter contains a description of Smibert's studio, as seen by Peale.
30. Pennsylvania Magazine of History and Biography, 1914, 262.
31. Op. cit., I, 160.
32. Dunlap, op. cit., I, 150.
33. F. F. Sherman, Early American Painting, 61.
34. Dunlap, op. cit., I, 165.
35. Repr., Art in America, vi, 191.
36. Joseph Hopkinson in a letter dated 1833, to Dunlap, op. cit., I, 378.
37. Op. cit., 44.
38. See Check List, Theodore Bolton and Harry Lorin Binsse, The Antiquarian, xvii, no. 3, 20.
39. Op. cit., I, 115.
40. Op. cit., I, 192, 296, 301.
41. Bulletin, Worcester Art Museum, vii, no. 1, 6.

CHAPTER IV

The Federal Period

WITHIN the years 1783 and 1800 — the formal end of the Revolutionary War and the social revolution of Jeffersonian Democracy — the colonies became a nation, struggling to reconcile ideals of liberty with practical problems in government and economics. Though Washington's election to the Presidency in 1789 may be taken as the point at which national consciousness in government was attained, there is no date which marks national consciousness in a social way. The minds of people of taste, and of artists, were of course not unanimous, nor as subject to the necessity for compromise as were political minds. People of different localities differed in their habits as much as during the colonial period. After the disruptions of war, society in general became looser; old cliques disappeared, and others were formed on a basis of new wealth and power, acquired by speculation in money, by manufacturing goods formerly the monopoly of England, and through political opportunity. The democracy, which was to sweep the elections in the new century, already was forming a rival social ideal in the newly settled frontiers of Vermont, Kentucky, and Tennessee; after the Revolution, these districts contributed an independent, gregarious, and rough type of society to the life of the nation. Of course, Virginia and South Carolina remained essentially aristocratic in tone. But New England and Pennsylvania went democratic before the name itself came into use. And they did not do it in the same way.

When Philadelphia became the seat of Federal government, with its tradition of "court" life, it had long been a melting pot for radical Quakers, conservative Dutchmen, and colonial Englishmen; it was the

principal port of immigration. It had the most liberal spirit of all American cities and could boast of the first circulating library, medical school, hospital, fire company, and legal journal in the country. It was a cross section of the America to be, as historians have pointed out.[1] No wonder that it furnished the first artist of the new nation in Charles Wilson Peale, whose frank realism and independence of mind and taste were sympathetic to its own realistic and liberal society.

Boston, on the other hand, no longer held the stage as a cultural center after the Revolution, and it did not gain its position as the intellectual "Hub of the Universe" until a period of renewed affluence, of social readjustment and intellectual independence, which furnished a supporting background for the arts two decades after 1800. Copley's patrons were in general driven out or financially wrecked by the war; Loyalists had their property confiscated, and the wealthy merchants had their business brought to nothing by depreciated money. Shay's Rebellion of 1786 not only marked hard times with a now familiar cry of the farmer's plight, oppressed by taxation, mortgage foreclosures, and no markets, but revealed the farmer as a growing power in the life of the country. Though Massachusetts, which meant Boston, put down the Rebellion, it conceded the importance of the problems raised by farmers. It had to do this, in order to survive as the capital city. No matter how vigorous were its political leaders, its social and financial leaders were eclipsed by the wealthy families of Salem, for example. And there was no guiding class to compare with the liberal minded aristocrats of colonial times. Artists had to wander far in search of patrons who were not necessarily familiar with the best of European art. Following the taste of the new purchasers of portraits, the typical painter of Federal New England became an itinerant peddler of likenesses.

Surely the day of English taste was fading, even if Boston's best painter was still active in London. Though many Americans made the

trip abroad to polish their style, the style itself was scarcely an advan-
tage when they returned home. Probably there is some relation be-
tween art and international politics in this. The resentment against
England was shortly to flare again in the War of 1812; America had
been the ally of France; the French Republic was trying the American
experiment. Whatever the deep-seated reasons, American artists found
fully as much of value in French art toward the end of this period as
they had before in English art. Thus the present chapter must deal with
the disruption of English influences on the painters of the States, as well
as the formation of a country taste. Because these tendencies were not
self-conscious, one must move cautiously in assigning any artist a posi-
tion in bringing about these changes. And, of course, one must recol-
lect that the career of an artist is not a fit unit for the discussion of ar-
tistic changes. Careers, tastes, and ambitions overlap to such an extent
that only from a general point of view will it be evident that the paint-
ers of the new nation differ consistently from the colonial painters.

12

RALPH EARL

The first artist to be mentioned in this connection was practicing before
the Revolution. Samuel King, born in 1749, less than a dozen years
after Copley, seems to have been self-taught. His few known pictures,
including portraits of *Benjamin Mumford* and his wife, *Mary Shrieve Mum-
ford* (Fig. 60), *Mrs. Richard Derby* (Dwight M. Prouty),[2] and the sensi-
tively painted head of the youthful *John Eliot*, dated 1779 (Massachu-
setts Historical Society, Boston), show that in the seventies he increased
in skill, although he seemingly never became a supple craftsman. In
the aristocratic air of Newport, he remained a Badger-like painter, re-
lying chiefly on careful observation for his likenesses, rather than on
tricks of style, and ignoring such matters as grace in design or pose.

Though the portrait of *Mrs. Derby* does attempt design, in a crude way, the difference between the realistically modelled head and the artificially constructed body suggests that two artists may have worked on the picture, just as two artists evidently painted the *Portrait of a Woman* (Miss Alice Heard, Ipswich, Mass.), which resembles in its duality of style the portrait of *Mrs. Derby*. In the portrait of the unknown woman, it is obvious that the head was painted later than the Lely-like costume, fancy column in the background, and elongated, clumsy hands. From a portrait of *Ezra Stiles* [3] one gathers that King painted hands flatly and stiffly, with extended thumb, as Badger did. Perhaps, then, King had someone else prepare the figures and backgrounds for his two portraits of ladies, leaving the heads unpainted so that he could make a likeness quickly and deliver a large, impressive portrait on short notice. This would be natural in the itinerant painter's procedure. And King's cramped modelling of features, even in the 1779 portrait of *John Eliot*, which is less tight than the 1771 portrait of *Ezra Stiles*, is also typical of the itinerant's practice, which was that of a craftsman doing a day's work copying faces. King spent at least one season at Salem, in 1771–72, and copied at least one picture in Boston, a portrait of *Washington* by Charles Wilson Peale; perhaps he travelled through Connecticut in search of work. That he gave some instruction to Gilbert Stuart, Washington Allston, Malbone the delicate miniaturist, and Ann Hall, whose feminine sensibilities will be mentioned later as symptoms in the romantic trend of early XIXth century style, indicates that King may have been a more sophisticated man than he was an artist. One may even suspect that the plainness of his art was dictated by his conditions, and that, when more portraits by him are identified,[4] he will be seen to have formulated a kind of taste which persisted in the Connecticut valley as well as in Salem, where can be seen such arbitrary but wholesome and vivid anonymous portraits as that of *Benjamin King* (Fig. 66), who wears a costume dating from the last years of the century.

Mentioning taste in this objective way, as though it were a physical entity existing in certain localities, may appear misleading. But it is necessary to convey some such idea, in order to explain why Ralph Earl, who had the benefit of English training and was a skilled painter while abroad, should have become an apparently less stylish artist on his return to Connecticut. His career, covering the period from the Revolutionary War to the Democratic Revolution of 1800, is not easily followed. Yet enough facts are known to show that he was a mature artist when he reached England, that his studies under West did not affect him deeply, that he was an independent observer and a landscapist of ability. He was indeed the first American painter to reveal sympathy for Nature unadorned by historical or romantic interests.

Born in Leicester, Massachusetts, his earliest portraits are said to have been painted in Connecticut in 1771 at the age of twenty. This early date refers, however, to no signed or documented portraits known to the writer. As Frederic Fairchild Sherman has said,[5] there are no dates and signatures on paintings earlier than Earl's return from England in 1786. Nevertheless Mr. Sherman attributes to the years 1774–79 a few portraits, including the hard, queerly drawn likeness of *Roger Sherman* (Fig. 65), which is traditionally dated 1775. About then, supposedly, Earl made five sketches of the battle of Lexington from which Doolittle is said to have made his rare engravings, only eight months after the battle. Some writers have believed that Earl's sketches were made into finished productions of generous proportions. And if the oil painting of the *British Marching into Concord* (Mrs. Stedman Buttrick, Sr., Concord, Mass.) is actually by Earl, it proves the rightness of tradition as to the size and scope of these paintings. This extraordinary, naive painting is by an artist only a little more skillful than Doolittle but full of enthusiasm for clean color and objective fact. In spite of the clumsy drawing and bad proportions of the two figures in the foreground among the gravestones, the scene has life and even intensity of

vision. An untrained realist was evidently on the scene, attempting to paint as truly as possible the tops of houses on which he was looking down.[6]

The portrait of *Roger Sherman*, who appears plunked into a chair in the bare corner of a room, also comes to life with astonishing success, considering the disproportionate hands and legs, the mask-like face, and the arbitrary curtain stuck in the upper corner of the canvas. Probably the intensity of the artist's concern for exactness of pose leads one to forget other matters, just as it apparently blinded the artist to them. The hands are each marvels of painstaking study, even though they do not agree in size. The bulk of the sitter's body makes one forget the weak perspective of his left thigh. The clarity of the modelling in the face, the deep-set eyes, the dominating shape of the skull and the firm mouth, override structural faults, such as the over-developed nostril and neglected neck. In other words, Earl struck in one of his earliest efforts a new attitude toward portraiture and discovered a provincial kind of realism, unrelated to the styles of other painters or to academic rules. Where Copley was gracious and formal in his accurate presentation of observed details, Earl is uncouth and simple. He did not enter into the life of his sitters any more than did Copley, but he hovered close to them and had the curiosity to move around them, viewing them from a complicated point of view, giving them tangible depths and projecting their limbs as if he were manipulating life-sized marionettes. His ability in this respect, his sense of space and of forms within forms, is unheralded in the art of the Colonies.

Yet Earl must have learned his trade somewhere, if only to have produced so neatly painted a detail as the chair upon which Roger Sherman sits. No written records supply a clue as to his apprenticeship. Although every student artist in New England during the five or six years before the Revolutionary War would have probably heard about Copley and could have had access to one or more of his pictures, the portrait

of *Roger Sherman* does not confirm the assumption that Earl studied Copley's work. A more plausible assumption is that Earl had come into contact with Samuel King, teacher extraordinary, who painted the *Rev. Ezra Stiles* in 1771, utilizing a simple and rather elementary book-shelf background, as Earl did later in such portraits as those of *Col. George Wyllys* (Connecticut Historical Society, Hartford) and the *Rev. Judah Champion* (Litchfield Historical Society, Litchfield, Conn.). King modelled lips with a tight precision which anticipates Earl's manner of painting the lips of *Col. Wyllys* especially. The latter, less formful and bulky than *Roger Sherman*, is seated in a well filled corner of a library which evidently attracted the artist nearly as much as the sitter himself; the neatly tied bundles of notes in the bookcase, the clearly painted still-life on the tip-top table, the glint of light on the brass drawer pulls of the secretary, all take their proper place in the room and reveal Earl as a loving student of the immediate present — of actuality in every deliberately noted detail.

The next fixed date in his development, 1779, appears on two portraits painted in England, representing *Mary* and *William Carpenter* (Worcester Art Museum). The point of view is that of Samuel King, Badger, and the young Copley; it is realistic, severe, objective. But it is also Earl's own point of view, which may be compared to that of a naturalist who records the differentia within given genera. That the portrait of *William Carpenter* seems more objective than the portrait of his sister may be taken to mean that Earl was not particularly concerned with aesthetic effects, that he achieved them naturally if at all, that his mind was fixed on the facts before him rather than on their meaning in design. What he failed to achieve in the portrait of *Mary Carpenter* was a splendid poise, such as he did achieve in many other portraits dating from his English sojourn. But aside from this perhaps casual interest in aesthetics, he made it clear that his taste was well developed when he reached England. He was instinctively a great artist. Compare his

portrait of *The Man with a Gun* (Worcester Art Museum), dated 1784, with a similar subject by Raeburn or Gainsborough. Earl's figure is reserved; his design is solidly planned on verticals and horizontals, broken only by the diagonal position of the gun and the direction of the dog's gaze; the landscape background is simple. Raeburn's full length portraits, like that of *Sir Ronald Ferguson* (R. C. Munro Ferguson)[7] which is comparable in subject matter, are all spontaneity and nervousness; the figure of *Sir Ronald Ferguson* steps forward alert, with gun cocked, while the dog whirls in the corner; brisk wind blows through the background; the design takes the general shape of a K, dashingly executed. Gainsborough's full length of a hunter, *William Poyntz* (Earl of Spencer, Althorp, England), is, on the other hand, more poetic in tone and romantic in pose; the hunter leans casually against a withered tree; the background is a tapestry-like design of vague shapes, setting off the vigorous modelling of the face and the detailed modelling of the smiling dog. Earl did not attempt the picturesque in either of these fashions, even though he did on other occasions study Gainsborough's technique. His point of view was still that of the American realist, duplicating independently the trend toward neo-classical austerity which Jacques Louis David was effecting in Paris, after four years in Rome.

Perhaps, when more is known about Earl's movements while abroad, from 1779 to 1786, during which time he became a member of the Royal Academy, there will be some explanation for the similarity in spirit between, for example, Earl's portrait of *Lady Williams* (Metropolitan Museum, New York), dated 1783, and David's portrait of *Mme. Chalgrin* (The Louvre, Paris), dating from the same period. A Danish painter, Christian Gullager, who painted the strong portrait of *Col. John May* (Fig. 74) in David's severe manner, was in Massachusetts in 1789, as the dates on this and other portraits prove. Perhaps he knew Earl, who was then in Connecticut, painting in his own version of David's

neo-classical style. But even if this was true or if eventually it is proved that Earl had studied in Paris, the fact remains that he was above all a simple, direct, and original artist, as shown by the consistency of his mature work. Perhaps Copley's influence may be found in the portrait of *Admiral Kemperfelt* (Fig. 69), dated 1783; David's influence, or a parallel to it, may make the 1790 portrait of *Col. William Taylor* (M. Knoedler and Company, New York) one of Earl's most distinguished pictures; and some influence similar to Charles Wilson Peale's may have given the portrait of *Samuel Stanhope Smith* (Estate of Thomas B. Clarke, New York) its hardness. But in the face of all these perhaps imaginary influences, Earl's pictures speak for themselves with their own characteristic accent.

It was said above that Earl's work became less stylish after his return to Connecticut. This is seen to be true only in a general sense, and then chiefly in the matter of design and posing. Before 1786 he was fond of tilting the figures of his sitters, making them appear to draw back from the spectator, as do *Lady Williams* and *Admiral Kemperfelt*. Beginning, however, with a portrait of *Thomas Barrow* (Ehrich-Newhouse, Inc., New York) dated "New York, May 5, 1786," and continuing through a number of portraits dated between that year and 1800, like the double portrait of *Oliver Ellsworth and his Wife* (Fig. 67), dated 1792, and the portrait of *Philo Ruggles* (Litchfield Historical Society), of 1796, this mild affectation becomes less noticeable; a more erect posture, with sometimes a slight leaning forward, takes its place. The difference may be due to a psychological change in the artist's attitude toward his sitters, the portraits of later date revealing his greater confidence and his sympathy with their simpler demands. On the whole, his English work seems more tense, less placid and assured, than the later American portraits; and this is but another way of saying that in England he was self-conscious. But let it be remembered that Earl, even when he took the most interest in his sitter, as presumably he did when painting his

English wife (Herbert L. Pratt, Glen Cove, L. I.), was an impersonal recorder of objective facts. The portrait of this, his second, wife — about which Hamilton Field could comment,[8] "The man who was married to such a woman had no business to die of intemperance" — is a lovely creation of flesh and blood, magically presented without personal feeling. *Mrs. Benjamin Talmadge* (Litchfield Historical Society, Litchfield, Conn.), dressed in her very best heavy satin, wearing an ornate headdress, and seated with her two daughters, also expensively dressed, before a window heavily draped, is represented, strange as it may seem, simply. She does not appear overdressed, and her surroundings are not ostentatious. The artist's straightforward fidelity to his observations of the child's toy coach, the fan, the design of the rug, the ribbon bracelet, as well as the mass of the figures and their placing in a room which looks out on a peaceful landscape, seems to have prevented him from making any comment on the appropriateness of these ornate accessories. Indeed, one aspect of his talent is that he never dragged in accessories; their presence was accepted, as in the portrait of *Oliver Ellsworth and His Wife*, because they seemed an essential part of portraiture. He did not sentimentalize nor refine nor caricature people's surroundings. He respected them, whatever they may have been, as he respected the peculiarities of people's appearances. He painted *Looking East from Leicester Hills* (Fig. 68) from the simple point of view of a bedridden gentleman who wished the familiar view to be reviewed indoors.[9] Here, as in the views of houses and fields which were incorporated into many of his American portraits, Earl's art shows at its most precise, simple, and moving best. He took literally the countryman's desire to have his own home put into the picture of himself, and he took no liberties with the facts about either the backgrounds or the sitters, even when they were stiff and natively formal. Unquestionably, Earl could have made them more graceful and stylized, had he wished; he had the skill and the English training. Instead he accepted the taste of his sitters so

whole-heartedly that one might credit him with their point of view and
believe he originated it, were it not disproved by the work of other
artists. That he could paint simply and cleanly, without being misled
by technical facility or sophisticated points of view, is his first claim to
fame. That he could utilize his art to express those objective appear-
ances which a large group of people considered to be the important
things in life, is of fascinating importance to the art critic, though prob-
ably of more importance to the social historian. It is here suggested
that Earl was to New England what Charles Wilson Peale was to Phila-
delphia, a leader of realistic American painting, independent and yet
consistent with the best artists of Europe. On the whole, Peale and
Earl have much in common, since each won personal independence
from England and painted in sympathy with the leaders of the neo-
classical race then running in France and Italy.

Like Peale in another way, Earl established his brother and son in
the production of portraits which show the fundamental solidity of his
point of view. James Earl, his brother, who married in England in 1789
and died in Charleston, S. C., in 1796, painted portraits delicately, like
those of *General Pinckney* (Worcester Art Museum) and *Ezra L'Hom-
medieu* (New York Historical Society), which are simple and effective,
even if they lack the subtle accuracy of Ralph Earl's work. Because of
its soft technique the portrait of *Henry Pendleton* (Fig. 70) seems to be by
James instead of Ralph, as has been supposed; in this case, James was
evidently a gracious painter, able in recording a mood. The family
tradition was carried on by Augustus, son of James Earl, born in 1793,
who was known in the XIXth century as "the wandering artist" and
was evidently a restless, energetic romanticist.

Ralph Earl's son, also named Ralph, was born in England, returned
with his father in 1786, and went back to London in 1809, where he
studied under West and Trumbull. His documented portraits of *Mrs.
Joseph Carew* (Springfield, Mass., Art Museum), which is dated 1803,

and of *Andrew Jackson* (National Gallery, Washington), dated 1835, are superficial imitations of bold realism and suggest a manner of painting similar to that in the portrait of *Thomas Earle* (Estate of Thomas B. Clarke, New York), which is signed R. Earl and dated 1800. Because Ralph the younger is said to have usually signed his work Ralph E. Earle, there is a possibility that the portrait of *Thomas Earle* is by the elder Earl in one of his worst moments; but it is dull and careless work, hard in design and insensitively executed. The coarse character of some other pictures attributed to the elder Earl in the Connecticut Historical Society, Hartford, and the New London Historical Society may be explained either by this assumption that young Ralph imitated his father, or by inference from a church record at Bolton, Connecticut, which states with scornful simplicity that Ralph Earl died of intemperance, August 16, 1801. Whatever were Earl's weaknesses as a citizen and family man, a succession of realistically poised pictures show that he had power as an artist. And one believes that the man who painted the *Ellsworths* in 1792 either would not or could not claim authorship of the portrait of *Thomas Earle* in 1800.

13

COUNTRY ARTISTS OF NEW ENGLAND

Boston, it was said at the beginning of this chapter, was no longer the hot-bed of artistry in New England after the Revolution. Few artists were practicing there until Stuart's return in 1805. Mather Brown, with his rather tame but skillful abilities, "a mediocre painter . . . full of business," as Tuckerman [10] characterized him, left Boston for London in 1780 at the age of nineteen and became artistically an Englishman, as the competent portrait of *Mather Byles* (American Antiquarian Society, Worcester) indicates. Edward Savage, born in Worcester County in 1761, was commissioned by Harvard University to paint

Washington in 1789; he did his best work in New York and Philadelphia, painting there the large *Washington Family* (Estate of Thomas B. Clarke, New York) and engraving it. John, son of Thomas, Johnston worked in Boston and the vicinity, carrying on a family tradition of craftsmanship in the arts. That he, with a journeyman's talent comparable to Gullager's, was a successful portraitist in his home city, illustrates the eclipse of sophisticated taste in Boston by a simpler, more countrified point of view. Johnston's portrait of *John McLean* (Fig. 71) is typical in pose and method of his manner of painting, which apparently varied little up to the time of his death in 1818.[11]

Emerson, thinking of the years 1790–1820, reflected the cultured point of view when he said there was not a book, a speech, a conversation, or a thought in the state. And if one looks only at the work of some journeymen painters, for instance at the portrait of *John Vinal* [12] by John Mason Furness, or the portrait of *Elizabeth Tuckerman* (Worcester Art Museum) which must be by the same crude hand, one applauds the generality. However, during that period Gullager was painting the Salisbury portraits in Worcester, formerly attributed to Johnston; and Christian Gullager was a lively, if uneven, artist. Born in Denmark in 1762, Gullager was evidently trained in Paris, shortly after David's return from Rome with an immediately successful ideal of neo-classicism. His best portraits, like that of *Colonel John May*, already mentioned (Fig. 74), and the elderly *Mrs. Salisbury* (Worcester Art Museum), both dated 1789, are firm, bright, vigorous portraits and only a little less reserved than Ralph Earl's well controlled work. Considering the styles of these two artists, one believes that the New England countryside may have been the first part of America to welcome the French ideals of strong, full design and cool, firm execution. At any rate, these ideals affected other painters, some of them nameless today, like the author of the suavely realistic portrait of *John Bush* (Fig. 72), who wears his hair long in Republican fashion. The portrait has been attributed to

McKay, who signed the portrait of *Mrs. Abigail Bush* (Fig. 73); but McKay is another artist, much closer to Gullager, it seems clear from comparison with Gullager's portrait of *Stephen Salisbury* (Worcester Art Museum). Incidentally, there is an unexplained resemblance between McKay's portrait and the portrait of *William Lytle* (lent to the Cincinnati Art Museum, 1932) which is signed "Williams" and dated 1795. The latter is presumably the William Williams born in New York in 1759, whom Dunlap knew, and the author of the portrait of *George Washington* (Washington Lodge of Masons, Alexandria, Va.), which also recalls Gullager's style. The same attention to hardness and accuracy of form appears again in twin portraits of *Charles Chauncey* (Harvard University, Cambridge, Mass., and the Massachusetts Historical Society, Boston). Since Chauncey died in 1787, and since the portrait owned in Boston is known to have been painted in 1786 for Joseph Woodward, the first appearance of this distinctive, neo-classical style must be dated at the time of Earl's arrival in New York, and before the date of Gullager's earliest American portraits. It may not be merely a coincidence that two likenesses of New Yorkers, *Gerardus* and *Nicolas William Stuyvesant* (New York Historical Society), seem to be painted in Williams' or McKay's or the *Chauncey* portraits' style. Since the Stuyvesants died in 1777 and 1780 respectively, the dating of this manner of painting may be set back still further.

However, the problem of identifying itinerant and often self-taught painters cannot easily be settled by comparison of techniques. Graduates of coach and sign painting seem to have had in general a hard, firm touch which accidentally resembles the sophisticated hardness of David's style; unconsciously they worked as if reacting from the pretty effects of painters at the French court. Although the difference in quality between Parisian and American country work is, of course, overwhelming, the superficial resemblances are strong enough to make one suspect that they are founded on similar social and political conditions. It is an

interesting speculation which encourages one to look further into the work of country artists, and which yields the strange fact that journeymen painters made a kind of international art in the farming districts. An Englishman, James Sharples, brought to America in 1793 a talent for delicately colored, small pastels which he executed in about two hours, turning out profiles at fifteen dollars apiece, full views at twenty dollars. A Frenchman, St. Mémin, did most of the important people of his time, between 1795 and 1814, in crayon sketches which are more precise and solid than the work of Sharples. Michele Felice Corné brought a crude version of Italian decoration to New England and painted ship pictures, harbor scenes, frescoes on walls, and even portraits in extraordinarily "modernistic" designs; his portrait of *Joseph Peabody* (Fig. 75), signed in 1815, shows the exciting results when an artist with a slim veneer of academic skill turns loose a sense of design on a realistic portrait. By 1804 Dr. Bentley could write in his Diary,[13] "In every home we see the ships of our harbor (Salem) delineated for those who have navigated them. Painting before unknown in its first efforts, is now common among our children." Unknown artists, like the Captain Fitch who painted *Noah Cooke* (Fig. 77) for fourteen dollars, as Cooke's diary says under date of 1800, contributed to a renaissance of painting which had little to do with the grand manner, as taught in London or Paris or Rome. Richard Jennys, for instance, painting in 1798 portraits of *Isaac Hawley* and *His wife* (Historical Society of New Milford, Conn.), was an Englishman who painted in the hard, country style noted above, in South Carolina, according to an advertisement of 1783, and also in Connecticut. Unconsciously, probably, he approximated the point of view of Williams, McKay, and Gullager, which point of view must have coincided with a widespread, popular taste.

But one must not assume that the country painters were all as positive or as limited or as brittle in their methods as these who have been named. Ezra Ames, for example, who was painting coaches in Albany

while the French Revolution was bursting with Rousseauistic dyna-
mite, had an ambition to paint in the best possible taste. He was, how-
ever, self-taught; so that when in 1790 he added miniature painting to
his established "line" of decorating, engraving, and gilding, he began
cautiously as a realist. If the critics are right in attributing to him the
small portraits of *Jesse Hawley* and *Gilbert Stuart* (New York Historical
Society),[14] he found in this exacting technique something which his
competent hands could do without too much discredit to his natural
taste for solidity of form and character. His large portraits, even the
most stiff and hesitating of them, like the portrait of *Maria Van Schaick*
(Fig. 79), which is probably one of his earliest, reveal an honest sensi-
tiveness to mood and respect for objectivity. The later portraits, like
that of *Clarkson Crolius* (Fig. 78), dated 1825, blend delicacy of mood,
firmness of contour, and a sure sense of space and weight. For a non-
intellectual graduate of coach painting, he was one of the most poised
and accomplished of early XIXth century painters. For an artist who
evidently admired Stuart's tricky flesh painting, as he revealed in the
portrait of *Governor Clinton* (New York Historical Society), which brought
him fame in 1812 at the Pennsylvania Academy, he was one of the best
neo-classicists of the period. Like Rembrandt Peale, who had the ad-
vantage of study in Paris, Ames could place his sitters in natural poses,
yet give them an easily borne austerity. How French the spirit of this
country painter from Albany could be is evident in the portraits of
Allan Melville and *Maria Gansevoort Melville* (Thomas B. Clarke Sale,
New York, 1919). Yet there is no possibility of French influences upon
him. His calm portraits, painted mostly for Western members of the
New York state legislature, as Dunlap noted,[15] prove only that Re-
publicanism in art took essentially the same intelligent form in Albany
that it took in Paris.

14

STUART, THE TECHNICIAN

But not all the painters of the Federal period were Republicans. Gilbert Stuart in his early years seemed destined to be as much of an Englishman as Copley had become; his taste, more modern and gracious than that of Copley, assured him an English success. But he was first and last a Scotch individualist, and he returned to America, and Boston, about the beginning of the Democratic period with a marvelous technique which had a limited but important effect on some artists of the new century. In spite of the fact that he did not practice in America all during the Federalist regime, he may be considered here in an account of the art within that period, because his career bridges colonial and democratic taste, pointing the way to a general shift in emphasis away from a subservient to a dominating, independent style, and illustrating the change in conditions between the time he left and the time of his return. Born in Newport in 1755, his first serious instruction as an artist came from Cosmo Alexander, a Scotchman trained in Holland and a practitioner of a solid, competent, but lifeless sort of portraiture, as one can see in the three quarter length study of *Sir Alexander Grant* (Stonington Historical Society, Stonington, Conn.) and the portraits of *Mr. and Mrs. William Byrd III* (Commonwealth of Virginia, Richmond). Alexander was in Newport in 1770. When he returned to Scotland in 1772 he took Stuart with him, to study in Edinburgh, where he might have met young Henry Raeburn, learning to paint miniatures. Whatever the results of this visit, Stuart was back in Newport before he went again abroad — this time to London, in 1775. He was still painting somewhat in Alexander's manner, if Frank Jewett Mather [16] is correct in dating the hard, static, and carefully finished portrait of *Dr. Waterhouse* (Redwood Library, Newport, R. I.) about 1776; but he rapidly developed a supple, spirited manner of painting, as shown in the *Self-Portrait*

(Fig. 76) which he proudly signed on the reverse in 1778. At this date Stuart had begun studying under West. Yet it was not West's influence which produced the change in style. Accepting Prof. Mather's theory, it was Gainsborough's "dragging manner of tinting," as Stuart called it, that was the inspiration for his mature mastery of flesh painting; it was an impressionistic combination "of all colours, not mixed, so as to be combined in one tint, but shining through each other, like the blood through the natural skin." [17] For twelve years he worked brilliantly in England; for five years more he worked in Ireland, producing such fine and romantic portraits as that of *James Ward* (Fig. 82), which is signed and dated 1789. He then returned to work in the United States, capitalizing, as the Peales had done and were continuing to do, the Republic's astonishing capacity for absorbing portraits of George Washington.

Now it is evident that Stuart was not a patriot any more than was Copley. In all the anecdotes which have been recorded about him,[18] there is little indication that Stuart thought of political events or took much interest in the struggle for national security. The anecdotes reveal a witty, sharp mind, selfish manners, and the fundamental strength of an honest recorder of Nature. "For my own part," Stuart said,[19] "I will not follow any master. I wish to find out what nature is for myself, and see her with my own eyes." But it is not strictly true that Stuart was independent of all English art. Not only does he seem to have derived a technique from Gainsborough, but he apparently found in the work of Reynolds and Romney a way of posing and of freshening reality so that his pictures appear thoroughly sympathetic with the portraiture being done in England shortly before 1800. When he returned to America he came as a famous foreigner, bringing a brilliance of style new to artists who had not been abroad. From the time that he settled in Boston in 1805 until his death in 1828, he was the most consulted artist in the United States, the painters' painter, who advised, encouraged,

and discouraged his admirers. Although blunt and honest, eccentric and independent in spirit, he appealed to his contemporaries as an exponent of an aristocratic, delicate, tinted art, rather than as a democratic, plain recorder of appearances. His patrons were the nouveaux riches as well as the social leaders in Washington, New York, and Boston. His portraits are realistic only as deep as the skins of his sitters and remain, however pronounced the likeness or glowing the pearly tones, limited to superficial effects, such as the moistness of skin, delicacy of hair, grace or majesty of carriage. Many comments on Stuart as a portrayer of character can be found in the extravagant praise quoted by Dunlap and his contemporaries. But modern criticism suggests that Stuart was a perfect painter of wild roses, all magic when in full bloom, unsubstantial and meaningless when faded. The point seems to be that Stuart's social accomplishments, his daring wit and quick tact, were the same as his artistic accomplishments. All sitters seem to be ladies and gentlemen of ease and distinction in Stuart's presence; and a general air of polite fiction pervades the realism of their faces. He knew how far to go in revealing oddities of personal appearance and character, at the same time making such observations suave and even charming. *Major General Knox* (Boston Museum of Fine Arts) presents a stylish and pleasant figure, in spite of some pomposity in his pose. *Josiah Quincy* (Fig. 83), painted in 1826, is a dreamy figure contemplating his civic improvements. Here is the crafty, romantic artificiality of the English tradition at its poetic best, transplanted to America.

That Stuart was so successful with this kind of amiable portraiture in the years of the new democracy, illustrates one of the subtle divisions in taste during the early eighteen hundreds. While he was making aristocratic portraits, Harding and Francis Alexander were making plain, blunt likenesses in the democratic spirit, and rivalling Stuart in Boston, without the aid of brilliant technique. It will be shown that both Harding and Alexander grew out of the school of native, itinerant

painters who were practicing their minor art while Stuart was abroad. And it will be evident that a rival group of stylists and romantic painters, including Sully and Neagle, developed as a result of Stuart's success. But in spite of Stuart's fame he did not found a school, unless the work of his daughter, Jane Stuart, and of many a copyist, be considered a school. With many admirers and imitators, he had few pupils. Freshness of technique, keenness of eye, and "clear as silver" flesh tones are not easily taught. Hence, his effect on American painting is confined to generalities, which are as true of most English portraiture of the time as of Stuart's own work. His magical tones inspired artists, like Charles Loring Elliott, who never knew him, or even Francis Alexander, his respectful rival, to paint in their own manners. Occasionally he gave bits of practical advice, as telling Sully how to stiffen the paint on a palette during warm weather. But for the most part he was the valedictorian of the English style, and a phenomenon in American taste.

15

TRUMBULL, ARISTOCRAT

Stuart was not, however, the last of the aristocratically trained artists. John Trumbull, whose long life from 1756 to 1843 — from Copley to William Morris Hunt — included the years here covered by many pages of criticism, combined in his helter-skelter career the foreign and democratic points of view. But he did not assimilate them. As a portrait painter and miniaturist he was a vivid and skillful practitioner of the best English methods. As an historical painter he was an energetic but not convincing imitator of Benjamin West. Traditions had a firm grip on his art. Yet as a man of action, a soldier of sorts, a dabbler in diplomacy and politics, a friend of the great and near-great, his life was keyed to his time; and his ambitions were democratic. All his mature life he seems to have had a plan for recording the great scenes of the

Revolution, so as to instruct posterity in the love of country and liberty. He actually began work on this plan, with the *Battle of Bunker Hill* (Yale University, New Haven, Conn.), while still a student under West in 1784, before there was a President of the United States. He was then twenty-eight years old and had been a soldier, although he did not take part in the Battle of Bunker Hill. He had taught himself something of painting, had been a prisoner in London and an admirer of Copley. During the next five years he came into contact with Jacques Louis David and the principles of the antique. All conditions were right for him to become the leading painter of the American Republic. An early *Self Portrait* (Boston Museum)[20] and the 1777 portrait of *Governor Jonathan Trumbull and Family* (Yale University, New Haven, Conn.) reveal a hard, realistic style, reminiscent of Copley's early work, though not as well drawn, and suggesting also the work of Ralph Earl. The *Battle of Bunker Hill* is carefully studied and carefully modelled, with no more romantic posing than one would expect from a student of West's historical pictures. The full length portrait of *Governor Clinton* (Fig. 86) is a severe likeness somewhat in the early style of Charles Wilson Peale. Many small studies of prominent people (Yale University, New Haven, Conn.), intended as sketches for details in his large historical paintings, prove his strength as an artist of spontaneous ability, as do his miniatures (Fig. 111D).

Nevertheless Trumbull failed to become the great American painter. The difficulty seems to be that he was not passionately interested in anything but himself; he did not look sympathetically on his fellow-citizens and country, both of which he deliberately chose as subjects. Even when he painted *Niagara Falls* (Fig. 112) he managed to reduce the spectacle to a mere record of facts. With native painters to guide him, he turned more and more to the traditional melodramatics of West's style. With knowledge of neo-classical ideals, he scorned David's restrained art. With an ambition to paint the Republic for posterity, he

sneered at the word — "that favorite phantom of the age" [21] — and shuddered at David's devotion to the state. The shudder may be excused since David had extravagantly wished "five hundred thousand more heads had passed under the guillotine"; but it is hard to excuse the indifference to republican ideals of this self-styled painter to the Republic and "warrior" who resigned from one war because his commission was dated a few months late and who passed another war painting in the land of the enemy. His own tastes were after all aristocratic and he, like Stuart, belonged to the English XVIIIth century rather than to the American XIXth century.

Thinking in terms of colonial culture, as he did, Trumbull naturally believed that artists are "necessarily dependent upon the protection of the rich and great." His own disappointment at the slowness and vagaries of government patronage emphasized this belief. When Trumbull founded the American Academy in New York, he stacked the board of trustees with influential laymen, instead of artists. Deeply resenting this subservient state, Dunlap and Morse founded, with the cooperation of many kinds of artist, a rival institution, the National Academy. The two Academies differed as do a gentlemen's club and a workers' union. Trumbull could not peddle likenesses for a living, as did both Dunlap and Morse. He finally "bequeathed" his life's work to Yale University, in exchange for an annuity, and retired from social and artistic surges of which he could not approve.

By carrying their abilities to country districts and portraying country people as plainly as they desired, the artists who succeeded Trumbull long before his retirement achieved a kind of success denied to the painter who dealt stiltedly in the grand manner. They had to meet the requirements of unsophisticated, self-reliant, amateur judges of art. Their pictures at best reflected the vigorous characteristics of their sitters, the naive beauties of unspoiled nature, and the sincerity of their own pioneering experiences. At worst, according to modern standards,

they succumbed to the new demand for sentiment in art. All their activities, their erratic variations on old themes, their search for novel aesthetic outlets and their scrambled efforts to acquire techniques, make a complex movement of long duration, which will be the general subject for the following chapters. Leaving Trumbull, the reader enters a new age and begins the study of what eventually becomes, through a process of elision with French art, modernistic painting.

NOTES

1. Samuel Eliot Morison and Henry Steele Commager, The Growth of the American Republic, 1930, 178, for instance.
2. Repr., Dunlap, op. cit., ii, 18.
3. Repr., frontispiece, The Literary Diary of Ezra Stiles, i, Charles Scribner's Sons, 1901. Under date of August 1, 1771, Dr. Stiles wrote, "This day Mr. King finished my picture. He began it last year — but went over the face again now, & added Emblems &c." Then follows a minute account of the symbolism of the pillar and its inscriptions, none of which are visible in the reproduction. Nor are the titles of the books in the background visible in reproduction, although Dr. Stiles selected them carefully to "denote my Taste for History." The portrait in 1901 was in the possession of Mrs. Charles C. Foote, New Haven.
4. For example, the portraits of a man and his wife (Essex Institute, Salem, Mass., numbered 107.922), which are drawn in the naive but alert manner, especially about the eyes, of the portrait of *Ezra Stiles*. The woman's dress sparkles with small, precise touches of color, the design is pleasingly simple, and the features of the sitters are carefully recorded. The same artist probably painted portraits of *Dr. and Mrs. Henry Barnes*, known to me only by reproductions with ownership unrecorded.
5. Art in America, xxii, 83; Mr. Sherman is preparing a book on Earl at the present writing.
6. There are differences between the painting and the engraving which seem to argue for the spontaneity of the former.
7. Repr., Fifty Portraits of Raeburn, 1909.
8. The Arts, ii, 107.
9. Bulletin, Worcester Art Museum, vii, no. 2, 6, no. 4, 7.
10. Book of the Artists, by Henry T. Tuckerman, 1867, 45.
11. See Frederick W. Coburn, Art in America, xxi, 132.
12. Repr., Dunlap, op. cit., iii, 304.
13. Op. cit., iii, 68.
14. Harry B. Wehle, American Miniatures, 1927, Pls. XXXIV and XLIII; Dorothy C. Barck, New York Historical Society Quarterly, x, no. 4, 131.
15. Op. cit., iii, 24.
16. Art Studies, iv, 4.
17. Neagle, quoted by Dunlap, op. cit., i, 252.
18. Life and Works of Gilbert Stuart, by George C. Mason, New York, 1879.
19. According to Neagle, quoted by Dunlap. op. cit., i, 216.
20. Repr., Dunlap, op. cit., ii, 12.
21. Autobiography, Reminiscences and Letters, by John Trumbull, New York, 1841, 229.

CHAPTER V

Vagaries of Democratic Taste

THE importance for artists of the "great revolution of 1800," as Jefferson called it, was the change in conditions which not only followed democratic victory at the polls, but which had helped prepare for that victory. As early as 1787 a play produced in New York contrasted yeoman and urban society and stated the fundamentals of democratic ideals by presenting a Yankee servant, contented with "twenty acres of rocks, the Bible, the cow, Tabitha (the cat, of course), and a little peaceable bundling." [1] Conscious nationalism is here voiced in praise of "homespun habits. . . . Whilst all which aims at splendour and parade must come from Europe and be ready-made." Jefferson's election was the triumph of an agriculturist who swore eternal hostility against every form of tyranny over the mind of man, including religion and industrial supremacy; who believed in science as an intellectual necessity, and who went to the Greeks for his ideas on architecture. A country which believed in Jefferson naturally believed in a self-reliant, natural, pseudo-scientific, pseudo-classical ideal of existence. This was the period when the phrase, Yankee ingenuity, had most meaning; Bentley in his notes of 1797 [2] pictures an acquaintance "providing to straiten the road by his own house, planting trees and having formed a model on which he expects to have a cutting machine for nails to head them at the same time." Nature and Science filled men's minds. Bowditch published The American Practical Navigator in 1802. Audubon was recording the birds of Ohio in 1812. Lewis and Clark made their famous expedition to Oregon in 1803–06. William Cullen Bryant published

"Thanatopsis" in 1817 without mentioning the Deity or the Resurrection or Immortality, although death was his theme; "Go forth," he wrote, "under the sky, and list to Nature's teachings. . . ." In short, the great revolution of 1800 was the coming to age of a nation, expanding in every direction, physically and psychologically. And the arts followed, when they did not anticipate, as in the case of New England country artists, these general movements.

16

NEW IDEAS FROM REPUBLICAN FRANCE

In the last chapter, French influences were suggested as a possible, but not proven, explanation for a characteristic type of precise and reserved, native American portraiture. Now the actual influences from France must be discussed, as they can be traced from the end of the Federal period into the first third of the XIXth century, when the expanding democracy, like France itself, found that neo-classical enthusiasm was only the door to romantic emotions. When David lay dying in Brussels in 1825, Delacroix was searching literature for scenes of violence to illustrate. Only David, as he himself pathetically said, could interpret the features of Leonidas; and Leonidas, with his love of country, his exalted, objective virtues, serves as the symbol for neo-classical art. Other artists who followed David's precepts did not interpret Leonidas; they imitated the outward form of neo-classicism, making hard forms in imitation of David's precision, flatly coloring after David's taste for chill tones, and making fiction of David's logic.

Like Adolph Wertmuller and John Lewis Krimmel, who adapted for America the so-called classic style, the imitators were, compared to David, very minor artists. Wertmuller's thoroughly academic training made his portraits of *George Washington* (Metropolitan Museum, New York), dated 1795, and *Andrew Hamilton* (John Frederick Lewis)[3] pic-

tures without a country. He was a Swede, trained in Paris, who visited Philadelphia in 1794, returned to Stockholm in 1796, and finally settled for the rest of his life after 1800 in America. Krimmel's background was Germanic, so that he brought to Philadelphia in 1810, for a brief period before his death in 1821, not only a hard technique, but a flair for sentiment which, in the *Family Group* (Estate of Thomas B. Clarke, New York), his most ambitious work, is a strange mixture for American tastes. Dunlap, however, was in 1834 enthusiastic [4] about Krimmel; and he was particularly impressed with his genre scenes, thus giving a good indication of the eclectic taste of the time. Three of these scenes, *The Country Wedding* (Fig. 92), *Centre Square, Philadelphia* (Pennsylvania Academy, Philadelphia), and *Fourth of July* (Historical Society of Pennsylvania, Philadelphia), lively and charming in their neat adaptation of facts to a reserved point of view, seem to belong to American art only incidentally, as symptoms, rather than as achievements of the new development.

A man who was of more importance, although his life was divided between art and science in such a way that Dunlap could curtly dismiss the artist in him as being "guilty of painting poor portraits in Philadelphia in 1782," [5] was Robert Fulton. Born in 1765, his first instruction in art seems to have come through Charles Wilson or James Peale, as miniatures of *Mr. and Mrs. Kittera* (Fig. 111A) indicate. About 1786 he entered West's studio, but became interested in inland navigation, obtaining patents from the British government in 1794. A *Self-Portrait* (Fig. 80), apparently painted under English influence, shows his skill at this period. By 1797 he was in Paris as a scientist, working on gunpowder and torpedoes. In 1801 he was at Brest, testing his submarine. In all his scientific activity, however, he found time to paint an occasional portrait, like that of his friend in Paris, *Joel Barlow* (Samuel L. M. Barlow, New York), which records how strongly he was influenced by Parisian standards of portraiture. Upon his return to New York in 1806

he set to work perfecting steam navigation, with the result that the Clermont made a five-mile-an-hour run to Albany and back in 1807. But he did not abandon painting; the severe portraits of *Henry* and *Marion Eckford* (Estate of Thomas B. Clarke, New York), painted in 1809, prove that he became a dignified follower of David's methods, and one of the first to practice those methods in the United States with first-hand knowledge. So sure is his sensitive and solid art, that one regrets the many years from 1793 to his death in 1815, when he was chiefly occupied with schemes to outlaw war through devastating explosives and with business incidental to his steamboat company. His portrait of *Mrs. Walter Livingston* [6] is accomplished without affectation of any kind, realistically modelled, timeless, simple, and deeply felt. If Fulton had been as much of a leader in art as he was in practical physics, the neo-classical influence from abroad might have had more of an effect on American art in general. As it was, his estimable restraint as an artist and the overwhelming novelty of his inventions combined to obscure his artistic talents, which have remained obscure, in spite of the Hudson-Fulton Exhibition held in 1909 at the Metropolitan Museum in New York. His influence on contemporaries seems to be limited to the fact that he was the first to paint a panorama in Paris and to show the way to Vanderlyn, Rembrandt Peale, and others in "exhibition" pictures.

John Vanderlyn, French trained, and a brilliant craftsman who bent his naturally romantic temperament, expressed in such monstrosities as the *Nightmare* (Metropolitan Museum, New York), to the discipline of neo-classicism, also produced fine portraits, ranging from the serenely realistic *Robert R. Livingston* (New York Historical Society), painted in 1804 at Paris, to the stirring, elongated full length of *Andrew Jackson* (New York City Hall), dated 1819. That Paris was his favorite residence for seven years, that he copied nudes from Correggio and Titian, and tried to duplicate Fulton's feat in making panoramas of Paris, Versailles,

Athens, etc., all indicate the modernity of his career, which had begun modestly with making copies of portraits by Stuart in New York in 1793. Befriended by *Aaron Burr*, whose small profile portrait (New York Historical Society) reveals Vanderlyn's search for purity of form within a narrow range, the artist chose Paris, instead of rushing off to Benjamin West, and painted in Rome one of his large exhibition pictures, *Marius amid the Ruins of Carthage*, in imitation of David. He also painted in imitation of David's manner an historical subject of more modernity, the *Death of Jane McCrea* (Fig. 109). At a time when public exhibitions of nudes horrified America, Vanderlyn sold a *Leda* in Paris to a gentleman of Salem, Massachusetts.[7] His widely known *Ariadne* (Pennsylvania Academy, Philadelphia) was delicately and fully modelled in 1812 without prudery; but it was scarcely a success with the public when he returned home in 1815. The current point of view was summed up by an anonymous contributor to the Analetic Magazine who in 1815 [8] felt that the nude was "to be regretted, that both in the subject and the style of execution it offends alike against pure taste and the morality of the art." We shall see later what pure taste became about the period of the Civil War. In the meantime, Vanderlyn's copy of Correggio's *Antiope* (Thomas B. Clarke Sale, New York, 1919) was, to its admiring owner, "altogether indecent. I can not hang it up in my house, and my family reprobate it." [9] The truth seems to be that a slight suggestion of the nude, as in Raphael Peale's *After the Bath* (William Rockhill Nelson Trust, Kansas City), sufficiently shocked the exhibition-goer; presumably people thrilled in 1823 to the sight of a model's forearm daringly exposed above an all-hiding sheet. But in private, discreet amateurs undoubtedly indulged in "the French taste" and subtly prepared the way for well clothed Americans to appreciate anatomy. The cumulation of such indulgences seems to have brought about the modern familiarity with the nude. If it is not altogether true that, as Virgil Barker has said in a discussion of American taste,[10] "not until the very

end of the XIXth century was the feminine nude brought out of the barroom," it is astonishingly true that Vanderlyn almost succeeded in making the nude respectable at a time when husbands left the room while their wives changed stockings.

That Vanderlyn could exhibit *Ariadne* at all was apparently due to his obvious ability as an artist. A deliberate painter, taking sixty sittings for a portrait,[11] he was nevertheless a lively one; and he was rightly successful with luminous, well modelled portraits of rather small size, like those of *Samuel V. Wilder* (Cleveland Museum) and *Joseph Reed* (Thomas B. Clarke Sale, New York, 1919). His *Self-Portrait* (Fig. 81) is a solid work of the same sort, quite in the spirit of David's fine portraits, though delicate in mood. In every way he seems to have been one of the most sophisticated artists of the time, with only occasional traces (Fig. 109) of that static intellectuality which affected most of David's followers.

Others who appreciated the precision and form of Republican French art also achieved a certain amount of sophistication. Rembrandt Peale, restless son of a restless father, studied eclectically under Benjamin West in 1802–03, under Gilbert Stuart in 1806, in Paris in 1807 and again in 1809; after experimenting with illumination by gas in Baltimore, he returned to Paris in 1830, from where he journeyed through Italy and England, not returning to New York until 1834. Since he lived until 1860, his art might be expected to show not only the eclecticism of his early life, but the alterations due to the growing eclecticism of American taste. But his work is surprisingly neo-classical. Setting aside a huge composition with twenty-two figures, reminiscent of the school of David, which he called the *Court of Death* and character-ized as a "personification at once philosophical and popular . . . equally understood and appreciated by the ignorant and the learned," [12] one finds in his portraits a clarity and fullness of form which suggest that the Parisian influence was most important to him. At the same time it

is evident that his technical training left him vacillating. A portrait of *Moses Levy* (J. J. Milligan, Baltimore) recalls Stuart's flicked manner, the portrait of *Thomas Jefferson* (New York Historical Society) recalls Charles Wilson Peale's lined modelling, the portrait of *Commander Louis Warrington* (Minneapolis Institute of Arts) is as smooth as a small portrait by Vanderlyn, and the hard surface of the portrait of *Mrs. Stennett* (William Rockhill Nelson Trust, Kansas City) shows that in 1835 he painted like a country Ingres. But the high achievement of a poised style in certain portraits, like that of *The Artist's Wife* (lent to Pennsylvania Academy, Philadelphia, 1923), wearing a light fur about her shoulders, makes him an important figure in American art. His color is richer than one might expect from a follower of the pale Parisian school. And even when he attempted a sentimental pose, as in the 1844 portrait of *Mrs. Daniel Haddock, Jr.* (Lent to Pennsylvania Academy, Philadelphia, 1923), he retained his birthright of realism and vitality. Like Ezra Ames, the coach painter, Rembrandt Peale, who preferred to be called simply Rembrandt, as he advertised in Philadelphia in 1804,[13] produced portraits (Fig. 89) which are better designed and more dignified than one might expect from the circumstances of his life.

In other words, it seems that the general level of accomplishment was briefly higher during the decline of English taste and the rise of a continental taste. A backwash of sophistication, already suggested by the work of country artists before 1800, extends down through the work of artists who painted in the first third of the XIXth century without the benefit of French training. Some of them are well known. Others, like Tilyard, the Baltimore sign painter who made strong portraits of *Mr. and Mrs. George W. Waring* (Fig. 84) in 1823, M. Vervoort, who signed in 1819 a stunning portrait of *Captain Ward Chipman* (Fig. 85), and William West, the southern miniaturist, who signed in 1818 a bold likeness of *Thomas R. Fosdick* (Frances L'Hommedieu Jones, Cincinnati), are generally ignored because so little is known about their activities.

But Vervoort, for instance, seems to have been a good decorative painter as well as a strong portraitist, a student of classical Italian forms, judging by the *Cupid Riding a Sea Shell* (Essex Institute, Salem, Mass.), which is signed and dated 1822, and at the same time an observer of character, as in the 1822 portrait of *William Chever* (Essex Institute, Salem, Mass.).

Henry Sargent's subject pictures illustrate the development away from English standards. Having painted portraits of *Jeremy Belknap* (Massachusetts Historical Society, Boston) in 1798 and *Benjamin Lincoln* (Massachusetts Historical Society, Boston) in 1806, for instance, which reflect the academic training of West and Copley, Sargent became discouraged in his career as a portraitist and turned to genre. He painted *The Dinner Party* (Fig. 96) and *The Tea Party* (Boston Museum of Fine Arts) with charming originality and accuracy, noting variations in light, difficult effects of candle and firelight, natural poses, details of dress and furniture, all combined in a spacious interior. The compositions are involved but well handled; and the point of view is sophisticated, for all its realism. Strictly speaking, one cannot claim Sargent as a neo-classical painter. Nevertheless, here are two pictures by him which reveal his preoccupation with an ideal of painting similar to that of Krimmel, the German, who died young in Philadelphia, and of Morse, whose spacious, sensitively painted *Old House of Representatives* (Fig. 90) was finished in 1823. All three artists adopted the French Empire spirit, yet neither Morse nor Sargent had been nearer Paris than London. The spirit which Morse adopted was suggested by François Granet's painting of the *Capuchin Chapel*, or rather one of the copies, which a Mr. Wiggins of Boston had brought from Europe and which Sully had copied in 1821 as a business venture. Thus the neo-classic attitude spread surreptitiously through the art of the Democracy. And it is difficult to tell exactly how far it spread, how many artists were consciously or unconsciously affected by its logic and precision. Probably most of the itinerant painters who are the subject of the next section felt

more sympathy for the art of France than for the art of England, even when, as in the case of Morse, they had studied faithfully in West's studio.

17

MORE ITINERANT REALISTS

The first part of the XIXth century is a period of such confusion of efforts that one is forced to simplify it arbitrarily, if anything like a comprehensive view is to be attained. Logically, after mentioning some French influence, one should go on to later French influences, giving a more or less connected account of the development of romantic landscape, impressionism, and modernistic art. But in the years about 1800 painters were active in almost every part of the United States, employing whatever training they had in an effort to make a living as itinerants. Self-taught painters, like Jarvis, came in contact with romantic artists, like Sully; and artists whose technique ripened in England influenced painters who struggled out of hack work into the grand style, as Stuart influenced Neagle. It seems best, therefore, to make a rough division between country and city artists, between those who travelled widely, continuing the realistic tradition of the Republican period, and those who moved comparatively less, from city to city, perhaps, but not through the back country, and who catered to a more polished society, subordinating realism to stylistic effects. Admittedly it is a clumsy arrangement and inaccurate from several points of view. But it may be considered still less accurate to put, for example, the facile Inman in the group that contains his austere teacher, Jarvis. Without laboring the point, it must be clear that any method of grouping which reveals relative points of view is satisfactory, even when that method, as in the present case, often cuts across chronological arrangements.

Samuel Finley Breese Morse may be included here, in spite of his training under Allston and West in London, in spite of his ambition

"to be among those who shall revive the splendor of the XV century, to rival the genius of a Raphael, Michelangelo or a Titian," and in spite of the kinship between some of his canvases and those of romantic English portraitists, because what he accomplished was, for the most part, simply the taking of likenesses in a realistic, careful way. Late in life he realized this when he bitterly wrote, "I have no wish to be remembered as a painter, for I never was a painter; my ideal of that profession *was* perhaps too exalted; I may say, *is* too exalted." [14] Full of enthusiasm for subject pictures, acclaimed for his *Dying Hercules* (Yale University, New Haven, Conn.), which he also executed in sculpture, he returned to America about 1815 to find that America did not want heroic art. So he became a journeyman portraitist, painting likenesses for what he could get in places as far apart as New Hampshire and Charleston, S. C. With his honest and penetrating character he took this stop-gap work so seriously that he created a new style for himself, as can be seen by comparing his *Self-Portrait* (Addison Gallery of American Art, Phillips Academy, Andover, Mass.), which he painted at London in a vaguely poetic mood, with the small and sturdy likenesses of *Rev. and Mrs. Bingham* (Fig. 91), done in 1817. A succession of firmly modelled characterizations show that he settled down to the job of face painting, substituting realism for ideals of splendor and genius. Typical of his success in this field is the strong portrait of *Gen. John Stark* (Mrs. Charles F. M. Stark, Concord, N. H.), painted in 1820. Evidently he resented the necessity for doing such work, since he turned readily from it to invent a fire pump and, in 1823, a marble cutting machine. In 1824 he revealed some enthusiasm for a subject picture (Mrs. Edward Bok, Philadelphia), "the full length portrait of Mr. Horne's little daughter, a pretty girl just as old as Susan. . . . I shall paint her with a cat set up in her lap . . . and she employed in feeding it." [15] Here Morse is only a step away from Sully and Inman, painting sentimental subjects. Yet about this time he was doing the portrait of *Mrs. Morse* (Fig. 87), which,

though expressive and gracious in tone, is modelled with clear-eyed objectivity. And in 1825, while overcome by the death of his wife, he finished his masterpiece, the full length, thundering, aloof portrait of *Lafayette* (New York City Hall), with its dramatic sky "indicative of the glory of his own evening of life" and its unobtrusive symbolism in the empty pedestal alongside the busts of Washington and Franklin. A series of portraits in 1826 show that he resigned himself for the time to being a first-rate character painter, as in the simple, impersonal study of *De Witt Clinton* (Metropolitan Museum, New York). But in 1829, after founding the National Academy in opposition to Trumbull's "high-handed" organization, he went abroad, copying and otherwise dodging the necessity for portrait painting. As a result of the trip, he finished in New York another exhibition picture, similar in scope to the *Old House of Representatives*, already mentioned (Fig. 90). On this occasion, however, not portraits of people, but a gallery in the Louvre and copies of the paintings in the *Salon Carré* (Syracuse University, Syracuse, N. Y.) were his concern. Few commercial portraits followed this trip. When he took up his brushes he painted in the grand style, for instance the portrait of his daughter called *The Muse* (Herbert L. Pratt, Glen Cove, L. I.), which combines straightforward study of character with the paraphernalia of Sir Thomas Lawrence's most official portraiture. And this practically closed Morse's career as an artist, the end of his life being devoted to the perfection of the telegraph, invented in 1838.

During Morse's struggles with realistic painting, John Wesley Jarvis, his elder by eleven years, had worked his way through an engraver's training under Savage and found that he could paint faces better than the "best portraitist in New York — a Mr. Martin." With good business instinct, he had formed a partnership with Joseph Wood for making cheap profiles on glass. Instead of poetizing on the art of the past as Washington Allston was doing (see section 18) or as Morse tried vainly

to do, Jarvis was busy making the art of the present. The still insistent demand for likenesses supported him in his rough and lusty tastes. Through Dunlap's vivid, and yet horrified, account [16] one feels the reality of the new democracy in art. Jarvis, though an Englishman by birth, ate, drank, and joked in the unrefined manner of the American backwoodsman. Instead of learning formulas for painting, he invented his own method for doing his work, by way of studying anatomy and phrenology, but most importantly by observation of people. He loved company and he loved to be the center of company. Small wonder that his art is real. It scarcely mattered that the bumps of character in which he interested himself revealed his own lack of scientific knowledge, since his instincts for solid modelling were strong, and since he had for model at one time Wertmuller's *Danae*,[17] typical of French academic painting. He practiced and said many things which his contemporaries thought foolish; he even criticized Stuart's rosy flesh tones as being "not nature." But he painted likenesses which speak, like the menacing full length of *Henry Clay* (Fig. 93), and he tossed off rapid portraits, like those of *Solomon* and *Mrs. Etting* (Maryland Historical Society, Baltimore), which have a full breath of life. Dependent on no one painter for his style, Jarvis approximated French firmness, probably by way of Wertmuller's academic nude, and executed his realistic conceptions with nervous intensity. Even when he was doing six portraits a week in New Orleans, with Inman's help, he produced assured likenesses which make most of the work done by the more polished painters seem artificial. His portrait of an *Unknown Lady* (Thomas B. Clarke Sale, New York, 1919), with its easy penetration of character and objective dignity, could be hung alongside a bold portrait by David without offense; and his portrait of *James Fenimore Cooper* (Fig. 88) might easily pass for the solid work of an energetic painter of the French Empire.

Energy was, in fact, the ideal of the time. The packed career of William Dunlap, whose History of the Rise and Progress of the Arts of

Design in the United States — to give the title in sonorous complete-
ness — is essential to any study of American painting, reveals the same
expansive spirit which appeared in the settling of the near West, the
voyaging of Yankee traders, and the rise of the Democratic party. Born
in 1766, son of an Irish soldier who fought with Wolfe in Canada, Dun-
lap recalled in his Autobiography some of the confusion of the Revolu-
tionary War and something of the clash of national feelings. From be-
ing literally a British subject, he developed along with his country into
a conscious American and a democrat. His life was too filled with
necessary action to be ordered. Nominally a student of West for three
years, he admitted in later life that his drawing "remained deficient."
Upon his return from London in 1787 he entered business, dabbled in
literature, was an active Abolitionist, freed the family slaves in New
Jersey, wrote plays and managed theatrical productions; with the net
result that in 1805 he was bankrupt. To support his family he turned
to miniature painting, setting up in Boston, where Malbone was splen-
didly at work (Fig. 111E), and obtaining business by the simple expedi-
ent of underselling his competitors. From there he travelled to Balti-
more and Washington, doing his work neatly and fully earning his way.
But when a chance to return to the theatrical business came to him in
his garden, he dropped the hoe and everything else; he worked furi-
ously as a producer until financial troubles again sent him back to
miniatures in 1812. Off and on he painted oil portraits, but it was not
until 1817, at the age of fifty-one, that he became a professional por-
traitist, again journeying anywhere that friends of past sitters brought
him new commissions.

Naturally Dunlap's art was limited. To make painting profitable he
had to paint quickly. His professional training having been negligible,
he had to rely on simple effects. But his sense of fair play made him
conscientious in taking likenesses; and he had through his many con-
tacts with people of all types, from Virginia to Canada, from Boston to

outposts of civilization, like Rochester, N. Y., a ready grasp of char-
acter. His interest in the theatre seems to have benefited him in pre-
senting his sitters effectively. It was, of course, an objective kind of
representation, humble in scope and undertaken under any conditions
of illness and travel, but accomplished to the best of his modest ability.
One learns his aesthetic point of view through his account of painting
huge exhibition pieces, to be sent throughout the country "playing the
sticks" for small but fairly consistent profits. His *Christ Rejected*, 18 ×
12 feet, contained figures borrowed from the description of West's pic-
ture, a pamphlet which accompanied the ticket of admission explaining
which figures were borrowed. *Death on the Pale Horse*, 20 × 10 feet, was
also taken over from West. Like David, whose *Coronation of Napoleon*
was about this time displayed in New York as an historical novelty,
Dunlap seems to have considered the ideas, the plan and conception of
a work of art to be more important than its actual execution. This is,
of course, a thoroughly democratic attitude and typical of the period
which hailed art — not portraiture — semi-philosophically. "That
painter," Dunlap quoted,[18] "is good for nothing who cannot impress us
with the moral sublimity of virtue, and give us the majesty of religion
with all her sweetness." Only the broadest effects were visible. With
so much to accomplish in the way of social reform, in establishing the
machinery of culture, in organizing literary and artistic clubs and so-
cieties, the intellectual artists of the new democracy could not find time
to reflect on the past, or to evaluate subtle personal feelings, as in mod-
ern times. Dunlap, author of a detailed history of the arts and a simi-
larly detailed history of the American theatre, was vice-president of the
National Academy, and an honest journeyman painter; naturally he
believed in an impersonal kind of art which "will be the friend and co-
adjutor of reason, the propagator of truth and the support of religion."[19]
Looking at his portraits with this in mind, one sees solid virtues, rather
than uninspired feeling; such honest accomplishments as the portraits

of *Mrs. Cooper* (Cleveland Museum) and *George Spalding* (Fig. 94) possess in addition to sturdy character a Utopian confidence in reality. And that is one approach to art.

Democratic taste, eager for objective truths from its artists, was enthusiastic over the work of Wilson and Audubon in ornithology. Nothing like John James Audubon's broadly designed water colors with their minute finish had been done before. It was scientific emphasis which made this artist of French ancestry respected by all, excepting Dunlap, who distrusted Audubon's honesty.[20] And it is a scientific interest in objective appearances, in the starched skirt worn by *Anna Cora Mowatt* (Estate of Thomas B. Clarke, New York) and the incredible wrinkles in the face of *Nathaniel Rochester* (Hiram Burlingham Sale, New York, 1934), which makes Audubon's few portraits seem typical of the democratic ideal.

Only a little less impersonal, patient, and keen-eyed were the most popular artists of the time, Waldo and Jewett, celebrated firm of likeness-takers, who were active for almost half a century. Although Samuel L. Waldo had been to West and Copley for instruction and could paint estimable portraits, like the one of *David Grim* (Fig. 100), dated 1812, with a good measure of the vitality which Charles Wilson Peale or Ezra Ames put into their work, he was in 1816 content to submerge personal expression beneath an impersonal partnership. The more conventional portrait of *David S. Boardman* (New Milford Historical Society, New Milford, Conn.), done by the partners jointly, shows their technical skill and the dashing effect of their combined talents. If F. F. Sherman is right in attributing to William Jewett alone [21] the portrait of *Asher B. Durand* (New York Historical Society) which fits the description of one exhibited under his name in 1819, his taste was softer than Waldo's. And this, in general, was the tendency of the firm's work, which ended with Waldo's death in 1861 on a rather smooth, undistinguished level. "The whole excellence of art," thought Jewett in his

youth,[22] lay in the "bold and judicious opposition of light and shade, and a free light manner of handling the color." In this he anticipated the preoccupation with technique which marks the work of painters more individualized than was he or his partner, and which establishes the point of view of the most stylized artists of the time.

Eliab Metcalf, a pupil of Waldo and Jewett, who also portrayed *Asher B. Durand* (New York Historical Society), began painting with serious realism, but did not live to follow the general trend. Bass Otis, self-taught graduate of coach painting, who appeared in New York in 1808 and settled in Philadelphia in 1812, did, however, live to help replace plain realism by studied charm. His uneven development can be suggested by comparing the faded but still dignified and intellectual portrait of *Thomas Jefferson* (Monticello, near Charlottesville, Va.), dating from 1816 and authenticated by a statement from the painter's sister pasted on the back of the canvas, with a portrait of *Master Josiah S. Wayne* (Ehrich-Newhouse, Inc., New York), which is as sweet and stylized as the former portrait is straightforward and vigorous. Jacob Eichholtz, influenced by both Sully and Stuart, shifted from the neo-classical poise of his early work, dating shortly after his acquaintance with Sully in 1809, to the affected daintiness and grace of the portrait of *Miss Thompson* (Fig. 95). His chief success was in Philadelphia after 1821, where he utilized Sully's firm, limpid manner, as in the portrait of *Thaddeus Stevens* (Pennsylvania College, Gettysburg), dated 1830. Matthew Harris Jouett, who acquired Stuart's subtle handling of the brush as well as he could in 1817 and who painted many portraits in the South before his death in 1827, changed little in his brief career but heralded the period of art for style's sake in, for example, his portrait of *Augustus F. Hawkins* (Estate of Thomas B. Clarke, New York). An earlier work, the portrait of *John Grimes* (Fig. 101), shows that he too began with realism. Finally James Frothingham, self-taught painter of sincere, but often clumsy, likenesses, came under Stuart's influence in 1810

and graduated from coach painting to fame. At least it must have
seemed like fame to have the great Stuart say, "There is no man in
Boston but myself can paint so good a head." [23] His modest productions
are a strange mixture of simple realism and sophisticated style, not vary-
ing fundamentally from first to last but shifting in general from linear to
smudged modelling, from the sharpness of form in the portrait of *Mrs.
Rachel Forrester* (Fig. 99) to the airy softness of *Mrs. Elizabeth Brooks*
(Worcester Art Museum).

These and other artists, "sprung from the true nobility of America
— the yeomanry of the land," as Dunlap said of Metcalf,[24] made a com-
promise between objective likeness and poetic methods. There were
many to do so — a flood of painters. As Stuart peevishly put it, "By
and by you will not by chance kick your foot against a dog kennel, but
out will start a portrait painter." [25] This was the period of "folk art,"
of simple likenesses by sign painters and amateurs who seem instinc-
tively to have anticipated the vogue for modernistic naïveté and inad-
vertently supplied the exhibitions of American Primitives recently so
popular.[26] Yet many of the self-taught were excellent painters. This
was especially true of Chester Harding, the frontier artist who recorded
his Rover-boy career in a charmingly written "Egotistography." This
chair peddler, who about 1816 sailed down the Allegheny River to Pitts-
burgh on a raft "with one bed and a chest of clothing and some cooking
utensils," became the rage in Boston in 1823, rivalling Stuart, not so
much on account of his technical ability as because of his natural dig-
nity and common sense. In his own words,[27] he accounted for his paint-
ing eighty heads in six months "while Mr. Stuart was allowed to waste
half his time in idleness" by the "circumstances of my being a back-
woodsman, newly caught; then the circumstances of my being self-
taught was trumpeted about much to my advantage." His success in
Boston enabled him to go abroad, where he won further successes, social
as well as artistic. In the words of Tuckerman,[28] he was "a fine manly

specimen of his race . . . unaffected, kindly, simple, frank, and social . . . his personal qualities greatly promoted his artistic success." Even to a modern taste Harding's art seems admirable, if not inspired; and it seems original, even though his technique resembles that of his contemporaries who fell under the influence of Stuart. The portrait of *Elizabeth Tuckerman Salisbury* (Fig. 98) is keenly studied, as well as being the epitome of amiable face painting. Less influenced by Stuart is the portrait of *Dr. James Jackson* (Mrs. James Jackson Putnam, Boston) or that of *John Randolph* (Corcoran Gallery, Washington), both of them earlier in date. A *Self-Portrait* (Boston Museum of Fine Arts) dating from the last years of his life — he died in 1866 — is almost photographic in its plain realism; it records the yeoman who was instinctively a gentleman and a faithful workman at his chosen job.

He was, of course, not unique in possessing these democratic virtues. Asher B. Durand, famous as an engraver and landscapist (Fig. 113), produced portraits in the thirties which share Harding's sincerity and are in addition rather dashingly executed. His portrait of *Luman Reed* (New York Historical Society) and a *Self-Portrait* (Fig. 97) indicate the dramatic ability and rich spirit of this versatile craftsman. Nathaniel Jocelyn, who painted the unobtrusively skillful portrait of *Mrs. Street* (Yale University, New Haven, Conn.), Robert Street, who exhibited in 1840 at Philadelphia more than two hundred historical subjects, landscapes, and portraits, and who was not as skillful as he was sincere, judging by a signed portrait dated 1834,[29] John Rand, E. D. Marchant, and probably many others of ephemeral reputation, turned out sturdy portraits which have dignity, whatever they lack in feeling. Hanging obscurely in homes and halls, their works, like Marchant's portrait of *William Rotch* (Miss Caroline Snelling, Lincoln, Mass.), often surprise one with their brightness and strength.[30]

One artist, however, deserves more extensive notice because of his excellence and because his taste, altered by success, it seems, took a

mid-century turn indicative of a general trend. Born in 1800, a farm-
er's boy with a self-contained, pleasant, reserved character, Francis
Alexander geared his uneventful life to the demand for sober likenesses.
His portrait of *Mrs. Jared Sparks* (Fig. 108), painted in 1830, is charm-
ing and sensitive and has nothing to do with the art of Stuart, who first
encouraged Alexander to settle in Boston. It is designed on a large pat-
tern and modelled delicately. Upon close examination it is clear that
Alexander's draftsmanship was not as good as his sense of design. But
the total effect is more than adequate and the modelling is firm. After
Alexander returned from a grand tour abroad he painted in 1834
Joseph Tuckerman (Harvard University, Cambridge, Mass.) with a pre-
cision of form that is almost neo-classical. Since the artist had only
spent twenty days in Paris, it would be far-fetched to say that he was
following a French influence. Like all good Americans of the time, he
seems rather to have realized his talents merely with increasing objec-
tivity and intensity. When Charles Dickens came to Boston in 1842,
Alexander stampeded the famous visitor into a sitting and pulled off a
social coup; but the portrait (Boston Museum of Fine Arts) contains no
hint of lionizing, nor any suggestion that Dickens was other than an in-
tellectual, modest young man sitting casually for a friend. Thus far
Alexander had shown himself to be a dependable craftsman, like Hard-
ing, with whom he exhibited in 1833, along with Doughty, the land-
scapist, and Alvan Fisher. The group were united by the simplicity and
clarity of their productions. Although Fisher in 1830 had learned to
imitate Stuart's breath-of-life flesh, in 1833 he painted the strikingly
naive profile of *J. G. Spurzheim* (Two versions, Harvard University,
Cambridge, Mass.) which is close to Alexander in spirit.

Nevertheless, what today would certainly be called a delusion of
grandeur afflicted the successful farmer's boy, so that he felt it necessary
to desert American crudities [31] and settle in Italy. There he painted the
portrait of *Hiram Powers* (Ehrich-Newhouse, Inc., New York) which is,

strange to say, artificial, affected, and frivolous in feeling. He had previously painted *Mrs. Fletcher Webster* (Boston Museum of Fine Arts) with delicate sincerity. That the change was from reality to sentiment should not be surprising, in view of the numerous examples of such a change already mentioned; but that it should have resulted from admiration for technical effects as studied abroad, and that it implies such complete interest in manner of painting as to obscure matter and realistic feeling, reveals a condition of affairs deserving special emphasis. The following paragraphs will attempt to trace this interest in subtleties of artistic expression which eventually challenged common sense and became a mere affectation of artistry.

18

THE CULT OF SENSIBILITIES

When Alexander succumbed in Italy to refinements of method he was doing only what had been done by other American painters at home, following the general trend to sentiment which has received the title, mid-Victorian taste. Although it was not only English, but universal, this taste is properly linked with the name of a Queen, since femininity triumphed in the arts. In one way or another, in the gentility of Sully's late work, the softening of style in Ingham's pretty portraits, and the literary sentiment which appeared in genre painting, there seems to have been a reaction from democratic plainness — an escape from reality and objectivity. "Art artists," as a modern politician well characterized the type, appeared on the scene, gradually educating the public to "elegance of fancy" and "correctness of character," much as the Ladies Repository had undertaken, in the hands of generous masculine educators, to improve the lot of the fair sex by publishing "poetical enigmas and rebuses to stretch their tender minds" and by giving the "elegant polish of the female pen" an outlet. The first of these

all-lady publications in America is dated 1792.[32] Mary Wollstonecraft's
Vindication of the Rights of Women was republished in Philadelphia
in 1794. By the time of Dunlap's History, 1834, the miniatures of Ann
Hall are praised for "the delicacy which the female character can in-
fuse into works of beauty beyond the reach of man — except it might be
such a man as Malbone, who delighted in female society, and caught
its purity." [33] Malbone will be considered later among the miniaturists
(Fig. 111E). In the meantime, one can appreciate his point of view
through the work of his friend Washington Allston, who characterized
Malbone as having "the happy talent . . . of elevating the character
without impairing the likeness." [34] This is the threshold of Romantic
painting in the United States.

Allston, "number one" in the catalogue of American painters, as
Sully reported to Dunlap,[35] was a fine gentleman, a student of West, an
admirer of the "poetic invention" in Reynolds' work, and a most liter-
ate observer of the art of Europe. His contemporaries believed im-
plicitly that he was a genius. Morse wrote home [36] proudly that he was
a pupil of Allston, not West; "They will not long ask who Mr. Allston
is; he will very soon astonish the world." Coleridge went so far as to
call him an "artistic and poetic genius unsurpassed by any man of his
age." But Allston's fame scarcely outlived him. Delighting in mood
for its own sake, sensitive to color and loving mystery to the extent of
leaving forms only half developed, he accomplished little. The sad and
lost figure of *A Spanish Girl* (Fig. 110) illustrates his conception of a work
of art. When he advised Morse "to resist the corruption of the French
school" he made an epitaph for himself, since his huge painting of *Bel-
shazzar's Feast* (Boston Museum of Fine Arts) so certainly resisted the
"corruption" of form, drawing, and design that it never materialized
and hung over his later life as an admission of failure in his chosen field,
history painting. His portraits, ranging in subtlety from the intimate
and firm *Self-Portrait* as a young man (Boston Museum of Fine Arts) to

the unsubstantial and superficial portrait of *Benjamin West* (Addison Gallery of American Art, Phillips Academy, Andover, Mass.), are generally indecisive and sentimental in character, even though more objective than his subject pictures. His preoccupation with "the imaginative faculty," so obvious in wild and desolate landscapes, some of them tricked out with biblical or legendary meanings, like *The Deluge* (Metropolitan Museum, New York) and *Elijah Fed by the Ravens* (Boston Museum of Fine Arts), made him the most romantic painter of his time, and left him completely out of touch with reality. "Nature sent him into the world," wrote James Russell Lowell, with unconscious pertinence to Allston's fame as an artist, "to fill the arduous office of gentleman."

Nature sent Thomas Sully into the world for the same purpose, but neglected to endow him with as much social and financial background. Born in England four years after Allston, Sully grew up in South Carolina and Virginia, the son of actor parents. Taken into the home of his brother, Lawrence Sully, an impoverished miniaturist, who soon followed his father and mother in death, Thomas Sully struck out on his own career, still without backing, and handicapped by the support of his brother's family. He had acquired some training under the aged Benbridge; he learned more from a visit to Stuart and from assisting Jarvis. By 1810, when he had returned from studying and copying in England, he was painting in a solid, graceful manner, tossing off the portrait of *Joseph Dougan* (Herbert L. Pratt, Glen Cove, L. I.) with as much ease and assurance as could be expected from an admirer of Thomas Lawrence. The full length of *Dr. Coates* (Pennsylvania Hospital, Philadelphia), painted in 1812, is not as obviously stylized, and is more real. But in his everyday practice, as in the 1821 portrait of *John Finley* (Fig. 104), he created charming surfaces which reflect a flattering image of polite society. He was not yet the romantic painter he was to become, even though a hint of the stage in posing and dramatization of sitters often suggests a liking for foot-light effects which was

probably born in him. His association with actors whom he portrayed in character, as he portrayed *George Frederick Cooke* in the part of Richard III (Pennsylvania Academy, Philadelphia), must have accustomed him to painting in terms of the theatre, exaggerating the height and grace of figures, powdering and rouging faces, arranging costumes and freeing gestures. Considering his portrait of *Thomas Handasyd Perkins* (Fig. 106), one doubts that a hard-headed New England merchant was ever again painted with such lightness of figure, delicacy of feature, transparency of complexion, condescension of pose, and mannered grace. The portrait is a mannikin fitted with a likeness. Sully's work of 1831 thus dealt in technical effects and a formula for style which made all his sitters actors and actresses. This, in the face of the realism of itinerant country painters, amounted to making them look genteel. As Tuckerman put it,[37] "He is keenly alive to the more refined phases of life and nature. His pencil follows with instinctive truth the principles of genuine taste. He always seizes upon the redeeming element, and avails himself of the most felicitious combinations." Five years before his death in 1872, Sully thus found his own particular taste grown into a popular and generalized one, which found a "redeeming element" in sentiment, in the sweet expression of *The Boy in the Torn Hat* (Boston Museum of Fine Arts) and in the fragile, artificial beauty of *Miss Pearce* (Worcester Art Museum).

When in 1826 Sully painted a Reynolds-like group of *Three Children* (Ehrich-Newhouse, Inc., New York) he seems to have been recapitulating effects which West had already used in a *Mother and Child* (Ehrich-Newhouse, Inc., New York) and which included a glimpse into the background, as in the work of Dutch genre painters. He was, in short, studying the old masters. But more than that, he was unconsciously establishing a sentimental mode which, through its popularity, enabled struggling artists of the thirties and forties to make sales when the vogue for vigorous realism faded. Joseph Wood, a miniaturist and painter of

small oils, had picked up this theme in 1828, as in the *Boy with a Dog* (Ehrich-Newhouse, Inc., New York), and perfected his feminine technique through Malbone. Daniel Dickinson, also influenced by Malbone, and by his own brother, the miniaturist Anson Dickinson, did fancy paintings illustrative of female beauty and grace, a naive example being the *Head of a Girl* (Ehrich-Newhouse, Inc., New York), which is done with an almost total absence of drawing. Even before this, in 1816, Charles C. Ingham had arrived in New York from Ireland with an original technique, consisting of superimposed glazings, which made him "principally the ladies' portrait painter," as Dunlap noted.[38] His *Flower Girl* (Metropolitan Museum, New York), over-wrought and precious on a large scale, gives less explanation for his success than do the clever portraits of *A New York Belle* (Berkshire Museum, Pittsfield, Mass.) and *Gulian C. Verplanck* (New York Historical Society), which are a combination of glassy flesh painting, liquid costuming, and careful posing. Even Henry Inman, pupil of Jarvis, who had a skillful, realistic manner of painting flesh, as in the Stuart-like portrait of *William Inman* (Chicago Art Institute) or the bland portrait of *Henry Pratt* (Pennsylvania Academy, Philadelphia), learned to add grace and to soften characterizations, as in the dainty poses of *Georgiana Wright and Her Mother* (Fig. 107) and the effeminate portrait of *Martin van Buren* (Metropolitan Museum, New York). He had protested that "the time will come when the rage for portraits in America will give way to a purer taste"; [39] and shortly before his death in 1846 he achieved his ambition to paint in purer taste. The well known genre painting called *Mumble the Peg* (Pennsylvania Academy, Philadelphia) seems to have charmed its public at once in 1842, chiefly through the novelty and simplicity of its subject. Nostalgic for the purity of childhood days, he painted *The Young Fisherman* (Fig. 103) on a tiny scale with meticulous sentiment. Certainly his type of highly finished art deserved to be popular at a time that finish appeared to be an aesthetic virtue. But *Mumble the Peg* is

more than merely well finished; it is the perfection of the trivial in subject and setting, the epitome of a romantic interest in minute generalities.

It is astonishing that many, who at a later date experienced such loosening of taste, began with a healthy respect for character and realism. That they could later exaggerate effects, apparently without an aesthetic twinge, shows how powerful was the movement that caught them. John Neagle's work is a striking example. Trained under the oldest old-master, experience, he began painting in 1818 in Philadelphia, Kentucky, and New Orleans, a journeyman artist as sturdy and direct as Jarvis. The portrait of a *Mr. Reilly* (Fig. 102) shows how boldly realistic he was in early life, and a landscape *View on the Schuylkill* (Julius Weitzner, New York), painted in 1823, how lyrical in spirit and original. But in 1825 came the almost inevitable influence of Stuart and a friendship with Sully, whose daughter he had married. The portrait which he painted of *Gilbert Stuart* (Boston Museum of Fine Arts) does not reveal the damage done by exposure to English methods; the cranky wit of the sitter is well suggested in a simple character study. Nor does the jolly portrait of *Mrs. Minor* (Brooklyn Museum, New York), dated the same year, 1825, lack simple objectivity. But in the following year Neagle received an extraordinary commission which he fulfilled in an extraordinary way, by painting *Pat Lyon at the Forge* (Boston Athenaeum, replica in the Pennsylvania Academy, Philadelphia) in an effective but polished manner, which only in a superficial sense followed the orders of the energetic and wealthy Irishman who asked to be painted "as a blacksmith — I dont wish to be represented as what I am not — a gentleman." [40] Here the anecdotal element, so popular in the next few decades, is unobtrusively handled; the smith is genteel and neat in his working clothes, the busy apprentice has the head of a cherub, and the rustic details of the shop are handled with a stylish ease comparable to Sully's. In 1829 Neagle painted *William Strickland* (Ehrich-Newhouse,

Inc., New York) with a Lawrence-like affectation of pose and wind-blown costume. And in 1830 he painted the perfunctory and flat portrait of *Gregory Biddell* (Detroit Institute of Arts) which shows how much of the probity of early likenesses had been lost in the acquisition of a manner. He admitted that he never improved upon his youthful ability as regards taking a likeness.[41] Presumably he was unaware that he sometimes deteriorated in that respect. Even when he did not actually neglect the plain facts about a sitter, he surrounded him with such complexity of light, and movement in the design, that the likeness became an ornate figure piece. Occasionally style and vitality triumph, as in the portrait of *Dr. William P. Dewees* (Fig. 105), where one scarcely misses the individuality of the sitter, so impressive is the artist's flair for handsome painting. Here, as in his greatest success, the much praised portrait of *Pat Lyon*, Neagle added fuel to romantic fires and prepared for a conflagration of interest in pictures which dictate an artistic message, rather than record observations. In Neagle's best work, the effect is sophisticated. But merely a slight shift in emphasis and subject matter could make the message as sentimental as it is in the popular art of the middle of the century. Returning from the grand tour with Italian grace and German literalness, the generation after Neagle painted moods rather than faces, and anecdotes instead of convictions. Genre rose to such importance that the Wadsworth Athenaeum had to pay $4250 in 1855 for Vanderlyn's fifty-years-old story picture of the *Death of Jane McCrea* (Fig. 109). However, the flowering of sentiment must wait for another chapter. There are other aspects of romanticism in the early part of the century which complete the panorama of the new age of artistic feeling.

19

MINIATURE PAINTING — A DIGRESSION

Inman's *Young Fisherman* (Fig. 103), measuring about 9 × 13 inches, appeared at a time when photography, taken out of the laboratory and transformed into a hobby, had become a business. Although the camera had no visible effect on Inman's work, nor on the painters who have been considered thus far, it may have subtly discouraged some portrait painters. It certainly affected one branch of art, as Tuckerman noted in 1867,[42] and that was miniature painting. Tuckerman believed that the time would come, as a result of photography, when only the best class of portrait painters could find encouragement, many of the others devoting themselves to historical and genre art. Morse, as President of the National Academy, had implied as much in 1839, according to the newspaper reports of his speech,[43] although he personally thought that Daguerre's process would clarify problems of perspective and lighting for the artist. From a modern point of view it is evident that the camera has done little to deter the best, or the worst, portraitists; and, in spite of the prevalence today of snapshots, studied studio photographs, tricks of soft focus, and mirror-like, automatic photographs of oneself, there is still a demand for "handmade" likenesses and a small but consistent vogue for that branch of art, miniature painting, which was most seriously affected by the invention of the camera. This then would be an appropriate moment to consider miniature painters as a group and to review their activity as it coincides with the major developments in painting previously considered.

A miniature is essentially a memento. In the XVIIIth century it was also a jewel, although the earliest small portraits — one hesitates to use the technical term, miniature — done in this country seem to be pen and ink sketches. John Watson of Perth Amboy, already mentioned in section 5 as possibly having an important effect on the taste of New

York and Philadelphia patrons of art, did such sketches in the first half of the century, his sketch of *Governor Kieth* (Historical Society of Pennsylvania, Philadelphia) being typical.[44] Jeremiah Theus, also mentioned previously as catering to the aristocratic tastes of southern planters, is said by Harry B. Wehle [45] to have painted a miniature of *Mrs. Motte*, which must be quite early, no matter who painted it. This is a typical example of miniature work, being painted in water color on a thin bit of ivory, and intended to be worn on a bracelet. It was perhaps more common to wear miniatures as pendants or as brooches. But that is insignificant. The technique, as can be guessed, is highly specialized, consisting of minute touches of the smallest of brushes, ending in a single hair, moistened with thin but clear color. Some miniaturists employed a stippling technique, touching the tiny drops of color to the ivory one by one. Others preferred hatching strokes which under a magnifying glass can be seen to make a latticework of fine lines. But in all except the late years of its popularity, the manipulation of color in miniatures is so delicate as to be almost invisible without the aid of a magnifying glass. The skill of the artist is concentrated on producing an easy, well proportioned likeness, richly colored without being heavy in texture or uneven — which is no small skill, under the cramped conditions of representing a head and shoulders within a space sometimes as small as one inch in width.

This skill many had who were also skilled in life-size portraiture in oil. Copley had it and produced an indefinite number of very small portraits, so fine and luminous as to appear enamelled. The twin portraits of *Mr. and Mrs. Samuel Cary* (Worcester Art Museum) and the *Self-Portrait* (Henry Copley Greene, Boston) reveal his talent for realism, as do his large oil portraits; and at the same time these miniatures have that delicacy of modelling which makes his pastels so remarkable. Copley receipted a bill for a miniature when he was twenty years old, at a time when his life-size oil portraits were emerging from the first impact

of Blackburn's style. He therefore may be considered to have begun these portraits-in-little before he had worked free from the influence of Badger, as in the oil portraits of the *Gore Children*. And it is puzzling that he did so, since the only miniatures attributed to him with certainty are sophisticated in technique and conception. Some of those miniatures reproduced by Frank W. Bayley,[46] without critical information, are coarse in technique, and may be questioned until more accurate study has been made, or until documentary evidence of the earliest work is forthcoming.

Before Copley's departure for Italy in 1774 his half-brother, Henry Pelham, had made his bow as a miniaturist. The Copley-Pelham letters contain the information that Henry was fully employed in 1775, though not paid in those anxious days.[47] His miniatures are quite different from Copley's in their free, comparatively long brushwork and fullness of modelling. The color is simple, as in Copley's work, but handled in such a "modern" way that the effect is almost impressionistic. The miniature of *Edward Holyoke* (Fig. 111B), documented by a bill dated 1769, and copied from the so-called Copley portrait of the same individual (Harvard University, Cambridge, Mass.), is brilliant in blue and pink tones. The miniature of *William Stevens* (Boston Musum of Fine Arts) is broad, robust, and jolly. Young Pelham's vigor and sureness of hand were such that he must be ranked as one of the chief artists of colonial times, even though few examples of his work are known. That he was a loyalist and spent his life after the second year of the war in Halifax, England, and Ireland, where he was drowned in 1806, that he seems to have assisted Copley with intense affection, that his temperament was apparently not of the conquering sort, does not alter the fact that his miniatures are realistic, independent, and great portraits on a small scale.

It is odd that Henry Pelham's generous technique should appear in between the minute and pearly techniques of Copley and Ramage. John Ramage was in essence a European artist. John Hill Morgan has

given in his study of the painter,[48] aided by Dunlap's knowledge of Ramage's personal appearance,[49] a vivid picture of a skillful dandy who was a delicate goldsmith as well as a dainty miniaturist. Although he was an Irishman and for a time a soldier in King George's army, his art seems to have a stylish vitality which is French. Active in Boston just before the Revolution, he painted there and went to Halifax, abandoned his military career in New York, where he became the fashion, and spent his last eight years in Montreal. The portraits of *John Pintard* (New York Historical Society), dated 1787, and *Margaret Rose* (Fig. 111C), typical of his neatness and punctilious taste, reveal his range in ability, the man's portrait being rather pretty, while the old lady's likeness is keenly observed.

Ramage's activity and success may have encouraged others to come to this country; if not, it is a misleading coincidence that Archibald and Andrew Robertson, Scotchmen, Walter Robertson, Irishman, Robert Field and William Birch, Englishmen, and Henri Elouis, Frenchman, all [50] brought their considerable talents to the Federal society which, as has been shown, patronized Ralph Earl and other country artists who were right up to the minute as regards the art of the new French Republic. In their special field these miniaturists had to compete with native artists of skill, especially the Peales, Savage, Bridport, Trott, and Ames. Earlier than these, however, was Joseph Dunkerley, whose signed miniature of *Mary Burroughs* (Alan Burroughs, Belmont, Mass.) has enabled Harry B. Wehle to re-attribute several miniatures formerly attributed to Copley. Or was Dunkerley not a native artist? All that is known about him is that he advertised in Boston in 1784–85 as a miniature painter and prospective teacher of drawing. The portrait of *Mary Burroughs*, dated 1787, is graceful and delicious; Dunkerley's technique seems to fall naturally between Copley and Ramage.

More substantial are the small portraits by Charles Wilson Peale and his brother James Peale, who certainly led the field during Federal

times in Philadelphia and the South. Perhaps Matthew Pratt was as good a miniaturist as he was a sign painter. Mr. Wehle attributes to him [51] the good study of *Mrs. Thomas Hopkinson* (Mrs. Francis T. Redwood, Baltimore, Md.). But the Peales were more skillful and better able to interpret character. The miniatures of Charles Wilson Peale, for example that of *Major William Jackson* (Independence Hall, Philadelphia), come close to Copley's on occasion; other examples are bolder in handling and plainly insistent on a likeness, as are the *George Washington* (Metropolitan Museum, New York) and *Mrs. Michael Taney* (R. T. H. Halsey, New York). James Peale's success was due apparently to his presenting sitters with a more delicate likeness than did his energetic brother; but his style cannot be considered dandified. Although his *Self-Portrait* (Herbert L. Pratt, Glen Cove, L. I.), painted in 1787, is, like Dunkerley's work of the same year, the production of a gentleman artist, his later miniatures, *Mr. and Mrs. Josiah Pinckney* (Metropolitan Museum, New York) for example, are more democratic in their objective and realistic drawing. Robert Fulton (see section 16) followed the style of the Peales in his early miniatures and produced strong likenesses in jewel-like color, as in the portrait of *Mrs. Kittera* (Fig. 111A). And Ezra Ames naturally conducted his trade as a miniaturist with the same simple thoroughness that he put into his trade in oil portraits, achieving good character in the small portrait of *Jesse Hawley* (New York Historical Society) without the aid of technical display.

But the chief miniaturists of the time were instinctively aristocrats. Trumbull's artistic reputation rests now chiefly on his small portraits and miniatures, like that of *Thomas Jefferson* (Fig. 111D), in spite of his ambition to be a painter of histories and the leader in official decorations (see section 15). His closest rival today, in the opinion of collectors of miniatures, is Edward Greene Malbone, who was always the gentleman and much admired for the "amenity of his manners." [52] Malbone did not go to England until 1801, and until after he had practiced his

delicate art for seven years. It is a comment on the character of his work that, although he considered Lawrence the best portrait painter in England,[53] his style did not alter as a result of his trip. In his hands all sitters became persons of taste, sensitive, poetic, and distinguished. His chief article of trade was dignified charm, and he could give people moods without being sentimental. Even his most ambitious miniature, *The Hours* (Providence Athenaeum), representing the past, the present, and the coming, in the form of dainty ladies wearing neo-classical drapery, is not mawkish, because Malbone was a crafty draftsman and an artist of hard-working integrity. Compared to him Charles Fraser, the best miniaturist of the South, seems superficial. Malbone produced a large number of clear, sensitive miniatures during his twelve years of activity, typical ones being those of *Richard D. Harris* (Herbert L. Pratt, Glen Cove, L. I.) and *Mrs. James Lowndes* (Fig. 111E). Fraser, over a long period in which the law and painting occupied him with almost constant success, produced a large number of sturdy but not lively transcriptions of people, none of which are as convincing as one of Malbone's fancy subjects, like the *Little Scotch Girl* (R. T. H. Halsey, New York). Fraser's early portrait of *William Manigault Heyward* (Herbert L. Pratt, Glen Cove, L. I.) shows how strongly he was influenced by Malbone. And the portrait of *Elizabeth Sarah Faber* (Henry Walters Collection, Baltimore), painted in 1846, shows how he developed with the taste of the times toward sentiment. But Fraser was not a prettifier of faces. At the time when the camera was coming into use he held a Retrospective Exhibition in Charleston of three hundred and thirteen miniatures, which must have shown that a sincere artist need not worry over the competition of mechanical likenesses.

The remaining years of popularity for miniature painters were few and decadent. Aside from the painters in oil who practiced in miniature as a side line, like Jarvis, Inman, Sully, and lesser known painters of the caliber of Marchant, whose *Chancellor Kent* (Mrs. Paine J.

McCarthy, lent to the Pennsylvania Museum, Philadelphia) is quite subtle, the list of XIXth century miniaturists contains the names of specialists who have little to do with aesthetics and art history. Thomas S. Cummings, pupil of Inman, may be taken as typical. Dunlap [54] considered him "the best instructed miniature painter then in the United States (1827)"; yet he painted smugly and with ostentatious skill. The large miniature of *The Painter's Wife* (Miss Lydia M. Cummings, New York)[55] seems to combine the affectations of an age of sentiment with those of a professor of drawing in the newly formed National Academy. Indeed the feminization of taste in the second quarter of the century seems fully illustrated by his miniatures and those of Nathaniel Rogers, pupil of Joseph Wood. Henry Williams, who died in 1830, had prophesied this development, as in the signed portrait of *Henry Burroughs* (Alan Burroughs, Belmont, Mass.). And Sarah Goodridge, who painted among others a miniature of *Gilbert Stuart* (Metropolitan Museum, New York), added an actual feminine touch. Yet these miniatures are not as fantastically sweet as the "elegant and well arranged bouquet" [56] which is Ann Hall's *Self-Portrait with Sister and Nephew* (Mrs. Lewis G. Morris, New York). One of the last successful practitioners of a sentimental period was Richard M. Staigg, whose miniatures of *Mr. and Mrs. John I. Linzee* (John T. Linzee, New York) are less pretty than usual, and consequently more dignified. The only development left for the miniaturist was that suggested by the hard lighting of daguerreotypes; and John A. MacDougall, a photographer as well as a miniature painter, active in the forties, strangely combined the two in a very small portrait of *Henry Clay* (Metropolitan Museum, New York). This development had, of course, no future. The art of the miniaturist as practiced today goes back to the feminine style of the Ladies Repositories of a hundred years ago, when the finer feelings were truly appreciated and when grace or daintiness of manner was more important than depth of character.

20

THE CULT OF NATURE

For the sake of clarity in a period of great and divergent activity, one may treat landscape painters as a group, as the miniaturists have been treated, even though the process cuts across stylistic influences, bringing Thomas Cole and George Inness together. It is, after all, clarifying to show the development from one kind of painting to another, from painting all the leaves on every tree to painting the sunset glow which almost hides the trees.

The great period of Dutch landscape preceded by only a few generations the first landscapes known to have been produced in the American colonies, and presumably the Dutch masters left their mark here as on the continent. The only "pure" landscapes surviving from the XVIIIth century in America seem to be Dutch in inspiration. Yet the earliest scenes, found in the decorative backgrounds of portraits by Badger, Feke, Smibert, and Blackburn, are glimpses of trees and sky in the Italian mode, popularized in England by Richard Wilson. Evidently the portrait painters used engravings for models. Even realistic details, like ships, were not always drawn from nature, as we know from Smibert's request in 1744 for a set of prints of ships; he wrote, "These ships I want sometimes for to be in a distant view in portraits of merchants etc. who chuse such." [57] It is rare that one finds a background, like the stiff pine trees in Pieter Vanderlyn's portrait of *Johannes Van Vechten*, painted in 1719, which seems really observed. The lost "landskips" of Smibert and Jeremiah Theus [58] may have been Italian, Dutch, or French in mode. The only clues to the taste of the time are fragmentary. They include chiefly a dark view of a bay with ships and trees in the foreground, which is mounted over the fireplace in one of the rooms at Mt. Vernon, Va., and which is unquestionably influenced by the designs of Claude Lorraine, although clumsily executed. [59] Dating from

about the same time probably, and showing the same dependence on foreign designs, is the view of a shore with travellers and baggage (see section 8) said to be signed by Feke. The *Landscape with Figures* (Rock Hall, Lawrence, L. I.), attributed to Feke and known to me only by a very small reproduction, appears to be Dutch in type. The background in the portrait of *Samuel Waldo* (Bowdoin College, Brunswick, Me.) follows a Dutch formula in representing the flatness of the land and water as opposed to the airy height of the sky. But in other portraits by Feke, in those of *Oxenbridge Thacher* and *James Bowdoin*, for example, the views suggest Wilson and the English Italianates, as in general would be expected from artists trained or influenced in England.

The same type, popularized by engravings, no doubt, seems to have furnished anonymous wall painters with their crude designs. Four panels (Maine Historical Society, Portland, and Mrs. Frederick Gay, Brookline, Mass.) painted early in the XVIIIth century for the Clark House in Boston, which was destroyed in 1833, are indeed said to be by a London painter who Edward B. Allen [60] suggests was R. Robinson, a decorator and engraver. The Warner House, Portsmouth, N. H., built in 1716 though probably not decorated until later, contains strange, full length figures of *Indian Chiefs*, an illustration of some story involving a maid spinning, a dog and an eagle carrying off a fowl, a stiffly drawn scene of *Abraham's Sacrifice*, and an equestrian portrait of *Sir William Pepperell*,[61] all done in amateurish fashion, Anglo-Italian in type. It was still an Italianate type which the artist named Beck [62] followed when he painted sometime between 1786 and 1790 a *View of Baltimore* (Maryland Historical Society, Baltimore), and which the Frenchman M. F. Corné adapted to the needs of Salem people about 1800. Corné painted such literal views as *Canton Factories* (Peabody Museum, Salem) as if he were painting a Neapolitan stage set. Washington Allston, of course, was a student of Italian effects and evidently an admirer of romantic landscapes approximating those of Salvatore

Rosa, as in *Elijah Fed by Ravens* (Boston Museum). And other artists, whether trained in Italy or not, naturally thought of nature in a romantic Italian mood, as did Neagle when he painted along the Schuylkill.

But along with this academic kind of landscape went another type, as matter-of-fact as prints of city views and topographical scenes. An anonymous *View of New York* (New York Historical Society) dating from about 1753, Christian Remick's *View of Boston Harbor* (New England Historic Genealogical Society, Boston), and George Ropes' 1806 *View of Salem Common* (Essex Institute, Salem, Mass.) illustrate the matter-of-fact type that is meant. The same type, transformed by the skillful Robert Salmon into stirring views of Boston Harbor and sailing vessels, or still later adapted by George Henry Durrie for Currier and Ives lithographs of farms in winter (Paintings in New York Public Library and Yale University, New Haven, Conn.), persisted up to Civil War times. Perhaps something of the same point of view helped form Ralph Earl's large and lovely composition of a *Landscape Near Sharon, Connecticut* (Litchfield Historical Society, Litchfield, Conn.), which is surely earlier than his *Looking East from Leicester Hills* (Fig. 68), dated 1800, and which may therefore be considered one of the earliest realistic American landscapes extant, painted as landscape for its own sake. That it is not unique is evident from comparison with Trumbull's *View of Niagara Falls* (Fig. 112) and Francis Guy's *View of Baltimore in 1800* (Maryland Historical Society, Baltimore), which is comparable in design and intention. Guy, an English dyer and calenderer who came to this country in 1795, exhibited landscapes at the Pennsylvania Academy of Fine Arts as late as 1811 and painted his chief work, the *Brooklyn Snow Scene* (Fig. 114) in 1816–17. Like Earl he had no grand style for model and painted what he saw without benefit of preconceptions about design and method. The stirring result is that his work resembles Earl's in naturalness, without, however, rivalling it in flowing rhythm. Com-

pared to Trumbull's, Earl's records of nature are full of feeling. The *Landscape Near Sharon* unfolds evenly, majestically, and peacefully. The view of *Leicester Hills*, seen from a height, became a literal but lively panorama. Ralph Earl unquestionably has importance as a landscapist since he often put views of buildings and lanes in the backgrounds of his portraits, and since these studies of definite localities reveal, in spite of stiffness, a genuine feeling for the lay of the land and for distant forms. Earl had nothing in common with either the Dutch and their lofty, dramatic skies or the English and their well kept parks; instead he looked at the homes of the people he painted and incorporated their surroundings as part of their portraits with appreciative faithfulness. In this sense he can be linked with the painters of the Hudson River School who in the second quarter of the XIXth century turned whole-heartedly to Nature, as the poet, William Cullen Bryant, had begun to do about 1815.

Considering the lateness of this landscape school, its origins are strangely obscure. Ralph Earl revealed the trend, as perhaps did Trumbull and Vanderlyn, both of whom painted *Niagara Falls*. Vanderlyn's panoramas, exhibited in New York and New Orleans just in time to anticipate the appearance of native landscapists in the twenties, may have had some effect in turning artists' attentions to Nature. A contemporary has said [63] that "panoramic exhibitions possess so much of the magic deceptions of the art as irresistibly to captivate all classes of spectators . . . for no study or cultivated taste is required fully to appreciate the merits of such representations." Perhaps this is explanation enough, that artists found accurate representations of scenes to be popular. Certainly the earliest landscapes by Thomas Doughty are topographically rather than aesthetically composed. Doughty, a self-taught artist, did not begin to paint seriously until his twenty-seventh or twenty-eighth year, as he told Dunlap,[64] which dates his tight, painstaking impression of an *Autumn Scene on the Hudson* (Corcoran Gallery,

Washington) or of a *River Glimpse* (Metropolitan Museum, New York) in 1820–21 at the earliest.[65]

At this time Thomas Cole, the best known of the early landscapists, was working in his father's paper-hanging business in Ohio; he had not yet met a travelling portrait painter, named Stein, who lent him an English book on painting. When he did read the book Cole became enthused; he wrote Dunlap [66] that "the names of Stuart and Sully came to my ears like the titles of great conquerors." Naturally these artists were mere names to him. As self-taught as Doughty and the majority of his contemporaries, Cole wandered through Ohio and Pennsylvania, meeting the competition of itinerant portraitists who seem to have covered the countryside. Life was hard, but the artist was persistent; lacking sitters, he painted trees and rocks. In 1823 he saw in Philadelphia landscapes not only by Doughty but by Thomas Birch, who had sketched after 1805 along the Schuylkill River with Jarvis and Sully [67] before becoming a painter of such historical marines as the familiar *Battle of Lake Erie* (Pennsylvania Academy, Philadelphia). Stunned by the skill shown in these sketches, Cole was inspired to a deeper, more accurate study of nature, "beautiful nature . . . the standard by which I form my judgment." [68] When Trumbull, Dunlap, and Asher B. Durand visited Cole's studio in New York shortly afterward, Trumbull confessed, "This youth has done what I have all my life attempted in vain," meaning perhaps that Cole had achieved reality; and Dunlap published an account of the painter.

What Cole had actually achieved was evidently the recording of a scene from a personal point of view, akin to that of the poets of Nature. He had arrived at a Wordsworthian interpretation through long study of single objects, a tree, a leafless bough; "every ramification and twig was studied, and as the season advanced he studied the foliage, clothed his naked trees," wrote the sympathetic Dunlap. From this intimacy with his subject matter, he developed a cult of Nature. In his own words,

landscape has "a great variety of objects, textures, and phenomena to imitate. It has expression also; not of passion, to be sure, but of senti-ment — whether it shall be tranquil or spirit-stirring. Its seasons — sunrise, sunset, the storm, the calm — various kinds of trees, herbage, waters, mountains, skies. And whatever scene is chosen, one spirit per-vades the whole — light and darkness tremble in the atmosphere and each change transmutes." So speaks a romantic painter who loved the intricate wildness of *In the Catskills* (Metropolitan Museum, New York) and the majestic, if somewhat taxing, forms of *Oxbow* (Fig. 116).

In 1834 Cole was engaged on a series; "it is to be the History of a Scene, as well as an Epitome of Man. There will be five pictures; the same location will be preserved in each. The first will be the Savage state; the second, the Simple, when cultivation has commenced; the third the state of Refinement and highest civilization; the fourth, the Viscious or state of destruction; the fifth, the state of Desolation, when the works of art are again dissolving into elemental nature." This is to paint with a moral purpose and to subordinate actuality to an intellec-tual ideal. It is significant that Cole made this change after he had been to England in 1831 and had noted the "gaud and ostentation" of the English School, the "mania for what they call generalizing; which is nothing more nor less than the idle art of making a little study go a great way, and their pictures are generally things full of sound and fury, sig-nifying nothing." The fact that Cole's *Desolation* (New York Historical Society) is a gaudy generalization, painted somewhat in Turner's style, may be linked with Cole's statement that "Turner is the prince of evil spirits. With imagination and a deep knowledge of the machinery of his art, he has produced some surprising specimens of effect . . . gor-geous, but altogether false. . . . Rocks should not look like sugar candy, nor the ground like jelly." It sounds almost like professional jealousy.

Thus the goddess Nature, as J. J. Rousseau admired her, substantial, independent of man, and soulful, became the slave of sentiment. Jasper

F. Cropsey a generation later took a "moral interest" in landscape, much to Tuckerman's admiration,[69] and painted historical and allegorical meanings into scenery, following Cole's lead, although his *Landscape* (Metropolitan Museum, New York), with the light coming toward the spectator, has no obvious message other than one of quiet joy and full peace in the face of Providence. It was only a short step to the lyric interpretation of landscape which has been the mode from Inness on down to the present day.

However, Cole's early work, minutely studied, was also developed into a cult of objective Nature. Asher B. Durand gave up portraiture about 1839 to devote himself, "while painting faithfully what he saw, not to paint all that he saw," as his son explained,[70] and treated landscape "as a sort of dramatic scene in which a particular tree or aspect of nature may be called the principal figure." *In the Woods* (Metropolitan Museum, New York), *Woodland Interior* (Fig. 113), and *Kosciusko's Monument* (Ehrich-Newhouse, Inc., New York) show how he anticipated in detailed study of bark on the trees, as well as of distant hills, the effects achieved by the grandiose landscapists, at least one of whom was also trained as an engraver in a minute style.

It was John F. Kensett, born in 1818, who popularized the idea of greatness in art and large-sized canvases being synonymous. As an unnamed art critic put it in 1853,[71] "The future spirit of our art must be inherently vast like our western plains, majestic like our forests, generous like our rivers." It may seem strange that a huge landscape should demand minute treatment; but it is evident that the broader the view, the sharper the technique must be in order to retain the accuracy which Durand had popularized. Tuckerman wrote feelingly [72] that the traveller recognizes localities in Kensett's pictures at a glance; he praised him for his "calm sweetness, patience in detail and harmonious tone." Patient indeed seems the *Autumn Afternoon on Lake George* (Corcoran Gallery, Washington) when one examines it closely. But one ordinarily

does not examine the details of a lovely design of subtle colors, which tells clearly of its author's love for far spaces. More meticulous perhaps is the vista called *Landscape in the Highlands of the Hudson* (Metropolitan Museum, New York). But Kensett's late work, broad and placid like the *River Scene* of 1870 (Fig. 115), is far from being as exhaustingly minute in detail, or as colossal in scope, as the work of Albert Bierstadt. The latter's *Yosemite Valley* (New York Public Library) and his *Rocky Mountains* (Metropolitan Museum, New York), painted in 1863, are typical of the new manner prepared for by Cole and Durand, no doubt, but made possible by the excessively careful training which Lessing and Achenbach gave to art students in Düsseldorf. Bierstadt was born in Düsseldorf and returned there for his technique in 1853, after twenty-one years in America. His trip to the Rocky Mountains for huge subjects worthy of his unbelievable ability anticipated the trip made in 1866 by Gifford, Whittredge, and Kensett. If *The Last of the Buffalo* (Corcoran Gallery, Washington) is one of his truest records of vast spaces, *Merced River* (Fig. 118) is one of the most poetic.

Sanford R. Gifford, who returned in 1868 to Europe, was not important in this connection, although he had been a disciple of Thomas Cole. More intense, more able, and much more grandiose was Frederick Church, an actual pupil of Cole, who began painting in his master's allegorical vein and ended by searching the world for stupendous, melodramatic scenes which succeeded in surfeiting the romantic taste which demanded new worlds of naturalistic phenomena and celestial disturbance. The invaluable Tuckerman,[73] while praising the painter, dropped a telltale characterization when he referred to Church's "descriptive physical geography." In another passage he summed up contemporary opinion by saying, "Time was when a landscape was painted by a kind of mathematical formula . . . but here is a painter who has never been to Europe. . . . Unhampered by pedantic didaction, he produced landscapes, or rather pictures, of special objects of the greatest beauty and

interest — like Niagara, Icebergs, and a Volcano — so true, impressive, and natural, as to charm with love and wonder veteran adherents of routine, and win the ardent praise of the most scientific and artistic lovers of nature." How coldly scientific Church could be is evident in *Niagara Falls* (Corcoran Gallery, Washington) and how romantically "artistic" in *Cayambe* (New York Public Library).

Although Thomas Moran, William Bradford, and William Keith carried on this tradition into the XXth century, it is obvious that the pseudo-scientific enterprise of Church was soon followed by a reaction in favor of intimate, lowly, and even drab bits of landscape. Worthington Whittredge, born in 1820 and trained for three years in the exacting methods of Düsseldorf, became in later life an intimate painter. Tuckerman described him as having a "chastened power" which appeals "quietly but with persuasive meaning to the mind of every one who looks on nature with even an inkling of Wordsworth's spirit." At a time when Kensett and Church were mapping many square miles on a single canvas, Whittredge turned from the great plains, from the *Platte River* (Century Association, New York), for instance, to an almost lyric interest in woods and brooks. He evidently loved the *Trout Brook in the Catskills* (Corcoran Gallery, Washington) and was delightfully at ease, painting the *Camp Meeting* (Fig. 117) with its dignified effect of dim light under the trees.

But the career of George Inness, covering the period of transition, illustrates the trend of landscape style in the second half of the century more completely. Beginning with *Juanita River*,[74] precisely painted in 1856 under the influence of Durand, one may follow Inness through a grandiose period, admirably illustrated by the broad view of the lovely *Delaware Water Gap* (Fig. 120), dating from 1861, to a final preoccupation with the mysterious, poetic, and emotionally pictured *Home of the Heron* (Fig. 119), dated 1873, which is derived from the romantic conception of French landscapists, particularly Théodore Rousseau. Inness

once said, discussing Corot's landscapes, that greatness lay in the realm of emotion and idea, not in the realm of fact.[75] And Elliott Daingerfield [76] quotes him as saying, "Art is the endeavor on the part of the mind to express through the senses ideas of the great principles of unity." He was thus thoroughly in sympathy with a modern point of view. His views were, in fact, so radical for his time that Tuckerman [77] in 1867 complained of the French style; his manner "overlaps the modesty of nature, and license takes the place of freedom." Even J. J. Jarves [78] ended his sensitive review by noting "startling inequalities and wantonness of brush, making Inness the Byron of our landscapists."

Thus Inness solved Thomas Cole's problem of painting landscapes with something deeper than camera-like fidelity, and opened the way for a group of French-inspired landscapists. The logical outcome of Inness' late manner can be seen in the sad little views painted by J. Francis Murphy, who was a pupil of Wyant, and thus of Inness at secondhand. The effect of romantic French landscapes on American taste was tremendous during these years; it was so great, in fact, that in 1921 at the time of Murphy's death it seemed sacrilegious to point out the sentimental limitations of his art. The tradition of the grandiose had been completely outgrown by the tradition of the intimate. And it seemed unkind to ask whether the late followers of Inness had anything to say in their intimate moments. One who did, although he was indeed limited in mood, was Ralph Blakelock. His Indian Encampments, a favorite theme, little different from the *Pipe Dance* (Metropolitan Museum, New York) and the *Brook by Moonlight* (Toledo Museum), are faintly shadowed by tragedy and noble melancholy. His *Moonlight* (Fig. 122) of a cold, green distance and well defined, lacy trees reveals Blakelock as an admirable craftsman, standing firmly on the slippery ground of visionary art. It is well for Blakelock's reputation to remember this particular painting when looking at the usual type of Blakelockian moonlight, which, if genuine, probably dates from his last insane years.

Alexander Wyant's development paralleled to some degree that of Inness. His *Mohawk Valley* (Metropolitan Museum, New York), dated 1866, is in the detailed, realistic spirit of Inness' *Peace and Plenty* (Metropolitan Museum, New York), dated the year before. And his study of the light on *An Old Clearing* (Metropolitan Museum, New York) shows how much he was influenced in 1881 by the "realm of emotion and idea," the mood of an afternoon in the woods.

Homer D. Martin's work changed less in spirit than did Inness', although the mechanics of his art changed from the detailed handling of the unpretentious *Preston Ponds, Adirondacks* (Minneapolis Institute of Arts) to the study of illumination in *Harp of the Winds* (Metropolitan Museum, New York) which reflects the influence of French Impressionism, as imposed in 1895 upon a self-taught follower of Hudson River School methods. Martin discovered, according to Suzanne La Follette,[79] that he could put "little bits of paint alongside each other to try to make them twinkle"; and that is an obvious interpretation of Impressionism. But instead of being an impressionist in the logical manner of Monet, he was rather a poet, influenced by Constable and Whistler,[80] and a late Rousseauist, going forth toward the end of the XIXth century to list to Nature's teachings, as William Cullen Bryant had urged toward the beginning of the century. Martin, especially in such austere scenes as *Autumn* (Fig. 121), was the last great exponent of landscape in the American manner. After him came the out and out Impressionists who will be included later in the discussion of French influences. And after the true Impressionists all that remains of landscape painting in this country may be considered under the heading American Modernism, since the cult of nature is today a cult of the individual in his setting. Inness, Blakelock, and Martin refined the early landscape of objective facts and achieved poetic moods. They helped their contemporaries, who painted figures and story pictures, to go beyond natural appearances for the sake of emotional experiences. And they helped to establish

the belief, now generally accepted, that artists are, like poets, privileged members of society and deserving of support no matter what their temperamental peculiarities.

21

THE TRIUMPH OF POETIC PAINTING

The first of the painters to turn inward upon his own imagination for his art was one of the most individual of artists. Scarcely known during his lifetime, his work is still generally ignored. Dunlap in 1834,[81] nearly fifty years before Quidor's death, seems to have written his epitaph: "His picture of Rip van Winkle has merit of no ordinary kind. His principal employment in New York has been painting designs for fire engines." But the vital fact is that John Quidor, born in 1800, found in Washington Irving's books a source of phantasy which transmuted jolly stories into highly intensified and poetic genre. There is not a trace in his work of Jarvis or Inman, who were his teachers in 1826. At a time when sentiment was becoming increasingly essential to sensitive painters, he was caricaturing and relishing in a Flemish spirit the uncouth, vivid Ichabod Crane. Technically he was far ahead of his time, painting in rough, misty, glittering touches, something like Monticelli's in effect. But Monticelli was of a later generation, and Quidor was apparently unique. *Peter Stuyvesant Watching the Festivities on the Battery* [82] has a bouncing, unworldly rhythm which echoes Edgar Allan Poe. Two Scenes with *Ichabod Crane* (Thomas B. Clarke Sale, New York, 1919) achieve an intensity of mood, and one of them a rushing movement, not attempted by any other American artist until Ryder found in moonlit clouds an outlet for his poetic visions (Fig. 123). Like Poe, Quidor was fundamentally clear-thinking in his most lyrical moods, if one dare judge his character merely by the excellent simplicity of his designs. Unlike William S. Mount, his contemporary (see section 26), Quidor evolved his compositions out of an idea, not from an observation of

nature. He did not hesitate to embower the festivities on the Battery, for instance, in a Watteau-like design; one assumes that he may have seen a print after Watteau. And he transposed the scene of *Peter Stuyvesant Entering Wall Street Gate* (Fig. 124), signed and dated 1863, into a merry dream, perhaps inspired by Dutch or Flemish prints. *Anthony van Corlear Brought into the Presence of Peter Stuyvesant* (The Brook, New York) recalls Rowlandson and Hogarth in a remote and non-imitative way. The chief point is that Quidor loved the characters he portrayed even as he was laughing at them and lolling Falstaff-like in his imaginative cups.

It was nearly two generations before artists thus successfully painted the idea as a living thing, as Inness did in the landscapes of the late seventies. It was not until 1876 that George Fuller, a farmer and recluse for seventeen years, blossomed into a country poet with his first exhibition. Even then, compared to Quidor, he must have seemed slightly precious and innocent. His gentle, misty figures, like the well known *Arethusa* (Boston Museum of Fine Arts) and *Lorette* (Corcoran Gallery, Washington), dated 1882, lack intensity of mood and method; even *The Romany Girl* (Fig. 128), which is stronger in modelling, is still a spirit rather than a face. Unquestionably he popularized poetic art, along with the poetic landscapists. By 1876, when the Centennial Exhibition was held in Fairmount Park, Philadelphia, the public, recognizing Rousseau and Corot as masters, could appreciate Fuller completely. At least an influential portion of the public did so. The stage was set for subjective art. Quidor was not yet dead, although nothing is known about his work at this time. Ryder was beginning to struggle with his obstinate materials, with bad eyesight, and the dreams of an immaterial world. It is not altogether strange that a period which also loved sentimental genre, done with minute thoroughness (see section 23), fostered emotional painting, done with misty vagueness.

Unlike Inness, Albert P. Ryder had no traditions to guide him. There was nothing like the Hudson River School in genre, nor a foreign

master to suggest how his dreams could be painted. His schooling was negligible. He evolved slowly out of his own mind, by the trial-and-error method, putting down what he could record of the imaginative life he led. Being a simple person, he painted simply. Being untrained, he made a mess of his pictures and had to torture his materials with frequent reworking. Sometimes he lost his pictures entirely, because the pigments cracked and changed color with successive coats of varnish and medium. Strangely, this struggle seems to have suited his temperament; at least it enabled him to achieve a perfection of romantic feeling which otherwise might have been as vague as in the work of Fuller. The necessity for intense effort strengthened his visions of moonlight, like *Smugglers' Cove* (Metropolitan Museum, New York), and brought into existence shapes, like *Siegfried and the Rhine Maidens* (Lady William van Horne, Montreal, Canada), which might have been more felt than seen. The wonder is that through his torturing process he remained patient and simple. His picture of *Jonah* (National Gallery, Washington), childlike in its drawing and design, was for him "a lovely turmoil of boiling water." [83] It was the loveliness of the turmoil which made art soar above mechanical difficulties and romantically involved subject matter. By merely reading the titles of his pictures one would be baffled to define his scope. A religious painter he was not, yet he painted *The Way of the Cross* (Addison Gallery of American Art, Phillips Academy, Andover, Mass.). Nor was he a genre painter, though he chose for subject and carefully studied *Mending the Harness* (Adolph Lewisohn, New York). Allegorical he was not, in spite of the *Temple of the Mind* (Albright Art Gallery, Buffalo). He was not a landscapist, though he painted *Autumn Meadows* (Fig. 127). His scope was actually indefinable, since the subject matter was always subordinated to a mood, which was delicately indefinite. His reasons for choosing certain subjects were apparently as accidental as his reason for painting *Death on the Race Track* (Cleveland Museum): because someone, a barber or a waiter,

according to different accounts, committed suicide after losing money at the races. Although he wrote poetry and chose scenes from literature for subjects of his pictures, he was not a literary painter in an obvious way, even in the *Flying Dutchman* (Fig. 123) and other masterpieces of subtle poetry. "At his best," says Suzanne La Follette,[84] "this man who lived so deeply in his thoughts that he could stand meditating for hours in a pouring rain among the noisy crowds of Broadway, at his best he is profoundly moving." He is so moving, as a matter of fact, that his admirers have developed a cult of romantic worship, and forgers have honored his success, finding his lack of a technique easy to imitate, even though it is obvious that they cannot imitate so fragile a quality as imaginative intensity. He had no school, but he seems to have had an influence on F. L. Schenck, a pupil of Eakins, who painted an *Indian Encampment* and *Merlin at the Fountain* [85] in Ryder's unaffectedly poetic mood.

Frank Jewett Mather [86] has seen in Fuller, Ryder, and Blakelock "the most American artists we have. Neither their minds nor their methods betray any alien tinge. That they have been so few suggests that there are depths in our American temperament which have as yet been inadequately sounded by our art." So it seems, when one considers other individualists and visionaries, widely separated in techniques and bearing little actual relationship to one another. Arthur B. Davies, combining a Blake-like sensitiveness to inner harmonies and practical abilities, disclosed in his earliest works a fairy-tale quality which reminds one vaguely of Fuller's portraits, though more rhythmically drawn and richer in color. Davies' interest in design as an emotional stimulant developed rapidly into his major interest. The series of California redwoods and mountains, where huge vertical masses are combined with rippling horizontal movements, seem to show the artist trying to make graphic the sound of chords and counterpoint. By introducing figures he obtained more contrast in rhythm, balancing the

majestic lines of mountain tops with an angular, tossing movement of a crowd of nudes in wild action, as in *The Girdle of Ares* (Metropolitan Museum, New York), piling up arms and legs in a spirit comparable to Ryder's "lovely turmoil." The drawing of his nudes, never academic, became more summary, as he used the nude more freely to suggest feelings of classical grandeur, luxury, tenuousness, and other purely emotional concepts, all as subjective as *Dreams* (Fig. 125).

Yet through Davies' feminine sensitiveness to mood ran a masculine sense of objectivity and practicality. He was one of the organizers of the Armory Exhibition of modern French art in 1913, the outstanding event in New York during two generations of artistic struggle; and he ingeniously experimented with new effects in etching, lithography, tapestry design, and decoration. For all his romanticism he had a sure footing in the XXth century and was a Yankee type, as indeed are Kenneth Hayes Miller and Bryson Burroughs. When he referred to *Maya, Mirror of Illusion* (Chicago Art Institute) as ten nudes on a railroad track, he was voicing a simple statement of fact without benefit of poetry, revealing himself between pictures, so to say. His taste was, if not always practical, extremely dependable, and he used it constantly, one may imagine, in place of objective study. Although he has been criticized [87] for the thinness of his landscapes, for the posturing of his figures, for too much nostalgia and too little robustness, it is only fair to remind the reader that such criticisms apply equally well to most of Davies' contemporaries, who were not as strongly individualistic as was he; and that in his own world of illusion Davies accomplished something, as did Ryder, which suggests depths of the American temperament as yet inadequately sounded.

Bryson Burroughs presents less of a puzzle, since the admirable clarity of his mind governed his art and opened a straight path through contemporary life to a charming world of fable. His pale, simple colors, neat draftsmanship, and excellently unostentatious technique enhance

the clarity of his subject matter. Like Davies he has been criticized for the nostalgic quality of his ideas. But unlike Davies he delighted in anachronisms which laugh at poetic poseurs and "strong-armed" realists. A Victorian coach and a haughty coachman in the story of *The Princess and the Swineherd* (Estate of Bryson Burroughs, New York) gave him incidental but thorough pleasure. However, his landscape backgrounds are real enough to establish his world and make evident, for example, that *Demeter and Persephone* (Corcoran Gallery, Washington) lived in a land of majestic fields, synthesized from sketching trips through Maine. Obviously the *Island of Naxos* (Whitney Museum of American Art, New York) is actually off the coast of New England; and the *Rape of Dejanira* takes place on Dogtown Common (Fig. 126), as the artist's signature testifies. His work is truly felt, sensitive, and strangely mobile, considering that he has deliberately founded his style on the majestic pattern of Puvis de Chavannes. One seeks vainly for reality in the old Hudson River School sense, or in the wholly subjective modern sense. Burroughs' reality is that of the romantic poet who, being a New Englander, is restrained in taste and intellectually tempered.

Jerome Myers, on the other hand, approaches contemporary life with sympathy and exclusive interest. His highly personal representations of crowded parks on hot nights, of tenements and children, are songs in a minor key, dealing with an emotional reality. Fairy-tale elements sometimes enter into his records of fact, and his excellent draftsmanship is turned to a lyric purpose; the charm of the slums is his true subject matter, as in *Summer Night* (Whitney Museum of American Art, New York) and the rich ochre tones of *Life on the East Side* (Fig. 130), painted in 1931. With lyric purpose also, Charles Prendergast painted the doings of children, decorating screens and panels in a rich technique which heightens the unworldly effect of their worldly adventures. His mood, simple and charming, is that of Aucassin and Nicolette, as Suzanne La Follette has pointed out; [88] his is "a world where almost

anything might happen, except the commonplace." In strange contrast are the gentle, hasty pictures of Louis Elshemus, or Eilshemius, self-styled Mahatma and Bachelor of Arts, whose *Delaware Water Gap Village* (Metropolitan Museum, New York) is as childlike and precocious in its lyricism as are his countless letters to the newspapers.

Yet the commonplace must not be excluded from the subject matter of the visionary and individualistic painters. Kenneth Hayes Miller has lately turned from classical figures, ideally conceived in an allegorical mood, to "flappers," shoppers, and studies of life on Fourteenth Street, New York. His eyes see there, it must be admitted, symbols of art, bulky forms and sculptural accessories, as in the *Fitting Room* (Metropolitan Museum, New York). In spite of modern subjects, his work is still allegorical. And one of his latest works, a large *Nude* (Fig. 129), symbolizes his love of classical order and intellectual peace. Nominally a pupil of William M. Chase, Miller worked his way to artistic independence through study of Renoir, Rubens, Titian, and almost any artist whose work he has admired. His intellectuality is such that he analyzes the works of others for principles applicable to his own work, refreshening his point of view with compositional and technical details, but retaining his individuality. Throughout his career he has been a painter "in the round." For him each canvas represents a new arrangement of objects, seen as a vision of life rather than as a story; and he scarcely differentiates between models, so engrossed is he in the sublimation of their forms, blending a dress, a hat, a face, and a column into an actual unit. This deliberate blending of reality to suit his conception, evident in his non-literal *Landscape* (Addison Gallery of American Art, Phillips Academy, Andover, Mass.), would reveal the romanticist in him, even were it not for his position as the foremost exponent of inner form and self-reliant theories now teaching a generation exposed to the widest extremes of art. Among his pupils have been many sturdy individuals, including Reginald Marsh, Alexander Brook, Katherine

Schmidt, Molly Luce, Yasuo Kuniyoshi, and others forming a long list; their works reveal a cross section of contemporary tendencies. If their styles ever showed traces of Miller's instruction, they are now independent. These paragraphs dealing with the triumph of individualistic conceptions of art appropriately end with an artist whose belief in such triumphs has been successfully transmitted to the next generation.

NOTES

1. The Rise of American Civilization, by Charles A. and Mary R. Beard, edition of 1930, I, 465 ff.
2. Op. cit., II, 219.
3. Repr., Dunlap, op. cit., II, 123.
4. Op. cit., II, 391.
5. Op. cit., I, 272.
6. Repr., Robert Fulton and the Clermont, by Alice Cary Sutcliffe, 1909, 215.
7. Dunlap, op. cit., II, 162.
8. Quoted by Dunlap, op. cit., II, 121.
9. Dunlap, op. cit., II, 162.
10. American Magazine of Art, XXVII, 240.
11. Tuckerman, op. cit., 126–135.
12. Dunlap, op. cit., II, 185. An engraving of this composition is owned by the Detroit Institute of Arts.
13. Dunlap, op. cit., II, 182.
14. Samuel Morse, by Harry B. Wehle, 1932, 28.
15. Harry B. Wehle, op. cit., 18.
16. Op. cit., II, 208.
17. Dunlap, op. cit., II, 219.
18. Op. cit., II, 194–195.
19. Op. cit., III, 202.
20. Op. cit., III, 202 ff.
21. Art in America, XVIII, 81.
22. Dunlap, op. cit., III, 23.
23. Dunlap, op. cit., II, 368.
24. Op. cit., II, 387.
25. Dunlap, op. cit., I, 243.
26. See, for example, Holger Cahill, Atelier, I, 417.
27. Dunlap, op. cit., III, 68.
28. Op. cit., 64.
29. Repr., Art in America, XVI, 129.
30. The Historical Society of Pennsylvania, Philadelphia, has eleven portraits by Marchant.
31. Isham, op. cit., 172.
32. In London, however, "The Lady's Magazine; or, Entertaining Companion for the Fair Sex, Appropriated Solely to their Use and Amusement" was first published in 1742.
33. Dunlap, op. cit., III, 162.

34. Dunlap, op. cit., II, 140.
35. Op. cit., I, 296.
36. Harry B. Wehle, Samuel Morse, 5.
37. Op. cit., 158.
38. Op. cit., III, 44.
39. Isham, op. cit., 201.
40. Dunlap, op. cit., III, 168.
41. Dunlap, op. cit., III, 166.
42. Op. cit., 398–399.
43. Quoted by Edward P. Buffet in a series of articles on W. S. Mount, The Port Jefferson, L. I., Times, 1924.
44. The portrait of Mrs. Kieth done in pencil seems to be a copy made in 1856, to which date an inscription on the back refers.
45. American Miniatures, 13–14.
46. Five Colonial Artists, 165.
47. Op. cit., 312.
48. John Ramage, by John Hill Morgan, 1930.
49. Op. cit., I, 268.
50. See American Miniatures, by Harry B. Wehle, for reproductions, sound criticisms, and biographical accounts by Theodore Bolton.
51. American Miniatures, 16–17.
52. Dunlap, op. cit., II, 140, quoting Charles Fraser.
53. Dunlap, op. cit., II, 142.
54. Op. cit., III, 199.
55. Repr., Wehle, American Miniatures, Pl. XL.
56. Dunlap, op. cit., III, 162.
57. Letter to Arthur Pond; Smibert-Moffatt Correspondence, op. cit., 31.
58. Theus advertised "Landscapes of all sizes" in South Carolina. See Rev. Robert Wilson, op. cit.
59. It is tempting to guess that here may be one of those landscapes by Theus which the Rev. Dr. Wilson, op. cit., 137, noted as not evincing any special ability. The painting can scarcely be judged now in its dirty condition.
60. Early American Wall Paintings, by Edward B. Allen, 1926, 7.
61. Edward B. Allen, op. cit., 25.
62. According to Lambdin's letter to Dunlap, op. cit., II, 382, this artist taught painting in Kentucky and died in 1814. A portrait of *James Hamilton* by J. Augustus Beck is illustrated in the Lancaster County Historical Society Proceedings, XVI, no. 10.
63. Quoted by Dunlap, op. cit., II, 165.
64. Op. cit., III, 176.
65. His later work is English in style. *Welsh Scenery* (Corcoran Gallery, Washington), for example, recalls George Morland.
66. Op. cit., III, 140.
67. Dunlap, op. cit., III, 26.
68. Dunlap, op. cit., III, 153.
69. Op. cit., 533.
70. F. F. Sherman, op. cit., 216.
71. Charles and Mary Beard, Rise of American Civilization, I, 805.
72. Op. cit., 513.
73. Op. cit., 372.

74. Repr., Pageant of America, XII, 76–79.
75. Frank Jewett Mather, Pageant of America, XII, 73.
76. George Inness, by Elliott Daingerfield, 1911.
77. Op. cit., 527.
78. The Art Idea, by J. J. Jarves, 2nd edition, 1865, 240.
79. Art In America, by Suzanne La Follette, New York, 1929.
80. Frank Jewett Mather, Pageant of America, XII, 80–82.
81. Op. cit., III, 87. The *Return of Rip van Winckle* (Estate of Thomas B. Clarke, New York) may be the painting seen by Dunlap, although another picture of Rip van Winkle (The Brook, New York), formerly in the collection of Thomas B. Clarke, is supposed to have been painted in the same year. A picture of this title was exhibited in the National Academy of Design, New York, in 1839.
82. Repr., Pageant of America, XII, 39.
83. William H. Hyde, The Arts, XVI, 597.
84. Op. cit., 198.
85. Repr., Art in America, XIX, 85.
86. Pageant of America, XII, 59.
87. As by Suzanne La Follette, op. cit., 322.
88. Op. cit., 312.

CHAPTER VI

The Grand Tour

TURNING back to a period before the Civil War, one finds another move-
ment in XIXth century painting which parallels the cult of Nature and
poetic individualism. In the opinion of Tuckerman, the fine finish and
painstaking technique of the Düsseldorf School, already mentioned in
connection with grandiose landscapes (section 20), put to shame the
uneven accomplishments of American painters.[1] Contemporary French,
German, and Dutch pictures fetched high prices from the plutocrats of
the Gilded Age, Goupil having sold $300,000 worth of this type of im-
ported art in the season 1866–67. A few years previously, Tuckerman
noted, the average prosperous dwelling contained a Copley, "stiff,
gorgeous, handsome, but official in costume and aspect, or a vigorous
old head by Stuart, full of character and magnificent in color, or one of
those sweet, dignified, little pastel profiles by Sharples. . . . Now, in
addition to these quaint relics, a landscape by Doughty . . . Bierstadt
or Durand, a genre piece by Eastman Johnson, a bust by Crawford,
Powers or Palmer, a group by Rogers, some specimen of the modern
continental schools, with a good copy of Raphael, Domenechine or
Guido — indicate a larger sympathy and a more versatile taste." In
short, an eclecticism to shame previous eclectic tastes. Rome and
Düsseldorf combined to furnish the sources of inspiration. It began
with a cultured taste for the breadth of the Italian grand style and an
instinctive desire for something more realistic and tangible in the way
of artistic training than was available at home. Shortly thereafter Wil-
liam Morris Hunt discovered Millet's back-to-the-soil realism. Through
their training in Munich Duveneck and Chase discovered Frans Hals'
delight in technical dexterity. Naturally French Impressionism did not

remain unnoticed by artists who considered Paris the gateway to the Grand Tour. And the stimulating "freedom" of post-Impressionism continued the spell which Paris seems to have always cast over young XIXth century artists.

<div align="center">22</div>

<div align="center">SOFTENING OF STYLE</div>

In the face of the "crudities" of late itinerant portrait painters and the simplicity of taste which patronized them, there was nothing for a sensitive young artist of about 1835 to admire in American art, provided he was not interested in landscape. The paternalistic influence of the English School had dwindled to a trickle of romantic genre. The French neo-classical influence was stopped at its source, Paris being in the doldrums of individual revolts against the official Academy. Badly in need of a solid foundation for his aspirations, the young American, or the mature but disappointed artist, like Francis Alexander, turned to Italy and the techniques of the old masters, much as the Pre-Raphaelites were doing in England.

John G. Chapman returned home from Paris and Italy in 1831 with copies of the old masters; he painted the *Baptism of Pocahontas* (Rotunda of the Capitol, Washington), and published a book of instruction on drawing, before settling at Rome in 1848, an expatriate like Alexander. William Page spent eleven years in Rome and Florence, between 1849 and 1860, experimenting with techniques. His trip was delayed by adventures into religion, family troubles, and an Allston-like inability to release himself fully in art. Having studied under and assisted Morse, he acquired a respect for draftsmanship which made his portraits of *Charles W. Eliot* (Fig. 134), of *Josiah Quincy* (Harvard University, Cambridge, Mass.), likewise dated 1847, and of *Ednah Parker* (Boston Museum of Fine Arts) sturdy and realistic. Although his *Ceres* (Boston Museum of Fine Arts) is also sturdy, Italian influences such as those

which afflicted Allston kept him vacillating, so that today one scarcely knows whether he was a thwarted romantic genius or a gifted amateur, in the sense of being a lover of all the arts. Henry Peters Gray, who went to Italy at the age of twenty in 1839, became more obviously Italian, turning abruptly to the great Venetians for design, color, and technique, as in *The Judgment of Paris* (Corcoran Gallery, Washington) and *Cleopatra Dissolving the Pearl* (Fig. 133). When he did portraits he softened features, eliminated character, and tried for a fashionably expressive mood, as in the mundane likeness of *Roderick Sedgwick* (Metropolitan Museum, New York).

This was the tendency of other portraitists, whether or not they had been trained in Italy or visited there in maturity, as had Joseph Ames in 1848 at the age of thirty-two. Even when their early work reveals hard accuracy, as does Ames' portrait of *George Southward* (Ehrich-Newhouse, Inc., New York), their later work turns delicate and diffused, as in Ames' portrait of *C. C. Felton* (Harvard University, Cambridge, Mass.), dated 1862. Charles Loring Elliott, who never went to Italy and had been an itinerant painter until he settled in New York in 1845, changed from the trim, clear realism of his portrait of *Conradt Ten Eyck* (Hiram Burlingham Sale, New York, 1934) to the soft-focus and gentle characterization of the portrait of *Col. Thomas L. McKenney* (Fig. 131). Elliott's training had been eclectic without a doubt; he had studied briefly under Quidor and admired Stuart to the point of imitating his technique, as Tuckerman[2] pointed out at length. It is not altogether a coincidence that he should have painted many portraits during the Civil War period in the new soft manner, or that James R. Lambdin, a pupil of Sully and an itinerant painter in Pittsburgh at the age of eighteen in 1835, should later follow the same taste, as in the portrait of *Daniel Webster* (Ehrich-Newhouse, Inc., New York). The fact is that Daniel Huntington, crowned President of the National Academy in 1862, had early shown the way to success with his pseudo-Italian conception of style.

That Huntington began his training under Inman, after brief con-
tact with Morse, might naturally account for the sentiment which filled
his work. But Inman's influence seems to have been forgotten when
Huntington studied in Italy. He visited there twice, acquiring from
Correggio a taste for soft forms and tender feeling which made him one
of the most popular of mid-century artists; his eclecticism was geared to
the sensibilities of the Victorian era. "He would not amuse, dazzle, or
simply please us," wrote Tuckerman;[3] "he teaches and inspires, by
some lofty, sweet, or pious feeling, represented with unaffected grace
and simplicity." By 1850, when he exhibited the popular *Mercy's
Dream* (Corcoran Gallery, Washington),[4] in which, again quoting
Tuckerman, the introduction of a cross "added a beautiful significance
to the composition," he was the leader in an idealistic kind of painting
which had no more to do with actual experiences than the pinkish
shadows in the angel's robe, and which seems today an affectation of
taste. In portraiture this manner became "the beauty of the inner
world," taking on a dreamy character similar to that in Allston's por-
traits, but lacking Allston's clarity of mood. *Albert Gallatin*, who died in
1849, was represented (Ehrich-Newhouse, Inc., New York) as if in a
trance. The portraits of *Benjamin Pierce* (Fig. 132), dated 1857, and
of *Robert Charles Winthrop* (Massachusetts Historical Society, Boston),
dated 1885, show the sitters musing on "love and faith," perhaps
the foremost realities for those who appreciated Huntington as did
Tuckerman.

23

THE DÜSSELDORF INFLUENCE

The good draftsmanship and solidity of mood, as well as of form, which
Huntington failed to get from Inman and Correggio he might have
obtained in Düsseldorf could he have waited a few years more as a

student. The training there in vogue was exhaustingly thorough, consisting of minute care for details, much preparatory drawing, even finish and, naturally, superficial realism. It was popularized in America by Emmanuel Leutze, born like Huntington in 1816, who made several trips back and forth, grafting his German sympathies on to patriotic American and classical Italian subjects. Although appreciated for his realism, Leutze was obviously an academician under a new disguise, especially in his *Amazon and Children* (Corcoran Gallery, Washington); and his realism was as false as the spirit of his most popular picture, *Washington Crossing the Delaware* (Metropolitan Museum, New York), which was painted in Düsseldorf from German models with all the pomp of official "Hoch der Kaiser" art. The German school utilized the little Dutch masters as guides, with such admiration for the spotless clarity of their techniques that they lost sight of the limitations of minute finish when applied to large pictures. The effect of this teaching has already been mentioned in connection with the landscapes of Bierstadt and the early views of Whittredge. Its effect in portraiture, as in Leutze's portrait of *A Spanish Lady*,[5] corresponded to the effect of Italian training on Huntington; it softened the modelling, brought out the details of dress and ornament, and left the portrait stranded away from life. So concerned were the students of this method with a nice finish that they found difficulty in giving vitality to their subjects. And this was essentially the difficulty faced by Huntington in his full length official-looking portraits, of which that of *Mrs. Benjamin Harrison* (Miami University, Oxford, Ohio) is most official. William H. Furness, Jr., a pupil of Leutze at Düsseldorf, thus painted the portrait of *James Savage* (Harvard University, Cambridge, Mass.) in a spirit close to that of Huntington and also of James R. Lambdin in his late work.

But the great success of the Düsseldorf training appeared in genre, where, of course, the technique of Gerrit Dou and van Mieris should be applied. There had been other painters of small subject pictures active

in America under the influence of English genre, as were Sully and Charles R. Leslie, for instance. And there were other influences brewing, as in the work of William S. Mount, who will be considered later in section 26. But to the public of Tuckerman's time the Düsseldorf manner seemed most desirable, as shown by the high prices paid for Bierstadt's landscapes and for imported German paintings. R. C. Woodeville went to Düsseldorf for the minute technique which he applied to subjects exaggerated in sentiment, like *Reading the News* (National Academy, New York), or frankly romantic and archaistic, like *The Cavalier's Return* (New York Historical Society). His pictures, along with many of the genre paintings of the time, were engraved and published in gift books, so that even an early death in 1855, after a mere decade of activity, did not prevent him from creating a popular type of art. In the fifties J. G. Brown began painting his "sub-artistic" newsboys, using the "sleek manner and overtly humorous episodes," as Frank Jewett Mather has put it,[6] which established his popularity down to the time of his death in 1913. In 1870 he painted the extraordinary *Music Lesson* (Fig. 140) which brings into focus casual details ordinarily missed, even by a camera. Though he was not formally enrolled as a pupil of the Düsseldorf system, Brown evidently knew the models used there, since his *Allegro and Penseroso* (Corcoran Gallery, Washington) is based on the Dou-van Mieris type. At any rate, "juvenile and sportive" genre seemed to Tuckerman [7] to have "expressive merit." And it evidently appealed to the same taste that found Woodeville excellent. That this taste was largely sentimental and literary is obvious. Naturally it was popular and therefore continued to attract painters, like Thomas Hovenden and many others, who brought up to date the Düsseldorf influence, without depending on Düsseldorf instruction. As a matter of fact, the choice of American artists in search of foreign training shifted soon from Düsseldorf and the tightness of little Dutch masters to Munich and the dash of Frans Hals, as well as

to the formal hardness of the Beaux Arts in Paris. Nevertheless, the
ideals of "untiring thoroughness" remained vigorous, if not aesthetically
convincing, for many years. Henry Bacon, who painted *On Shipboard*
(Boston Museum of Fine Arts), had studied in Paris but utilized Ger-
man realism. Charles F. Ulrich painted *The Land of Promise* (Cor-
coran Gallery, Washington) after study in Munich. T. W. Wood did
among many others a large, minutely finished composition of *The
Drunkard's Wife* (Fig. 141). Edward L. Henry, trained in Paris, re-
corded every detail of the *Old North Dutch Church* (Metropolitan Mu-
seum, New York) and brought his painstaking skill to bear on such sub-
jects as *A One-Sided Bargain* (Francis P. Garvan, New York). As late as
the Chicago World's Fair of 1893, the chief characteristics of the art
exhibited were sleekness of manner and overwhelming interest in epi-
sodes. Whether painted in Dutch, French, or English style, the story
pictures, the picturesque figures, the sentimental scenes, the tearful
melodramas, seem to recall early XIXth century German genre.

It is a pity that this later, popular art was not founded on the work
of other early genre painters — David G. Blythe, for example (Fig. 136),
or Mount (Figs. 170 and 171), who could represent daily life with
enough intensity to make it seem important. To any but superficial
observers, Eastman Johnson's genre, rarely duplicated in its finer points,
though much imitated in range of subject, must have seemed more
subtly worth while than the insistent detail of T. W. Wood (Fig. 141)
or the scenes of childhood by S. J. Guy. Johnson had been trained in
Düsseldorf. But the four years he spent in The Hague loosened the
tight manner to which he had been exposed. When he painted in 1871
the genre-like *Family Group* (Fig. 137), disposed about the table in their
parlor, he produced lively, characterful gestures, and yet he subor-
dinated them to the atmosphere of the room as a whole, much as Henry
Sargent had done in his reserved but vigorous study of *The Dinner Party*
(Fig. 96), painted about two generations earlier without the aid of con-

tinental training. Johnson's companion in student days, Leutze, doubt-
less influenced the production of *The Drummer Boy* (Union League Club,
New York); but this stirring presentation of a sentimental subject has
little of the complacent artificiality of Leutze's *Washington Crossing the
Delaware*. Even when he painted *Old Kentucky Home* and *Knitting for
Soldiers* (New York Public Library), which cry out for sentimental
handling, Johnson remained surprisingly realistic and reserved. His
modelling is sure, if slight, and he proved that a native, vigorous point
of view had not been completely covered by the self-conscious realism
of the German imitators of Dutch genre. A comparison between John-
son's scenes and those of Woodeville, Brown, or Wood shows the differ-
ence between a genuine eclectic searching for any subject that will give
him an opportunity to come to grips with reality, and opportunists who
specialize in endowing real events with false sentiment. Johnson's genre,
as in *The New Bonnet* (Metropolitan Museum, New York) and other
works mentioned, is healthy, sensitive, and accurate, like good por-
traiture. He was one of the few artists of eclectic taste and foreign train-
ing who had strength of character sufficient to keep him away from too
much sentiment on one side and too involved technical experimenta-
tion on the other. The solid presentations of character which give
weight to such portraits as those of *Wilder Dwight* (Harvard University,
Cambridge, Mass.), *Sanford R. Gifford* (Thomas B. Clarke Sale, New
York, 1919), and an *Unknown Lady* (Alex Simpson, Jr., lent to the Penn-
sylvania Museum, Philadelphia) show the value of long lessons in draw-
ing for an artist born in an age of emotional painting. One may believe
that Johnson's sitters were posed, like Huntington's, in retreat with
their own thoughts; it was the style. Yet Johnson could give them firm
bodies and tangible spirits; he gave them a bulk in which their minds
could retreat. In at least one case he gave them so much reserved vitality
and weight that they hold their own amid a scene of fulsome detail, the
Two Men (Metropolitan Museum, New York) being seated in a parlor

even more realistic than that shown in the *Family Group*, already mentioned.

This is a long way from the finish of Düsseldorf painting, because Johnson had emphasized the character of actuality, instead of his technical skill in presenting its details. One may go farther still from Düsseldorf methods by concluding this section with G. P. A. Healy, who, wandering through Europe, eclectic in technique as well as ideals, practiced portraiture in a style which occasionally links him with Johnson and Huntington. Born in 1813, he studied under Gros in Paris, had a flattering success in Europe, and returned to this country in 1855, where he painted, for instance, the elaborate full length portrait of *Mrs. Harrison Gray Otis* (Bostonian Society) in a manner paralleling that of Leutze's *Spanish Lady*. Though he scattered his interests in several directions, he seems most at ease in the Parisian portrait of *Mrs. John C. Cruger* (Fig. 135), when he accepted the vogue for smooth finish and fine detail.

24

THE DOMINATION OF FRENCH ART

At the time Healy returned after sixteen years in Paris, William Morris Hunt returned after nine years of rather independent activity, which began in 1846 as a student of sculpture at Düsseldorf and quickly changed to Paris, the scene of new artistic revelations. Being a well connected, aristocratic, and poetic youth, he found the "system" to which he first apprenticed himself difficult and discovered for himself under Couture in Paris a mixture of easy deference and lively instruction which suited him for several years. He thought of becoming an expatriate, as Whistler and Vedder were shortly to become, and might have done so had he not come into contact with Millet, the peasant, who asked abruptly what Hunt planned to do with his recently acquired technique. What to do, was easily answered: Hunt went back

to the soil with Millet. Although it was an incongruous situation, with Hunt wearing sabots, living the simple, honest life and buying Millet's paintings with enthusiasm, he proclaimed on his return to Newport in 1855 the new movement away from academic inspiration and instructed polite people in the true greatness of an art that dealt with such themes as *The Angelus* — which painting, as Henry McBride has said,[8] remained long unnoticed in Paris, until someone remarked, "You can hear the bell ringing." Had Hunt not been a social charmer and a brilliant companion, probably the Boston Museum would not today be rich in Millet's art, nor would the Rousseauistic doctrine of the common man as nature's noblest creation have become so quickly re-accepted in this country. It was another Rousseau who revealed the nobility of nature's simplest moods; it was Millet who inspired Hunt to search for humanized subjects, major truths, character, and a sense of proportion between subject and material effect.

As a result, Hunt's early work, of which *The Belated Kid* (Boston Museum of Fine Arts) is typical, imitated Millet to an overwhelming degree. Sentiment all but obscured the genuinely poetic artist who eventually painted the reserved and novel sketch of *The Bathers* (Worcester Art Museum). In spite of his aspirations, Hunt was not wholly romantic. He recognized with clear-headed practicality that a mood was only the beginning of art, and that character was essential. His advice to art students was solid and sophisticated; his intelligence was great and masculine in its thorough objectivity. Among the portraits which seem today to have been his most serious efforts are many striking and keen characterizations, including that of the charming *Mary B. Claflin* (Fig. 139) and the less romantic portrait of *Levi Lincoln Thaxter* (Boston Museum of Fine Arts). A *Self-Portrait* (Boston Museum of Fine Arts), dated 1866, suggests the positive masculinity of Courbet. Though his technique was capable of conveying the rich textures of material things, he was not sidetracked by the physical elements of painting and re-

tained throughout his twenty-five years of mature work the point of view of a gentleman poet. That is to say, he was strictly honest with himself; he could only be an observer of the peasant point of view, and could only paint in a way appropriate to his social background, with refinement. The portrait of *Charles Francis Adams* (Harvard University, Cambridge, Mass.), dating from 1867, is robust and dominating. Open-air studies, like *St. John's River*, *Pine Woods*, and *Gloucester Harbor* (Boston Museum of Fine Arts), reveal a lightness and trueness of feeling which are unexpected in a disciple of Millet, and which make the landscapes of Allston and Daniel Huntington seem smug and a little silly.

Yet Hunt lacked what a modern critic would call structural sense. He refused, for instance, to correct the anatomy in *The Bathers* for fear of losing the delicate pose of the figures. The freshness of his impressions was always valuable to him; and he early turned away from a training which might have enabled him to sharpen those impressions by accuracy and firmness of draftsmanship. One wonders whether the now ruined decorations for the State Capitol at Albany, done in 1878, were ever as good as the sketches he made for them, which are, considering their date, astonishingly classic in their simplicity and fullness of form. As decoration for a large-sized fan the sketch for *The Flight of Night* (Boston Museum of Fine Arts) is a perfect piece of work, without any of the sentimentality which a subject picture seems to have demanded in the sixties. Hunt's structure was intellectual rather than instinctive. From Couture he evolved a broad method of blocking in a head. But that was not necessarily a solid foundation. The head of a *Young Woman* (Addison Gallery of American Art, Phillips Academy, Andover, Mass.), broadly painted in 1865, anticipates an effect often produced by Abbot Thayer and other Boston artists of the last half-century; it contains the elements of solid painting, including simplicity of shape, well defined textures, and depth of modelling. Yet the relationships between these elements are not sufficiently developed to give one an

idea what Hunt was doing with his technique. He should have been one of the best painters. But he is not so considered. That he said of himself,[9] "In another country I might have been a painter," shows the aesthetic weakness of his background, rather than personal weakness. At least, other painters were afflicted by the same difficulties of dispro-portion between feeling and equipment, and a general tendency to in-completeness.

It was evidently a difficult time for the most intelligent artists. Whistler, born in 1834, wandered in his search for aesthetic satisfaction as far as Courbet, La Tour, and the Impressionists, and ended by jumping into the fire of mid-Victorian English sentiment, to escape the frying pan of American Civil War sentiment. Elihu Vedder, two years younger, abandoned a false morality found in the art of the United States for a lifeless academic tone in Italy, which had nothing to do with his personal interest in flowing symbolism, revealed in his illustrations to Omar Khayyam, the murals in the Congressional Library, Washing-ton, and the lunette *Rome* in the Walker Art Building, Bowdoin College. John La Farge, who trained himself here, there, and everywhere, found in Hunt a sometimes exasperating but invaluable guide, who helped crystallize an aristocratic background to a point where it became of practical use. "You go," said Hunt, "too deep into things. You pay too much attention to refinements which not one artist in a hundred would understand." [10]

Eclectic to an extraordinary degree, intelligent and studious, La Farge was more concerned than Hunt over problems of light. In the early landscape, *Paradise Valley* (Miss Mary Lothrop, Boston), which he painted out-of-doors, he bathed the ground with light and covered-over a kneeling figure in the foreground which evidently inter-fered with his final interest in the scene. Light was primarily important to him when he became interested in stained glass and invented a method for deepening its color. The *Battle Window* of 1880 (Memorial

Hall, Harvard University, Cambridge, Mass.) has indeed a rich effect. And light became increasingly important as he worked on murals in dimly lit churches. But he had to go to Japan and the South Seas to find a blaze of hues which entranced him and flooded his *Scene in Tahiti* (Fig. 142) with reality and vigor.

It was not so much his interest in light which made him seem one of the most important of recent painters, as it was his writing and his lecturing; he published Considerations on Painting as a result of a series of lectures given at the Metropolitan Museum, New York, in 1892, which showed that he was a most articulate artist. Other publications, The Gospel Story in Art, The Higher Life in Art, Great Masters, Letters from Japan, and Reminiscences of the South Seas, indicate the scope of his mind. And, of course, he was the leader in a new school of decoration which tackled practical as well as aesthetic problems. The co-operative effort which La Farge led in the rapid decoration of Trinity Church, Boston, in 1876, was a genuine revival of the Renaissance spirit, with St. Gaudens numbered among his assistants. In 1905 he did four murals on the Law for the Supreme Court Room in the Capitol at St. Paul, Minnesota. And the following year he painted the *Lawgivers* for the Baltimore Court House. These established a Renaissance type of decoration which was practiced by Kenyon Cox, who was also an assistant in the decoration of Trinity Church, and Edwin H. Blashfield — to name but two of the later decorators. La Farge's work was quite eclectic, combining Japanese landscapes and figures from Palma Vecchio, as Frank Jewett Mather has pointed out,[11] in the *Ascension*, painted for the church of that name in New York City. The mural called *Athens* (Fig. 144) seems to capture a Bellini-like clarity and serenity; the sketch of *Christ and Nicodemus* (National Gallery, Washington) for one of the murals in Trinity Church recalls Titian. But La Farge borrowed from all sources with restraint, and he kept his individual taste, well illustrated by the firm drawing, soft mood, and insistent color

of *The Muse of Painting* (Metropolitan Museum, New York), without being swamped by the pomp of Italian decoration. Kenyon Cox's lunettes in the Library of Congress, Washington, and one in the Walker Art Gallery, Brunswick, Me., called *Venice*, seem to be impersonal when contrasted by La Farge's sensitive borrowings, as do Blashfield's papery efforts in the series on the Law in the Appellate Court, New York, and his hasty war poster, *Carry On* (Metropolitan Museum, New York). But Cox was an excellent technician; his portrait of *Augustus Saint Gaudens* (Fig. 145) summarizes the cold perfection of academic training.

The later decorators have never assimilated, and rarely advanced beyond a superficial imitation of, Venetian models. Their draftsmanship and technique, correctly learned in the studios of Bonnat, Gérôme, and Carolus-Duran, are cold, formal, and impressive without being as aesthetically true as the slightest sketch by La Farge. Thus it is rare that one finds in decorations of public buildings anything simple and moving. Edwin A. Abbey's sketchy *Holy Grail* series in the Boston Public Library is an exception, since the feeling is genuinely poetic, and the subjects are easily understood, which Sargent's series on *Religion* in the same building is not. Abbey was a self-taught painter who found his escape from contemporary crudities through illustrations in which he reproduced period costumes and settings with the faithful enthusiasm of an antiquarian; *King Lear* (Fig. 143) is rich in Gothic drama, and the drawing of *Sally in our Alley* (Metropolitan Museum, New York) is set in the XVIIIth century very pleasantly. His pupil, J. W. Alexander, only four years younger, dealt in present generalities rather than in realities of the past, but shared Abbey's taste for gentle phantasy. Naturally the portrait of *Walt Whitman* (Fig. 148) is painted in poetic style. But so is the *Pot of Basil* (Boston Museum of Fine Arts) and even *The Crowning of Labor* (Carnegie Institute, Pittsburgh). His subtly colored designs seem to be studio conceptions and are not nearly so vivid as Abbey's rejuvenations of the past in black and white.

Between La Farge and J. Alden Weir, both of whom studied light as it affected subjects before them and who were constantly referring to reality, there were many painters of ideas whose ideas were not necessarily pictorial. Although Abbot Thayer's virgins and allegorical figures — *Caritas* (Boston Museum of Fine Arts) is a favorite — are solidly painted, they deal with an ideal beauty which has less to do with actuality than with romantic poetry. Learning his trade under Gérôme, Thayer established in Dublin, N. H., a school with a positive tradition which today affects many painters working in and about Boston, as it seems to have influenced William James and John Sharman. He had a definite idea of reviving the guild spirit, and did not hesitate to utilize his pupils' works in his own productions. This was only possible because his personality dominated that of his pupils and was chiefly concerned with generalities, fundamentals of form, purity of womanhood, and the best instincts in man. He dealt in generalities even when he was doing the portrait of *Mrs. William F. Milton* (Fig. 138). Compared to his contemporaries Thomas Dewing and J. Alden Weir, who were moved by the new French interest in light, Thayer seems academic. But when compared to the true academician, like George De Forest Brush, whose smooth technique is most often found in two types of subject, Mother and Child themes and scenes of noble redmen, Thayer seems an intellectual painter of almost radical tendencies. Because these painters had the same training at about the same time, it is not surprising that Thayer's portrait (Fig. 138) should vaguely resemble Brush's full length study of *Henry George* (Fig. 146). What is surprising is that Thayer insisted on saying something with his solid technique, even if that something was limited to a few often repeated generalities. Many of those who studied the academic style in Paris lost sight of a fundamental purpose in search of effects. They may deserve the name of good painters, as Royal Cortissoz calls Tarbell and De Camp,[12] but their ideas might well seem derivative and inconsequential to a simple

American taste. The effects produced by Dutch painters of interiors are, of course, admirable. Effects of the same kind, softened and diminished through a veil of French training, as in Joseph De Camp's *Guitar Player* (Fig. 149), seem less admirable. With subtle half-lights the artist painted a fragmentary bit of reality, subdued in meaning as in color. Edmund C. Tarbell's technique, equally impressive, has been used to record intimate scenes, like *Josephine and Mercie* (Fig. 147), which are singularly impersonal.

Other events were taking place in Paris, and other American students were entering a new phase of French domination. Mary Cassatt, born in 1855 and a foreign resident from 1868 to the time of her death in 1926, managed to keep her American taste, in spite of an overwhelming admiration for the art of Degas. In her own words,[13] Degas' work "changed my life. I saw art then as I wanted to see it." This was about 1886. But Mary Cassatt, with her uncompromising honesty and habits of structure, is an exception to all points of view. She worked for modern art among her friends, including Mrs. Havemeyer, the collector, but she herself remained aloof — not only from American art in general, but from the later developments of French modernism. The new phase began in the late eighties with a general shift to the spot-technique of Monet, evolved from the knowledge that light is physically a blend of all colors. It was surely not a sudden discovery from the artist's point of view. Augustus Vincent Tack, pupil of La Farge, had evolved a glazing method which produced a shimmer of light without benefit of scientific impressionism; and Thomas Dewing, pupil of Boulanger and Lefebvre, had developed a taste for lost contours and glinting colors. But the spot-method came as a revealing technical idea to J. Alden Weir and J. H. Twachtman, who had begun painting in other manners. There was nothing radical in the new mode except its manner of applying pigment. From painting the mood of an object, as Dewing did in the head of a *Young Girl* (Fig. 151), to painting the mood of the light on

that object is but a small shift in viewpoint. And the shift was made easily by Twachtman, who abandoned the old-master browns and blacks, acquired through Munich training and still traceable in *The Inlet* (Fig. 152), for dabs of light and sparkling color, such as those which make *Hemlock Pool* (Addison Gallery of American Art, Phillips Academy, Andover, Mass.) a Monet-like impression sharing the chief defect of Monet's method in vagueness of modelling. Weir, however, made the change less easily, remaining a conscientious student of form even when he attempted the brilliant light of *Upland Pastures* (National Gallery, Washington). At first enthusiastic about Manet and his strong brushwork, Weir saw in Impressionism chiefly subtle effects of mood; he did not paint in pure tones, but adapted the broken surfaces of Monet and Pissarro. His interest in character seems to make the portrait of *Albert Ryder* (Brooklyn Museum, New York) and *The Rabbit Hunter* (Fig. 150) more solid and realistic than anything done completely in the Impressionistic manner.

Theodore Robinson, who was a friend and pupil of Monet, tried to avoid the fundamental weakness of the purest Impressionism by insisting on draftsmanship. One of his water colors, *Children Fishing* (Brooklyn Museum, New York), dated the first year after his return from Paris in 1880, resembles somewhat the contemporary work of Winslow Homer, though lacking that intensity of vision which made Homer exceptional. Robinson was content with simple subjects, posing the horses and boy as a natural group in the *Halt on the Road* (Whitney Museum of American Art, New York) and emphasizing the airy space around them. His activity between 1880 and 1896, when he died, was equally divided between Europe and America. But one does not hesitate to place him among the American Impressionists, rather than among the French. His realism was only slightly affected by French methods.

Childe Hassam achieved solidity and effects of weight, although he too was a student of light in Paris, along with Weir and Twachtman,

and although he continued to paint any kind of subject with sparkling light in the approved manner. His energy had carried him farther than it did them, allowing him to run through the basic problem of the moment. *Columbus Avenue, Rainy Day* (Fig. 153), an early work, shows how realistically and firmly he could paint an impression of darkening rain without benefit of impressionism. His scope is unusually broad, and his results are naturally uneven, especially in figure studies out-of-doors. But when he tried a lively subject, like *Fifth Avenue in Winter* (Carnegie Institute, Pittsburgh), he proved himself a masculine and independent artist, unconfined by his rather specialized technique and rising above the dangers of popular success.

Today, of course, Impressionism seems to be a dated movement, in spite of the fact that other artists, like Ernest Lawson and Allen Tucker, both pupils of Twachtman, have utilized its principles more or less consistently. Allen Tucker's development followed that of Van Gogh toward a more personal and freer Impressionism, as can be seen in *Headlands* (Metropolitan Museum, New York) and *The Orange Dress* (Whitney Museum of American Art, New York). Lawson's moody landscape called *After Rain* (Phillips Memorial Gallery, Washington), painted in 1915, his *Boat House, Winter* (Fig. 155), and his well modelled *Fishermen* (Whitney Museum of American Art, New York) make plain the fact that he has worked strictly within the technical limits of Impressionism. Maurice Prendergast, brother of the poetic Charles who has already been mentioned, broadened the familiar manner until it became a flat design which resembles tapestry or wool knitting and anticipated the highly intensified effects of post-Impressionism. His amiable talent, personal and pathetic in its struggle for survival — he tried to show his unpretentious, novel pictures in Boston while Sargent was at the top of his fame — seems to have been stimulated by Cézanne, although *Sunset and Sea Fog* (Fig. 154), which consists actually of his favorite theme, children in the park, shows that he was at heart a simple poet of

flat patterns, original but not profound in the literal sense, and not pre-
occupied with depths of form. That he, born in 1861, survived at all in
his premature modernity was due probably to the fact that his fellow-
artists, becoming dissatisfied with merely a formula for painting light,
knew him as a prophet of the subjective post-Impressionistic movement.

The cult of modernistic art, and it must be called a cult because of
the fanatical point of view taken by its supporters as vehemently as by
its enemies, makes use of theories with French thoroughness and yet
rests ultimately on the necessity for originality in art. The modernist
stipulates that a superficial resemblance to nature is not the whole of
reality, that there are relationships and facts in the objective world
which are unaltered by varying effects of light and mood. Everything
in nature, for example, can be classified as a geometrical form; hence
cubism.[14] Everything in nature is a structure in itself; hence intrinsic
form and inner character, as distinct from mere appearance. And
everything in nature is subject to the mind of the beholder; hence the
distortion of the obvious in order to shatter conventional reality and to
depict psychological reality. Naturally there have been critics who
violently opposed the validity of cubes and neurological states, just as
there have been ingenious attempts to paint in color music, with every-
thing eliminated from this ultimately pure art except colored shapes;
one theoretician would even eliminate shapes.[15] Some critics have justi-
fied modernism by comparing it with primitive art. However, all the-
oretical discussions may be reduced to the simple fact that inquisitive
artists have found excitement in adventuring for themselves, whether
stimulated by African, Egyptian, and Oriental art, or interested in
analyzing their own feelings and visions; and they have produced tangi-
ble results from such adventures. In fact, the results have in some cases
been so tangible that others have imitated them without the necessity of
adventuring for themselves. There is, in other words, already a tradi-
tion of modernism which appeals to art students of the immediate pres-

ent as did the academic tradition in Paris to the art students of two generations earlier.

Following closely the revolutionary movement in French art, a few American painters in the early years of the XXth century began experimenting, as Maurice Prendergast had done, with their personal reactions to subject matter and materials. But it was not until 1913, when the famous Exhibition was held in the New York Armory, that the public learned what was taking place. In spite of scandalized academicians, humorous publicity, and exploitation, the cult of freedom in art gathered momentum, until a dozen years later post-Impressionism was fully accepted as part of the *décor moderne*. Today a list of artists painting in sympathy with this movement seems at first glance an index of living painters. Few indeed have escaped some kind of influence, whether in technique or in mental attitude.

William Glackens turned from black and white illustrations to the luscious tones of Renoir about 1910 and developed from a realist, somewhat influenced by Manet and Degas, as in *Chez Mouquin* (Chicago Art Institute), dated 1905, to a painter of mood almost exactly in Renoir's gayest manner, as in the portrait of a *Young Girl* (Barnes Foundation, Philadelphia), or *The Dream Ride* (Fig. 161). Max Weber, who came to America in 1891 at the age of ten years, developed in 1907 directly out of Matisse and the background of French modernism, Persian and Indian miniatures, Coptic textiles and African sculpture; he has painted purely cubistic patterns, like the *Chinese Restaurant* (Whitney Museum of American Art, New York), and figure compositions, such as *Eight Figures* (Mrs. Nathan J. Miller, New Rochelle, N. Y.), which seem connected with the early work of Cézanne. Walt Kuhn, one of those who helped stage the Armory Exhibition in 1913, has eclectically drawn on Derain, Pascin, and others, accepting modernism as the natural mode of his own hard-headed, incisive style, as in *The Acrobat* (Fig. 158) and *The White Clown* (Museum of Modern Art, New

York); his unabashed handling of show-girl studies, raucous, real, and as American as Tin Pan Alley, brings the influence of French modernism to a field which is little connected with France. John Marin, born in 1870 and an academic draftsman in his early work, fought his own way via cubism to the representation of "single, intense, poignant instants," as Lloyd Goodrich [16] characterized them. He prefers to work in water color instead of oils because of "the extreme velocity of his vision, impulse and power of projection," to quote another critic and artist, Alexander Brook.[17] The most rapid and freshest of color mediums allows him to capture the brief essentials of the *Presidential Range* (Fogg Museum, Cambridge, Mass.) and the layout of *Maine Islands* (Fig. 156) as if seen through formalized tree branches. Sharply personal as his visions are, they apparently could never have materialized without cubistic technique. Nor could Georgia O'Keeffe, seemingly, have found her way to a decorative, almost psychological kind of painting without cubism and its surrealistic development, which changes *Skunk Cabbage* (Whitney Museum of American Art, New York) into a vortex of flaming light, *Black Flower and Blue Larkspur* (Fig. 162) to a vision of inner life, and *Rancho Church* (Phillips Memorial Gallery, Washington) to a papery assemblage of purposely unsubstantial blocks.

These artists have accepted French painting naturally; yet they have not become expatriates or Francophiles. Their position as a group in American art seems as sure as the position of those who studied in the Parisian academies shortly after the time of Hunt. Even Guy Pène Du Bois, influenced by Steinlen as much as by Chase and Henri and naturally sympathetic to French art, has vigorous and uncompromising respect for reality, which makes the *Woman with Cigarette* (Whitney Museum of American Art, New York) an American rather than a French picture. Bernard Karfiol, though born in Budapest and influenced by Picasso and his background of Greek and Egyptian art, looks through French modernism to a local, realistic kind of classicism, well

illustrated by *Summer* (Fig. 164). Henry McFee, as fully influenced by Cézanne and the cubists as Glackens was by Renoir, gives the *Crow with Peaches* (Whitney Museum of American Art, New York) tangible reality. In spite of his endeavor "to find the essential planes by right placing of color and line, and by such a just relation of shape to shape, that the canvas will be . . . not a representation of many objects interesting in themselves, but a plastic unit expressive of my understanding of the form-life of the collection of objects," [18] in spite of theories and subject matter borrowed whole from Cézanne, as in *Still Life* (Fig. 157), he achieves reality in an emotional way.

Emotional also are other painters who work in the young tradition of cubism, the old mode of Oriental art, or a mixture of XVIIIth century refinement and coal elevators, as Charles Demuth has done in *My Egypt* (Whitney Museum of American Art, New York). Preston Dickinson mixes Japanese delicacy with factories in *Industry* (Whitney Museum of American Art, New York). Charles Sheeler, trying to "suspend the forms in a vacuum," [19] seems to have been influenced by his own excellent photographs, as in *Classic Landscape* (Edsel B. Ford, Dearborn, Mich.) and *Upper Deck* (Fig. 160), or at least by the reality of details which a camera catches; his *Interior* (Whitney Museum of American Art, New York) is cubism superimposed on the definite materials of rugs, tables, and pottery.

This stylization of matter-of-fact subjects involves a sophisticated mental conception of the purpose of art. But there are other kinds of stylization, such as that of Ernest Fiene and Joseph Pollet, whose studies under Henri and Sloan, respectively, did not hamper them in absorbing the French meaning of style, with different emphases. Fiene's *Hudson Navigation Boat* and portrait of *Concetta* (Whitney Museum of American Art, New York) illustrate his intellectual conception of painting, based on his appreciation of the simple and experimental in French modernism; his thoroughly American subject matter is never treated intimately.

Joseph Pollet, on the other hand, lavishes attention on every detail in the landscape called *Neighbor Green* (Whitney Museum of American Art, New York) and reveals his emotional method, derived without intellectual reserve, it seems, from Van Gogh.

The domination of French art is thus recorded through contemporary painting with all variety and in all degrees of influence; many artists — serious, competent, and admired — have felt it. As one walks through large exhibitions of representative modern American painting, one must think of France, if only to discount what is derivative and to reveal by contrast what is native in the art of the present. It is not easy to separate these elements. The artists themselves seem unaware of any contrasting tendencies in their work. Consider the work of Alexander Brook, born in Brooklyn in 1898, a pupil of Kenneth Hayes Miller, and one of the most open personalities among present-day painters. His mind and taste are known through his excellent criticisms written for The Arts, one of which has been noted in connection with the work of John Marin. His faith in simple principles, expressed in such a statement as that a "picture when done should represent a surprising experience completed," [20] gives his work a certain amount of inevitability, of disarming sincerity and emotional conviction. He is certainly one of the valued painters working in America today. Yet his technique, his drawing, and his taste are so sympathetic to French modernism that the uninformed might easily mistake his work for that of a new discovery from abroad, influenced by Cézanne, of course, and also Vuillard, Segonzac, and Matisse, painter-poets of textures. *Children's Lunch* (Chicago Art Institute) and the portrait of *My Wife* (Fig. 159) are both very sensitively composed, richly painted, luxurious in feeling, and actually not imitative of French art. Nevertheless, without a tradition of French modernism they could not have been painted so well, as the artist himself would readily agree. In fact, Alexander Brook typifies the international artist of the day, the recorder of extra-national, extra-racial,

and extra-local truths; the subjective painter of "surprising experi-
ence," who takes what he needs to heighten his emotional life from any-
where, far or near, and from anything, exotic or commonplace.

This, of course, is the latest work in eclecticism. The modernistic
movement seems to have broken international boundaries even more
easily than Impressionism. But it is not the whole study of eclectic
tendencies in the United States. There remains a movement toward
objectivity and realism in the old sense, rather than one dealing with
light, pattern, subjectivity, and abstraction of form. And this may
eventually be seen as a movement more lasting than that derived from
post-Impressionism.

25

OLD MASTERS FROM MUNICH

A full decade before Weir, Twachtman, and Hassam began exploring
Impressionism, Shirlaw, Chase, and Duveneck were studying in Mu-
nich, where they learned to paint directly with large brushes, somewhat
in the manner of Frans Hals, and, incidentally, where they acquired
the darkened, mellow tones of old masterpieces. Frank Duveneck, born
in 1848, spent ten years in Munich developing his taste for robust,
simple planes, strong contrasts in light and dark, and rapid, spontane-
ous execution, here illustrated by the small study of *The Old Professor*
(Fig. 163). His models were Hals and Rembrandt, but he looked at
them through the eyes of a young man avid for a method of painting.
Even when he decorated the portrait of a *Young Man* (Cincinnati Art
Museum) with an XVIIth century ruff, or dressed the *Woman with For-
get-me-nots* (Cincinnati Art Museum) in a costume of similar date, his
conception remained fresh and his point of view modern. It was a pop-
ular combination of qualities. As a result of an exhibition at the Boston
Art Club in 1875, Duveneck became famous in this country and at-
tracted young artists to a new freedom of manner. Brushwork became

intrinsically important. The "big planes" stood out more importantly than details. It had previously become apparent to admirers of Civil War art that Corot's delicately toned and poetic *Orpheus* was incompletely modelled and slovenly, without technical or literary excellence.[21] After Duveneck's success, about a decade later, it was apparent to most artists that the closely finished works painted in the Düsseldorf manner were aimed in the wrong direction, toward lifelessness. Duveneck was showing the way to new life, by way of technique. Indeed the technique is almost the whole of his art, even in the study of *Squire Duveneck* (Addison Gallery of American Art, Phillips Academy, Andover, Mass.), which is one of his most intimate portraits. In his more formal pictures, as in *The Turkish Page* (Pennsylvania Academy, Philadelphia), Duveneck altered his technique to that of the Parisian academics, which was scarcely the vehicle for living thought. And this was the development of artists associated with him, whose technical facility distracted from whatever their pictures had to say and who were in danger of losing themselves in echoes of style. Duveneck buried himself as a teacher in Cincinnati at a time when Hassam, for example, was finding something new to report about light. His contribution to art was quickly made. One of his best followers, Frederic P. Vinton, did not daringly adopt his innovations in method, but contented himself with breaking up the surface reflections of the pigment, emphasizing the features, and even caricaturing them in a gentle way. The portraits of *Thomas G. Appleton* (William Sumner Appleton, Boston) and *William Warren* (Fig. 165) are typical of his sturdy work.

William M. Chase, energetically teaching, lecturing, organizing, and painting anything in any medium, after mixing the influence of Tintoretto and Velazquez on top of Munich training, became the leader of a cult of technicians. For him subject matter was negligible, provided it was compatible with a mysterious "beauty" which, often invoked, has been seldom defined — except by inference from the work of Velazquez,

chief of technicians. His primary purpose, baldly stated, was the execution of a picture, whether the subject was the young man called *The Leader* (Addison Gallery of American Art, Phillips Academy, Andover, Mass.), a *Skate and Bowl* (Pennsylvania Academy, Philadelphia), or *James McNeill Whistler* (Fig. 167). Three portraits for which Chase posed reveal the points of view from which he can be criticized. One, painted by Sargent (Fig. 166) with a quick turn of the wrist, shows an assertive, keen-minded man who has just made a sweeping gesture with his whole body; Chase the stylist is well portrayed. Another, by Eakins (John F. Braun, Merion, Pa.),[22] is the study of a dandy with a grim and dissatisfied look in his face, the artist "deficient in inner gravity," to use Frank Jewett Mather's words.[23] The third is a *Self-Portrait* (Corcoran Gallery, Washington) painted in 1915 as if echoing Sargent's work. One feels that Sargent represented him for the benefit of his contemporaries as the dashing artist Chase wanted to be. And Eakins saw through superficial style into the future. Yet this feeling of disappointment in surface excellence does not interfere with one's admiration for Chase as a teacher. Among his pupils were the men who were to carry vitality of technique deep into American art and to practice the principle stated so simply by Eakins, that "if America is to produce great painters and if young art students wish to assume a place in the history of the art of their country, their first desire should be to remain in America, to peer deeper into the heart of American life. . . ."

NOTES

1. Op. cit., Introduction.
2. Op. cit., 300. Tuckerman says Elliott studied under Trumbull, but this is denied by Col. T. B. Thorpe, a lifelong friend who wrote of Elliott in the Evening Post, published separately, no date.
3. Op. cit., 325.
4. The replica in the Metropolitan Museum, New York, is signed and dated 1858.
5. Repr., Art in America, XIX, 220.
6. Pageant of America, XII, 53.
7. Op. cit., 487.
8. Creative Art, X, 260.
9. Isham, op. cit., 315.
10. Isham, op. cit., 321.
11. Pageant of America, XII, 100.
12. Isham, op. cit., 573.
13. The Arts, XI, 294.
14. Andrew Dasburg, The Arts, IV, 279.
15. Willard Huntington Wright, The Future of Painting, 1923.
16. The Arts, XVI, 345.
17. The Arts, III, 272.
18. The Arts, IV, 251.
19. The Arts, III, 335.
20. Creative Art, V, 715.
21. Isham, op. cit., 369.
22. Repr., Arts Weekly, I, 73.
23. Pageant of America, XII, 118.

CHAPTER VII

The Struggle for Nationality

EAKINS' principle may sound old-fashioned and too simple, in the hearing of sophisticated artists of today, who have continued to study either abroad or from the imported masterpieces of modern art. In the wake of post-Impressionism the idea of a local, native art seems inconsistent with the basic theory of the new movement, that art is personal, spontaneous, and has nothing to do with citizenship, accidents of birth, and choice of residence. Many a mature artist of the present studied under Chase, for example, where he learned good craftsmanship, and then turned naturally to whatever art he admired for guidance in aesthetics. This is the normal situation today. And because of the growth of American collections, the rapidly increasing size of museums, and the number of art markets, there is no reason why he should not have the entire range of painting to study, from the primitive to the very latest productions of all countries, without going abroad. In the face of such eclecticism, mentioning nationality might seem unimportant.

Yet there are groups of American painters who, in spite of various loyalties and foreign associations, have produced pictures which do not as a class resemble the work produced in other countries. Even among the moderns there are those who, although they have, as a general rule, admired Manet, and certainly would not neglect to name him among the foremost artists, are not French in sympathy. Admiring style and strength wherever they find it, these artists, past and present, do not paint haphazardly in foreign styles. Consciously or not, they seem to be working away from European domination in taste and emphasizing the point of view of "the yeomanry of the land," the simple, realistic view

of the self-taught Copley and the independent Ralph Earl. William Sidney Mount, Winslow Homer, and Thomas Eakins, all self-taught in the largest sense, continued to work in this fashion. Some realists of to-day follow them in spirit, although admittedly there is little influence from Homer and none at all from Mount and Eakins. Instinctively ferreting for the exact and characteristic feeling of their subjects, certain modern artists, who will be discussed in the last section of this final chapter, may be considered inheritors of an artistic attitude and sharers in a modest struggle for independence. It does not seem, therefore, merely an exaggerated patriotism which prompts giving to the discussion of these painters the title, A Struggle For Nationality.

26

THE LOCAL SCENE

Breaking again the chronology as a whole, in order to appreciate the background of present-day realism, one may contrast with the average genre of the first half of the century the obviously accurate accomplishments of William Sidney Mount, who lived from 1807 to 1868 and who furnished Goupil with illustrations of everyday events to be made into engravings and lithographs. Mount evidently was less suited to the romantic artificial genre of Woodeville and Inman than to a sophisticated, realistic taste. Devoting himself to study of country people and their lives, as did Ostade, whom Allston suggested for his model, this most reserved of American genre painters belonged to the localities he painted. He did not have to search for subjects, since in every barn in his neighborhood, in every store and field, there were people doing things which he considered worth painting. Unquestionably he belonged to a generation which was affected by romantic ideals of art. But his art made little of those ideals. Instead it transcribed specific events with such knowledge and such accuracy of vision that he ele-

vated horse trading to a humanistic subject. His *Power of Music* (Century Association, New York), dated 1847, the *Goose Raffle* (Metropolitan Museum, New York), and *The Painter's Triumph* (Fig. 170), because of their solid characterizations, firm drawing, well studied light and genuine feeling, suggest comparison with Jan Steen. There is no affectation in any of the poses, or in any handling of a theme. All is related to fact. He managed to make the figures in *Bargaining for a Horse* (New York Historical Society) look not only as if they were disguising their shrewdness in nonchalant attitudes, but as if they were solid human beings, occupying a given space in a given barn-yard. His interest in technique seems to have been subordinated to visual meanings exclusively, to the point of stiffness, as in the *Couple in a Landscape* (Pennsylvania Academy, Philadelphia), where the directness and simplicity of the execution recall Morse's few excursions into out-of-door painting, as in the *View from Apple Hill* (John A. Dix, Mount Kisco, N. Y.).[1] Had Mount not been so serious a painter, striving for exactness of shape on every occasion, as is shown by a number of fine sketches in pen and ink and water color, belonging to Moses Hale Douglass, Newton Highlands, Mass., in which he recorded essential facts, he might have drifted into cuteness and humor. At least he seems to have saved from artificiality subjects, like the *Boys Caught Napping in a Field* (Mrs. John Strong, Setauket, L. I.), which contain the elements of the most sentimental kind of genre, by the process of living the scene. In a letter dated 1846, Mount wrote,[2] "I shall endeavor to copy nature as I have tried to do with truth and soberness. There has been enough written on ideality and the grand style of Art etc. to divert the artist from the true study of natural objects. Forever after let me read the volume of nature — a lecture always ready and bound by the Almighty." In this statement the painter puts himself squarely among the realists, who, from Charles Wilson Peale to Thomas Eakins, have fought shy of foreign entanglements and looked closely at the nearest facts for inspiration. As Frank

Jewett Mather has suggested,[3] one visualizes in his work the dramatis personae of Lowell's Biglow Papers, which appeared a decade after Mount's first success, treating the American public with a gentle ribbing in country dialect. With complete understanding of his subjects, Mount's humor is even more gentle; it is scarcely humor at all. Some of his sketches, mere notes of costume and pose, are amusing because of their accuracy, rather than because of the artist's intention to employ a light touch. The tone is intimate, but hard-eyed. It illumines those portraits in which the delicacy of the execution implies loving care for every configuration and contour. Ingres-like in his taste for perfection of form, as in the pencil portrait of his *Mother* (Moses Hale Douglass, Newton Highlands, Mass.), dated 1841, Mount clung to the immediate present for material, perfecting details of actions which are not necessarily deserving of immortality, according to modern tastes, but which were evidently to the artist the basic factors of his country existence. So *Dregs in the Cup* (New York Historical Society) became more than an illustration of girls at tea, and *The Tough Story* (Corcoran Gallery, Washington) more than a depiction of boredom; Mount painted the subtleties of the life he knew with vitality, if at a sometimes lazy pace. The exactness of the pale shadows thrown across the *Long Island Farm House* (Fig. 171) seem of intense importance, as Mount studied them.

It is an odd fact that in Missouri a boy, pioneering from Virginia with his parents, taught himself to see with Mount's eyes and to paint before 1845 *Fur Traders Descending the Missouri* (Metropolitan Museum, New York) as if bewitched by the misty light on the river, the sliding motion of the boat, and the reality of the cheerful traders. It was not merely instinctive skill which led George Caleb Bingham to paint in this way, since he had been to Philadelphia about 1837 [4] to study at the Pennsylvania Academy, where he might possibly have seen some of Krimmel's work (Fig. 92). At any rate he might evidently have shared Dunlap's view that Krimmel had "the style in which Wilkie excelled

and the humor which had inspired the pencil of Hogarth," [5] since he approached art from Krimmel's point of view. Dunlap had seen a Philadelphia election scene by Krimmel which may have suggested to Bingham a similar subject, even though Krimmel himself had been dead sixteen years. Before a second trip to Philadelphia in 1853–54 Bingham painted *Daniel Boone Coming Through Cumberland Gap* (Washington University, St. Louis, Mo.) with the skill of a student of European art. Probably he had been busy with engravings, copying compositions and groups. The strong light on Daniel Boone is the light used by Louis Le Nain two centuries before. In *Stump Speaking* (Fig. 173) Bingham seems to have adapted a Teniers-like design to a local subject, in the same way that Mount adapted Jan Steen to a Long Island barnyard. But by 1857 Bingham forgot the XVIIth century masters in favor of their XIXth century German imitators, who at Düsseldorf taught him to refine and polish subjects which are essentially as spontaneous and rowdy as *The Jolly Flatboatmen* (Mercantile Library Association, St. Louis, Mo.). His talent seems not to have survived his political career as State Treasurer and unsuccessful candidate for Congress. He made his living chiefly by portrait painting; but none of his portraits — not even that of *Dr. Benoist Troost* (Board of Education, Kansas City), painted in 1859, which is obviously a "speaking likeness" — contains the life which is conveyed by merely a glimpse down the river, a soaring sky, or the set expression on the face of a man listening. Bingham's best was a knowledge of the everyday thoughts and feelings of his fellow-citizens. And in this respect he is fully the equal of Mount.

But neither Bingham nor Mount could rival an obscure, itinerant wood carver and portraitist who, settling down at Pittsburgh in the middle of the century, turned suddenly on contemporary life a sophisticated, sardonic, and twinkling eye. Born in 1815, David G. Blythe was evidently gifted with a temperament akin to Quidor's. But whereas Quidor retreated into literature for inspiration, Blythe went to the *Post*

Office (Fig. 136) for action and watched the fight for letters at the General Delivery Window, or stopped to chuckle at *Dry Goods and Notions* (The Duquesne Club, Pittsburgh). Whatever his training may have been, he ended by painting roisterously in the combined styles of Ostade and Brouwer. His little boys are not cherubs, but sneak thieves; and his noble citizens are sly carpet-baggers. If it is strange that little has been made till recently of the work of Bingham, and nothing of the work of Mount, it is stranger still that Blythe has remained unknown outside of Pittsburgh, since his genre has all the racy vigor which is lacking in the "sub-artistic" productions of Brown and the technical feats of Woodeville and Wood.

Against this mid-century background of Long Island charm, Missouri truth, and Pittsburgh satire, the young Winslow Homer stands out as an impersonal recorder of Civil War incidents. Mount and Bingham were still living, and Blythe had just died, when Homer had an immediate success with *Prisoners from the Front* (Metropolitan Museum, New York), exhibited at the National Academy in 1865. In view of the freshness of the subject, and the illustrator's simple point of view, it must then have been difficult to see that a great and dramatic artist, who saw meanings clearly and turned his full energy to their accurate, emphatic statement, was in the making. Born in 1836, Homer was twenty-three before he received slight formal instruction in art at the Academy of Design; he was a mature draftsman when he painted *Prisoners from the Front*. Yet this was only the beginning of his art. Had he stopped there, with the quiet observation of *Army Teamsters* (Harold T. Pulsifer, lent to the Walker Art Gallery, Bowdoin College, Brunswick, Me.), *Playing Old Soldier* (Murray Ryder, lent to the L. D. M. Sweat Memorial Art Museum, Portland, Me.), or *Rainy Day in Camp* (Fig. 172), we should have had, as Frank Jewett Mather said,[6] merely a more rugged Eastman Johnson — the Johnson of *Corn Husking* (Versions in Syracuse Museum of Fine Arts, Metropolitan Museum, New York, and

Chicago Art Institute). From the study of men more or less in action, during war time, he soon turned to quiet, country subjects, some of them like those Mount had painted, and done in Mount's thorough, un-affected way with simple colors; subjects such as the *Unruly Calf* (Brook-lyn Museum, New York), and the *Croquet Players* (William Sumner Appleton, Boston), whose stiff, crinkled skirts are sharply drawn in a hard sunlight. Then he moved to the sea-coast, where the dramatics of war and the charm of peace might well have seemed inconsequential. His technique, which had been chiefly a matter of drawing and shading in occasionally harsh tones, was inadequate for the liquid movement of the sea. And it was liquidity which he studied in *A Summer Night* (Lux-embourg Gallery, Paris), painted in 1880, with the swirling skirts of the dancers set against the shimmer of moonlight on a restless ocean, chal-lenging him to new skill and subtlety of values. He still held to a genre painter's ideal, but gave the life and action of people less importance in the scene, without, however, lessening their intensity; instead of sub-ordinating his interest in the figure, he rather increased the importance of backgrounds. On a trip abroad he painted the fine vista of a *French Farm*,[7] concentrating on effects of softened light, and painting in recol-lection the poetic *Hark! the Lark* (Milwaukee Art Gallery) with great simplicity.

It is impossible to be exact in tracing Homer's development from war correspondent to the painter of Bermuda seas, and from hard, pre-cise draftsman in pen and ink to the summary, exact water colorist, blocking in the major forms with impetuous sureness; because his one, clearly enunciated purpose was merely a general one: to record ex-actly what he saw. "When I have selected the thing carefully," he said,[8] "I paint it exactly as it appears." So one must believe, especially when gazing at *Woodman and Fallen Tree* (Fig. 174), *The Guide* (John T. Spaulding, Boston), *Shore and Surf* (Metropolitan Museum, New York), *Under the Cocoanut Palm* (Fogg Museum, Cambridge, Mass.), *Deer Drinking*

(Mrs. J. M. Sears, Boston),[9] and many others, where the vivid shadows, dark horizons, active bodies, burnt stumps, and every rapidly stamped detail reveal the prosaic realist at his best. Yet Homer's results are not prosaic. Look at the fox and crows, called *Winter* (Pennsylvania Academy, Philadelphia), and say what exact appearances make the design so stirring. What kind of careful selection makes *Cannon Rock* (Metropolitan Museum, New York) a lifting movement? Obviously Homer's realism was applied with visionary force and compelling sense of mood. Although he is said to have boasted in a modest way about his skill in recording the varying degrees of tan on a canoeist's arm, it is safe to say that none but students of technique would ever notice the alterations in shade from the hand to the forearm and the upper arm; it is the rush, the swerve, and the descent of the canoeist — the broadest elements of realism — which are truly remarkable in his work.

Perhaps Homer was unconscious of aesthetic feelings and painted instinctively fine designs without being aware that he was simplifying, arranging, altering, and even inventing details. But since it is impossible to believe that all his subjects were seen as they are represented, one must assume that his interest in making a picture took an aesthetic form. Indeed, his excursion to England seems to have opened a way to painting ideas rather than facts and sentiments rather than events. There is, for example, a large share of melodramatic sentiment in *The Life Line* (Fig. 175), dated 1884, in *Eight Bells* (Boston Museum of Fine Arts), and in *The Gulf Stream* (Metropolitan Museum, New York), painted in 1899. The last work, with its neat, impersonal painting of the negro and the boat, may not at first glance seem to contain sentiment. But it does contain obviously an imaginative element different from that in Homer's records of sea and rocks. *The Gulf Stream* is a "program piece" and allows one to glimpse the artist's mind, toying to some degree with an idea of tragic suffering. That it is a shy mind, only letting itself out in communion with his work, does not lessen its strength

and masculinity. Like Mount, and like Thomas Eakins, who scorned aesthetics as such, taking refuge in the phrase, "That's the way it was," Homer seems today less real than his work, and less clear as a person than, for instance, Ralph Earl, about whom little is actually known, or Charles Wilson Peale. His scope was, of course, much greater than that of Ryder, his subjects more varied, more numerous; yet Ryder the silent dreamer seems a knowable man and more familiar than Homer who tells of a thousand things he has seen and done. This exalted impersonality and emotional reserve, suggested in Mount, climaxed in Homer and Eakins, suggests one characteristic of XIXth century painting which cannot be traced to foreign influence. As in the previous century, and the controlled realism of Copley, Earl, and the elder Peale, there is no explanation for its appearance in a particularized form other than a broad coincidence of taste and background. Although birth seemingly has little to do with it, since several artists of similar impersonality, like Jarvis, were actually born in England, the effect of American residence, of American concepts of life, and of American habits seems to have resulted in an American type of artist, defined by the local character of his paintings, whether the pictures were of people, landscapes, or events. Of course, among these painters of local character Homer is unique, because he remained a painter of the most specific kinds of events, such as the fish leaping from the water, the palm whipping the wind, and all the incidents which a keen eye or a sense of weather, of weight, and of distance appreciates. The same kind of local character studied in people — subject matter, which Homer did not attempt — carries one into a discussion of Thomas Eakins, the portrait painter, who did for human beings what Homer did for the sea and the traveller.

27

THE SCIENCE OF THOMAS EAKINS

We are still in a period of eclectic taste. At the time of Duveneck's first success in Boston, Thomas Eakins, recently returned from his schooling under Gérôme and a trip to Spain, had completed his first important canvas, *The Gross Clinic* (Jefferson Medical College, Philadelphia), dated 1875. He was painting home scenes and portraits of his family, rowing pictures, and minutely observed sketches, which show no real dependence on the work of other artists. As Lloyd Goodrich has shown,[10] Eakins discovered early in his student days that he would have to work out for himself the unfamiliar problems of color, light, and the handling of oil. Gérôme and Bonnat he respected as teachers, but found inadequate for what he wished to do. The Spanish art he studied in Madrid, "so good, so strong, so reasonable, so free from every affectation," he described in letters[11] as "what I always thought ought to have been done and what did not seem to me impossible." This brief quotation reveals the temper of the realistic artist at the very beginning of his independent career. Although the portrait of *Margaret in Skating Costume* (Pennsylvania Museum, Philadelphia), painted in 1871, seems to be planned and drawn in the manner of an early Velazquez, the brushwork is without bravura, unaffected, and even clumsy in its avoidance of an effect of technique. Eakins had already written from abroad, "I know perfectly what I am doing and can run my modelling, without polishing or hiding, or sneaking it away to the end."[12] In the first and most stunning of the rowing pictures, *Max Schmitt in a Single Scull* (Fig. 179), also painted in 1871, the limpid light, the exact drawing of the trees on the bank, the literal point of view, all recall something of Asher B. Durand's landscapes or the early work of Wyant before he came under the influence of the Barbizon painters. Yet there is nothing to show that Eakins admired, or even knew, the work of the Hudson

River School. Certainly his entire training abroad and his own ambitions, quoted above, were not in sympathy with the American school of early landscapists. One is forced to believe that Eakins instinctively shared their taste and, in the early seventies, was showing that birth and background made him an American artist distinctly not influenced by French, English, Italian, or German artistry.

When Eakins presented to the Metropolitan Museum in 1881 a carefully detailed study of *Chess Players*, painted five years earlier, Eastman Johnson was working in the same vein, observing with the greatest care the *Two Men* already mentioned (section 23). That Johnson and Eakins, differing to such a degree in their technical training, should produce pictures with similar points of view and techniques, is one of the clearest bits of evidence of a national trend in American art. That E. L. Henry, trained in Paris under Gleyre, the academician, and Courbet, the iconoclast, had painted genre with the same insistence on honest detail, as in *Old Westover Mansion* (Corcoran Gallery, Washington), and that Winslow Homer, self-taught, had painted *Prisoners from the Front*, contrasting in its detailed realism with the sentimental, nonsubtle genre of J. G. Brown and Woodeville, corroborate this evidence. One might even go back another generation and compare with the same results the careful, sturdy realism of William Sidney Mount, illustrated by *The Painter's Triumph* (Fig. 170), and Eakins' search for the "solid, springy and strong," illustrated by *Elizabeth at the Piano* (Addison Gallery of American Art, Phillips Academy, Andover, Mass.) or *William Rush Carving the Allegorical Figure* (Pennsylvania Museum, Philadelphia).

Thus from the very beginning of his professional career, Eakins may be considered as an American type of artist. And because of his intense preoccupation with objective character he soon became the arch-example of what XIXth century America could produce in the way of an unromantic, scientifically realistic painter. Working steadily in his own

way, studying perspective, anatomy, and movement with the logical thoroughness of an engineer and a doctor, he produced pictures which give new meaning to realism. The *Crucifixion* (Pennsylvania Museum, Philadelphia) is a nearly dead figure, glaring in the sun; *The Pathetic Song* (Corcoran Gallery, Washington) is a voice materialized from a sculpturesque figure in a party dress; the portrait of *Prof. Rowland* (Addison Gallery of American Art, Phillips Academy, Andover, Mass.) is the essence of a scientific attitude. It was not only the surface reality which Eakins studied, it was the complex reality of mind, habit, and character which he interpreted through surface appearances. With constant practice he developed sureness of insight, as well as of hand, so that his portraits dating from about 1890 to 1910 are powerful analyses of people and human studies of the first importance. Heads, bodies, hands, and clothes, gestures and poses, convey meanings; drawing, design, and color emphasize these meanings. His mind was deliberate, impersonal, and judicial. Yet the man who worked out mathematically the perspective of a boat sailing and the laws of bas-relief, who wrote a paper on "The Differential Action of Certain Muscles Passing More than One Joint," and who was apparently one of the pioneers in the theory of motion picture photography,[13] utilized a technique which was not coldly impersonal, but sensitive and variable. In even the most ruthless interpretation of character, such as the sketch of *General E. Burd Grubb* (Reginald Marsh, New York), Eakins reveals himself through his brush-work as a kind of psychiatrist, outwardly laconic and even-tempered, inwardly rushing his mind and senses over the problem that utterly absorbed him. Although his style could never be called intimate, it erected no barriers to personal feeling and allows the spectator to glimpse a rather reserved person subordinated to his own intellectual activity.

Evidently the realism of other American painters had a different emphasis. Copley, for instance, seems to have relied in his strongest

work on an instinct for clarity; his portraits of *Mrs. Gill* (Tate Gallery, London), *Mrs. Bourne* (Metropolitan Museum, New York), and *Mrs. Appleton* (Fogg Museum, Cambridge, Mass.) are some of the most telling records of individual appearance, poise, and social position in all art. Compared to these, Eakins' portraits of *Mrs. Edith Mahon* (Smith College, Northampton, Mass.), *Signora Gomez D'Arza* (Metropolitan Museum, New York), and *Clara* (The Louvre, Paris) seem more truly penetrating. Eakins in his late work thus went beyond Copley's amiable acceptance of surface facts and studied overtones of personality, although in his earlier portraits, like that of *Mrs. Letitia Wilson Jordan Bacon* (Brooklyn Museum, New York), dated 1888, which can be compared with Copley's pastel of *Mrs. Joseph Green* (Boston Museum), he parallels Copley in scope almost exactly. When in 1900 he painted *The Thinker* (Metropolitan Museum, New York), Eakins produced a portrait which, compared to one of Copley's finest full lengths, the portrait of *Jeremiah Lee* (Thomas Amory Lee, Boston), stands out as a warm and sympathetic work. Eakins' interest was focused on the general meaning of the particular details of his sitter, instead of on the details themselves; and he therefore painted a figure which stands for an American type.

As one looks back on the realistic portraits by Charles Wilson Peale and Ralph Earl, it may be clear that Eakins had no monopoly in his ability to generalize about details. It does seem true, however, that neither Peale nor Earl had Eakins' intellectual approach to reality. Or, in other words, neither Peale nor Earl came near to a Rembrandtesque ideal of portraiture; whereas Eakins' portraits do suggest a solid, spiritual, and timeless poise, as does the portrait of *Mrs. Mary Hallock Greenwalt* (Fig. 177), dated 1903. This is readily explained by Eakins' recorded admiration for the great Dutchman,[14] although the fact that Eakins in his notebooks often coupled Rembrandt's name with Ribera's indicates the limits of his admiration. Probably Eakins appreciated any artist most for the probity of his methods. He might have appre-

ciated Smibert in this way, though Smibert seems not to have appreciated Rembrandt; the foremost American realists of the XVIIIth century were not deeply intellectual.

In this connection, the point of view of Eakins' contemporaries must not be overlooked. A public appreciative of Chase's brilliant technique might naturally ignore paintings by a man who thought that respectability in art was appalling.[15] Isham, writing sensitively in 1905 about modern portrait painters,[16] believed that Eakins "fails of the popular appreciation that he merits because of his neglect of the beauties and graces of painting. . . . The eye longs for beauty of surface, richness of impasto, or transparent depths of shadow. . . . Compare his work with that of Beckwith and see how much more effective was the training given by Carolus-Duran." The difficulty was that sitters, Academy officials, and professional critics did compare Eakins' work with the work of stylists. They did not think always of J. Carroll Beckwith, prize and docile pupil of Carolus-Duran, as Frank Jewett Mather called him,[17] but of John Singer Sargent, who had more to say about people than had Beckwith, and a more brilliant technique to convey his meaning. Isham might with greater fairness have contrasted Eakins' freedom from "any foreign superficialities" with Sargent's "amazing jugglery" and long foreign residence.

Lloyd Goodrich has done so, making the distinction between Sargent's purely visual realism and Eakins' intellectual realism.[18] This is, of course, the basic difference between them and the one that is important, rather than that they studied under different systems. Carolus-Duran taught the necessity of painting the salient character of the model directly, without preliminary drawing; he believed in the value of fresh impressions. And John Singer Sargent, painter of a vivid transcript of life, "with all its changing effects struck instantly upon the canvas," as Isham said,[19] is the perfect contrast to Eakins, master of anatomical dissections.

Sargent began his capacious, successful career with a sweeping facility which gives his work its distinction. Precociously he achieved immediate popularity in 1877, at the age of twenty-one, with his Salon portrait of *Carolus-Duran* (The Luxembourg, Paris), an elegant, facile, accomplished, and illuminating work. In the Salon of 1882 he exhibited *El Jaleo* (Fenway Court, Boston), which captures the verve, rhythm, and melodramatic effect of a Spanish dance without hesitation, without difficulty, and, it must be admitted, without comment of any kind from the painter; the tour de force of making a life-size sketch with eight other figures in the background appears almost automatic. In 1884 he exhibited the portrait of *Mme. Gautreau* (Metropolitan Museum, New York); "C'est Japonais," wrote Albert Wolff, summing up its novelty of pose and pattern. That year he settled in London, becoming the most fashionable painter of English society for many years and "the first portrait painter since Reynolds and Gainsborough," as Isham concludes.[20] With devastating clarity he painted what he saw, from life, without alteration of specific appearances, making records of moments. "If the statesman bends his brows and puffs up his chest," noted Isham,[21] "he is displayed not as a thunderbolt of debate, but as a pompous ass." The *Wertheimer* portraits (Tate Gallery, London) are marvels of such records.

Yet the influence of English style apparently crept upon Sargent and robbed him of his chief asset, accuracy of eye. In certain portraits, like *Lady Warwick and her Son* (Worcester Art Museum), dated 1905, he slips into exaggerated hauteur, elongated elegance, affected poise, and the same stylizations that run through English portraiture from the time of Lely to the time of Lawrence. If he had done so sarcastically, the effect might have been different. As it is, all the technique at his command is frittered away on artificiality, to such a degree that Walter Pach was justified in reproducing Sargent's portrait of *Lady Warwick* on the cover of his book, Ananias, the False Artist. Sargent himself seems to have

been aware of his position. After giving the public what it wanted — "rotten stuff," he called it — he gave up portraiture about 1910 and tried to regain his artistic soul by way of water colors, painted for pleasure. He had performed studious miracles in mural painting, making the history of religion in the Boston Public Library a standard for formal decoration. He was to perform new technical miracles before his death in 1925 with the Boston Museum's classical allegories. But the undermining of his taste was serious, as is evident in the *War Memorial* (Widener Library, Harvard University, Cambridge, Mass.), which combines the effects of a Liberty Loan poster in one panel and an adaptation of the High Renaissance in the other. His water colors reveal his limitations in every direction; they lack solidity, selection, and clarity, especially when compared with his early oils. The reality he painted was literally superficial and ephemeral. His magnificent personality, which Eakins found so pleasant, was overridden by pretty feminine effects, the triumph of grace over rightness. At his best, Sargent was positive in his improvisations, as in the portrait of *Edwin Booth* (Players' Club, New York). Yet even so hauntingly real a likeness seems thin, delicate, and unsubstantial when compared to Eakins' portrait of *John McLure Hamilton* (Fig. 176), which is casually posed and lighted in the same way. Although Hamilton must have been a rather precise and dainty person, Eakins conveys that information in definite, masculine touches. Sargent's appreciation of Booth's presence is femininely recorded in fleeting touches which, no matter how skillful and evocative, remain feminine and merely approximate.

Thus the fashionable portrait painters who have worked Sargent's field deal in surfaces and techniques rather than in characters. Without Sargent's precosity they seem to be merely poseurs. It seems obvious that only a painter who can draw with Sargent's precision and model with his mind, if not with his brushes, should attempt the short-cuts of Sargent's method. But the short-cuts appeal chiefly to those incapable

of the long way to substance. One exception must be noted in the intelligent work of Charles Hopkinson, who, although a pupil of Denman Ross and influenced by the theories of Jay Hambidge, paints in a fresh, spontaneous manner seemingly derived from Sargent. His portrait of *Prof. Joseph H. Beale* (Fig. 169), vigorous and solid in modelling, is a dramatization of character which makes the work of other trained portraitists, Cecilia Beaux, for example, as in the portrait of *Mrs. Dupont* (Boston Museum of Fine Arts), seem unfinished, slight, and immaterial.

<div align="center">

28

MANET AND THE NEW REALISM

</div>

Carolus-Duran was, of course, not alone in teaching the value of spontaneous impressions, of "values" and accents. Duveneck had learned the same lessons from his study of Hals. Chase, under the same stimulation, chose Velazquez for his ideal. And Chase, along with J. Alden Weir, admired Manet to the extent of seeing that the *Woman with a Parrot* and the *Boy with a Sword* were donated to the Metropolitan Museum in 1889.[22] The fact is that whether young students went to Carolus-Duran for values, or to Munich for Dutch and Flemish techniques of the XVIIth century, many of them had some relationship, at more or less distance, to Manet. Perhaps this was so chiefly because of the coincidence that Manet paralleled their ambitions in a spectacular, independent manner, painting broad planes and bold lights with freedom. He seems to have summed up the strongest tendency of the period during his activity in Paris from 1850 to 1870, with an eclectic interest in a style which was not dry, labored, and minute, as it was in the academies. Although many Americans followed this trend without benefit of Manet, just as Eakins broke away from the academic because of his own convictions, some of them found in Manet's strength a new emphasis on realism, massing of forms, and vigor of ideas, rather than on studio vision and surface neatness.

Robert Henri and George Luks did so. Henri had a most eclectic taste, which included admiration for Rembrandt, Courbet, Goya, and Whistler as well as frank dependence on Manet. In a book of criticism, gossip, and ideals,[23] Henri gives one the hurry, the vigor, and the confusion of the new realism thus inspired. As Royal Cortissoz phrased it,[24] the ebullience of life is in his portrayals of "any number of racial physiognomies." With ebullience Henri looked at the work of Eakins, saying, "Forget for a moment your school, forget the fashion . . . you will find yourself, through the works, in close contact with a man who was a man, strong, profound and honest, and above all, one who attained the reality of beauty in matter as it is . . . who had no need to falsify to make romantic, or to sentimentalise to make beautiful." Henri's paintings, like his writing, are enthusiastic and unfalsified, romantic and "strong," hurried and influential. Sometimes genre-like in their direct interest in the picturesque, as in the portrait of *Herself* (Chicago Art Institute), sometimes melodramatic, as in the *Dramatic Dancer* (Fig. 168) and the *Snow Scene*,[25] his painting is always lively, as in Sargent's early work. Like Sargent, Henri stated with an American bluntness the facts which he observed, but he painted with abandon where Sargent painted craftily. The influence of Manet appears in his large constructional brushwork, in the especially technical dexterity of the portrait of *Tom Cafferty* (Rochester Memorial Gallery, Rochester, N. Y.).

George Luks was more exclusively sympathetic to Manet's style, and more exclusively American in subject matter. He was frankly a genre painter, probably because of his Düsseldorf training. Full of gusto and humor, he gave to a gay specimen of the slums the title of *Duchess* (Metropolitan Museum, New York). Yet he could pull out the tremolo stop on occasion, as in *Little Madonna* (Fig. 178). His triumph is the combination of Manet's breadth and directness with his own curiosity in incidental events — the glimpse of a sly child, an old "soak," a gesture or a

movement. One of his most successful glimpses, *The Spielers* (Addison Gallery of American Art, Phillips Academy, Andover, Mass.), is a poetic interpretation of children dancing. Like Henri he passed on to his pupils a respect for the realities of time and place, and a technique which out-blustered difficulties of drawing and modelling. Aside from a few Manet-like studies, of which the *Czecho-Slovak Chieftain* (Newark Museum) is one,[26] he seems thoroughly involved in the life he led, careless of conventions, and avid for sensations.

It was the next generation of Manet followers who brought into the art gallery the circuses, prize fights, tumble-down architecture, cheap restaurants, and factories which were the vehicle for their aesthetic convictions. That the convictions were still those of Manet might be overlooked because of the novelty of the subject matter. One can imagine the reactions to such themes of the conservatives who had condemned Eakins for his *Gross Clinic*, who believed that "to sensitive and instinctively artistic natures such a treatment as this one, of such a subject, must be felt as a degradation of art." [27] But the early XXth century admired strength, even as it squirmed. Whether or not it was the effect of greater familiarity with the work of the Dutch and Spanish realists, or the effect of coarser techniques upon subject interest, there was a reaction from intellectual ideals to the stimulation of the unexpected. Painters deserted the noble womanhood of Abbot Thayer to attend with George Bellows the *Stag at Sharkey's* (Cleveland Museum). The sensibilities of women and children no longer set the boundaries of subject matter; it was the headstrong tastes of young men finding freedom in the arts.

John Sloan, born in 1871, and a person as independent as the Society he organized in 1917 with the slogan, "No jury, no prizes," began his career as an illustrator, paralleling Daumier and Gavarni in their search for exact and freely transcribed characterizations of reality. A friend of Henri and the only member of The Eight, the advance guard

of modernism in America,[28] who was not actually a student from abroad, Sloan nevertheless adopted Manet most completely, recording in *The Wake of the Ferry* (Phillips Memorial Gallery, Washington) his acceptance of dirty weather, almost exactly as Manet had painted it. *Pigeons* (Fig. 181), dated 1910, *McSorley's Bar* (Detroit Institute of Arts), painted in 1912, and prints such as *Roofs, Summer Night*, 1916, and *Sunday — Drying Their Hair*, 1923, contain his aesthetic ideal of a masculine, realistic, vigorous art.

He is even more direct than George Bellows, who was born ten years later and indelibly marked by what Royal Cortissoz has called [29] "recondite theories of design." The mixture of Manet, as taught by Henri in New York, and "dynamic symmetry," as taught by J. Hambidge, seems to have resulted in more melodrama than realism, more dash and vim than meaning. Bellows painted the *Crucifixion* [30] with the same hoarse-voiced relish that he painted the *Dempsey-Firpo Fight* (Whitney Museum of American Art, New York). He constructed the stage setting of *Edith Cavell* [31] with the same deliberation that he constructed the portrait of *Emma in Black Print* (John T. Spaulding, Boston). But his enthusiasm flared more potently than his theories; and his admirers can find in *Up the Hudson* (Metropolitan Museum, New York) and *Forty-two Kids* (Fig. 182) a gusty strength which is the epitome of the new realism.

Compared to Bellows, his friends Eugene Speicher and Leon Kroll must seem mild and even academic in their efforts. Suavity takes the place of ruthless energy in their work, perhaps because of other influences from abroad. At least Kroll's *Babette* (Whitney Museum of American Art, New York) recalls the work of Laurens, the academician, while Speicher's portrait of *Sara Rivers* (Corcoran Gallery, Washington) recalls Renoir to a slight degree. In both cases, craftsmanship seems emphasized above meaning; and this is especially true of Speicher, who obtains luxurious textures with apparent ease, as in the *Torso of Hilda* (Fig. 184). This is exceptional among the pupils of Henri, for

whom the strength of the impression was paramount. Gifford Beal, pupil of Chase and slightly older than Bellows, establishes the norm with his boldly drawn and unemotional *Fisherman* (Whitney Museum of American Art, New York) and his *Albany Boat* (Fig. 180). Rockwell Kent, gathering momentum from various sources of strong painting — from Chase, Henri, Abbot Thayer, and even Winslow Homer, and Blake — succeeds with unconquerable energy in blending these strangely assorted influences, producing large patterns, broad movements, and intellectual ideas with little emotion. *Toilers of the Sea* (Adolph Lewisohn, New York), painted in the style of a Homer water color in 1907, and *Voyaging* (Phillips Memorial Gallery, Washington), painted in 1923, with its dream figure suspended over pyramids and a square-rigged ship, show his restlessness, which, though a long way from Manet, is characteristic of the new realism. Thoroughly American in his voracious energy, he stands, as does Bellows, for an art which is almost entirely reportorial and coldly vigorous. His masterpiece of clear painting is *Mount Equinox, Winter* (Fig. 183).

Edward Hopper, a more austere personality, has developed out of Henri with a special concern for the "melancholy relics of the Age of Innocence," as Suzanne La Follette [32] calls the old houses, like the *Libby House* (Fogg Museum, Cambridge, Mass.), which he has painted with impersonal thoroughness, seeking, as he has said,[33] "to grasp again the surprise and accidents of nature." Hopper's development was slow, and his success has little to do with the "intimate and sympathetic study of moods" which he has envisaged in the painting of the future. His *Highland Light* (Fogg Museum, Cambridge, Mass.), the *Tables for Ladies* (Fig. 185), and *Early Sunday Morning* (Whitney Museum of American Art, New York) are severe, self-contained, and impersonal records of facts which he has observed. As Guy Pène Du Bois has put it,[34] he is "in search of harmony or peace — a noiseless architectural world whose solid beauty of line and mass will be unblemished, unspoilt by the im-

pertinent presence of so much sloppier, since so much less dignified, people." Yet Hopper's development seems to be directed away from this impersonal world toward "the intensely emotional and personal vision of the American scene" which he has admired [35] in the work of Charles Burchfield. Indeed, Hopper's water color of the *Adams House*,[36] painted in 1928, not only is less austere than his earlier work, it is perhaps unconsciously a variation on the design of Burchfield's *House by a Railroad*,[37] and a highly emotional record of the commonplace. With sincere appreciation Hopper has noted [38] about one of Burchfield's pictures, "There is no too cold detachment here. The thing was seen. Time was arrested. And we re-live again the thrill, transposed by mind into the parallel of art." One suspects that here is the Hopper of the immediate future, slowly working away from still-life and "decorative calligraphy," which is but another term for stylization. Searching for "the thrill," the human meaning in art, Hopper seems to represent a transition from the sometimes impersonal dash and vitality of the Manet-inspired realists to the phenomenon of what can be called American modernism, the instinctive, subjective acceptance of reality in its broadest sense, involving research among overtones of personal feeling and at the same time an intense effort to generalize those feelings.

29

AMERICAN MODERNISM

The word "modernism" is perhaps too loosely used by critics and artists to have much value in this connection. To the critic it means, if it means anything tangible, the result of the post-Impressionistic movement in France. But to the artist it may mean merely life, air, reality, sincerity. It has been said [39] that "thanks to the moderns we are slowly coming to look for meaning not in the objects that the artist represents, but in the quality of form and color that is in his representation." And this applies

obviously to French modernism as well as to the abstractions of the Maine coast (Fig. 156) and New York streets in which Marin sums up his battle for existence, and to the glowing abstractions of flowers and buildings in which O'Keeffe records her search for poetic life (Fig. 162). But it seems to be no less true that "the quality of form and color" in Winslow Homer's representations (Fig. 174) conveys aesthetic meaning for appreciators of modernism, even though Homer himself looked conscientiously for meaning in the objects themselves, and took great pains to make the qualities in his painting correspond to those in the objects. Consequently modernism, from one point of view at least, seems to be not merely a conscious effort to get down to the essentials of art, by way of abstraction; it may also mean the unconscious aim of craftsmen who feel a necessity for doing a neat job, for eliminating, coordinating, and heightening their records of experience, just as Homer seems unconsciously to have tampered with the photographic appearances of objects in order to record his blunt, masculine impressions of the blueness of the sea or the satisfaction of a successful fisherman. From this point of view modernism is not so much the saving grace of contemporary art as a time-honored demand for honest records of the values of experiences, as well as of appearances. Admirers of sophisticatedly painted post-Impressionistic still-lifes occasionally admit this point of view, as when they appreciate the blunt, crude records of American Folk Art, the bland likenesses painted by anonymous amateurs of the early part of the last century, the cigar store Indians, ship carvings, decorative paintings on glass and textiles, and the meticulous, expensive, painfully worked pictures of the recently deceased Pittsburgh house painter, John Kane, which are now, or have recently been, popular. The very lack of skill and the very simplicity of character make Folk Art, whether new or old, exceptionally attractive to admirers of post-Impressionism, who are fully conscious of their own sophistication. Yet the fact remains that the amateurs, and even the most skillful of the older professionals, were

probably not interested in the intrinsic meaning of form and color; they were merely concerned with objective meanings and in adapting their techniques to those meanings.

Among the artists of the immediate present, Boardman Robinson, Thomas Benton, "Pop" Hart, Charles Burchfield, Grant Wood, Reginald Marsh, Molly Luce, John Steuart Curry, and others may be included together under the heading, American Modernism, because of their realistic points of view, their neglect of post-Impressionistic stylization, and their refusal to divorce form and color from representation. They cannot properly be included among the realists who derived from Manet, since they are less concerned with the surface appearance of actions and scenes than with their own experience in such scenes. Obviously they are not dominated by French art, even when they have acquired French habits in the laying on of pigment. Their spiritual predecessors in a realistic, expository kind of painting are Homer, Eastman Johnson, Mount, and even the great portraitists, from Eakins back to the youthful Copley, who also believed that " the likeness" was the main part of excellence in art. Some of them, like Doris Lee, whose bustling view of a *Thanksgiving* kitchen (Walker Galleries, Inc., New York) won a prize at Chicago, seem to renew the almost grotesque realism of David G. Blythe.

Naturally these moderns are not self-conscious of their position, even when aware of certain aims. Thomas Benton has stated [40] his concern for linear and cubic movements in design, "the existence of certain facts and certain conclusions of a mechanical nature . . . which may form the basis of a working analytical principle"; and his paintings show the influence of his concern for a kind of realistic cubism. But this does not deny him a place among the independent American painters of today. Charles Burchfield, according to the catalogue of one of his exhibitions,[41] attempted in a certain picture "to express a childhood emotion — a rainy winter night — the churchbell is ringing and it terri-

fies me — the bell ringing motive reaches out and saturates the rainy sky." In spite of the romantic point of view, Burchfield, like Benton, tries to generalize a particular experience and to illustrate a unique meaning in such a way that it becomes common property; they both follow Winslow Homer in making the qualities of form and color correspond with a most realistic meaning.

Benton's torturous but outspoken murals of everyday scenes in the New School for Social Research, which C. Adolph Glassgold called [42] "as complete a picture of the kaleidoscopic vertigo of the American temper as the news reel or the illustrated tabloid," are cubistic only in arrangement, not in idea; the details are vivid; the characters are accurate. In the study of an old couple at table, called *The Meal* (Whitney Museum of American Art, New York), and in the *Cotton Pickers* (Fig. 186), Benton frankly employed a post-Impressionistic manner of simplified modelling and again revealed his interest in cubical form; but the meaning of his pictures and the illustrator's insistence on the local character of his mid-western and southern subjects have nothing to do with France. Nor is it merely a direct transfer of what one might feel in the presence of the subject. Benton, especially in the murals for the Library of the Whitney Museum, has generalized his personal experience and evidently has attempted to get at a poetic truth beneath surface reality.

Boardman Robinson, born in 1876, thirteen years earlier than Benton, also attempts to penetrate the surface of scenic realism and combines spiritual ideals with a crafty dependence on French technique. In his series of murals on the history of trade (Kaufmann's Department Stores, Pittsburgh) he subordinated details, about which he probably knew nothing, to an intellectual arrangement of figures, as in *The Portuguese in India*. Scenes he might easily have visualized with more realism, like the *Clipper Ship Era*, he reduced to a casual pattern of warehouses and merchandise, making these faintly modernistic forms the back-

ground for his real interest, which is the people of the scene — the old sailor, the forceful owner, the calm captain, and the worn stevedore. His work thus seems to be American in character, in spite of the formality of his methods. Without adopting the local American scene for subject — one of the "infantile devices of patriots," as Guy Pène Du Bois bitterly said [43] — Robinson has succeeded in illustrating a local theme with clarity and as much realism as one could expect from idealized portraits. A satirical sketch entitled *The Club* (Whitney Museum of American Art, New York) shows how vigorous the artist can be, given a contemporary theme. The *Sermon on the Mount* (Eugene Schoen, Inc., New York), painted in 1926, reveals a struggle to subordinate every detail to a conception of gravity and deep thought, as told by the expressions on the faces and the poses of the Apostles. In spite of eliminations, it is plain that Robinson sought real people to convey his own particular symbolization of the subject.

Of course, one does not expect only American subjects in the work of contemporary artists; it is immaterial to discuss American art merely from the point of view of subject matter, as has been done with the old houses and street scenes of Edward Hopper. The local scene is naturally used; it is essential to the artist who knows no other. But it is not exclusively necessary in order to produce a native art. What is essential is to peer deeper into American life, as Eakins said. Even so broad a satirist as George Overbury Hart, whose easy, casual attitude toward painting is reflected in his use of the nickname "Pop," and who travelled in Italy, Egypt, Tahiti, Samoa, Hawaii, Iceland, West Indies, France, Mexico, and Morocco, seems to have gazed upon the world with unassuming American directness of vision. *A Mule Car, Mexico* (Dr. B. D. Saklatwalla, Crafton, Pa.) and an *Old French Market, New Orleans* (Brooklyn Museum, New York) seem to be not so much the caricature records of a keen-eyed wanderer as they are the genial, personal comments of the king of the hobo painters.

Although Charles Burchfield, as was suggested above, is a romantic water colorist, he too is an unaccountable figure in native painting. Born in Ohio in 1893, he did not come into contact with sophisticated modernistic art until after he had produced his "bell ringing motive," *Church Bells Ringing — Rainy Winter Night* (Miss Louise M. Dunn, Cleveland), which is "surréaliste" in spirit and which seems to depict a primitive point of view analogous to that of Alaskan Indians. He did not see the work of Van Gogh until 1929,[44] after he had painted the boldly patterned *Railroad Gantry* (Stephen C. Clark, New York) with its sweeping rails. And in 1929 he was far from the romantic mood either of his early work or of Van Gogh, as can be seen in the reserved but rich study of a suburban yard called *Sulphurous Evening* (Rehn Gallery, New York). The fact seems to be that Burchfield's subject matter has changed from the intensity of personal feelings to the intensity of a solid and objective reality. He has grown out of himself and found that *Winter Twilight* (Whitney Museum of American Art, New York) and *November Evening* (Fig. 187), which is his first oil painting and is dated 1932, are not as personal in mood as they are entities which he must recreate with matter-of-fact details. Nevertheless he might still echo Walter Savage Landor's boast, "Nature I loved; and next to Nature, Art." He darts out upon reality at such odd moments that his most accurate transcriptions seem often phantastic and imbued with a spiritual meaning of some sort. He remains a romanticist in essence. These "intimate interpretations of the common phases of existence . . . the look of an asphalt road as it lies in the broiling sun at noon," as Edward Hopper has written,[45] are most simply done, with "no time wasted on useless representation — no slavery to values, to color or to design as ends in themselves." Burchfield gives one the immediate reality of the senses without conscious style. And he is in this way one of the truest painters of the local scene today.

Grant Wood, born in Iowa a year earlier than Burchfield, began

painting with admiration for style and stylistic effects, but found at the
end of one of several trips abroad that he was not after all interested in
French art. He was interested in Iowan life. Judging by the *Woman
with Plant* (Cedar Rapids Art Association), his "first departure from his
former style," [46] he evidently began to see with a camera-like eye, and
he recorded merely what he saw. But in *American Gothic* (Chicago Art
Institute), painted shortly afterward, he revealed his mind, actively ar-
ranging the most obvious details of costume and setting into a coolly
critical record of a farmer and his wife. Although the artist seems in
such portraits to be wholly realistic, his landscapes, for instance the
Fall Ploughing (Walker Galleries, Inc., New York), show, in addition to
his detached interest in actuality, a taste for bulbous, luxurious curves
which seem to grow out of a desire to enhance reality. It is obviously
too soon to say how far this combination of plain fact and emotional
generalization will carry him. But at least the effort to paint *Nan*
(Fig. 188) with feeling and to make over the local scene into something
aesthetic, as in *Dinner for Threshers* (Stephen C. Clark, New York), illus-
trates again the current struggle for independence from foreign artistry.

Molly Luce, several years younger than Wood and Burchfield, has
calmly undertaken widely contrasted scenes of New England life in
which realism is but thinly obscured by her obvious feeling for the
moods and rhythms of events. *Beach at High Tide* (Metropolitan Mu-
seum, New York) combines a succession of details faithfully studied in a
sweeping pattern which is in itself also typical of a certain portion of the
Rhode Island coast; yet the whole is a generalization. In her earlier
work, as in *The Zoo* (Whitney Museum of American Art, New York),
her point of view seems to have been faintly satirical, the details of
people and trees being manipulated for a smile's, as well as a pattern's,
sake. But her latest canvases, while retaining her characteristic insist-
ence on the individuality of each form represented, exist as units of ex-
perience, as does the *Full Moon* (Fig. 190), which shows people sledding

down a suburb street under the magic light of street lamps and house lights. Each of her paintings seems to be a final experience. The point is, of course, that her concern for actuality is so compelling that she is apparently led by her subject matter and its exacting moods to subordinate her early analytical, and perhaps technical, interests to the fundamental truth of "That's the way it was." Her painting is not feminine in being a weaker kind of masculine art; but it is subtle and intuitive. She also is struggling to reveal her native background and to give a *Reading from Robert Frost* (Walker Galleries, Inc., New York) the hard-headed sense and sensitivity which is found north of Boston.

Reginald Marsh's subjects are far less subtle, but no less native. An artist of the city and its crowds, a draftsman with newspaper experience, an etcher and water colorist, he may range occasionally over the fields occupied by Burchfield and Hopper, but his true interest lies in the ceaseless rhythm of people on the streets, in flop-houses, at the burlesque show, on the beach at Coney Island. *Why Not Use the "L"* (Whitney Museum of American Art, New York) gives his realistic point of view in simple terms; it is a direct transcript of a commonplace experience. Other canvases contain more motion. *Negroes on Rockaway Beach* (Fig. 189), with tossing, blatant energy, combines a painstaking study of people in action with a spontaneous dramatic arrangement. Presumably Marsh's apprenticeship drawing cartoons from vaudeville for a New York tabloid, and later cartoons for The New Yorker, has given him a lasting interest in action and gesture. But some of his work, like *The Bowery* (Metropolitan Museum, New York), reveals a search for the character of people, clothes, and scenes. It is interesting to compare his rapid, heterogeneous impressions with the more conscious "kaleidoscopic vertigo" of Thomas Benton's *City Activities* (New School for Social Research, New York) to show two independent approaches to the same kind of subject; one implies living the life portrayed, and the other an objective interpretation of life.

Undoubtedly the fast pace of the crowd challenges the city artist more than the artist who lives in less hurried communities. A critic has said [47] that Marsh "needs to ponder the old maxim of Degas that you make a crowd not with fifty figures but with five." From the painter's point of view, this is to mistake his purpose, which involves the feeling that five figures do not actually make a crowd; his problem is to make all fifty into the real thing; he is not interested in an approximated old symbol of a crowd. The same type of problem seems to have interested John Steuart Curry in painting *Baptism in Kansas* (Whitney Museum of American Art, New York), where the crowd is grouped without formality of design about a tub in the center. A close-up of the center figures probably would have conveyed the essentials of the subject in a more orderly composition; but Curry evidently does not want simplifications. It is the flat land, the big distance, and the press of forty people filling the large yard which give his work originality, just as it is the tempestuous movement of the figures dashing for the cellar in *The Tornado*,[48] painted in 1929, which makes his work effective. Even a still-life subject, he has shown, can be treated as a moving one, his solidly painted sunflower of the variety called *Russian Giant* [49] being full of energy and aspiration above its luxurious cabbage patch background. His landscape called *Spring Shower* (Fig. 191) is full of poetic implications and consciously composed so that the ground turns and runs with the motion of the sky.

In short, after considering a large number of artists who have been recently and are still painting in this country, one feels that the domination of foreign style is less important today than it was twenty years ago, or even ten. It is still visible in such exhibitions as that of Paintings from Sixteen American Cities, held at the Museum of Modern Art in December, 1933, where among a hundred canvases a mere fifth showed any effort to get away from the mannerisms and intellectual conceptions of French modernism. That this particular exhibition was

selected locally in Seattle, San Francisco, Los Angeles, Minneapolis, St. Louis, Santa Fé, Dallas, Atlanta, Chicago, Detroit, Cleveland, Pittsburgh, Baltimore, Philadelphia, Buffalo, and Boston, means that it was truly a cross section of contemporary American painting, outside of the most sophisticated art center of the United States. Although the count of one native to five foreign inspirations may not be a fixed and important ratio, it probably indicates some kind of proportion for artistic independence. That the independent minority are unequal, unorganized, and sometimes amateurish, does not mean that they are negligible; several of them have been named above for their strength and sincerity. That the one characteristic which joins them together is their dependence on fact — that is, on the likeness — indicates the only kind of attitude which seems traditional in American art.

It is scarcely necessary to add that there are different kinds of realism: that of the eye, the emotions, the mind. But it may not be obvious that there is only one attitude which permits any kind of realism to thrive, and that is one of respect for the thing seen, or the feeling aroused, or the attendant thought. The true realist conforms to experience, he does not misrepresent experience for the sake of an imposed taste or style. The aesthetic value of his records of experience depends first of all on the trueness of his experience; the more complete the character of the realist, the more pointed the value is apt to be. In this sense, then, the tradition here described consists of a succession of individual records linked by a common point of view, and not developing out of one another as in European traditions, from master to pupil. Although American realism seems at its clearest to ignore aesthetic qualities as such, and theories of design, of movement, and color, or formulas of representation, it does not ignore aesthetic virtues, such as craftsmanship, persevering study, and honesty of vision; therefore it cannot be dismissed as an impotent source of art, negligible when compared with the cultural sources of European art. Copley, Earl, and Peale may not

be completely satisfying to admirers of Hogarth, Reynolds, and Jacques Louis David, just as Mount, Homer, and Inness may disappoint admirers of Jan Steen, Daumier, and Corot, or Eakins seem to fall short of Goya in aesthetic stature. Nevertheless these men represent American painting at its independent best. Although their successors of the present time may still less appeal to an audience appreciative of Renoir, Degas, Cézanne, and Matisse, they also represent the American contribution to art. There they are. Their contribution is sincerely made; their honesty is beyond question; their ideals are tangible in that they go in for recognizable truths, rather than for "beauty in the large sense" as their predecessors did,[50] sometimes to the exclusion of common sense. It is fitting that this survey of their efforts as related to the efforts of their fellow-artists should end, not on an analytical, stylistic note, but on the broad chord of reality, the tradition of the limner and a heritage of likenesses. There is no substitute for vitality in painting.

NOTES

1. Dated by Wehle in 1827–28; Samuel Morse, 47, Fig. 52.
2. Edward P. Buffet, Port Jefferson, L. I., Times, 1924, Chapter XLIX of a series of articles.
3. Pageant of America, XII, 37.
4. George Caleb Bingham, by Helen Fern Rusk, 1917. The most accessible source of information on the artist is the catalogue of the Bingham Exhibition, Museum of Modern Art, New York, 1935.
5. Op. cit., II, 392.
6. Pageant of America, XII, 54.
7. Repr., The Arts, I, 50.
8. W. H. Downes, Life and Works of Winslow Homer, 1911.
9. Repr., The Arts, IV, 212.
10. Thomas Eakins, op. cit., 16.
11. Lloyd Goodrich, op. cit., 28.
12. Lloyd Goodrich, op. cit., 27.
13. Lloyd Goodrich, op. cit., 65.
14. Lloyd Goodrich, op. cit., 29.
15. Eakins, quoted by Charles Bregler, The Arts, 1931, March and October.
16. Op. cit., 525–526.
17. Pageant of America, XII, 94.
18. The Arts, VIII, 345.
19. Op. cit., 437.

20. Op. cit., 438.
21. Op. cit., 433.
22. Suzanne La Follette, op. cit., 122, 165.
23. The Art Spirit, by Robert Henri, 1923.
24. Isham, op. cit., 576.
25. Repr., The Arts, II, 35.
26. Repr., The Arts, I, no. 3, 35.
27. Quoted by Lloyd Goodrich, op. cit., 52.
28. Edward Hopper, The Arts, XI, 169.
29. Isham, op. cit., 577.
30. Repr., Memorial Exhibition, Metropolitan Museum, New York, 1925, 96.
31. Repr., Memorial Exhibition, 71.
32. Op. cit., 330.
33. Notes on Painting, Catalogue, Retrospective Exhibition of the works of Edward Hopper, Museum of Modern Art, New York, 1933, 18.
34. Creative Art, VIII, 190.
35. The Arts, XIV, 5.
36. Repr., Creative Art, VIII, 189.
37. Repr., The Arts, XIV, 6.
38. The Arts, XIV, 7.
39. Suzanne La Follette, op. cit., 319.
40. Mechanics of Form Organization, The Arts, 1926–27, November, December, January, February, and March.
41. Museum of Modern Art, 1930, April.
42. Atelier, I, 286.
43. Creative Art, VIII, 187.
44. Catalogue, Museum of Modern Art, New York, 1930, April, 6.
45. The Arts, XIV, 6.
46. Marquis W. Childs, Creative Art, X, 461.
47. Royal Cortissoz, quoted in The Art Digest, VII, no. 14, 16.
48. Walker Galleries, Inc., New York; Repr., The Arts, XVI, 415.
49. Walker Galleries, Inc., New York; Repr., The Arts, XVI, 605.
50. Royal Cortissoz, Creative Art, XII, 20.

BIBLIOGRAPHY

BIBLIOGRAPHY

The principal books used in the foregoing criticism are:

British Painting, by C. H. Collins Baker and Montague R. James, Boston, 1933

Portraits of Early American Artists, by Thomas B. Clarke, Philadelphia (*sic*) Museum of Art, 1928, no illustrations

Portraits of the Founders, by Charles K. Bolton, Boston, vols. I and II, 1919, vol. III, 1926

Seventeenth Century Painting in New England, edited by Louisa Dresser, Worcester, Mass., 1935

Early American Painters, by John Hill Morgan, New York, 1921

Early American Painting, by Frederic Fairchild Sherman, New York, 1932

Robert Feke, by the Rev. Henry Wilder Foote, Cambridge, 1930

History of the Arts of Design, by William Dunlap, Bayley-Goodspeed edition, Boston, 1918, 3 vols.

The American Spirit in Art, by Frank Jewett Mather, Pageant of America, vol. XII, 1927

Art and Artists in Provincial South Carolina, by the Rev. Robert Wilson, Charleston Year Book, 1899

Notes Concerning Peter Pelham, by William H. Whitmore, Cambridge, 1867

Thomas Eakins, His Life and Works, by Lloyd Goodrich, New York, 1933

The Copley-Pelham Letters, Massachusetts Historical Society, Boston, 1914

Five Colonial Artists, by Frank W. Bayley, Boston, 1929

Arts and Crafts in New England, by George F. Dow, Topsfield, Mass., 1927

Annals of Salem, by Joseph Felt, Salem, Mass., and Boston, edition of 1849

The Diary of William Bentley, D.D., Salem, Mass., 1905–1914, 4 vols.

History of American Painting, by Samuel Isham, New York, edition of 1927, Supplement by Royal Cortissoz

Book of the Artists, by Henry T. Tuckerman, New York, 1867

American Miniatures, by Harry B. Wehle, New York, 1927, with Biographical Notes by Theodore Bolton

Life and Works of Gilbert Stuart, by George C. Mason, New York, 1879

Samuel Morse, by Harry B. Wehle, New York, 1932, including a catalogue of the Exhibition held at the Metropolitan Museum of Art, New York

Jacob Eichholtz, Lancaster County Historical Society Papers, XVI, no. 10, 1912, Supplement

Early American Wall Paintings, by Edward B. Allen, New Haven, Conn., 1926

Art in America, by Suzanne La Follette, New York, 1929

Jeremiah Dummer, Craftsman and Merchant, by Hermann F. Clarke and the Rev. Henry Wilder Foote, Boston, 1935

Additional references may be found in the footnotes. For a large and complete bibliography of the subject see the references in the third volume of Dunlap's History, Bayley-Goodspeed edition, and in The History of American Painting by Samuel Isham, mentioned above. For additional illustrations of pictures by American artists, see The American Spirit in Art by Frank Jewett Mather, which is the twelfth volume of the general survey, the Pageant of America. The catalogue of the Whitney Museum of American Art, New York, contains many illustrations of the work of contemporary painters. References in the text to paintings sold in New York are taken from the American Art Association catalogues as follows: American Historical Portraits, Estate of Hiram Burlingham, sale number 4076, New York, January 11, 1934; and Early American Portraits collected by Thomas B. Clarke, January 7, 1919.

ILLUSTRATIONS

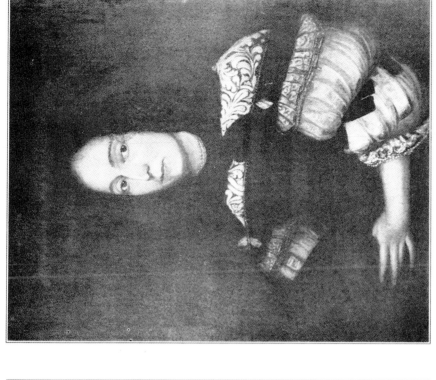

2. MRS. NICOLAS ROBERTS, ANTE 1675

Massachusetts Historical Society, Boston

1. PETER STUYVESANT, ANTE 1665

New York Historical Society

4. JOHN DAVENPORT, 1670
Yale University, New Haven, Conn.

3. CALEB HEATHCOTE
New York Historical Society

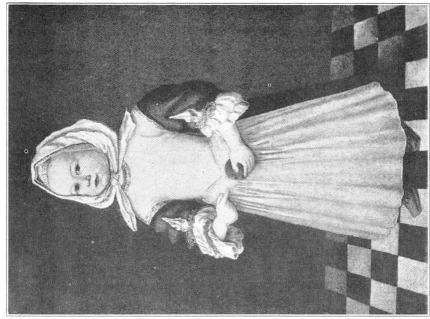

6. JOHN QUINCY (OR ALICE MASON?), 1670
Adams Memorial Society, Quincy, Mass.

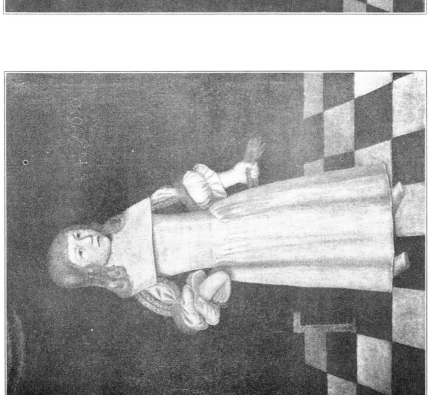

5. ROBERT GIBBS, 1670
Theron J. Damon, Waban, Mass.

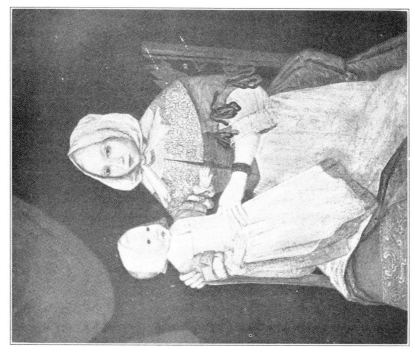

7. JOHN FREKE, 1674?

Mrs. William B. Scofield and Andrew Wolcott Sigourney,
Courtesy of the Worcester Art Museum

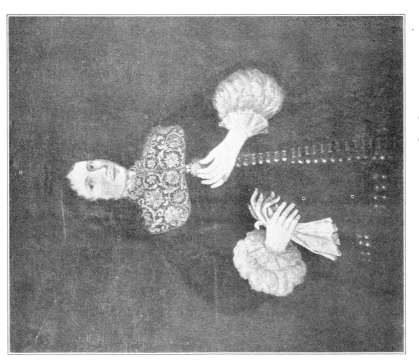

8. ELIZABETH FREKE WITH BABY MARY, 1674

Mrs. William B. Scofield and Andrew Wolcott Sigourney,
Courtesy of the Worcester Art Museum

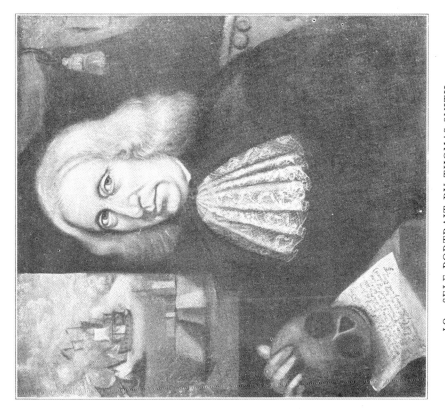

10. SELF-PORTRAIT BY THOMAS SMITH

Edmund B. Hilliard, Courtesy of the American Antiquarian Society, Worcester

9. GEORGE CURWEN, DETAIL

Essex Institute, Salem, Mass.

12. MAJOR THOMAS SAVAGE, 1679

Henry L. Shattuck, Boston

11. MRS. PATTESHALL WITH HER BABY, CA. 1674?

Miss Isabella Curtis, Boston

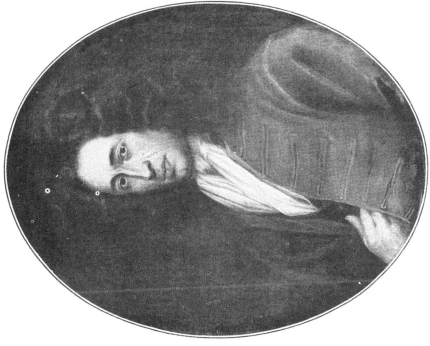

14. SELF-PORTRAIT BY JEREMIAH DUMMER? 1691?

Paul M. Hamlen, Boston

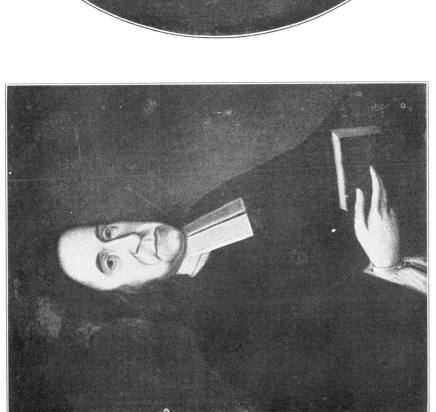

13. REV. THOMAS THACHER?

Old North Church, Boston

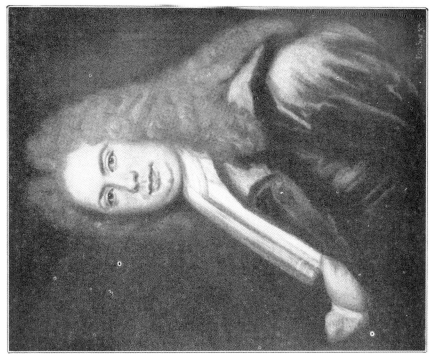

16. RICHARD MIDDLECOTT? BY N. BYFIELD? 1713

Mrs. Richard M. Saltonstall, Boston

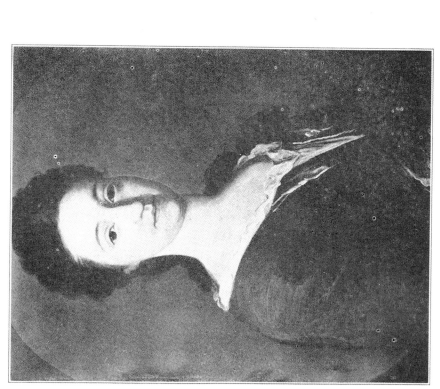

15. MRS. MARY HOOKER PIERPONT, 1711

Allen Evarts Foster, Courtesy of the Gallery of Fine Arts,
Yale University, New Haven, Conn.

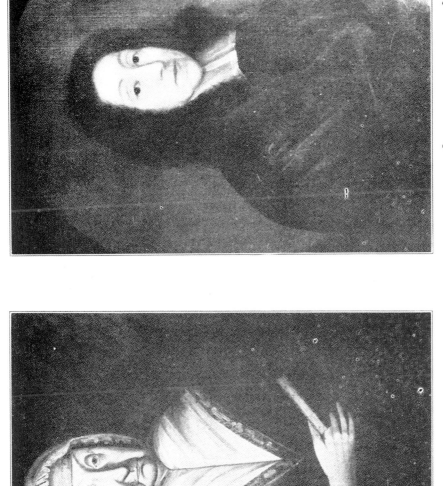

18. REV. JOHN WILSON?

Massachusetts Historical Society, Boston

17. ANNE POLLARD, 1721

Massachusetts Historical Society, Boston

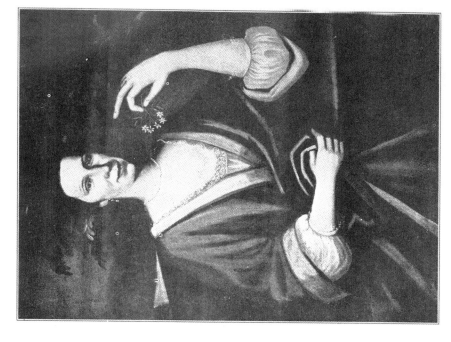

19. WILLIAM STOUGHTON, 1701?

Harvard University, Cambridge, Mass.

20. MARIA VAN ALEN BY PIETER VANDERLYN, 1721

New York Historical Society

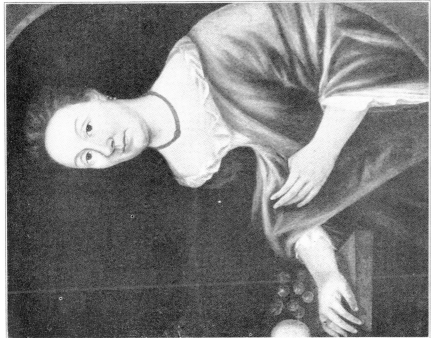

22. MRS. GERRET DUYCKINCK
BY GERRET DUYCKINCK

New York Historical Society

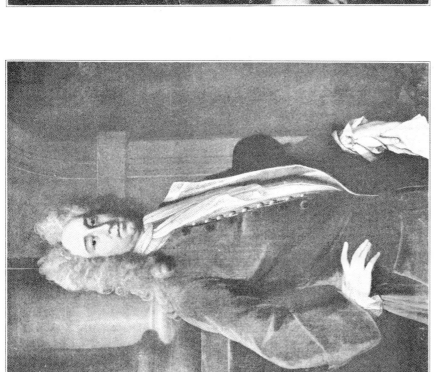

21. GOV. HUGH DRUYSDALE, 1725
BY CHARLES BRIDGES

Ehrich-Newhouse, Inc., New York

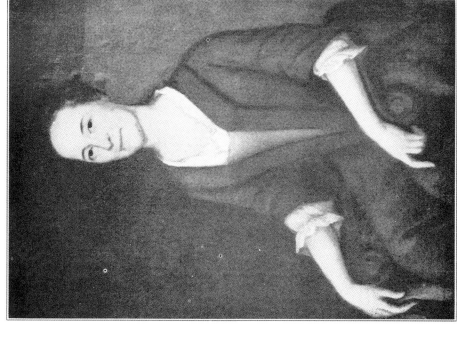

24. MRS. GUSTAVUS HESSELIUS
BY GUSTAVUS HESSELIUS

Historical Society of Pennsylvania, Philadelphia

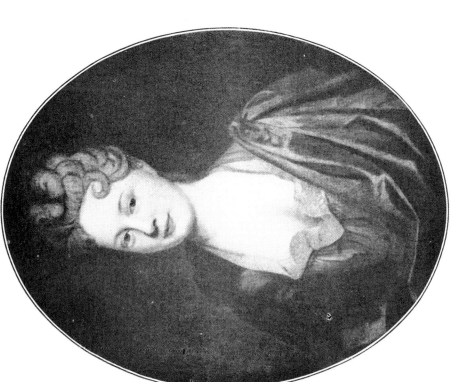

23. MARY HET SMITH
BY GUSTAVUS HESSELIUS, 1729

Cleveland Museum

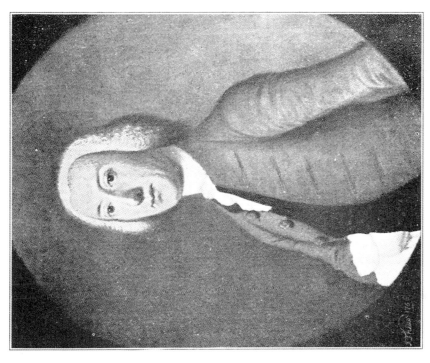

26. DR. LIONEL CHALMERS BY JEREMIAH THEUS, 1756

Ehrich-Newhouse, Inc., New York

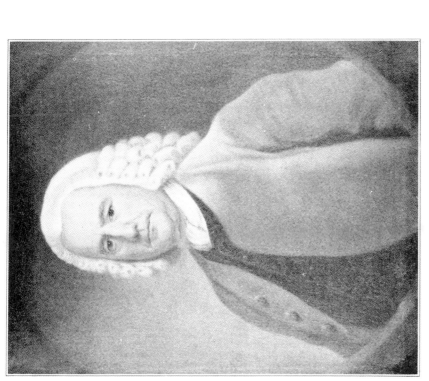

25. THEODORE ATKINSON? BY JEREMIAH THEUS, 1755

Mrs. C. Wharton Smith, Boston

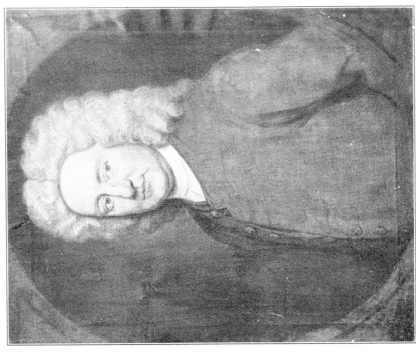

28. GOV. WILLIAM GREENE BY PETER PELHAM, 1750

Charles Pelham Curtis, Boston

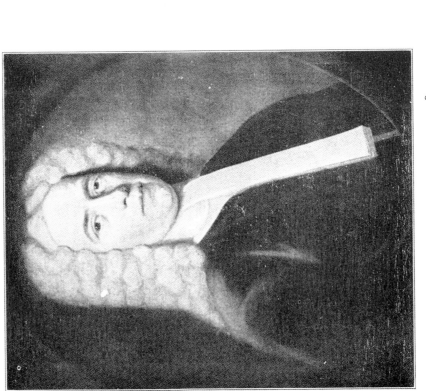

27. JUDGE QUINCY BY PETER PELHAM?

Boston Museum of Fine Arts

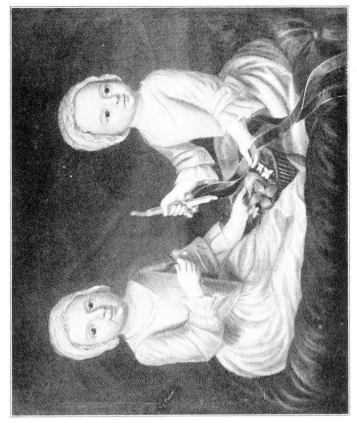

30. JOANNA AND ELIZABETH PERKINS?
Paul M. Hamlen, Boston

29. DEBORAH CLARKE
Essex Institute, Salem, Mass.

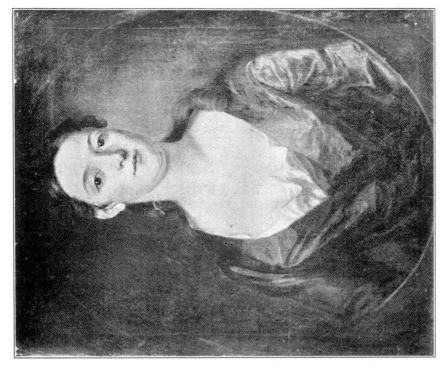

32. MRS. THOMAS BULLFINCH BY JOHN SMIBERT

Cleveland Museum

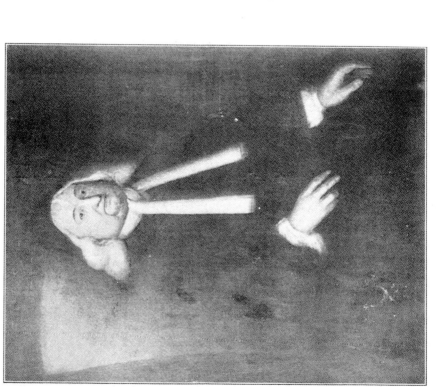

31. JUDGE SAMUEL SEWALL BY JOHN SMIBERT, 1730?

Massachusetts Historical Society, Boston

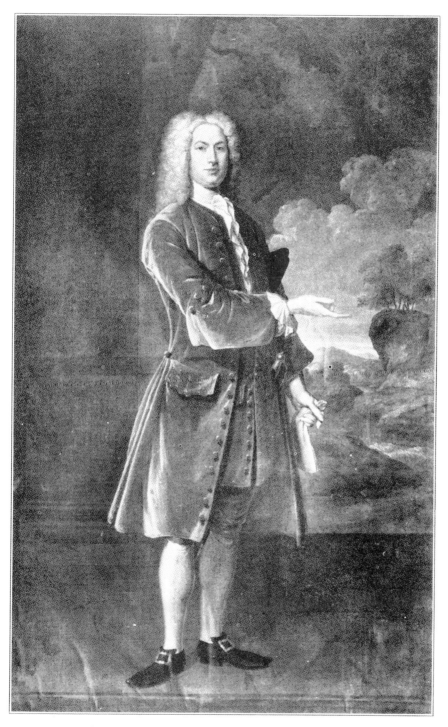

33. WILLIAM BROWNE BY JOHN SMIBERT
Johns Hopkins University, Courtesy of the Baltimore Museum

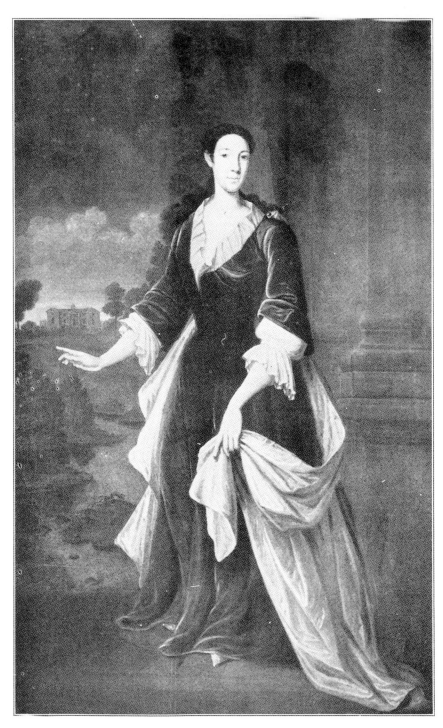

34. MRS. WILLIAM BROWNE

Johns Hopkins University, Courtesy of the Baltimore Museum

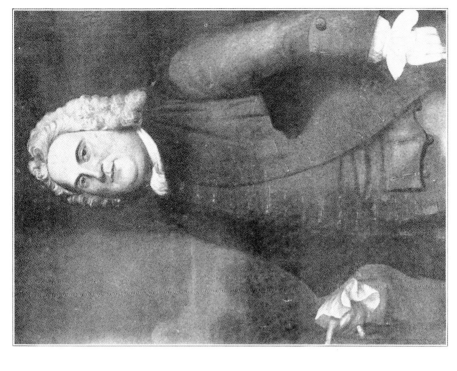

35. MRS. JAMES BOWDOIN BY ROBERT FEKE

Bowdoin College, Brunswick, Me.

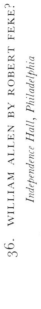

36. WILLIAM ALLEN BY ROBERT FEKE?

Independence Hall, Philadelphia

37. ISAAC ROYAL AND HIS FAMILY BY ROBERT FEKE, 1741

Harvard Law School, Cambridge, Mass.

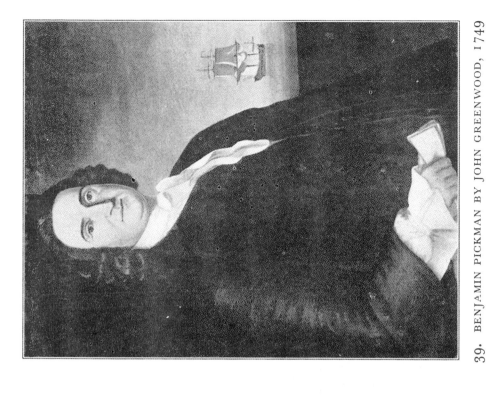

38. BENJAMIN FRANKLIN BY JOHN GREENWOOD?

Harvard University, Cambridge, Mass.

39. BENJAMIN PICKMAN BY JOHN GREENWOOD, 1749

Essex Institute, Salem, Mass.

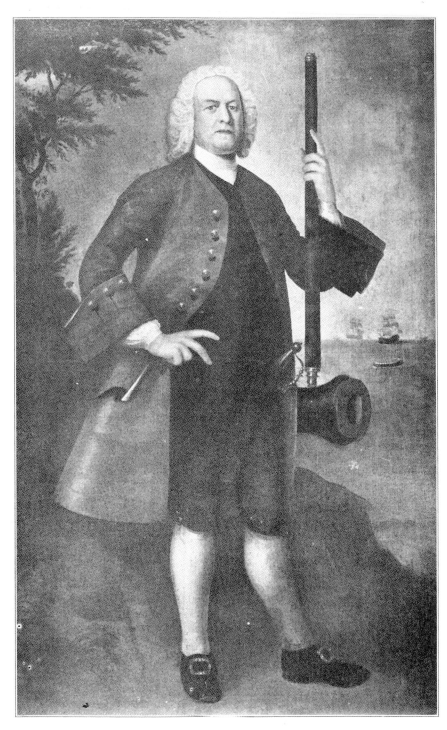

40. CAPT. JOHN LARRABEE BY JOSEPH BADGER
Worcester Art Museum

42. REV. GEORGE WHITEFIELD BY JOSEPH BADGER?

Harvard University, Cambridge, Mass.

41. MRS. JONATHAN EDWARDS BY JOSEPH BADGER

Boston Museum of Fine Arts

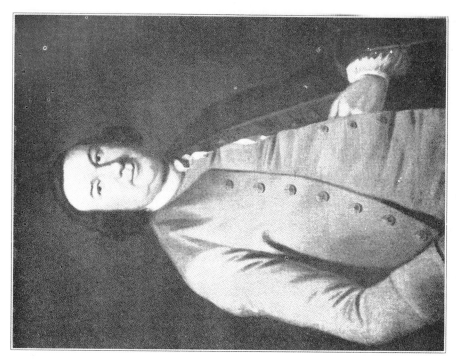

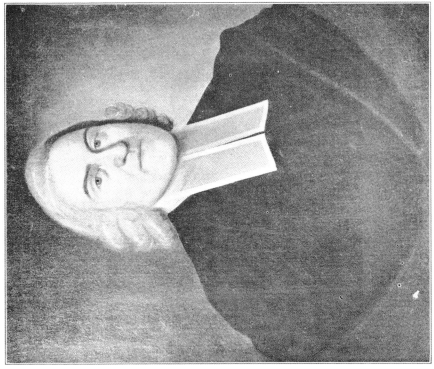

46. REV. WILLIAM WELSTEED BY JOHN S. COPLEY, 1753
Massachusetts Historical Society, Boston

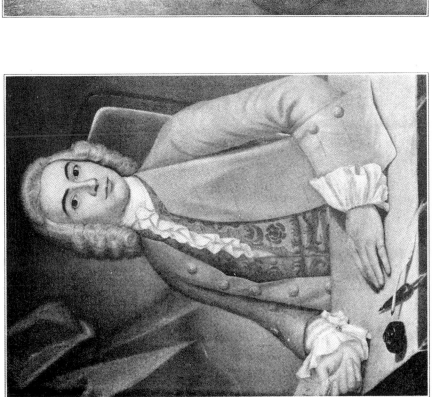

45. CHARLES (?) PELHAM BY JOHN S. COPLEY
Charles Pelham Curtis, Boston

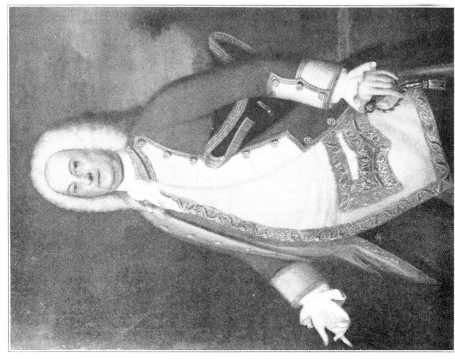

48. WILLIAM BRATTLE BY JOHN S. COPLEY, 1756
Mrs. Thomas Brattle Gannett, Boston

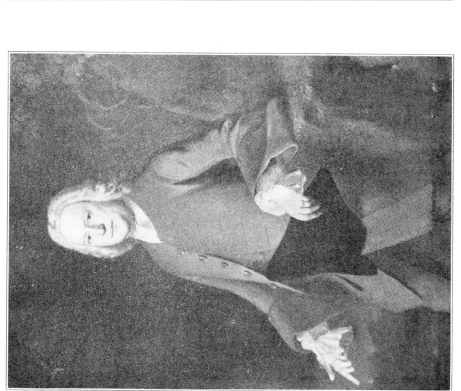

47. JOSEPH DWIGHT BY JOSEPH BLACKBURN, 1756
Berkshire Museum, Pittsfield, Mass.

50. MARY SILVESTER DEERING BY JOSEPH BLACKBURN

Metropolitan Museum, New York

49. ANN TYNG SMELT BY JOHN S. COPLEY, 1756

Miss Grace Edwards, Boston

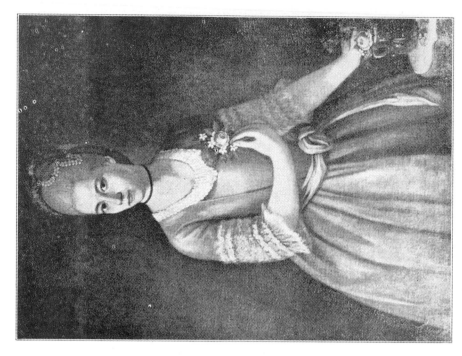

52. MRS. HENRY CARPENTER BY JOHN DURAND?

Pingree House, Salem, Mass.

51. THEODORE ATKINSON, JR., BY JOSEPH BLACKBURN

Rhode Island School of Design, Providence

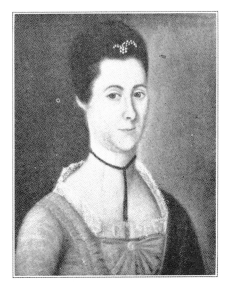

53. ELIZABETH STONE WHITE
BY BENJAMIN BLYTH
Essex Institute, Salem, Mass.

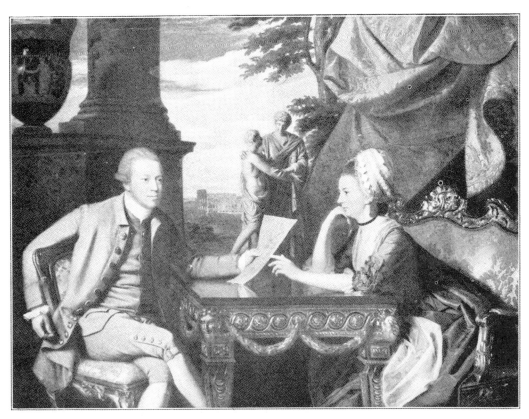

54. MR. AND MRS. RALPH IZARD BY JOHN S. COPLEY
Boston Museum of Fine Arts

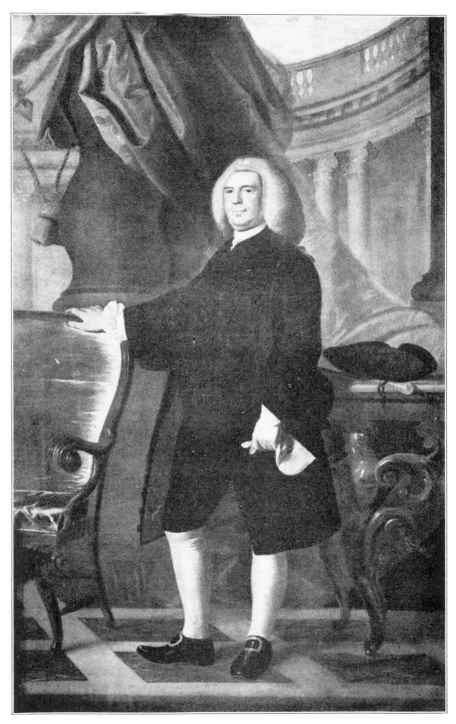

55. THOMAS HANCOCK BY JOHN S. COPLEY

Harvard University, Cambridge, Mass.

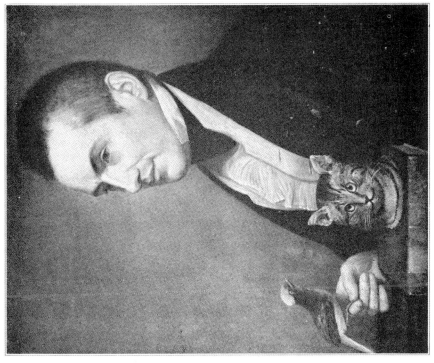

57. CHARLES WATERTON BY CHARLES WILSON PEALE

National Portrait Gallery, London

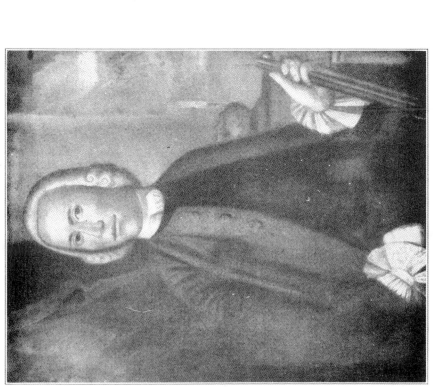

56. WILLIAM HENRY BY BENJAMIN WEST, 1756?

Historical Society of Pennsylvania, Philadelphia

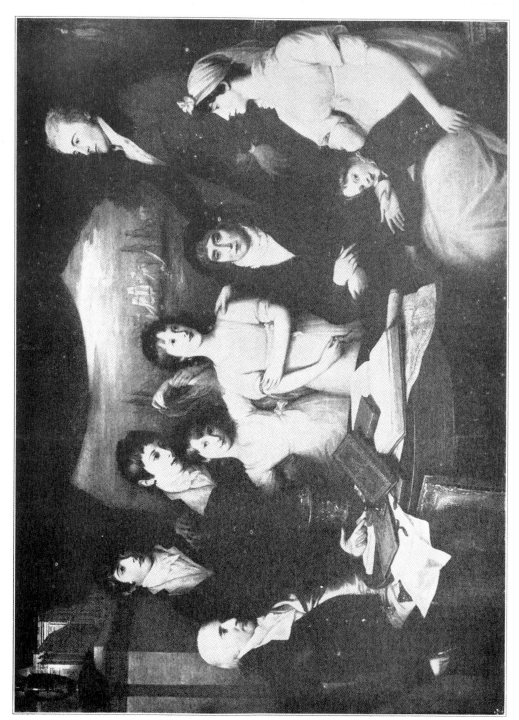

58. FAMILY OF ADRIAN HOPE BY BENJAMIN WEST

Boston Museum of Fine Arts

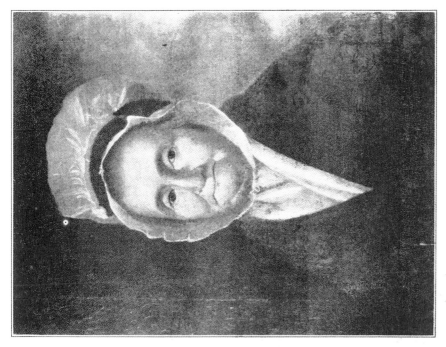

60. MRS. BENJAMIN MUMFORD
BY SAMUEL KING

Newport Historical Society, Newport, R. I.

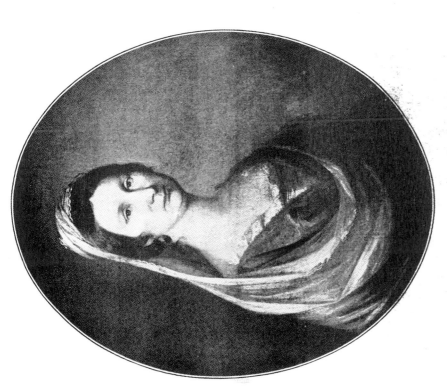

59. ELIZABETH COLDEN DE LANCEY
BY MATTHEW PRATT

Herbert L. Pratt, Glen Cove, L. I.

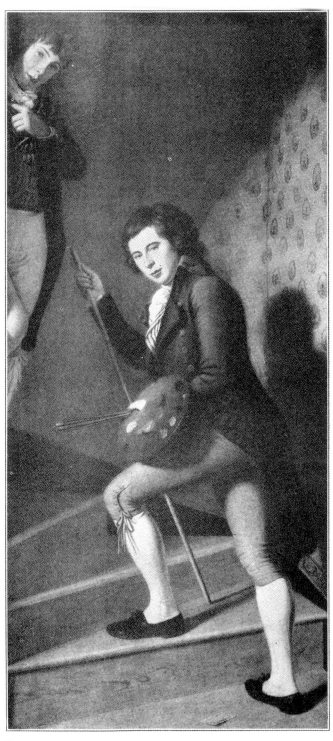

61. STAIRCASE GROUP BY CHARLES WILSON PEALE

Dr. Harold S. Colton, Courtesy of the Pennsylvania
Museum, Philadelphia

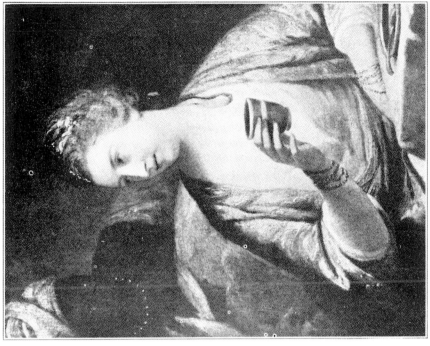

63. MRS. REID AS A SULTANA BY ROBERT EDGE PINE

Metropolitan Museum, New York

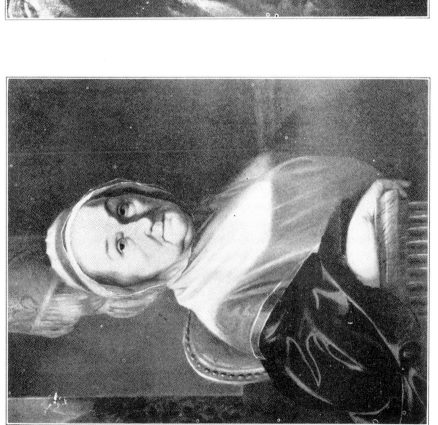

62. MRS. SIMMONS BY HENRY BENBRIDGE

Metropolitan Museum, New York

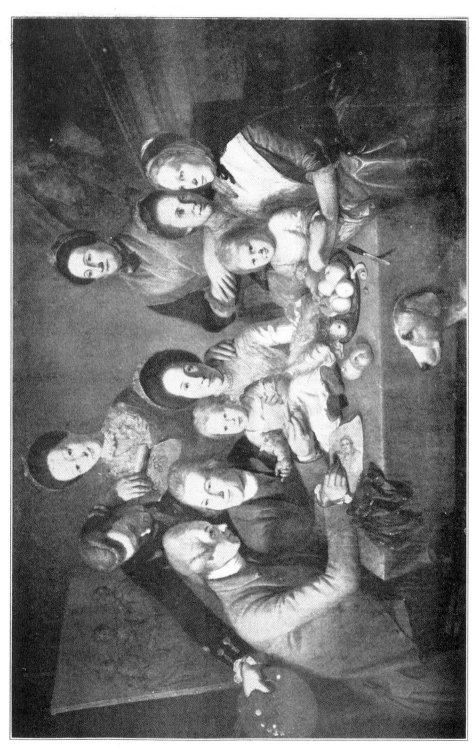

64. FAMILY GROUP BY CHARLES WILSON PEALE, 1773–1809

New York Historical Society

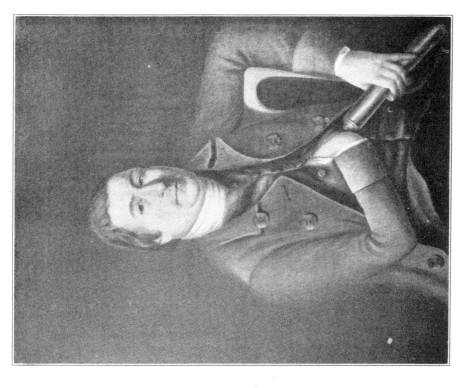

66. BENJAMIN KING
Essex Institute, Salem, Mass.

65. ROGER SHERMAN BY RALPH EARL, 1775?
Yale University, New Haven, Conn.

67. OLIVER ELLSWORTH AND HIS WIFE BY RALPH EARL, 1792

Wadsworth Athenaeum, Hartford, Conn.

68. LOOKING EAST FROM LEICESTER HILLS BY RALPH EARL, 1800

Worcester Art Museum

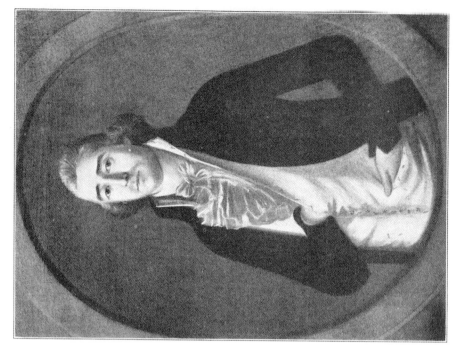

70. HENRY PENDLETON BY JAMES EARL

Worcester Art Museum

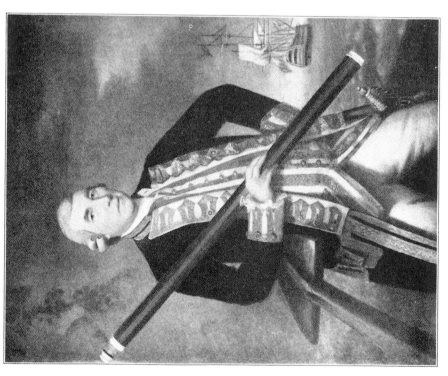

69. ADMIRAL KEMPERFELT BY RALPH EARL, 1783

National Portrait Gallery, London

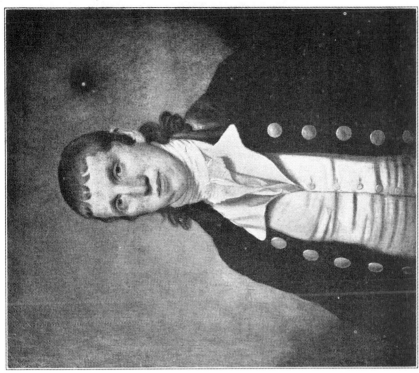

72. JOHN BUSH

American Antiquarian Society, Worcester

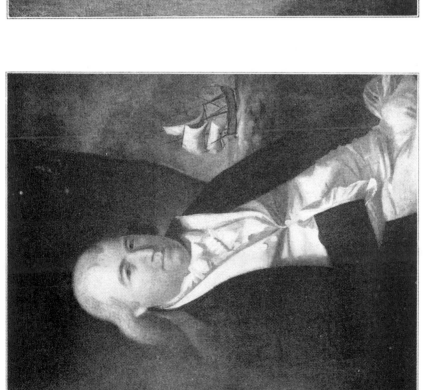

71. JOHN MCLEAN BY JOHN JOHNSTON

Harvard University, Cambridge, Mass.

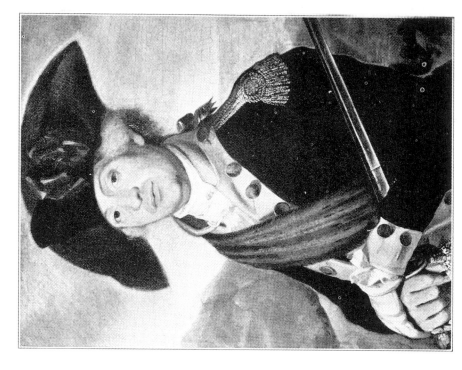

74. COL. JOHN MAY BY CHRISTIAN GULLAGER, 1789

American Antiquarian Society, Worcester

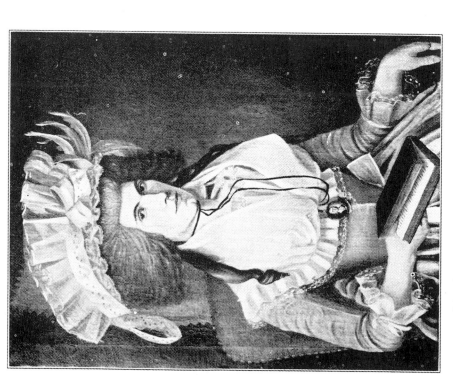

73. MRS. ABIGAIL BUSH BY MCKAY

American Antiquarian Society, Worcester

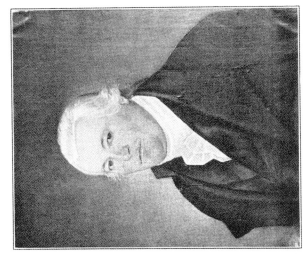

77. NOAH COOKE
BY CAPT. FITCH, 1800
Harvard University, Cambridge, Mass.

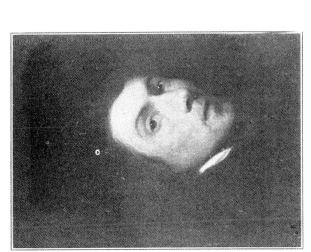

76. SELF-PORTRAIT
BY GILBERT STUART, 1778
Redwood Library, Newport, R. I.

75. JOSEPH PEABODY
BY M. F. CORNÉ, 1815
Ehrich-Newhouse, Inc., New York

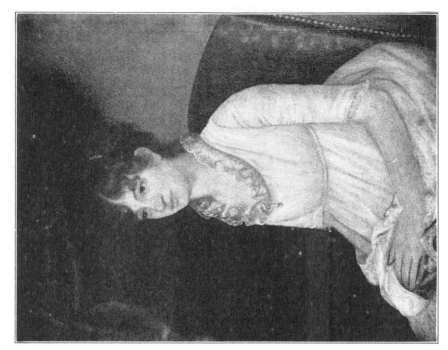

79. MARIA VAN SCHAICK BY EZRA AMES
Albany Institute of History and Art

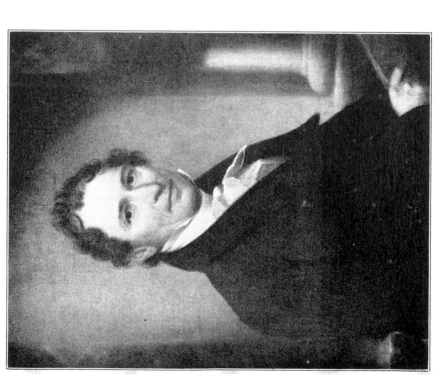

78. CLARKSON CROLIUS BY EZRA AMES, 1825
New York Historical Society

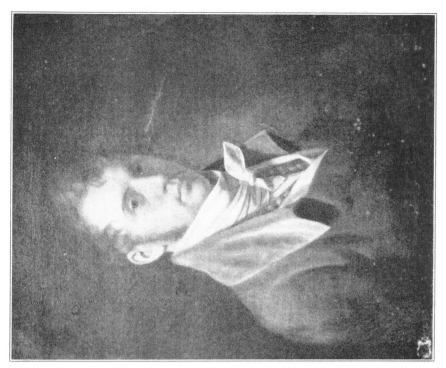

81. SELF-PORTRAIT BY JOHN VANDERLYN

Metropolitan Museum, New York

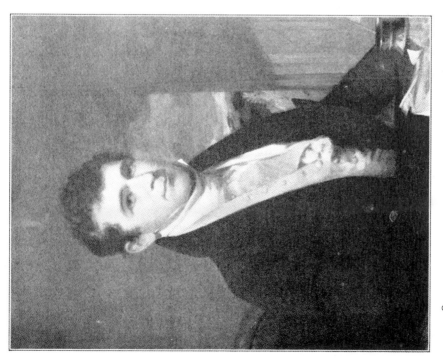

80. SELF-PORTRAIT BY ROBERT FULTON

William Rockhill Nelson Trust, Kansas City

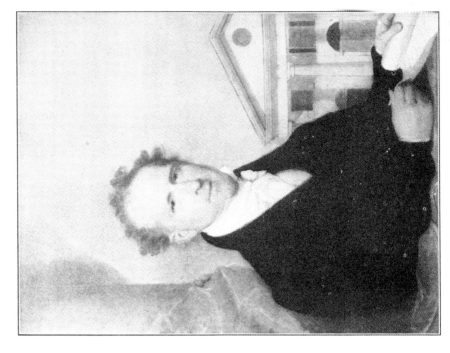

83. JOSIAH QUINCY BY GILBERT STUART, 1826
Boston Museum of Fine Arts

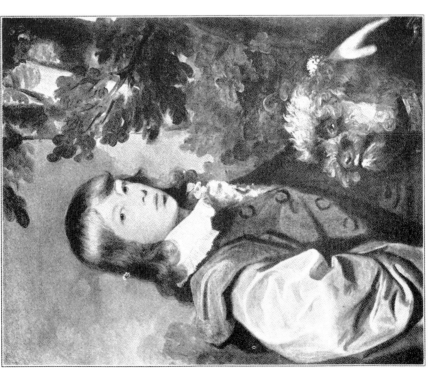

82. JAMES WARD BY GILBERT STUART, 1789
Minneapolis Institute of Arts

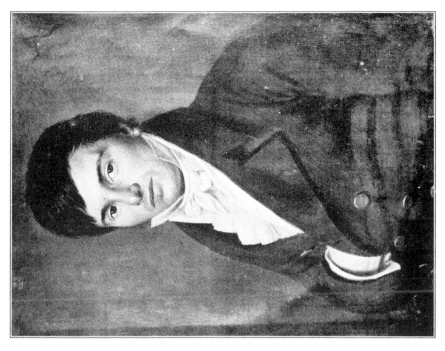

85. CAPT. WARD CHIPMAN BY M. VERVOORT, 1819

Photo. courtesy of Ehrich-Newhouse, Inc., New York

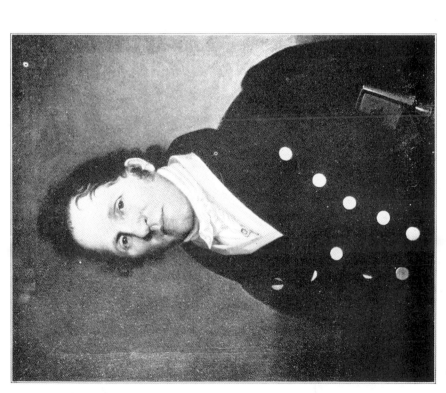

84. GEORGE W. WARING BY PHILIP TILYARD, 1823

Photo. courtesy of Ehrich-Newhouse, Inc., New York

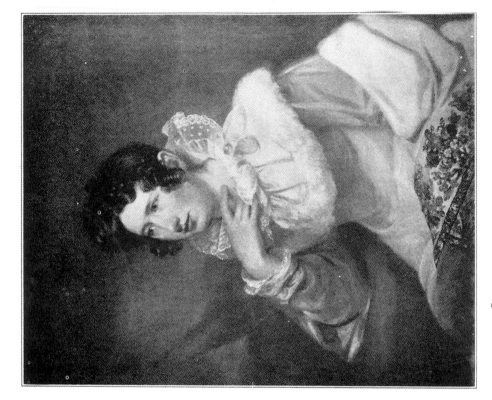

87. MRS. MORSE BY S. F. B. MORSE

Herbert L. Pratt, Glen Cove, L.I.

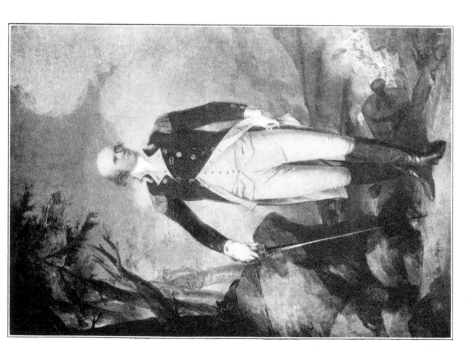

86. GOV. CLINTON BY JOHN TRUMBULL

New York City Hall

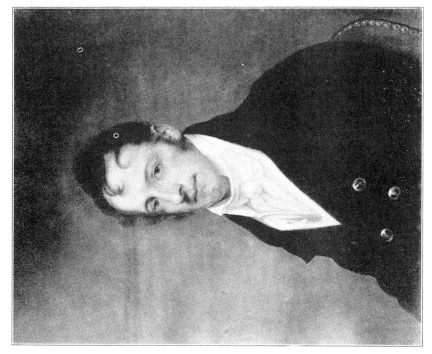

89. RICHARD PETERS, JR., BY REMBRANDT PEALE

Pennsylvania Academy, Philadelphia

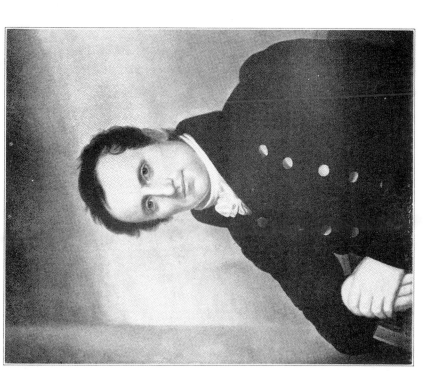

88. JAMES FENIMORE COOPER BY JOHN WESLEY JARVIS

Yale University, New Haven, Conn.

90. OLD HOUSE OF REPRESENTATIVES BY S. F. B. MORSE, 1823

Corcoran Gallery, Washington

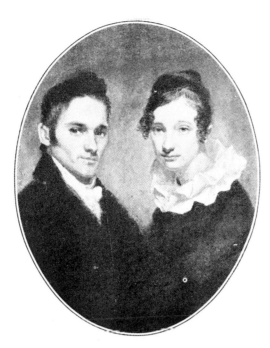

91. REV. AND MRS. BINGHAM
BY S. F. B. MORSE, 1817

*Hiram Bingham, Courtesy of the Gallery of Fine Arts,
Yale University, New Haven, Conn.*

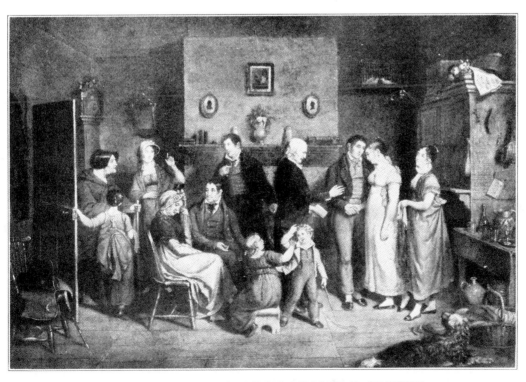

92. THE COUNTRY WEDDING BY JOHN L. KRIMMEL

Pennsylvania Academy, Philadelphia

93. HENRY CLAY BY JOHN WESLEY JARVIS

New York City Hall

95. MISS THOMPSON BY JACOB EICHHOLTZ

Worcester Art Museum

94. GEORGE SPALDING BY WILLIAM DUNLAP

Worcester Art Museum

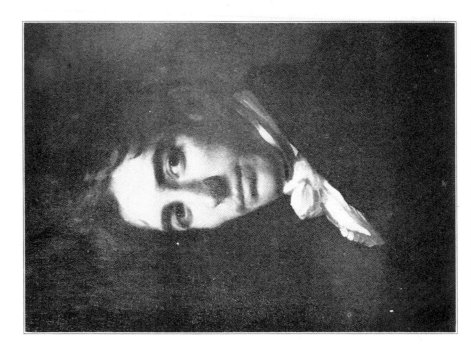

97. SELF-PORTRAIT BY ASHER B. DURAND

New York Historical Society

96. THE DINNER PARTY BY HENRY SARGENT

Boston Museum of Fine Arts

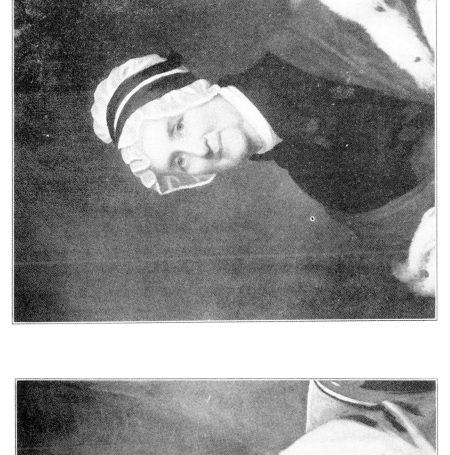

98. ELIZABETH TUCKERMAN SALISBURY
BY CHESTER HARDING
Worcester Art Museum

99. MRS. RACHEL FORRESTER BY JAMES
FROTHINGHAM
Essex Institute, Salem, Mass.

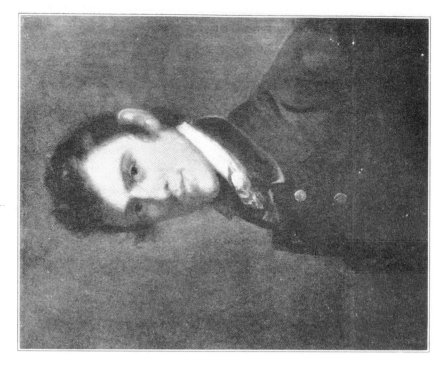

101. JOHN GRIMES BY MATTHEW HARRIS JOUETT
Metropolitan Museum, New York

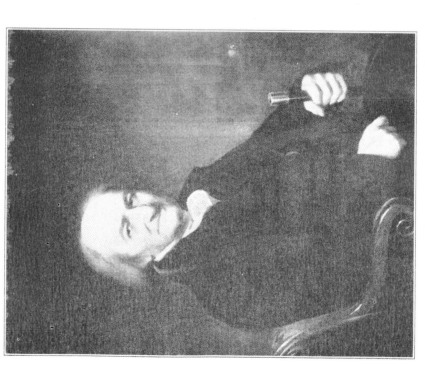

100. DAVID GRIM BY SAMUEL L. WALDO, 1812
New York Historical Society

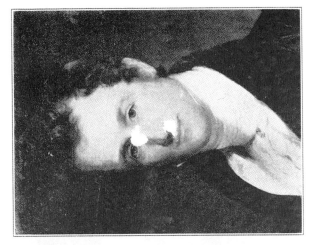

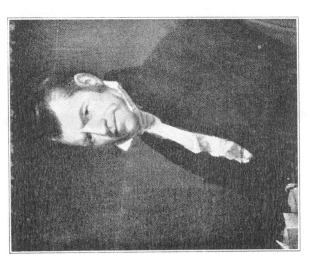

104. JOHN FINLEY
BY THOMAS SULLY, 1821

Metropolitan Museum, New York

103. THE YOUNG FISHERMAN
BY HENRY INMAN

Metropolitan Museum, New York

102. MR. REILLY
BY JOHN NEAGLE

Minneapolis Institute of Arts

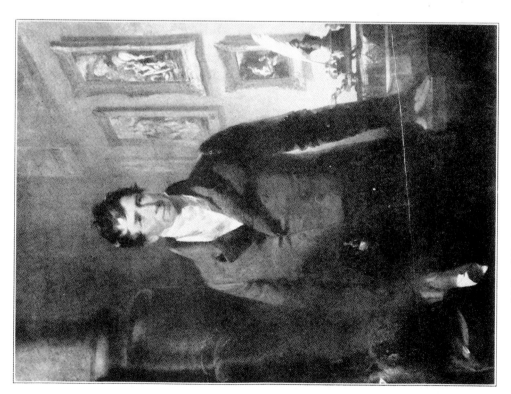

105. DR. WILLIAM P. DEWEES
BY JOHN NEAGLE
University of Pennsylvania, Philadelphia

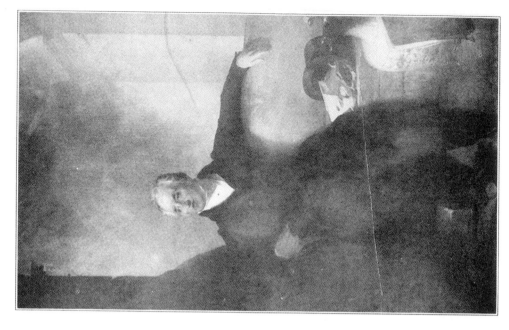

106. THOMAS HANDASYD PERKINS
BY THOMAS SULLY
Boston Athenaeum

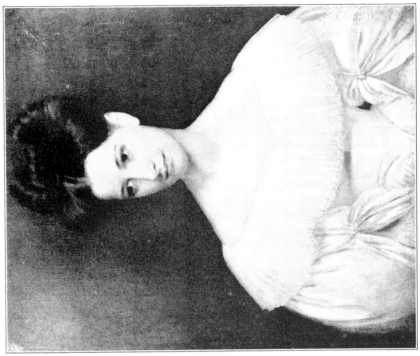

108. MRS. JARED SPARKS BY FRANCIS
ALEXANDER, 1830

Harvard University, Cambridge, Mass.

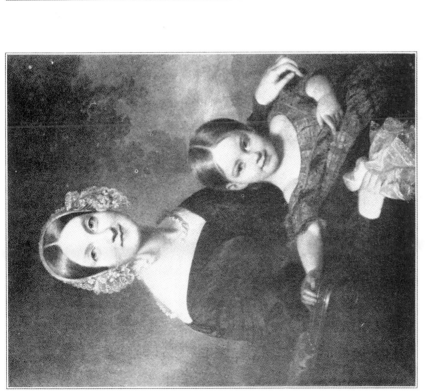

107. GEORGIANNA WRIGHT AND HER MOTHER
BY HENRY INMAN

Boston Museum of Fine Arts

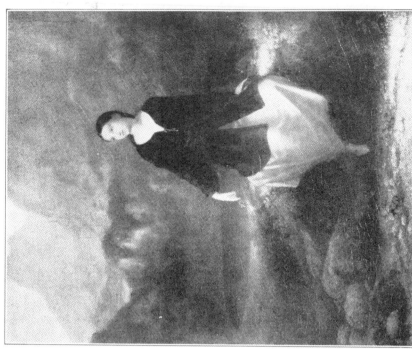

110. A SPANISH GIRL
BY WASHINGTON ALLSTON
Metropolitan Museum, New York

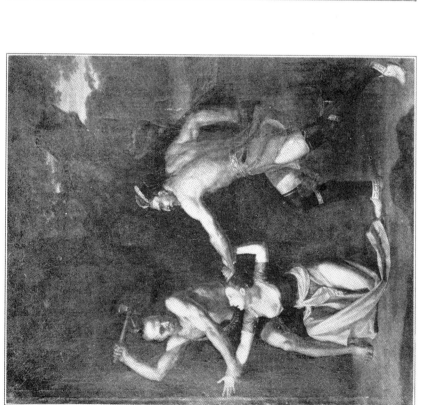

109. DEATH OF JANE MCCREA
BY JOHN VANDERLYN, 1803–05
Wadsworth Athenaeum, Hartford, Conn.

IIIA. MRS. KITTERA
BY ROBERT FULTON
Historical Society of Pennsylvania, Philadelphia

IIIB. EDWARD HOLYOKE
BY HENRY PELHAM, 1769
Paul M. Hamlen, Boston

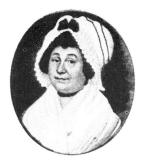

IIIC. MARGARET ROSE
BY JOHN RAMAGE
Boston Museum of Fine Arts

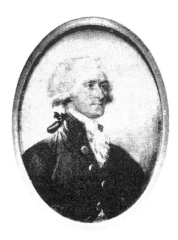

IIID. THOMAS JEFFERSON
BY JOHN TRUMBULL
Metropolitan Museum, New York

IIIE. MRS. JAMES LOWNDES
BY EDWARD G. MALBONE
Metropolitan Museum, New York

112. VIEW OF NIAGARA FALLS BY JOHN TRUMBULL
Wadsworth Athenaeum, Hartford, Conn.

113. WOODLAND INTERIOR BY ASHER B. DURAND

Addison Gallery of American Art, Phillips Academy, Andover, Mass.

114. BROOKLYN SNOW SCENE BY FRANCIS GUY, 1816–17

Brooklyn Museum, New York

115. RIVER SCENE BY JOHN F. KENSETT, 1870

Metropolitan Museum, New York

116. OXBOW BY THOMAS COLE, 1836

Metropolitan Museum, New York

117. CAMP MEETING BY WORTHINGTON WHITTREDGE, 1874

Metropolitan Museum, New York

118. MERCED RIVER BY ALBERT BIERSTADT

Metropolitan Museum, New York

119. HOME OF THE HERON BY GEORGE INNESS, 1873
Chicago Art Institute

120. DELAWARE WATER GAP BY GEORGE INNESS, 1861
Metropolitan Museum, New York

121. AUTUMN BY HOMER D. MARTIN

Metropolitan Museum, New York

122. MOONLIGHT, INDIAN ENCAMPMENT, BY RALPH BLAKELOCK

National Gallery, Washington

123. FLYING DUTCHMAN BY ALBERT P. RYDER

National Gallery, Washington

124. PETER STUYVESANT ENTERING WALL ST. GATE
BY JOHN QUIDOR, 1863

Photo. Courtesy of Robert C. Vose, Boston

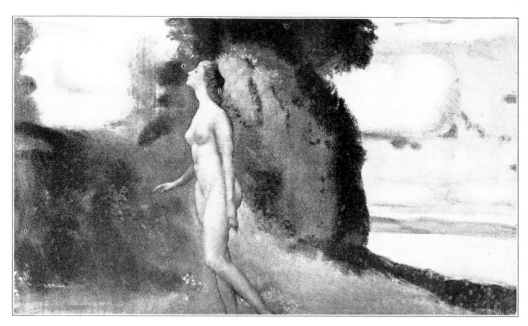

125. DREAMS BY ARTHUR B. DAVIES

Metropolitan Museum, New York

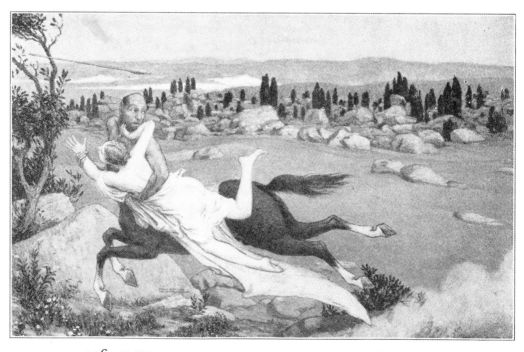

126. RAPE OF DEJANIRA BY BRYSON BURROUGHS, 1930

Herbert E. Winlock, New York

128. ROMANY GIRL BY GEORGE FULLER

Addison Gallery of American Art, Phillips Academy, Andover, Mass.

127. AUTUMN MEADOW BY ALBERT P. RYDER

Metropolitan Museum, New York

130. LIFE ON THE EAST SIDE BY JEROME MYERS, 1931

Corcoran Gallery, Washington

129. NUDE BY KENNETH HAYES MILLER

Rehn Gallery, New York

132. BENJAMIN PIERCE BY DANIEL
HUNTINGTON, 1857

Harvard University, Cambridge, Mass.

131. COL. THOMAS L. MCKENNY
BY CHARLES LORING ELLIOTT

Corcoran Gallery, Washington

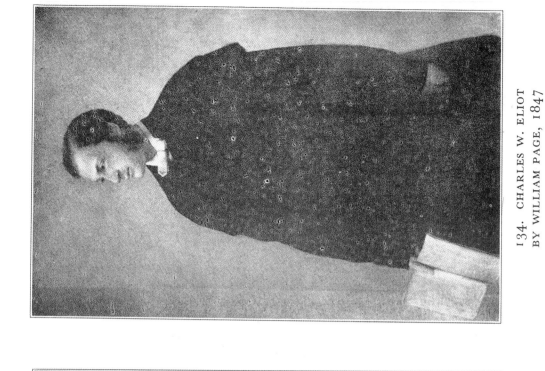

134. CHARLES W. ELIOT
BY WILLIAM PAGE, 1847

Harvard University, Cambridge, Mass.

133. CLEOPATRA DISSOLVING THE PEARL
BY HENRY PETERS GRAY, 1868

Metropolitan Museum, New York

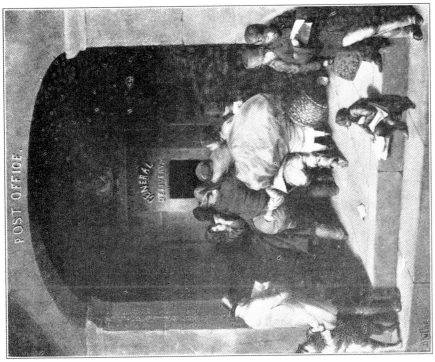

136. POST OFFICE BY DAVID G. BLYTHE

Mrs. James D. Hailman, Pittsburgh

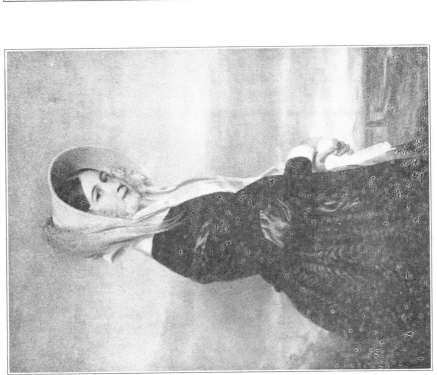

135. MRS. JOHN CRUGER BY G. P. A. HEALY

Metropolitan Museum, New York

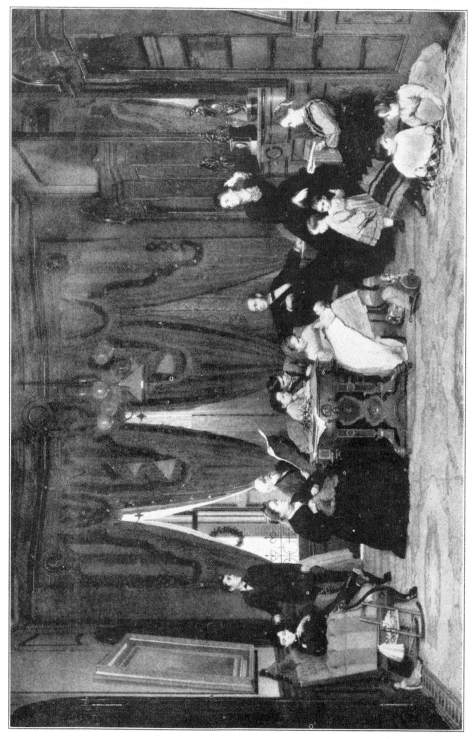

137. FAMILY GROUP BY EASTMAN JOHNSON, 1871

Metropolitan Museum, New York

139. MARY B. CLAFLIN
BY WILLIAM M. HUNT
Boston Museum of Fine Arts

138. MRS. WILLIAM F. MILTON BY ABBOTT H.
THAYER, 1881
Metropolitan Museum, New York

141. THE DRUNKARD'S WIFE
BY THOMAS W. WOOD, 1887
The Wood Art Gallery, Montpelier, Vt.

140. THE MUSIC LESSON
BY J. G. BROWN, 1870
Metropolitan Museum, New York

142. SCENE IN TAHITI BY JOHN LA FARGE

Robert Laurent, Brooklyn, N. Y.

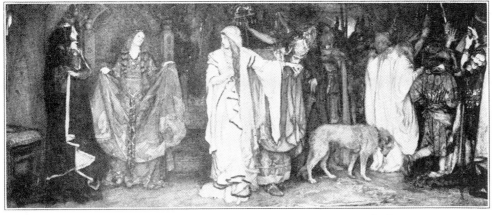

143. KING LEAR BY EDWIN A. ABBEY, 1898

Metropolitan Museum, New York

144. ATHENS BY JOHN LA FARGE, 1898

Walker Art Gallery, Brunswick, Me.

145. AUGUSTUS SAINT GAUDENS BY KENYON COX, 1908

Metropolitan Museum, New York

147. JOSEPHINE AND MERCIE
BY EDMUND C. TARBELL
Corcoran Gallery, Washington

146. HENRY GEORGE BY GEORGE DE FOREST
BRUSH, 1893–1903
Metropolitan Museum, New York

149. GUITAR PLAYER
BY JOSEPH DE CAMP, 1908
Boston Museum of Fine Arts

148. WALT WHITMAN
BY JOHN W. ALEXANDER, 1889
Metropolitan Museum, New York

151. YOUNG GIRL BY THOMAS W. DEWING
Addison Gallery of American Art, Phillips Academy, Andover, Mass.

150. THE RABBIT HUNTER BY J. ALDEN WEIR
Addison Gallery of American Art, Phillips Academy, Andover, Mass.

152. THE INLET BY J. H. TWACHTMAN

Addison Gallery of American Art, Phillips Academy, Andover, Mass.

153. COLUMBUS AVENUE, RAINY DAY, BY CHILDE HASSAM, 1885

Worcester Art Museum

154. SUNSET AND SEA FOG BY MAURICE PRENDERGAST

Phillips Memorial Gallery, Washington

155. BOAT HOUSE, WINTER, BY ERNEST LAWSON

Corcoran Gallery, Washington

156. MAINE ISLANDS BY JOHN MARIN, 1922

Phillips Memorial Gallery, Washington

157. STILL LIFE BY HENRY L. MCFEE

Metropolitan Museum, New York

158. THE ACROBAT BY WALT KUHN
Addison Gallery of American Art, Phillips Academy, Andover, Mass.

159. MY WIFE BY ALEXANDER BROOK
Corcoran Gallery, Washington

161. THE DREAM RIDE BY WILLIAM J. GLACKENS

C. W. Kraushaar, New York

160. UPPER DECK BY CHARLES SHEELER, 1929

Fogg Museum, Cambridge, Mass.

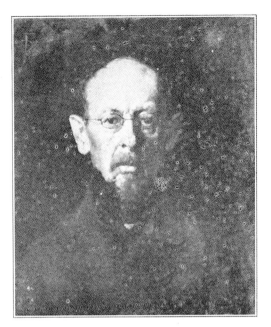

162. BLACK FLOWER AND BLUE
LARKSPUR BY GEORGIA O'KEEFFE

Metropolitan Museum, New York

163. THE OLD PROFESSOR
BY FRANK DUVENECK, 1871

Boston Museum of Fine Arts

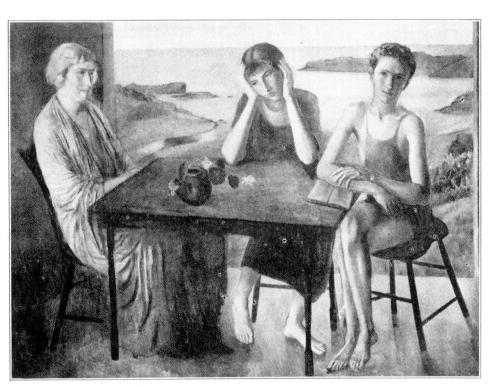

164. SUMMER BY BERNARD KARFIOL

Corcoran Gallery, Washington

165. WILLIAM WARREN BY FREDERIC VINTON, 1882

Boston Museum of Fine Arts

167. JAMES MCNEILL WHISTLER
BY WILLIAM M. CHASE, 1885
Metropolitan Museum, New York

166. WILLIAM M. CHASE
BY JOHN S. SARGENT, 1902
Metropolitan Museum, New York

169. PROF. JOSEPH H. BEALE
BY CHARLES S. HOPKINSON, 1927
Harvard Law School, Cambridge, Mass.

168. DRAMATIC DANCER
BY ROBERT HENRI
City Art Museum of St. Louis

170. THE PAINTER'S TRIUMPH
BY WILLIAM S. MOUNT, 1838
Pennsylvania Academy, Philadelphia

171. LONG ISLAND FARM HOUSE BY WILLIAM S. MOUNT
Metropolitan Museum, New York

172. RAINY DAY IN CAMP BY WINSLOW HOMER, 1871

Metropolitan Museum, New York

173. STUMP SPEAKING BY GEORGE CALEB BINGHAM, 1854

St. Louis Mercantile Library Association

174. WOODMAN AND FALLEN TREE BY WINSLOW HOMER, 1891

Boston Museum of Fine Arts

175. THE LIFE LINE BY WINSLOW HOMER, 1884

George W. Elkins Collection, Courtesy of the Pennsylvania Museum, Philadelphia

176. JOHN MCLURE HAMILTON BY THOMAS EAKINS, 1895

Stephen C. Clark, New York

178. LITTLE MADONNA
BY GEORGE LUKS

Addison Gallery of American Art, Phillips Academy, Andover, Mass.

177. MRS. MARY HALLOCK GREENWALT
BY THOMAS EAKINS, 1903

Mrs. Greenwalt, Philadelphia

179. MAX SCHMITT IN A SINGLE SCULL BY THOMAS EAKINS, 1871

Metropolitan Museum, New York

180. THE ALBANY BOAT BY GIFFORD BEAL, 1915

Metropolitan Museum, New York

181. PIGEONS BY JOHN SLOAN, 1910

Boston Museum of Fine Arts

182. FORTY-TWO KIDS BY GEORGE BELLOWS

Corcoran Gallery, Washington

183. MOUNT EQUINOX, WINTER, BY ROCKWELL KENT, 1921

Chicago Art Institute

184. TORSO OF HILDA BY EUGENE SPEICHER

Detroit Institute of Arts

185. TABLES FOR LADIES BY EDWARD HOPPER

Metropolitan Museum, New York

186. COTTON PICKERS BY THOMAS BENTON

Metropolitan Museum, New York

187. NOVEMBER EVENING BY CHARLES BURCHFIELD, 1934

Metropolitan Museum, New York

188. NAN BY GRANT WOOD, 1933

Walker Galleries, Inc., New York

189. NEGROES ON ROCKAWAY BEACH
BY REGINALD MARSH, 1934

Frances Goodrich and Albert Hackett, Beverly Hills, Calif.

190. FULL MOON BY MOLLY LUCE, 1933

Grace Horne Galleries, Boston

191. SPRING SHOWER BY JOHN STEUART CURRY, 1931

Metropolitan Museum, New York

INDEX

INDEX